Florida's

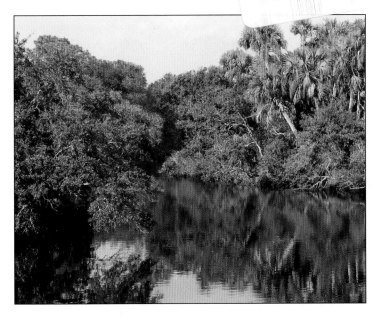

Charles R. Boning

Maps and Photographs by the Author

Pineapple Press, Inc.
Sarasota, Florida

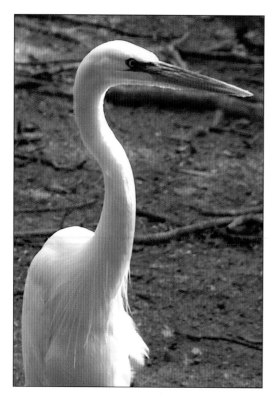

Inquiries should be addressed to:

Pineapple Press, Inc.
P.O. Box 3889
Sarasota, Florida 34230

www.pineapplepress.com

Library of Congress Cataloging-in-Publication Data

Boning, Charles R.
 Florida's rivers / Charles R. Boning ; maps and photographs by the author. — 1st ed.
 p. cm.
 Includes bibliographical references and index.
 ISBN 978-1-56164-400-1 (pbk. : alk. paper)
 1. Rivers—Florida. 2. Stream ecology—Florida. I. Title.
 GB1225.F6B66 2007
 551.48'309759—dc22
 2007023188

First Edition
10 9 8 7 6 5 4 3 2 1

Printed in China

Contents

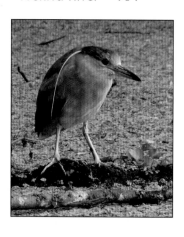

Preface

Florida's rivers comprise a tapestry of natural wonders. They support rich ecosystems. They define the landscape and lend character to the regions through which they pass. While development has touched many of these waters, others remain unspoiled. A few appear much as they did to native populations before European contact. Florida's rivers provide access to some of the most exotic locations in the eastern United States.

Those who seek to escape the pressures of modern life can find tranquility and reflection within the waters. Those determined to discover the "real Florida" may encounter this lost world in fish camps, small towns, and other enclaves along the banks. Those who seek adventure will find that Florida's rivers offer delights that surpass any of the short-lived thrills provided by theme park attractions. Indeed, anyone who spends time on or around Florida's rivers is sure to develop cherished, lifelong memories.

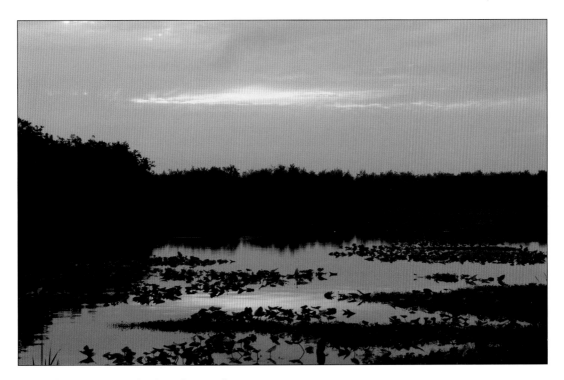

Sunset from Hontoon Island on the St. Johns River.

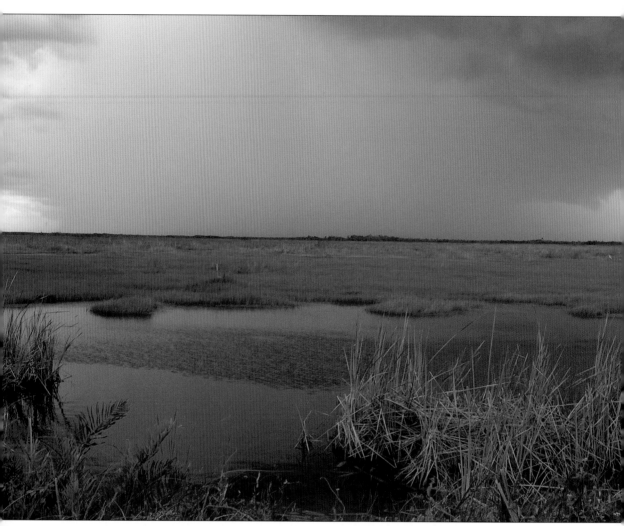

A summer shower replenishes the headwater marshes of the St. Johns River.

Introduction

This book invites the reader to embark on a journey, to follow 60 rivers from source to end. It traces the flow of these streams as they weave through cypress swamps, pine-studded hills, and hardwood hammocks. It introduces plants and animals endemic to each. It reveals the fragility and beauty of waterways that so many people depend on, but that so few people really know.

This book also takes the reader on a journey through time. It tracks the history of Florida's rivers, from the dawn of the Paleoindians through the Spanish conquest to the present. It traces human efforts to confine and harness these waters. Finally, this book looks at conservation. It examines efforts to preserve Florida's rivers and return them to their natural states.

Every river begins as precipitation. This precipitation may flow across the ground to form rivulets that converge into ever-larger streams. It may also soak into the ground, to reemerge as springs or seepages. This fallen water eventually carves a path through the land and discharges into an ocean, lake, or other water body. For purposes of this book, a river is defined as a large natural stream with unidirectional flow that passes through a defined bed or channel.

This definition excludes three types of waterways that are commonly thought of as rivers. The first is the coastal lagoon. Along Florida's east coast, many lagoons are referred to as "rivers" due to their elongate configuration. Such waterways include the Amelia River, Banana River, Guana River, Halifax River, Indian River, and Matanzas River. Because coastal lagoons lack a unidirectional current, they are not considered rivers for the purposes of this book.

The second type of waterway that is sometimes thought of as a river is the drainage canal. An elaborate network of artificial canals transects south Florida. These waterways are usually straight with U-shaped bottoms. They may be navigable, they may have a unidirectional current, and they may support complex ecosystems. However, because they are not natural components of the landscape, they do not qualify as rivers under the definition provided here.

The third type of water feature that is sometimes thought of as a river is the flowing marsh or swamp. The most prominent example is the Everglades, often referred to as the "river of grass." However, because such sheet flows lack a defined bed or channel, they do not fall within this book's definition of a river.

Rivers defy simple analysis. They display some traits associated with living organisms. They grow as they receive nourishment from tributaries and other sources. They consume the land and create new land through deposits of sediments. They are sources of energy and agents of change. They are subject to moods and phases. Rivers may be healthy or sick, based on the quality of water entering the system. If stripped of their natural components, they can even be killed.

The significance of Florida's rivers is a matter of perspective. Early Floridians viewed rivers as rich sources of fish and game, as canoe routes, and as paths of communication. During the state's economic development, Florida's rivers were thought of as convenient locations for industry, as generators of power, and, regrettably, as conveyers of waste. Today, most Floridians value rivers as key components of the natural environment.

Yet, individual outlooks continue to vary. To biologists and naturalists, Florida's rivers are corridors of life supporting

Artificial waterways, such as the Tamiami Canal, do not qualify as rivers.

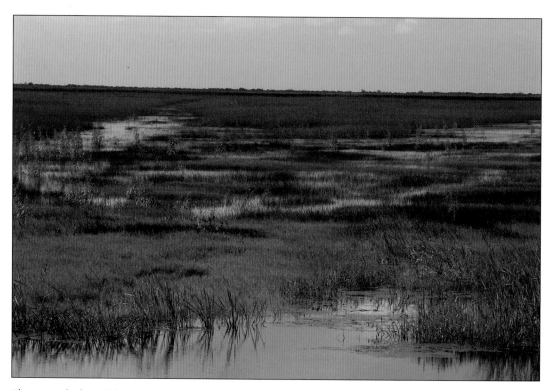

The Everglades, although not a river, derives its flow from two waterways covered within this book – the Kissimmee River and Fisheating Creek.

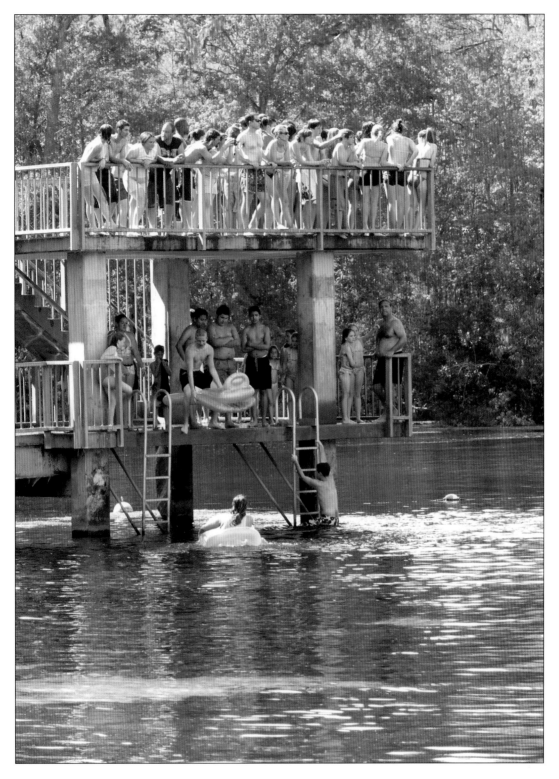

 Florida's rivers offer unparalleled opportunities for recreation. Here, Tallahassee-area teenagers enjoy a dive platform on the Wakulla River.

diverse plant and animal communities. To geologists and fossil hunters, rivers offer links to the past. To historians, they represent avenues of exploration, battlefield markers, and places of settlement. To paddlers and boaters, they are gateways to recreation. To anglers, they are a source of bounty and sport. This book attempts to capture the essence of Florida's rivers from each of these perspectives.

Florida's rivers have witnessed 25 million years of evolution and history. Mastodons, saber-toothed cats, giant ground sloughs, and giant armadillos once quenched their thirst along the shores. Their teeth and bones lie preserved in river sediments. Humans have lived along these waterways for at least 12,000 years. Prior to the arrival of the Spanish, native peoples such as the Timucua, Apalachees, and Calusas settled along river systems. When Hernando de Soto and other Spanish conquistadors ventured into the interior of Florida, they found no gold. However, they found riches of a different sort—the glittering waters of Florida's springs and rivers. During the 1800s and early 1900s, rivers played a crucial role in the development of the state. They served as avenues of trade and were plied by steamboats. More recently, the state's rivers and springs have drawn tourists from around the globe. These waterways continue to contribute to the state's image as a verdant, subtropical paradise.

Florida's rivers are also a resource under pressure. The state's population has grown from 3 million in 1950 to 17 million in 2008. Water consumption has soared. If water is withdrawn at a rate faster than it is replenished, rivers will run dry, water tables will drop, and salt water will seep inland from the coasts and contaminate underlying groundwater. These events have already affected some heavily populated areas of the state. Development has overtaken land along many rivers. Rivers have been subjected to increased recreational use by boaters, paddlers, tubers, anglers, and others. Water control projects have drastically altered the configuration of some streams. Pollution continues to plague many systems. Exotic plants and animals have multiplied and have taken over some waterways.

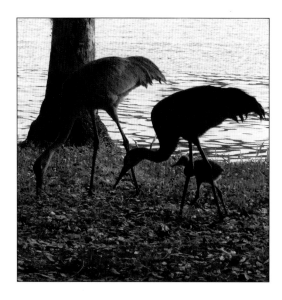

A sandhill crane pair and their offspring feed beside the Ocklawaha River.

How to Use This Book

This book consists of two parts. Part I provides a general overview of river systems and some of the forces affecting these systems. It examines rivers as components of the natural environment. It addresses concepts such as watersheds, drainage basins, and aquifers. It also looks at Florida's rivers within the human context. It assesses the physical changes that have been wrought in the nearly 500 years since Ponce de León landed on Florida's shores. Finally, it reviews efforts to protect and restore Florida's rivers.

Part II contains profiles of 60 rivers and large creeks. While this book does not cover every river in Florida, it addresses every major river and dozens of smaller waterways. The river systems covered within the text drain approximately 55 percent of the land area of the state. Small coastal streams, sinks, lakes, and marshes provide drainage for the remaining 45 percent of the state. The rivers covered within this book also drain about 30 percent of the land area of Georgia and 15 percent of the land area of Alabama. Rivers were selected based on their volume, length, biological diversity, and overall signficance. A few were included primarily as a result of their historic import or proximity to population centers. Profiles are 2, 4, 6 or 8 pages in length, depending on the significance of the waterway.

This book groups Florida's rivers according to geographic location. Each regional section covers between 6 and 9 river systems. Coverage moves from west to east across the northern part of the state, then drops south to cover the peninsula. The specific regions covered are: Western Panhandle, Central Panhandle, Eastern Panhandle, North Central Florida, Northeast Florida, West Central Florida, Southwest Florida, and Southeast Florida. Within each geographic sector, this book

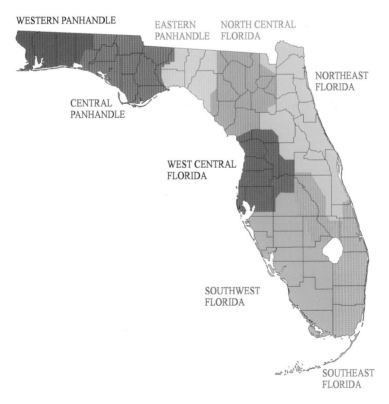

presents the rivers in alphabetical order.

The introductory pages of each river profile contain a map and a text-box summary. The 60 river maps encompass several noteworthy features. They portray the main channel of the profiled river in dark blue. They show tributaries and downstream discharges in medium blue. They show detached waterways and upstream portions of connected waterways in light blue. The maps provide greater detail in areas immediately adjacent to the profiled river so as to highlight that waterway. While the maps show county borders within Florida, they do not show county borders in adjoining states. To avoid confusion, most boundaries that follow river systems are omitted.

The text box summary provides a quick overview of the river. The first item shows the type of river, noting whether the river is predominantly alluvial, blackwater, coastal, or spring fed. The second item identifies the material lining the riverbed. The third item ranks the ecological condition of the river with from 1 to 5 stars. The ranking is derived from criteria such as water quality, human modification, biodiversity, the presence of non-native species, shoreline development, land use within the basin, pressures from recreational use, and the amount of trash present in and along the waterway. The fourth item lists the government entity with jurisdiction over the waterway. Florida's five water management districts are the Northwest Florida Water Management District (NWFWMD), the Suwannee River Water Management District (SRWMD), the St. Johns Water Management District (SJWMD), the Southwest Florida Water Management District (SWFWMD) and the South Florida Water Management District (SFWMD). The fifth item shows whether the river is the subject of any special government designations.

The categories addressed are Outstanding Florida Water (OFW), Canoe Trail (CT), Aquatic Preserve (AP), Federal Wild and Scenic River (WSR), and Florida Wild and Scenic River (FWSR). The final two items show the length of the river and the area of the river basin.

For rivers that receive significant input from springs, this book provides tables of major springs within each basin. Latitude and longitude are given in decimals rather than in minutes and seconds. Locations are approximate and should not be used for purposes of navigation. The average discharge rates are displayed in cubic feet per second (cfs). Discharge rates can vary dramatically with the year and season. Therefore, the rates shown should be viewed only as a general gauge of the strength of each spring or spring group.

The text also follows a specific format. The first section addresses geography and hydrology. It describes the source, route, major tributaries, and physical features of each river. Geographic descriptions begin upstream and proceed downstream.

The second section addresses the role of each river in the history of the state and region. It is organized chronologically, often beginning with indigenous populations that inhabited the region. Where information is available, this book explores the role of each river in the Seminole Wars and Civil War. In some cases, this book looks at early industries that were associated with the river basin.

The third section discusses human impact on each system, including pollution, development, dams, dredging, and land use. Water quality within each system changes over time and varies with location. Therefore, any statement regarding water quality should be viewed as a general indication, rather than as part of any formal ranking system. For more precise information, readers should consult the latest data provided by Florida Department of Environmental Protection pursuant to the Clean Water Act.

The fourth section identifies recreational opportunities afforded by each river. Where appropriate, it describes fish-

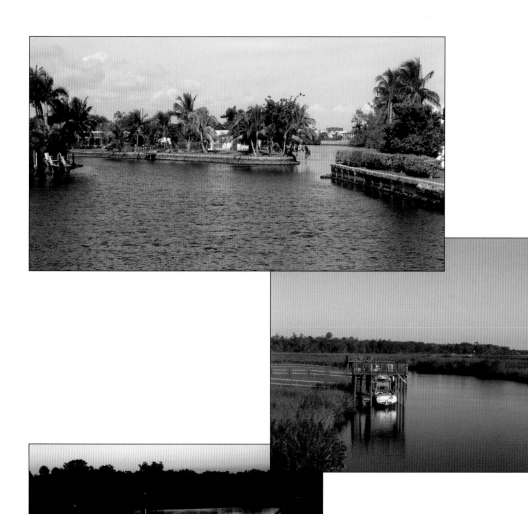

Several small coastal rivers are not covered in this book. These photographs show (from top to bottom) the Middle River of Broward County, Spruce Creek of Volusia County, the Pithlachascotee River of Pasco County, and the Imperial River of Lee County.

ing, boating, and activities available on public land surrounding the river. The text provides general notes on canoeing and kayaking. However, the reader who is considering a paddling excursion should refer to a paddling guide for detailed information concerning access points, routes, and potential hazards.

The fifth and final section discusses plants and animals found within each river basin. While the text describes species that the casual observer may see, it also focuses on rare and endangered species. The animals and plants listed represent an informal sampling, and do not comprise an inventory. Birds, reptiles, fishes, bivalves, gastropods, dragonflies, and shoreline plants are treated in some detail.

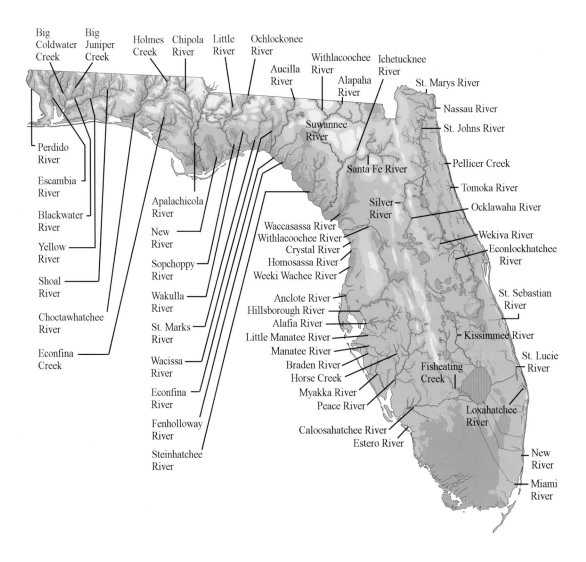

Part I
An Overview of Florida's Rivers

Rivers derive their character from the environment. They reflect the local topography, geology, climate, ground cover, land use, and other variables. While Florida's rivers bear an outward resemblance to rivers in many parts of the nation, they are also unique in their physical and biological makeup. Most bear the stamp of some or all of the four factors described below.

First, the topography of the state is relatively flat. The highest point, Britton Hill in Walton County, is a mere 345 feet above sea level. The average elevation is only about 100 feet above sea level. As a result, Florida's rivers do not tumble through steep canyons. They do not hurl themselves over rocky precipices. Florida's rivers tend to be quiet, low-gradient streams. Most have a gentle current and wander across the coastal plain in broad loops. A few exceptions exist. Minor rapids appear on sections of Econfina Creek, and on the Aucilla, Hillsborough, and Suwannee Rivers. As a result of the state's flat landscape, the water table approaches the surface in many locations and gives rise to vast wetlands. Many rivers have extensive interfaces with these wetlands and are surrounded by cypress swamps and sluggish backwaters.

Second, the state's porous limestone foundation exerts a strong influence on its waterways. Some rivers in north Florida have carved narrow gorges through this bedrock. Others rise from underground aquifers or disappear into limestone sinks. Florida contains by far the largest number of springs of any state in the nation. These features and many others can be attributed to the limestone deposits that underlie the state. This karst landscape, as it is called, is the subject of additional discussion in the sections that follow.

Third, proximity to the coast influences the makeup of Florida's rivers. No part of the state is located more than 100 miles from the Atlantic Ocean or Gulf of Mexico. Rivers that empty into these bodies are subject to tidal influence. The mouths of many rivers give rise to extensive brackish estuaries. A few rivers flow with brackish water as a result of contact with subsurface salt deposits. Predominantly saltwater fishes have infiltrated many of the state's freshwater systems. Regular distinctions between salt water and fresh water are therefore blurred.

Finally, Florida's climate affects the character of its rivers. The humid subtropics, which span much of the state, support specialized flora and fauna. Many species that inhabit Florida's waterways are endemic only to Florida. Some species are more closely associated with the Caribbean region than with the North American continent. Irregular rainfall patterns cause the state to suffer intermittent periods of drought and flood. Tropical storms and hurricanes serve to compound fluctuations in river levels. Florida's unique climate gives rise to unique ecosystems. These, in turn, influence the appearance and physical makeup of Florida's rivers.

While the foregoing discussion contains some general precepts, the text that follows provides a more comprehensive overview of Florida's rivers. It examines Florida's rivers as a resource, reviewing their geologic history and physical features. It provides a short history of drainage projects and other works that have fundamentally altered the flow of these streams. It looks at the pressures placed on Florida's rivers by a growing population. Finally, it reviews efforts to conserve Florida's freshwater resources.

Florida's Freshwater Resources

Florida has vast freshwater features, including 7,700 named lakes, and 1,700 rivers, creeks, and streams. Significant rivers and streams encompass over 12,000 linear miles of waterways. Rainfall in Florida averages 53 inches per year, making it the second wettest state in the nation. This rainfall amounts to an average of about 150 billion gallons per day. More than two thirds of this amount is lost to evaporation. The remainder is absorbed into the earth, is consumed by people, plants, and animals, or flows over the land as surface water.

In the subsections that follow, this book examines the physical characteristics of Florida's rivers. It contains a brief review of Florida's geologic history. It discusses groundwater and surface water features that are common to the state. It then offers an approach for classifying Florida's rivers. Finally, this chapter provides a brief discussion of the plants and animals that inhabit Florida's rivers.

Geologic History

The deep-rock foundation beneath Florida was once attached to the super-continent Pangaea. It was closely associated with the land mass that would eventually become the continent of Africa. About 210 million years ago, Pangaea split into two major continents. Gondwana was composed of the land that would eventually become Africa, South America, Australia, and Antarctica. Laurasia was composed of the land that would eventually form Europe, North America, and Asia. As Laurasia drew away from Gondwana, it dragged with it an underwater shelf—the Floridan Plateau. The Floridan Plateau remained attached to the North American plate as it slid to the northwest.

Over time, deposits of shells, bones, sand, and other sediments rained down from the water column above. These deposits formed layers of limestone and dolomite, and gradually added to the height of the Floridan Plateau. Eventually, a shallow bank formed, trailing from the southeastern tip of the North American continent. Coral reefs grew and marine life in the area prospered.

As the oceans receded, the uppermost portions of the Floridan Plateau were exposed. Florida probably first emerged from the ocean about 35 million years ago as a chain of low islands. However, the state's present form did not result from a single, gradual drop in ocean levels. Rather, the peninsula emerged sporadically over the course of millions of years. During some periods only the highest points showed above the water. By contrast, at the end of the last ice age, about 18,000 years ago, the land area of Florida was twice its present size.

Over the last 25 million years, global temperature cycles caused the ocean to advance and recede about 25 times. On each occasion the water left its mark on the land. Evidence of these rises and falls in sea level can be seen in the form of multiple dune lines paralleling the coast, exposed barrier islands, underground salt deposits, and elongated depressions that were formerly coastal lagoons. Further evidence of past incursions by the ocean can be found in the form of shells, shark teeth, and marine fossils that are present in many areas of the state.

The Floridan Plateau covers an area more than twice as large as the area of present-day Florida. It extends out well beyond the coastline, gradually falling away in the Gulf of Mexico and Florida Bay, dropping off more abruptly along the

Atlantic coast. The surface of the plateau is covered with a veneer of sand, clay, and recent sediments. This layer ranges from a few inches thick to several hundred feet thick. However, at all points, this loose material is underlain by a foundation of sedimentary rock.

While the Florida landscape is relatively flat, it is not featureless. North Florida contains a series of uplands, which comprise the foothills of the Appalachians. These uplands, which exceed 300 feet in several locations, are divided by a series of river valleys. The central ridge extends down the spine of the peninsula. It eventually fades into the coastal plain west of Lake Okeechobee. Some of this terrain is surprisingly steep and rugged. Sugarloaf Mountain, in Lake County, has an elevation of 312 feet. Other high ground can be found in connection with the narrow coastal ridge that parallels the east coast.

In many respects, Florida's rivers are a product of the geologic forces that shaped the state. Their courses often follow depressions formed by intrusions of the ocean. They carve their way through soft rock composed of marine sediments. Because of the relative youth of the land, Florida's rivers have not had sufficient time to etch deep canyons into the landscape. Yet, as will be seen from the discussion that follows, they have produced a profound impact on the land through which they pass.

Groundwater

While Florida has an abundance of surface water, most fresh water in the state is groundwater. This water is stored in huge underground reservoirs called aquifers. The aquifers occupy cracks, shafts, and grottos that riddle the state's rock underpinnings. Florida's aquifers contain over a quadrillion gallons of fresh water.

Not all of Florida is flat. These central Panhandle hills lie within the Econfina Creek watershed.

Three major aquifers are located in Florida. The largest of these is the Floridan Aquifer. It stretches from South Carolina, through coastal Georgia, and across virtually the entire state of Florida. In some locations it is near the surface. In other locations it descends to hundreds of feet below the surface. The Biscayne Aquifer is located in Miami-Dade and Broward Counties. A sand and gravel aquifer occupies portions of the western panhandle. The aquifers are recharged by rainfall. The aquifers lose water through seepage, spring discharges, and human withdrawals. In some locations, water flows quickly through broad underground channels. In other areas, groundwater may creep along at only a few inches per year.

A considerable volume of water enters Florida though underground flows from Georgia and Alabama. Curiously, a hydrologic divide bisects the state. North of this divide, Florida's groundwater is linked to that of the rest of the continent. However, south of this divide, all groundwater comes from local precipitation and does not mix with that of other states. The line making up this divide stretches from the Cedar Key area, on the west coast to just south of Daytona Beach on the east coast.

The aquifers, and many other water features common to Florida, can be attributed to the state's karst landscape. Karst refers to a region resting on a porous layer of sedimentary rock. As indicated in the section on geologic history, limestone is a sedimentary rock composed of compacted shells, marine organisms, and silt. It is the dominant type of rock found in Florida and is present throughout the state.

Rainwater is typically slightly acidic. As this water flows across the land it filters through decaying plant material, which further raises its acidity. When this same water percolates down through the soil and into the limestone bedrock it slowly dissolves the rock, forming nooks and crannies. Over time, this process has created a maze of water-filled tunnels, passages, and pockets.

Karst formations often give rise to extensive cave systems, such as those in Arkansas, Kentucky, and Virginia. However, in Florida most of these cave systems are inaccessible as a result of the high water table. Other features such as sinkholes, river sinks, river rises, depression ponds and lakes, and spring systems owe their existence to Florida's karst landscape.

Surface Water Features

A watershed is a land area that drains into a water body. Every portion of the state is part of a watershed. Every person living in Florida lives within a watershed. A watershed consists of the land surface from which runoff occurs, surface water, and groundwater. Within a watershed, surface water and groundwater may be linked through springs, seepages, sinkholes, depressions, and recharge fields. While groundwater often flows in the same direction as surface water, this is not always the case. Divides separate watersheds from one another. These divides usually consist of low ridges that shed water in opposite directions. However, in Florida, the edges of watersheds are indistinct as a result of the state's relatively flat topography.

A river drainage basin consists of the river and all tributaries, springs, flows, seepages, and land areas that contribute water to its flow. For example, the St. Johns drainage system includes the St. Johns River, and three large tributaries that also qualify as rivers. It also includes about a dozen large creeks and springs, more than 20 large lakes, flows, swamps, marshes, and dozens of minor creeks. While all river drainage basins qualify as watersheds, not all watersheds comprise river drainage basins. Some watersheds lack any defined channel. They may encompass coastal regions, sheet flows, or areas that eventually drain into the aquifer.

Florida's Freshwater Resources

When assessed in terms of discharge, not a single river in Florida ranks among the largest 25 rivers in North America. Nevertheless, six major rivers exist within the state. These are the Apalachicola, Choctawatchee, Escambia, Kissimmee, Suwannee, and St. Johns. Each of these rivers drains a basin that exceeds 3,000 square miles. Florida has a dozen medium rivers. These are the Alapaha, Caloosahatchee, Chipola, Ochlockonee, Peace, Perdido, St. Marys, Santa Fe, north Withlacoochee, south Withlacoochee, and Yellow. Each drains a basin with an area of 1,000 to 3,000 miles. The remaining systems covered within this book are relatively small and drain areas of less than 1,000 square miles.

Several other surface water features may be linked with or may give rise to rivers. As indicated above, in Florida, a number of rivers originate with or receive significant input from springs. A spring is formed by water that wells up through a gap or vent in the limestone bed that confines the aquifer. Springs are ranked in terms of size. First magnitude springs have a discharge rate of more than 100 cubic feet of water per second. More than a third of the first magnitude springs within the United States are found in Florida. Second magnitude springs have a discharge rate of between 10 and 100 cubic feet of water per second. The ranking system descends all the way to eighth magnitude springs, which have a discharge rate of less than 1 pint per minute. New springs are still being discovered, as some vents are located within riverbeds or in other obscure locations.

At the time of European contact, wetlands covered about two-thirds of the Florida peninsula. Today, well over half of these wetlands have disappeared. Most have been drained to make way for development and agriculture. Nevertheless, wetlands still make up a significant percentage of the state's land area. The Wetlands Protection Act of 1984 (Section 403.91, Florida Statutes) and various federal laws have drastically slowed wetlands destruction over recent years. Wetlands can be subdivided into numerous categories, a few of which are described below.

Cypress swamps are one of the most

Ultra-clear water wells up from many of Florida's spring vents.

The springs shown here, from top to bottom and from left to right, are the Blue Hole Spring of Jackson County, Weeki Wachee Spring of Hernando County, Wakulla Spring of Wakulla County, Lithia Springs of Hillsborough County, and Homosassa Spring of Citrus County.

Florida's Freshwater Resources

common types of wetlands in Florida. They are found in many regions of the state and often form part of river flood plains. The water in cypress swamps tends to be tea-colored, although this is not the case where such swamps receive regular infusions of spring water. Rivers that flow through extensive cypress swamps include the Aucilla, Econlockhatchee, Fisheating Creek, Hillsborough, Ochlockonee, Sopchoppy, and southern Withlacoochee.

Freshwater marshes can occur along the boundaries of rivers, in flatwood depressions, or along lakeshores. They contain emergent vegetation, shallow water, and abundant wildlife. Several Florida rivers derive part of their flow from freshwater marshes, including the Econfina, Fenholloway, Steinhatchee, Suwannee and Loxahatchee. Extensive freshwater marshes also exist around the headwaters of the St. Johns River and around some tributaries of the Kissimmee River.

A bog is an area of shallow, acidic water, typically colonized by sphagnum moss. It usually contains heavy concentrations of decaying plant matter. While bogs are most frequent in northern states, a few are present in north Florida. Water may accumulate from rainfall or seepage. Portions of the Okefenokee and Pinhook Swamps, along the Georgia-Florida border, fall within this category. The Suwannee, St. Marys and Perdido Rivers derive some of their initial flow from bogs and bog seepages.

River backwaters, sloughs, and oxbow lakes also require mention. River backwaters are stationary or near-stationary bodies of water that are loosely connected to the main channel or that are only connected to the main channel during periods of high water. Extensive backwaters exist along the Escambia, Choctawhatchee, and Ochlockonee Rivers. Some sloughs are connected to river systems, while others form in isolated depressions. Sloughs are stagnant, poorly oxygenated bodies of water that flow only during wet conditions. Oxbow lakes are found in river flood plains. They form over time, when a river finds a shorter course; when it abandons a loop or bend through which it formerly passed.

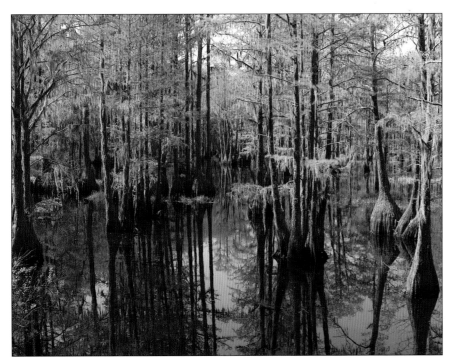

The cypress swamp is a common feature of the Florida landscape. Cypress is a deciduous conifer that can live for hundreds of years and that can attain a spectacular size and girth. Unfortunately, most of the old giants were felled for lumber in the late 1800s and early 1900s.

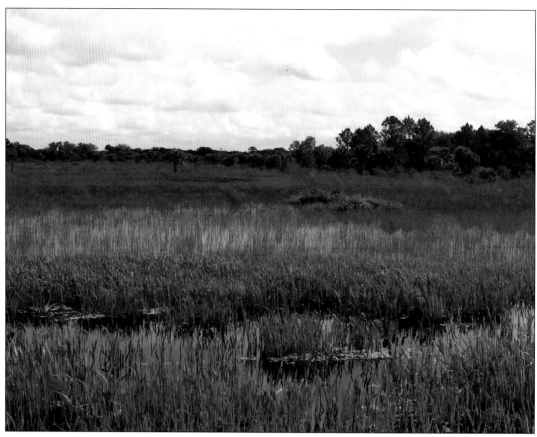

The freshwater marsh teams with life. The marsh shown here lies within the Peace River basin.

A few rivers of the Florida peninsula, including the St. Johns, Kissimmee, and Ocklawaha, begin as a chain of lakes. Lakes in Florida tend to be shallow and tend to form over depressions in the underlying limestone. Most have saucer-shaped bottoms composed of sand or silt. Shorelines are typically lined with exotic hydrilla and various types of emergent vegetation. The water is often fertile, especially where surrounding land has been farmed or developed.

When reviewing surface water features, it is also necessary to examine those features present around river mouths. Estuaries form in inlets, lagoons, and bays, where the fresh water from rivers mixes with salt water from the Atlantic Ocean or Gulf of Mexico. The salinity in such areas can vary dramatically with the tides and seasons. Because estuaries receive a constant influx of nutrient-rich water, they often support rich concentrations of shellfish and other marine organisms. They represent critical breeding and feeding areas for many saltwater fishes. Major estuaries occur at the mouths of the Escambia, Choctawhatchee, Apalachicola, and Suwannee Rivers, in Tampa Bay and Charlotte Harbor, and in Florida Bay along the fringe of the Everglades.

Farther offshore, such estuaries can grade into seagrass beds and marine meadows. Closer to shore, they may give rise to tidal marshes or mangrove swamps. Tidal marshes are prevalent along many areas of the northern Gulf coast. Extensive tidal marshes exist in the Big Bend region. They are also common in several areas of northeast Florida, such as around the mouths of the St. Marys River, Nassau River, and Pellicer Creek. In most loca-

Florida's Freshwater Resources

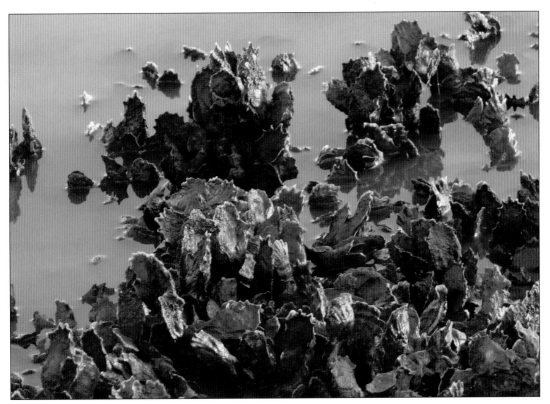

Oysters and other shellfish can be found in estuaries around river mouths.

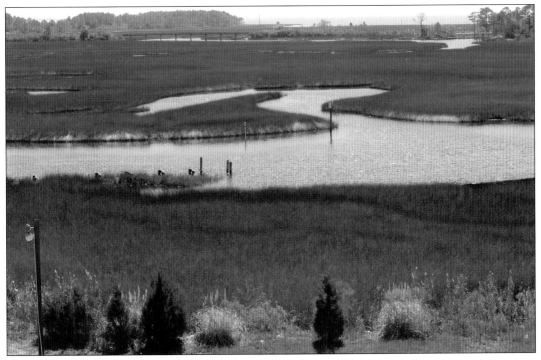

This salt marsh is located along the Carrabelle River in Franklin County.

Florida's Freshwater Resources

tions the most common substrate is mud. Cordgrass and needlerush are the dominant plant species. Notable animals include the fiddler crab, killifish, mullet, mosquitofish, and mosquito.

Mangrove swamps line many estuarine shorelines along the peninsula. Mangroves are quasi-tropical in habit and can tolerate only a few degrees of frost. Such swamps may extend many miles inland along the banks of coastal rivers. The red mangrove can grow within the tidal zone and can tolerate high salt concentrations. It uses prop roots to anchor itself into mud or other substrates. The black mangrove occurs slightly further back from the edge of the water. It puts out thousands of pencil-like, upright roots called pneumatophores. Mangrove ecosystems provide shelter for a multitude of juvenile crustaceans and fishes.

Types of Rivers

Florida's rivers do not lend themselves to neat categorization. Many have characteristics typical of several types. Some shift from one type to another as they flow through different geographic regions. Nevertheless, all fall within one or several of the five general categories set forth below.

Most Florida rivers are predominantly blackwater streams. Blackwater streams are characterized by tea-colored water. This water appears black when viewed from a distance or when it reaches a depth of 1 to 3 feet. Blackwater streams tend to have high concentrations of organic carbon. They also tend to be somewhat acidic. The water is stained, not because it is dirty, but because it has absorbed tannins and flecks of organic matter from the surrounding landscape. Blackwater streams often drain areas dominated by cypress, cedar, and other conifers. They support little submerged vegetation because their dark waters reduce the amount of sunlight that can reach the bottom.

Spring-fed rivers are characterized by extremely clear, alkaline water and heavy

In peninsular Florida, salt marshes are replaced by mangrove swamps. Prop roots of the red mangrove, shown here, provide shelter for juvenile fishes and marine invertebrates.

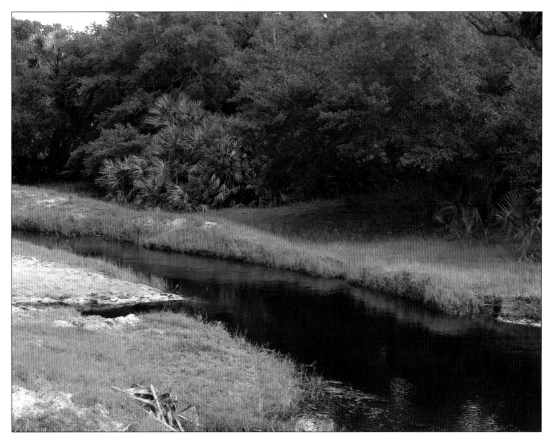

Blackwater streams, such as this Polk County creek, are common throughout the state.

aquatic vegetation. More than 700 springs exist within Florida. Most are found in north Florida, from the central Panhandle to the northern suburbs of Orlando. A few rivers derive most of their flow from an individual spring or spring group. Such rivers are rare outside Florida. Spring-fed rivers described in this book include the Chipola, Crystal, Homosassa, Silver, Wakulla, Weeki Wachee, and Wekiva Rivers. Many other rivers, including the Choctawhatchee, Ocklawaha, St. Johns, St. Marks, Santa Fe, Suwannee, northern Withlacoochee, and southern With-lacoochee receive significant input from springs.

The limestone-rimmed rivers of north Florida are largely calcareous streams. They typically flow with alkaline water and derive some or most of their flow from springs. However, they may also flow with dark, tannin-stained water from swamps and seepages. Whatever their source, these rivers are characterized by high limestone banks and beds lined with limestone, limestone rubble, scour holes, and gravel bars. The Aucilla, Chipola, Santa Fe, Sopchoppy, and Suwannee Rivers fall within this category.

Alluvial rivers—which are the predominant type of river in many parts of the country—are relatively rare in Florida. Nevertheless, some of the state's largest rivers, such the Apalachicola and Choctawatchee, are alluvial in character. Others, such as the Yellow, Escambia, and Ochlockonee possess alluvial characteristics. Alluvial rivers are generally relegated to the Panhandle. They carry a high sediment load, run through a broad flood plain, and have broad deltas or marshes occurring around the river mouth.

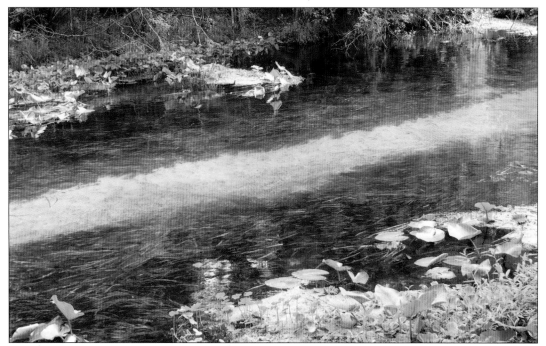

Spring-fed rivers give rise to unique ecosystems. Rock Spring Run, a tributary of the Wekiva River, derives almost its entire flow from springs.

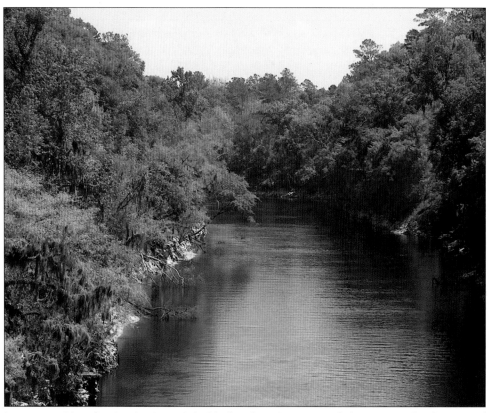

The Suwannee River begins in Georgia's Okefenokee Swamp and derives much of its initial flow from drainage and seepage. However, it is also fed by voluminous springs. It is the largest of several limestone rivers that cut across north Florida and portions of the Panhandle.

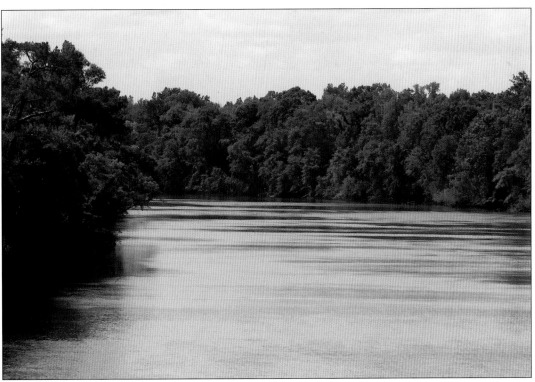

The Choctawhatchee is a typical alluvial river, with a strong current and heavy sediment load.

Coastal rivers are slow, low-gradient streams. They meander across the coastal plain, but carry less eroded material than alluvial rivers. Lower reaches are broad and are subject to tidal influence. Brackish water often extends upstream a considerable distance from the mouth. The water is typically brown and clouded, although some coastal rivers are typical blackwater streams in their upper reaches. Coastal rivers are most common on the peninsula. The Estero, Loxahatchee, Manatee, St. Lucie, and Tomoka Rivers fall within this category. The St. Johns is also a coastal river in many respects.

Biological Components

As is evident from the discussion above, Florida's rivers encompass diverse habitats. These habitats support rich ecosystems. This section provides a general discussion of some of the plants and animals that inhabit Florida's rivers. Other information is provided within the river profiles.

South Florida is home to numerous species that are also endemic to the Caribbean. Plants such as the gumbo limbo, sea grape, cocoplum, mastic, pond apple, and mangrove grow in southern parts of the peninsula. Rare fish such as the bigmouth sleeper, rivulus, and slashcheek goby can be found in some south Florida waterways. Semitropical birds such as the roseate spoonbill, woodstork, crested caracara, mangrove cuckoo, and others are endemic to the southern peninsula.

North Florida is home to many species typically associated with northern states. Vegetation such as beech, white cedar, hickory, and pawpaw may be encountered along rivers in the Panhandle. Striped bass, redhorses, and numerous darters inhabit rivers in northern parts of the state. Birds such as the Mississippi kite, red-cockaded woodpecker, various warblers, and others inhabit the forests along the shores.

Many species found in Florida are

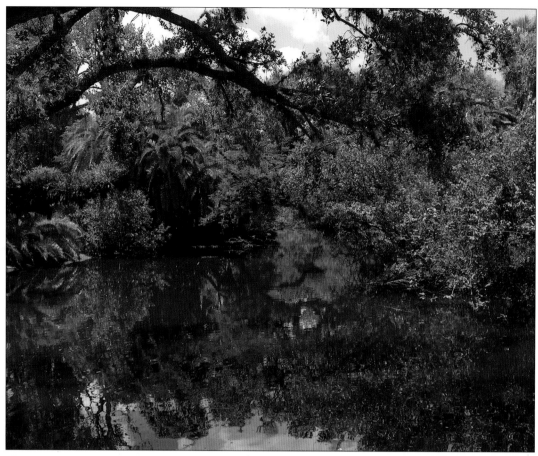

The small Estero River of Lee County has its origin in marshes and flowing wells. For purposes of this book, it is considered a coastal river.

endangered or exceedingly rare. In fact, only Hawaii and California have a greater number of endangered plants and animals. Most residents are familiar with the plight of the Florida panther and manatee. Yet there are many unfamiliar animals, such as the Chipola slabshell, purple bankclimber, shortnose sturgeon, and Okaloosa darter, that are also threatened with extinction. Many rare plants and animals depend on Florida's rivers for survival.

Three status categories are typically employed when discussing species with struggling populations or poor prospects. Endangered species are those that are under immediate threat of extinction. Threatened species are those that have declining populations or that are otherwise at risk, and that might eventually be placed on the endangered list. Species of special concern are vulnerable to environmental change or over-harvest, as a result of narrow distribution or rarity. With minor adjustments, the federal government and the state both employ these categories. The federal government lists about 100 species, found in Florida, as either endangered or threatened. The state of Florida lists about 500 species as endangered, threatened, or species of special concern.

Space constraints make it impossible to provide a detailed discussion of the many life forms that inhabit Florida's rivers and surrounding lands. It has been estimated that Florida is home to 120 species of native freshwater fishes, 700 species of land vertebrates, 4,000 species of plants,

Florida's Freshwater Resources

and over 50,000 species of invertebrates. Therefore, this book focuses on the common, the visible, the rare, and the curious, so as to give an overall impression of the biological components of Florida's rivers.

This book provides some coverage of snails and freshwater mussels, although information is lacking on the distribution of many species. The apple snail is a species with which residents should become better acquainted. This species is the largest freshwater snail native to North America, reaching a diameter of about 2 inches. It is the exclusive food item of the endangered Florida snail kite. It was a major food item of Native American populations. It occurs throughout the peninsula and as far west as the Chipola River. The apple snail is an important component of most river ecosystems.

As indicated above, about 120 species of native freshwater fishes occur in Florida waters. This number is supplemented by about 36 saltwater species that breed in fresh water or that make occasional forays into river systems. In addition, a number of strictly marine species are found in river estuaries and at the periphery of river systems. Finally, about 50 non-native fishes have gained a foothold in Florida.

Rivers of the Florida Panhandle tend to support a greater number of native fish species than rivers elsewhere in the state. Several contain more than 70 species, including various darters, suckers, and minnows that are at the southernmost fringe of their range. Rivers of north central Florida are less diverse than those of the Panhandle, typically harboring between 55 and 70 fish species. They nevertheless support a greater number of fishes than rivers in south Florida, which usually support between 35 and 50 species. This disparity is probably due to the physical isolation of south Florida from the main body of the North American continent.

In nearly every river, members of the Centrarchidae, or sunfish, family are prominent. The largemouth bass, redear sunfish, bluegill sunfish, black crappie, and warmouth are present throughout the state. They are numerous in most waters and are considered important game fishes. Members of the gar family and catfish family are also populous and widely distributed. The striped mullet, primarily a saltwater species, is found in all river estuaries and regularly ascends into the freshwater portions of many rivers.

Florida's rivers also support a wide array of reptiles and amphibians. The American alligator is a keystone species and is present in nearly all the state's rivers. This reptile was hunted to near extinction during the 1950s and 1960s, and was listed as an endangered species in 1967. Populations have since rebounded. In 1987 the alligator was removed from the endangered species list. That same year, the alligator was designated as the state reptile. Because populations have stabilized, Florida now allows limited hunting under permits issued by the Florida Fish and Wildlife Conservation Commission.

Alligators are opportunistic feeders. While the threat they pose to humans is often exaggerated, scattered attacks have occurred throughout the state. In May of 2006, spate of 3 fatal attacks occurred over a 4-day period. Feeding of alligators is strictly prohibited. Alligators that have become accustomed to taking handouts soon begin to associate humans with

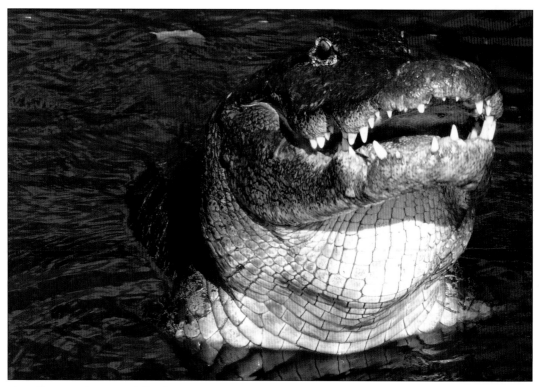

The alligator does not fully deserve its reputation as a fearsome creature, poised to attack any humans that come too close. However, it is a potential threat, has made unprovoked attacks, and must never be fed or harassed.

food. This association, in turn, may lead to aggressive behavior. Game officials may be required to remove and destroy animals that have lost their natural fear of humans. As a rule, alligators will not approach a kayak or canoe and will not intrude more than a few feet onto land to take prey. The best safeguard against attack is to maintain a safe distance and to avoid swimming or wading in water where alligators are present.

Another fascinating reptile, present in the Panhandle and the Suwannee River drainage system, is the alligator snapping turtle. This is the largest freshwater turtle in North America and may reach weights of over 200 pounds. It is almost entirely aquatic in habit. It lies on the bottom of rivers and streams and wiggles a wormlike appendage on its tongue to attract fishes within range of its powerful jaws. Unfortunately, populations of this species have declined over recent years due to a long maturation cycle and habitat loss. In addition, this species has been mercilessly hunted as the primary ingredient in turtle soup. Florida currently lists the alligator snapping turtle as a species of special concern. Protections for this species should be upgraded.

Most of the water snakes encountered along Florida's rivers are harmless. The water moccasin is an exception. It is the only venomous snake in Florida that is predominantly aquatic in habit. The water moccasin will typically flee from humans. It will drop into the water from logs or other sunning spots with the approach of boats or canoes. However, this snake also has a short temper and, when cornered or molested, it will strike aggressively.

While many mammals are found in association with river systems, two require detailed comment. The river otter, distributed throughout Florida, is a member of the martin family. It frequents rivers,

This abandoned beaver pond, in Santa Rosa County, provides wetland habitat for wading birds and other species. Pitcher plants grow in damp areas along the shoreline.

marshes, and estuarine habitats. It lives in a den excavated in the bank. The species is carnivorous and feeds on fish, crayfish, snails, clams, and amphibians. The otter is agile and has a seemimngly endless supply of energy. It is also a social animal and engages in many hours of play, using natural slides and floating objects for entertainment. Because the otter is at the top of the river food chain, it is susceptible to mercury poisoning, a subject addressed in the next chapter.

The beaver is found throughout north Florida, ranging as far south as the Suwannee River and its tributaries. During the late 1800s, as a result of hunting and trapping, the beaver was eliminated from most of the state. It has gradually returned and is now common in some areas of the Panhandle. The beaver is Florida's largest native rodent and can attain a weight of up to 50 pounds. Conflicts with humans occur when beaver dams block drainage culverts or flood fields and roads. Beavers may also raid crops and fell valuable trees. Various nonlethal means have been developed to reduce beaver-inflicted damage. A permit is required to trap and relocate problem animals. Through their dam-building activities, beavers create valuable habitat for fish, wading birds, and other creatures that depend on wetlands.

The Condition of Florida's Rivers

As is true in many areas of the country, Florida's rivers have been tapped and modified to meet the demands of a burgeoning population. These demands come in the form of agricultural use, industrial use, domestic use, recreational use, flood control, power generation, transportation, and navigation. In some cases, Florida's rivers have been tainted with pollution. A few have been degraded to the point that they are no longer suitable for most recreational uses. Finally, Florida's rivers have been invaded and colonized by plants and animals introduced from other regions and other parts of the globe. This chapter focuses on these threats to the natural balance.

Physical Modifications

In 1821, when Spain ceded Florida to the United States, much of the peninsula consisted of uninhabitable wetlands. Little had changed by the time Florida achieved statehood. In 1850, the federal government transferred 20 million acres of "overflowed lands" to the state. Florida subsequently sold or transferred much of this land to private interests who pledged to drain the swamps and to open the land to agriculture.

In 1881, the state sold 4 million acres to Philadelphia businessman Hamilton Disston. The price was 25 cents per acre. Disston's vision was to direct water from the swampy interior of the state through the Kissimmee River to Lake Okeechobee. From there, water was to be diverted to the Gulf of Mexico through a canal linking Lake Okeechobee with the Caloosahatchee River to the west. Disston managed to transform huge tracts of land between Orlando and the north shore of Lake Okeechobee into dry prairie. Between 1962 and 1971, the United States Army Corps of Engineers expanded on Disston's work by straightening and channeling the Kissimmee River in an effort to control flooding.

Many others participated in "reclaiming" land across the southern half of the peninsula. In 1905, when Napoleon Bonaparte Broward was elected governor, he launched an ambitious effort to drain the Everglades. By 1920, four major canals connected Lake Okeechobee to the southeastern coast. These waterways dropped the water table and paved the way for the development of Palm Beach, Broward, and Miami-Dade Counties.

In 1937, the United States Army Corps of Engineers completed excavation of the Okeechobee Waterway. This 155-mile-long channel connected Stuart, on the east coast, with Fort Myers, on the west coast. It permitted small vessels to cross the state through a system of locks. These modifications enabled engineers to redirect water from Lake Okeechobee into the St. Lucie River to the east, as well as into the Calloosahatchee River to the west. These freshwater releases would have a profound impact on these two rivers, reducing the salinity of their estuaries and causing declines in water quality. These releases would also have a negative impact on the Everglades, as water was now being diverted away from that water-based ecosystem.

The Cross Florida Barge Canal, another public-works project, substantially altered the flow of the Withlacoochee and Ocklawaha Rivers. It was first envisioned as a sea-level canal that would allow ships to sail across the state from Palatka to the Gulf of Mexico. The plan was later scaled back. Construction started in 1935, but was discontinued a year later. Work commenced again in the 1960s, but was abandoned after just over a quarter of the canal had been excavated. The project was permanently cancelled in 1990.

This lock and dam, on the Caloosahatchee River, is part of the Okeechobee Waterway. Unfortunately, discharges of nutrient-rich water from Lake Okeechobee, as well as extensive dredging, have led to the decline of this river.

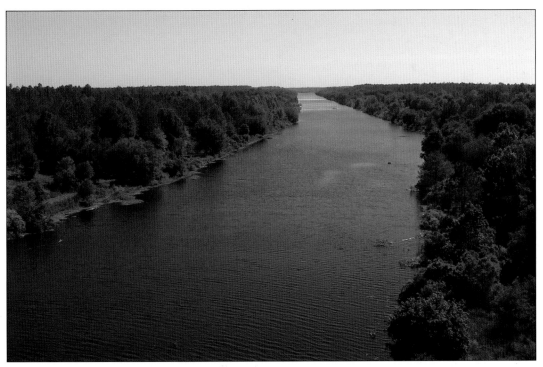

Fortunately, the Cross Florida Barge Canal was never completed. It would have destroyed the historic Ocklawaha River and would have radically altered several watersheds.

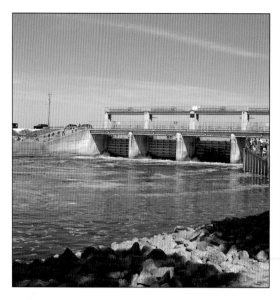

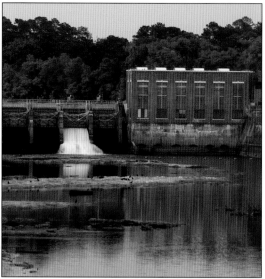

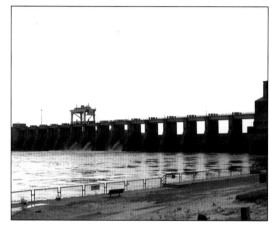

Dams on Florida rivers include the Rodman Dam on the Ocklawaha River (top left), the Lake Talquin-Jackson Bluff Dam on the Ochlockonee River (top right), and the Jim Woodruff Dam on the Apalachicola River (bottom).

The projects discussed above were undertaken with the best intentions. Each, with the possible exception of the Cross Florida Barge Canal, sought to address a tangible problem. It is easy to forget that much of Florida would be uninhabitable but for the efforts of Hamilton Disston and those who followed in his footsteps. At the same time, each of these projects was conceptually flawed and resulted in unintended consequences. They degraded water quality, eliminated thousands of square miles of wetlands, increased erosion, and had negative effects on native ecosystems.

Dams have been constructed across a few Florida waterways. They interrupt the flow of the Apalachicola, Ochlockonee, Caloosahatchee, Hillsborough, Braden, southern Withlacoochee, Kissimmee, and Manatee Rivers. Water control structures exist on other waterways.

Every river presented in this book, with the exception of the Silver, Homosassa, and Crystal Rivers, is crossed by at least one road. More than a dozen bridges span many streams. While bridges raise a number of environmental concerns, they provide some offsetting benefits. Many concrete river bridges, for example, provide prime habitat for bats. A study conducted between 2002 and 2005 for the Florida Department of Transportation found bats roosting in 152 of 487 of the bridges surveyed. Species observed included big brown bats, free-tailed bats, evening bats, and southeastern

myotis. Martins and swallows also nest along bridge beams and in cavities within bridge structures.

The foregoing discussion suggests that many substantial modifications to Florida's rivers have been poorly conceived and have caused ecological damage. However, this book does not suggest that all human intervention is destructive or unwarranted. Flood control is essential in some areas. People require water for survival and must have access to an adequate supply. As long as humans occupy the land, they will rely on rivers and will harness these waterways to suit their needs. The mistakes of the past must be recognized and understood to help guide decisions of the future.

Water Quality Issues

Beyond the physical modifications described in the preceding section, another major human impact on Florida's rivers comes in the form of pollution. Many sources of pollution affect Florida's rivers, including street and urban runoff, agricultural runoff, industrial waste, and domestic wastewater. These sources all fall into one of two broad categories: point-source pollution and non-point-source pollution.

Point-source pollution is that which can be traced to a single source, such as a sewage treatment plant or factory outflow. Over the past several decades, the state and federal governments have made significant strides in curtailing many forms of point-source pollution. Non-point-source pollution stems from multiple sources spread over a wide area. For example, it may result from intermittent septic tank leaks along the entire course of a river. Non-point-source pollution is exceedingly difficult to trace, identify, and eliminate. To one degree or another, non-point-source pollution affects every waterway in Florida.

Human senses do not provide a reliable indication of water quality. Clear water does not always correspond with clean water. Dark water is not always dirty or polluted. Polluted water may be devoid of any foul odor or sheen. Consequently, scientists carefully monitor the state's waters and use various tests to assess water quality. They measure the turbidity, pH, and dissolved oxygen content. They test for nutrients, chemicals, harmful pathogens, and metals such as mercury, lead, and copper. The data they collect provides a valuable measure of the health of Florida's rivers, and also provides information on water quality trends.

The federal Clean Water Act requires each state to conduct water quality assess-

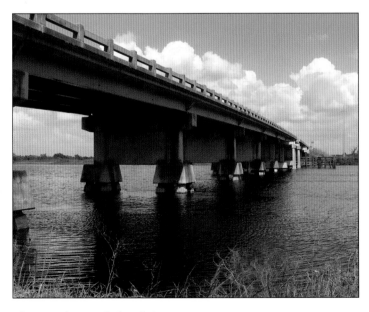

An extensive network of bridges spans Florida's rivers. Here, US Highway 98 crosses the Kissimmee River at Fort Basinger.

The common cattail is an endemic plant, but tends to grow in poor, nutrient-rich water. Native Americans made extensive use of this species. The interior of young shoots can be prepared like asparagus. The pollen can be made into flour. The rootstocks can be boiled like potatoes.

ments and to report those findings to the United States Environmental Protection Agency. The assessments are aimed at determining whether the state's rivers and lakes are sufficiently clean to meet their designated uses. Waterways are sorted into five classes. Class I includes waters suitable for potable water supplies. Class II includes waters suitable for shellfish propagation and harvest. Class III includes waters suitable for recreation and a healthy population of fish and wildlife. Class IV includes waters suitable for agricultural use. Class V includes waters suitable for navigation, utility, and industrial use. If a river or other body of water falls short of water quality standards for its designated use, it is considered an "impaired water." The list of impaired waters in Florida is extensive.

Poor water quality is often associated with urban areas and locations subject to intense agricultural use. However, even in suburban and rural settings, runoff from lawns, golf courses, orchards, and pastures may carry chemical contaminants into wetlands and rivers. Nutrients leached from fertilizer and septic tanks can cause algae blooms, rampant plant growth, low dissolved oxygen levels, and fish kills.

The use of pesticides, in particular, poses a number of threats to Florida's rivers. Even the most benign pesticides are a form of poison. Even trace levels can prove lethal to zooplankton, which form the base of several aquatic food chains. Strict compliance with directions and warnings can minimize such impacts.

Another form of pollution that plagues some of Florida's rivers is mercury contamination. While low levels of mercury are present in the environment, high levels are toxic to animals and humans. Power plants, cement plants, and other industrial facilities may be responsible for releasing mercury into the environment.

When mercury finds its way into waterways, it becomes concentrated in organisms at the top of the food chain, such as game fish. Human exposure most often occurs through the consumption of fish. Largemouth bass, bowfin, and gar

Cattle ranchers tend to be good stewards of the land. Impact on the environment is relatively low and rangelands provide critical wildlife habitat. Nevertheless, cattle waste can foul streams, over-grazing can lead to erosion, and cattle dipping vats have contaminated groundwater in some locations.

The Condition of Florida's Rivers

often contain elevated levels of mercury. Mercury poisoning can lead to brain damage and other debilitating effects. Pregnant women and children are especially vulnerable. The Florida Department of Health provides consumption advisories for certain species of fishes taken from particular bodies of water. The United States Environmental Protection Agency and the Food and Drug Administration issue recommendations for species and water bodies not covered by state advisories.

Invasive Exotics

Habitat alteration, pollution, and over-harvest have all played a part in the decline of native species. But an equally serious threat comes in the form of invasive exotics. Invasive exotics are species of plants and animals that originated in other regions or other countries and that have shown up in Florida's natural environment. Some exotic species—such as the peacock cichlid— were purposely introduced. Most were accidentally introduced or escaped captivity. Invasive exotic species often compete with and displace native species. Once they become established, exotic plants and animals are very difficult to eradicate.

Within a few south Florida waterways, the population of exotic fishes exceeds that of native fishes. Throughout the peninsula, it is difficult to find a major waterway that has not been colonized by non-native fishes. The most successful invaders include the brown hoplo, suckermouth catfish, black acara, blue tilapia, and oscar.

Non-native water plants have also proliferated within Florida's waters and clogged many river systems. Hydrilla, introduced through the aquarium trade, is now the most common form of submerged vegetation in the state. Water hyacinth, native to South America, is now the most common floating plant. Both of these exotics have impeded navigation and harmed native plant communities.

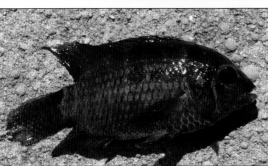

Non-native fishes have invaded many rivers of the Florida peninsula. Shown here are the oscar (top left), tilapia (top right), black acara (bottom left), and suckermouth catfish (bottom right).

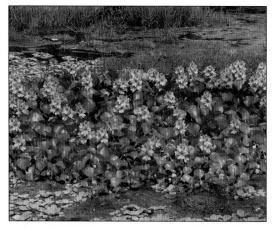

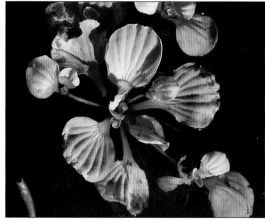

Nonnative plants that have invaded Florida's rivers include water hyacinth (top left), hydrilla (bottom left), and water lettuce (top right).

Other invasive aquatic plants include water lettuce and alligator weed.

The channeled apple snail, native to South America, has invaded many waters in south and central Florida. In some locations it has displaced the smaller, native apple snail. The channeled apple snail consumes native plants and reproduces at an alarming rate. While the channeled apple snail is reportedly edible, it carries a parasite that can cause meningitis. Both species lay their eggs on stems, cypress trunks, or pilings a few inches above the water surface. However, the channeled apple snail lays masses of hundreds of small pink eggs, while the native apple snail lays masses of dozens of large, white, pearl-like eggs.

From physical alteration to chemical contamination to invasion from abroad, Florida's rivers are under assault from many forces. With the advent of stronger environmental laws and evolving attitudes regarding stewardship, the pace of change may be slowing. However, much of the damage that has occurred cannot be reversed; many exotic species are now permanent residents and many artificial works have become permanent features of the landscape.

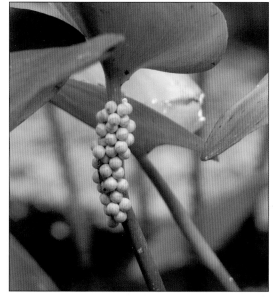

Eggs of the native apple snail

The Condition of Florida's Rivers

The Preservation of Florida's Rivers

Florida is one of the fastest-growing states in the nation. As pointed out in earlier discussions, population increases have placed extreme demands on existing resources. The need for residential, agricultural, and commercial property has led to the development, clearing, and draining of land across much of the peninsula. These pressures are likely to intensify over the next several decades. To ensure that future generations have an opportunity to enjoy Florida's rivers, natural areas must be set aside and protected against development. Many organizations, both public and private, are working to prevent fragmentation of Florida's river corridors, to safeguard water quality, and to promote public awareness of these critical issues.

Water Management Districts

The Florida Department of Environmental Protection has supervisory authority over the state's water resources. However, the primary task of safeguarding the state's rivers falls to Florida's water management districts. The current structure of the water management districts was established by the state legislature through the Water Resources Act of 1972. The duties of the districts are set forth in chapter 373, Florida Statutes. A board, composed of 9 members, oversees the activities of each district. Members are appointed by the governor and confirmed by the Florida Senate. Some board members are appointed to represent particular river drainage basins. Others serve in at-large positions. Florida has five water management districts.

FLORIDA'S WATER MANAGEMENT DISTRICTS

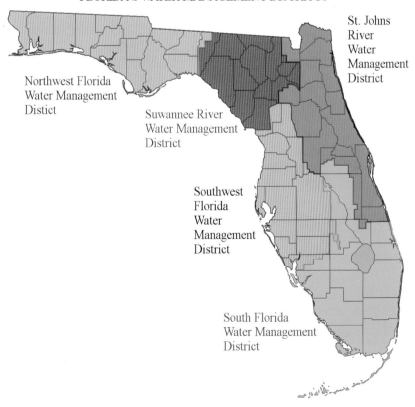

St. Johns River Water Management District

Northwest Florida Water Management Distict

Suwannee River Water Management District

Southwest Florida Water Management District

South Florida Water Management District

The Northwest Florida Water Management District has jurisdiction over waters of the western and central panhandle. Its territory extends east to portions of Jefferson County. The Suwannee River Water Management District has jurisdiction over waters of north central Florida and the eastern panhandle, extending as far west as the Wacissa River in Jefferson County. The St. Johns River Water Management District covers the St. Johns River and its tributaries, the St. Marys River, and other coastal rivers of northeastern Florida. The Southwest Florida Water Management District has responsibility over an area ranging from parts of Marion County down the west coast of the peninsula to Charlotte Harbor. The South Florida Water Management District has jurisdiction over the southern third of the peninsula, and the Kissimmee River drainage basin. This basin extends northward to the southern suburbs of Orlando.

The water management districts perform many functions. They oversee conservation programs and environmental regulations. They are responsible for flood control efforts. They develop plans for water use and water shortages. They establish minimum rates of flow for rivers within their jurisdiction. They carry out permitting functions. They monitor water quality. They provide informational and educational services. They acquire and manage land required for conservation or to enhance water quality. They partner with other state and federal agencies and interface with local governments. The water management districts administer many of the programs and initiatives described in the section that follows. Considering the broad scope of their reach and responsibilities, Florida's water management districts are among the most important and powerful government agencies that operate within the state.

Programs and Initiatives
Land acquisition programs, programs aimed at improving water quality, and educational programs all play a role in protecting and preserving Florida's rivers. The paragraphs that follow provide a brief overview of these efforts.

The Florida Forever Program, initiated in 2001, replaces its forerunner, the Preservation 2000 Program. The Florida Department of Environmental Protection, Division of State Lands, has administrative responsibility. The Florida Forever Program uses bonds and creative strategies to acquire and protect tracts of environmentally sensitive property. It is the largest program of its type in the nation. In its first five years of operation, the Florida Forever Program succeeded in acquiring more than 500,000 acres of land. Many of the parcels purchased by the state through this program lie along river corridors.

The Surface Water Improvement and Management Program (SWIM), is a program administered by the Florida Department of Environmental Protection in partnership with Florida's five water management districts. SWIM develops plans for managing and improving water quality within watersheds, lakes, and estuaries, and addresses each watershed as a system of connected resources. Money for the program comes from general state revenues and from water management districts.

The Save Our Rivers Program (SOR), administered by the Florida Department of Environmental Protection, was created in 1981. This program enables water management districts to acquire lands for conservation and water management through the Water Management Lands Trust Fund. Revenues for this program are generated by the documentary stamp tax.

The Outstanding Florida Water program, administered by the Florida Department of Environmental Protection, accords special protection to waters with outstanding natural attributes. Storm water runoff and other types of discharge into such water bodies are strictly regulated. Many of the rivers covered within this

book qualify, in whole or in part, as Outstanding Florida Waters.

In 1975, the Florida Legislature enacted the Aquatic Preserve Act. Since then, over 40 aquatic preserves have been set aside. While most of these preserves encompass coastal areas, some extend to river mouths, river estuaries, and freshwater systems.

The Wetlands Reserve Program, administered by the United States Department of Agriculture Natural Resources Conservation Service, is a voluntary program that aims to preserve wetlands on private property. The program gives certain landowners the option of granting a conservation easement while retaining ownership over the land.

The United States Congress passed the Wild and Scenic Rivers act in 1968. At the time of this publication, only two rivers in Florida—the Loxahatchee and the Wekiva—have received federal designation as Wild and Scenic Rivers. The state has also designated two rivers, the Wekiva and the Myakka, as Florida Wild and Scenic Rivers.

In addition to the government programs listed above, several private organizations have been instrumental in conserving and preserving lands surrounding rivers in Florida and elsewhere. The Nature Conservancy is a nonprofit organization with a goal of protecting natural areas to protect the life that depends on those natural areas. It has purchased and protected more than a million acres of land in Florida.

Legal Considerations

Much of the land along the banks of Florida's rivers is in private hands. Paddlers and boaters must respect property rights and should not intrude without the owner's explicit permission. Land lying beneath navigable waters is known as sovereignty land and belongs to the state. According to the Florida Supreme Court, in *Geiger v. Filor,* 8 Fla. 325 (1859), when Spain transferred Florida to the United States, "the right to the shores of navigable waters and the soils under them

enured, first to the General Government and then to the State." In tidal waters, public ownership extends inland to the high-water mark. Swampland and other wetlands, by contrast, can be purchased and held by private interests.

Florida requires those fishing within the state to have a fishing license. Exemptions are carved out for those who are 65 or older, for children under 16 years of age, and for certain other categories of people. Florida requires a freshwater fishing license to take freshwater fish and a saltwater fishing license to take saltwater fish. The license required depends on the species pursued, not on the salt content of the water. For example, a saltwater fishing license is required to take a snook, even if the fish is taken near a freshwater springhead, many miles from the ocean. Bag limits and size limits apply to various game fish and panfish.

Those who seek to hunt fossils in Florida's rivers should familiarize themselves with regulations affecting that activity. Section 240.516, Florida Statutes, provides that it is the intention of the Legislature to preserve vertebrate fossil sites within the state. Subsection 3 of that section provides that "all vertebrate fossils found on state-owned lands, including submerged lands, and uplands, belong to the state with the title to the fossils vested in the Florida Museum of Natural History" Collecting in state parks and certain other state-owned lands is prohibited. A permit is required for systematic collecting activities, for those involved in the fossil trade, and for certain other activities. Section 240.5162, Florida Statutes, provides that the Florida Museum of Natural History may adopt rules with respect to "nonessential" vertebrate fossils. Fossil shark teeth and invertebrate fossils are exempted from the regulations. Questions regarding permitting and regulations should be directed to the Program of Vertebrate Paleontology, Florida Museum of Natural History, University of Florida,

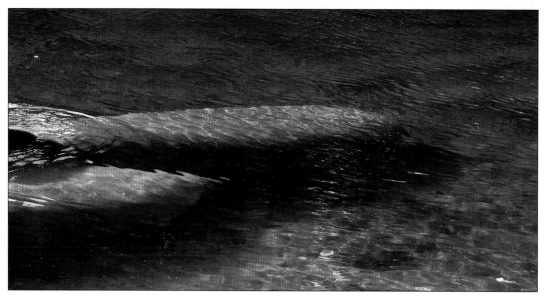

While the manatee is relatively easy to spot in clear water, boaters operating in dark or murky water should reduce their speed and keep a careful lookout.

Gainesville, Florida 32611.

Various laws, including the Florida Manatee Sanctuary Act of 1978, the federal Endangered Species Act, and the federal Marine Mammal Protection Act of 1972, protect manatees in Florida. The Florida Manatee Recovery Plan has led to the creation of sanctuaries and slow speed zones within manatee habitats. Boaters should exercise great caution within such areas and within all estuaries, spring outflows, power plant discharges, and other areas frequented by manatees. These animals are very difficult to spot, especially in dark or murky water. The majority of adult manatees in Florida bear propeller scars. Collision with powerboats is the leading cause of mortality.

To protect native plant and animal communities, the Florida Fish and Wildlife Conservation Commission prohibits the live transport, sale, possession, or introduction of a number of exotic species. Species introduced from elsewhere that have a tendency to reproduce in the wild are termed invasive exotics. Unfortunately, non-native plants and fishes have colonized most waterways in Florida. It is illegal to release any non-native species in Florida without a permit.

Restoration

Once a river has been significantly altered, returning it to its natural state becomes a daunting task. The process requires historic reviews, extensive planning, intensive physical reclamation efforts, and long-term monitoring. However, such complex activities may be essential to restore health and balance to degraded watersheds. The good news is that rivers are resilient. Once the basic hydrology and natural connections have been repaired, native plants and animals rapidly move in and repopulate rivers and associated flood plains.

At the time of this writing, two major river restoration projects are under way in Florida. The Kissimmee River Restoration Project is the largest, most costly, most ambitious river restoration project in the world. It is a key component of the Comprehensive Everglades Restoration Project. The Kissimmee River Restoration Project is described within the profile of the Kissimmee River. The Lower St. Johns

River Basin Restoration Project is also a highly ambitious undertaking. It aims to reduce pollution and restore marshes and natural connections around the headwaters of the St. Johns. Marshes in this area have been lost to agriculture and development and have become fragmented as a result of drainage projects.

Several other damaged rivers, including the St. Lucie, the Caloosahatchee, the Fenholloway, and portions of the Ocklawaha, might benefit from restoration efforts. However, the cost and disruption occasioned by such projects should serve as a warning to those contemplating physical alteration to Florida's rivers. The consequences of human interference with natural processes can be catastrophic.

Conservation

While Florida is blessed with abundant freshwater resources, these resources must not be taken for granted. Scientists estimate that fresh water makes up only about 2.5 percent of all the water on earth. Most fresh water is trapped in glaciers and ice caps. Most liquid fresh water is contained in lakes and aquifers. The world's rivers only contain about 2 percent of the world's liquid fresh water. Notwithstanding the overall scarcity of fresh water, it gives rise to some of the richest and most complex ecosystems on the planet. A potable supply of fresh water is essential for human life.

As a result of withdrawals for human use, water tables in Florida have dropped alarmingly in many areas. Several springs have dried up or have decreased output. Water resource caution areas have been extended over thousands of square miles of land. Water management districts impose water restrictions with increasing frequency. With these trends in mind, Floridians must become more efficient in their water use.

Ensuring an adequate supply of water also depends on protecting the quality of water entering the system. Storm water management is vital to such efforts. Impermeable surfaces such as parking lots, streets, roofs, and sidewalks interfere with the earth's ability to absorb water. As runoff flows across lawns and pavement and gushes through roadside ditches, it picks up trash, debris, pet waste, fuel byproducts, and other contaminants. Unless some means exists for storing, screening, and treating this water, it will flow directly into steams, rivers, and estuaries. Various statutes and codes outline methods for handling storm water runoff. Pollution entering watersheds can be reduced through the use of vegetated swales, storm water retention ponds, filtration systems, trash traps, buffer zones, and other controls. State leaders must strengthen regulations aimed at protecting water quality. Water managers must enforce current regulations. Law enforcement must devote adequate resources toward enforcing anti-littering and anti-dumping laws.

Agricultural interests can reduce the flow of nutrients, pesticides, and other contaminants into Florida's rivers and waterways by implementing Best Management Practices (BMPs). BMPs are techniques designed to enhance the conservation of natural resources. Slow-release fertilization and targeted fertilization can reduce the amount of nitrogen and phosphorous contained in surface runoff. The use of natural buffer zones separating crops from streams and rivers can further diminish the amount of nutrients and chemicals entering these waterways. Buffer zones, mulch, and other soil stabilization devices can prevent erosion and siltation. Farmers should carefully choose and apply pesticides to minimize impact on water quality. Finally, by switching from overhead sprinkling systems to more efficient drip irrigation systems or micro sprinklers, farmers can conserve water, save energy, and limit runoff. The Florida Department of Agriculture and Consumer Services, Office of Agricultural Water Policy (OAWP), has worked with agricultural interests to develop BMPs suitable for different types

of agriculture in all parts of the state.

Those who use Florida's rivers for recreational purposes must also do their part to protect Florida's water resources. Paddlers, hikers, and campers should carry out trash and any other items toted into natural areas. Anglers should practice catch-and-release fishing and should attempt to retrieve and dispose of every scrap of monofilament line. Monofilament line is not biodegradable. It can remain in the environment for years and entangle fish, turtles, birds, and other wildlife. The Florida Fish and Wildlife Conservation Commission, in partnership with other entities, administers the Monofilament Recovery and Recycling Program. Recycling bins have been installed in key locations throughout the state.

Finally, readers should note that conservation begins at home. A few common-sense practices can substantially reduce water use. Turning off the tap between tasks can save thousands of gallons over the course of a year. Fixing minor leaks as soon as they occur will also produce water savings. Wherever possible, low-flow showerheads, toilets, and appliances should be installed. By watering in the early morning or evening, homeowners can minimize evaporation. Homeowners can reduce the frequency of watering by planting drought-tolerant plants. Techniques such as those outlined within this paragraph have led to a significant decline in per capita residential water use over the past several decades.

Proper use of household chemicals also plays a vital role in protecting local waterways. Residents should dispose of solvents, pesticides, petroleum-based products, and other hazardous substances at authorized sites. They must never dump such chemicals into toilets, storm drains, or landfills.

Within the home landscape, pesticides should be viewed as an option of last resort. They should only be applied when insect problems become too pervasive to ignore, and should never be applied along the margins of streams and rivers. By making a few minor adjustments, Florida residents can minimize their impact on the environment.

Despite its proximity to suburban areas and agricultural lands, Rock Springs pours forth water of excellent quality.

The Preservation of Florida's Rivers

Part II
The Rivers

River mouths and estuaries provide a quiet anchorage for sailboats and other small craft.

Western Panhandle

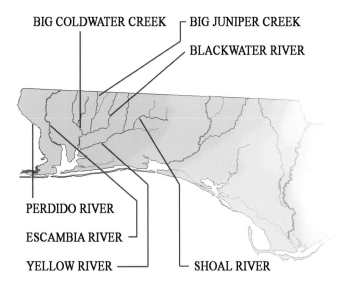

BIG COLDWATER CREEK BIG JUNIPER CREEK
BLACKWATER RIVER

PERDIDO RIVER
ESCAMBIA RIVER
YELLOW RIVER SHOAL RIVER

Rivers of the western Panhandle fall under the jurisdiction of the Northwest Florida Water Management District. Most are blackwater streams. Most originate in Alabama and flow south, emptying into bays along the Gulf of Mexico. They tend to be high-gradient waterways, especially in their upper reaches, flowing among sandhills, low ridges, and rugged terrain. Some of the fishes, turtles, and flora endemic to rivers of the western Panhandle have a closer association with the Mississippi drainage basin than with the eastern coastal plain. The ecological condition of these rivers is very good to excellent, owing to low population density, few physical alterations, and large tracts of protected wilderness.

Big Coldwater Creek

Waterway Type: Upland Stream

Substrate: Sand, Gravel

Ecological Condition: ★★★★

Oversight: NWFWMD

Designations: CT

Length: 28 miles

Watershed: 238 square miles

The swift, tea-colored current of Big Coldwater Creek courses through the rolling sand hills of the western Panhandle. This pristine waterway is a major western tributary of the Blackwater River, also discussed within these pages. In many respects, Big Coldwater Creek resembles a northern, upland stream, rather than a typical Florida river.

GEOGRAPHY AND HYDROLOGY Big Coldwater Creek originates from several small tributaries that begin near the border between Escambia County, Alabama, and Santa Rosa County, Florida. It flows through central portions of Santa Rosa County. The East Fork originates northeast of the border town of Sellersville, Florida. The East Fork is joined by Dixon Creek, which originates further to the west. Other tributaries of the East Fork include Surveyors Creek and Wolf Creek. The West Fork originates near the border town of Dixonville. Tributaries flowing into the West Fork include Cobb Creek, Malloy Branch, Cobb Branch, Blackjack Creek, Mare Branch, Juniper Creek, and Manning Creek. The water is generally shallow, flowing over a fine sand bottom. Logjams and sandbars occasionally interrupt the current. High clay and sand bluffs arise along the banks in the area immediately south of State Road 4. Just south of the confluence of the East and West Forks lies Party Island, a popular picnic and swimming spot. Coldwater Creek merges with the Blackwater River about 3 miles northeast of Milton. The Blackwater River drains into Blackwater Bay, which is connected with Pensacola Bay. To the west of Big Coldwater Creek lies the Escambia River drainage basin. To the east, lands are drained by Big Juniper Creek.

HISTORY At the time of Spanish exploration, the Panzacola Tribe of Native Americans inhabited

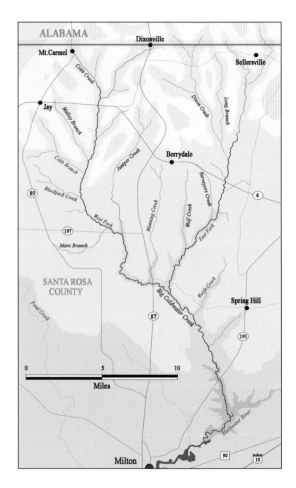

the area around Big Coldwater Creek and other waters flowing into what is now Pensacola Bay. Santa Rosa County, through which this waterway runs, was established in 1842.

HUMAN IMPACT Most portions of Big Coldwater Creek pass through undeveloped land and the Blackwater River State Forest. However, tributaries of the West Fork drain cotton fields, peanut

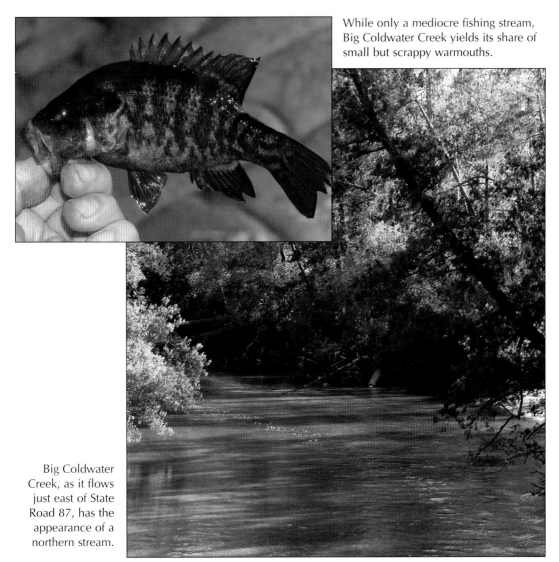

While only a mediocre fishing stream, Big Coldwater Creek yields its share of small but scrappy warmouths.

Big Coldwater Creek, as it flows just east of State Road 87, has the appearance of a northern stream.

farms, and other agricultural land. They therefore receive some nutrient-rich runoff laced with pesticides. The West Fork passes east of the small towns of Cobbtown, Allentown, and Roeville. The East Fork passes through pristine forests. It passes under State Road 4 between the towns of Berrydale and Munson. The Whiting Field Naval Air Station is located about 2 miles west of Big Coldwater Creek.

RECREATIONAL ACTIVITIES The Coldwater Creek Canoe Trail runs through the Blackwater River State Forest for a distance of approximately 18 miles. It begins at the State Road 4 bridge, west of Munson, and ends at the State Road 191 bridge, a few miles northeast of Milton. Fishing pressure is relatively light. This waterway is home to small but scrappy panfish, including warmouth, longear sunfish,

redear sunfish, and shadow bass.

FLORA AND FAUNA Juniper, pine, magnolia, water tupelo, swamp chestnut oak, laurel oak, and live oak grow along the banks. Big Coldwater Creek supports a relatively low biomass due to its shallow depths, uniform bottom, and tannin-stained water. Damselflies associated with this waterway include the smoky rubyspot, sandhill bluet, turquoise bluet, and blackwater bluet. Turtles associated with this stream include the Mobile turtle, common mud turtle, and common musk turtle. Snake species found in or along this waterway include the gulf crayfish snake, the yellowbelly watersnake, and the banded watersnake. Beaver are common in tributaries of this stream.

Big Juniper Creek

Waterway Type: Blackwater Stream
Substrate: Sand
Ecological Condition: ★★★★★
Oversight: NWFWMD
Designations: CT
Length: 21 miles
Watershed: 155 square miles

Big Juniper Creek is a swift waterway that threads its way through the undeveloped uplands and sand hills of the western Panhandle. It is one of the prettiest streams in Florida and should not be missed by visitors to the region. Like Big Coldwater Creek to the west, it is a tributary of the Blackwater River.

GEOGRAPHY AND HYDROLOGY Big Juniper Creek originates just north of the Alabama border, near the Florida town of Belandville. Seepages, bogs, and overland drainages contribute to its flow. Big Juniper Creek runs almost directly south for most of its length. Although it is classified as a blackwater stream, the water is fairly clear and is not heavily stained. Tributaries include Wolf Creek, Turkey Creek, Hog Pen Branch, Pittman Creek, Ellis Creek, and Alligator Creek. A major tributary, Sweetwater Creek, joins Big Juniper Creek just below the town of Munson. Sweetwater Creek also has its origins north of the border, in Escambia County, Alabama. Tributaries of Sweetwater Creek include Reedy Creek and Cedar Creek. About 3 miles south of the confluence of Big Juniper Creek and Sweetwater Creek, Big Juniper Creek flows past the Red Rock Recreation Area, where a high sandstone bank rises along the east side.

HISTORY The Panzacola people inhabited this region at the time of European contact. The name Panzacola, in Choctaw, is thought to mean "long-haired people." The Panzacola appear to have disappeared as a result of conflict with other native peoples or exposure to European diseases. The name of this group nevertheless lives on through Pensacola Bay and the city of Pensacola. Creeks moved into the region in the 1700s. In late 1814, noted frontiersman Davy Crockett came to Florida in connection with the Creek War. He reportedly

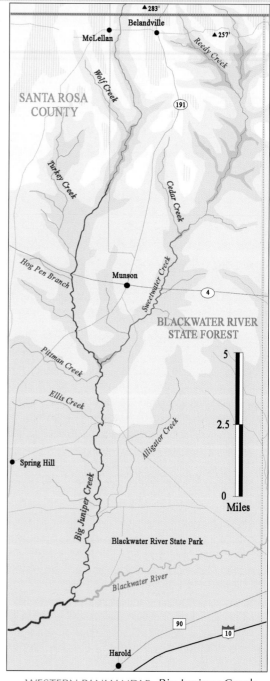

50

Fallen trees and other debris often accumulate against bridge pilings. This bridge is located on Big Juniper Creek, just east of the town of Springhill.

fought with Creek warriors in land around the Blackwater River and its tributaries. From the mid-1800s through the early 1900s, extensive lumbering took place in the region. Big Coldwater Creek, Big Juniper Creek, and the Blackwater River were used to transport logs to sawmills around Blackwater Bay.

HUMAN IMPACT Big Juniper Creek and its tributaries lie within the massive Blackwater River State Forest. As a result, most of this stream is in pristine condition. Water quality is very good to excellent.

RECREATIONAL ACTIVITES Both Big Juniper Creek and Sweetwater Creek are popular with kayakers and canoeists. Fishing in this stream is fair to good, with bream being the most popular quarry. Blackwater River State Forest provides opportunities for camping, hiking, biking, and equestrian activities.

FLORA AND FAUNA Blackwater River State Forest contains extensive forests of longleaf pine. Other foliage found along Big Juniper Creek and its tributaries include water oak, alder, water tupelo, magnolia, and persimmon. Lower story plants found along this stream include blackberry, titi, and wax myrtle. Boggy areas support carnivorous plants including various pitcher plants, sundews, and bladderworts. The rare pine barrens tree frog is found in seepage bogs associated with Big Juniper Creek. The chicken turtle, yellow-bellied turtle, common mud turtle, Mobile turtle, and rare alligator snapping turtle are found in this waterway. Birds include various herons, pileated woodpeckers, Mississippi kite, red-shouldered hawk, and red-tailed hawk. Whitetailed deer are plentiful in areas surrounding Big Coldwater Creek.

The red-shouldered hawk is often seen perched in trees along the banks of Big Juniper Creek.

Blackwater River

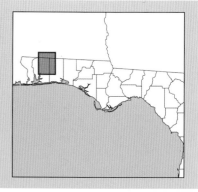

Waterway Type: Blackwater Stream
Substrate: White Sand
Ecological Condition: ★★★★★
Oversight: NWFWMD
Designations: OFW, CT
Length: 56 miles (45 in Florida)
Watershed: 880 square miles

The Blackwater River, with its tannin-stained current and banks of pure white sand, is one of the most pristine streams in the southeastern United States. Scenery along the river is unsurpassed. Water quality is excellent. The Blackwater is ranked by the Florida Department of Environmental Protection as Outstanding Florida Water.

GEOGRAPHY AND HYDROLOGY The Blackwater River originates in the Conecuh National Forest in southern Alabama. The upper river flows through gently rolling highlands, entering Florida in Okaloosa County. To the east lies the Yellow River watershed. To the west lies the Escambia River watershed. The water of the Blackwater River is clear, turning yellow-brown then black as the depth increases. The upper half of the river runs south. The lower half makes an abrupt turn and runs to the west. During this stretch several major tributaries join the river. These include Big Juniper Creek, Big Coldwater Creek, and Pond Creek. Below the junction with Big Coldwater Creek, the Blackwater broadens and slows. The banks become marshy. Near Milton, the river turns south again, broadening into Blackwater Bay, an extension of Pensacola Bay. Tidal influences extend upriver about 14 miles from the mouth.

HISTORY The Creek people referred to the river as Oka Lusa, meaning "water-black." The city of Milton, near the mouth of the river, was established as a trading post in 1825 and incorporated in 1840. During the early years of its existence, Milton was an important center for brick

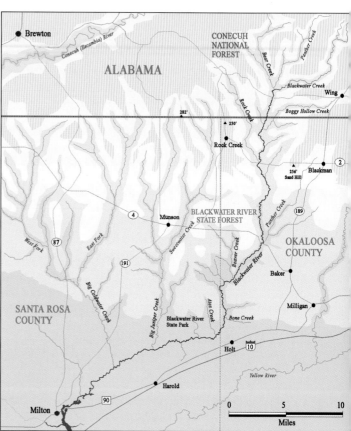

making. In the 1850s, it developed into a shipping port for cotton. The town contains a historic business district and many well-preserved homes. A Confederate army camp, Camp Milton, was established near the mouth of the Blackwater River in 1864. The town of Bagdad, also located near the mouth of the river, was an important lumbering center. It housed a large sawmill that operated for more than 100 years, until shutting its doors in 1939. Hurricane Fredrick, in 1979, and Hurricane Ivan, in 2004, caused some damage and flooding in this area.

Every bend of the Blackwater River is a treat for the eyes. The dark waters form a sharp contrast with banks of pure white sand.

HUMAN IMPACT The Blackwater River is wild and unspoiled. Only tidal portions have been touched by development. The towns of Milton and Bagdad are located on the lower river.

RECREATIONAL ACTIVITIES A 31-mile canoe trail, part of the state's system of greenways and trails, runs through the Blackwater River State Forest. It starts at the Kennedy Bridge, on State Forest Road 24, and ends at the Deaton Bridge, just north of Harold. Fishing in the river is fair to good. Bass tend to be small but scrappy. The upper river is home to spotted bass, longear sunfish, and shadow bass. Largemouth bass can be found in the lower river. Redfish and speckled sea trout are present near the river mouth. The Blackwater State Forest and Wildlife Management area, surrounding the river, consists of over 189,000 acres. It provides opportunities for hiking, camping, biking, swimming, and horseback riding. Motorboats are often present in tidal portions of the river, especially around the Milton area.

FLORA AND FAUNA The banks are lined with Atlantic white cedar, longleaf pine, cypress, dogwood, wax myrtle, hazel alder, and water oak. Carnivorous pitcher plants are present around backwaters and boggy areas. The rare flatwoods salamander is found in pine woods around the Blackwater River. Turtles in this river system include the alligator snapping turtle, loggerhead musk turtle, chicken turtle, and yellow-bellied turtle. The red-cockaded woodpecker and Mississippi kite may be seen overhead. Other bird species associated with this waterway include red-tailed hawk, osprey, great blue heron, red-bellied woodpecker, and various warblers. Bobcat and deer can sometimes be observed along the banks. The non-native coyote is also present in the area.

A water strider glides across a quiet backwater of the Blackwater River. This predatory insect relies on surface tension to stay dry and find food.

Escambia River

Waterway Type: Alluvial River
Substrate: Sand, Mud, Gravel
Ecological Condition: ★★★★
Oversight: NWFWMD
Designations: None
Length: 230 miles (62 miles In Florida)
Watershed: 3,850 square miles

The Escambia River of the western Panhandle is a significant waterway draining an extensive watershed. Approximately three-quarters of the area it drains lies in Alabama. North of the Alabama border, the Escambia is known as the Conecuh River. Within Florida, only the Perdido River lies farther to the west.

GEOGRAPHY AND HYDROLOGY The Escambia River arises in the Chunnenuggee Hills, near Union Springs, Alabama. It drains portions of 9 counties in Alabama. Major tributaries in Alabama include Patsaliga Creek and the Sepulga River. The river flows in a southwesterly direction until it intersects the Florida border, about 5 miles east of Flomaton. It then flows directly south, forming the boundary between Escambia and Santa Rosa Counties. For much of its journey through Florida, the river is braided with numerous side channels and backwaters, and is bordered by extensive cypress swamps. Notable tributaries joining the river in Florida include Big Escambia Creek, Canoe Creek, Moore Creek, and Pine Barren Creek. About 10 miles north of Pensacola, the Escambia River divides into several channels looping through a broad, marshy delta. These waters flow into Escambia Bay, which is part of Pensacola Bay. The Blackwater River and Yellow River also discharge into Pensacola Bay. Tidal influences extend up river nearly 38 miles from the mouth.

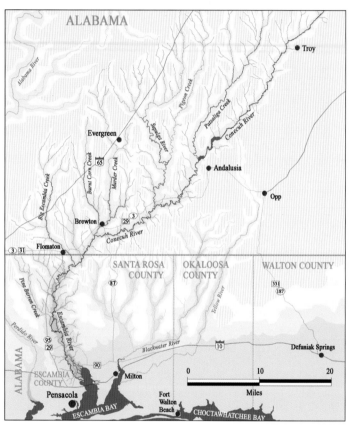

HISTORY Some sources indicate that the name Escambia is a corruption of the Creek word *shambia*, meaning "clear water." Others indicate that it was derived from the Spanish word *cambiar*, meaning "to exchange" or "barter." Still others claim that it was derived from the Spanish name given to a Native American village in the area, San Cosmo y Damian de Scambe. The name of the river in Alabama, Conecuh, has Native American origins. It is thought to mean "cane land" or "cane breaks," possibly referring to marshes surrounding the river tributaries.

Creek and Poarch people are thought to have occupied the river basin at various times during the period leading up to European contact. In 1516, Spanish explorer Diego Miruelo mapped Pensacola Bay. Tristan de Luna, during

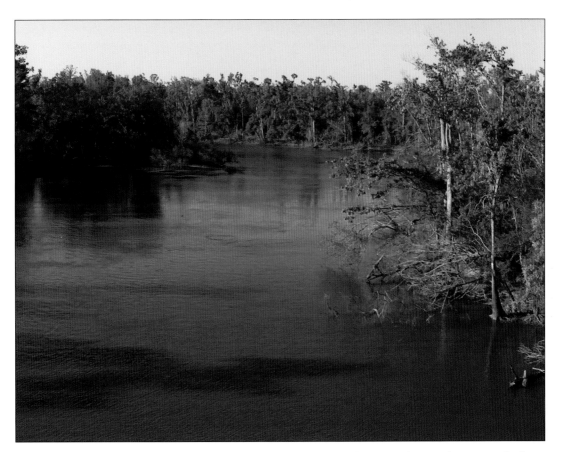

The Escambia is a major river draining a broad belt of southern Alabama. Its waters often carry a high sediment load.

his ill-fated settlement attempt in 1559, conducted additional explorations of the area. After his ships were wrecked and supplies ruined, de Luna sought help from the Nanipacna Indians who lived along the Alabama River to the north.

Escambia County, created in 1821, took its name from the river. It is the westernmost county in Florida. Along with St. Johns County, Escambia County was one of the first two counties in the state. Upper portions of the Escambia River were the scene of extensive battles between settlers and native populations during the early 1800s. The Battle of Burnt Corn, the first engagement of the Creek War, took place in 1813 along an Alabama tributary of the Escambia.

The Alabama and Florida Railroad, completed in 1861, ran along the west bank of the Escambia. This line, which linked Pensacola with Montgomery, Alabama, was the first railroad to operate in the western Panhandle. Confederate forces tore up the rails during the Civil War to prevent use by federal troops. The

Battle of Bluff Springs, also referred to as the Battle of Pine Barren, took place near Pringle Creek, a tributary of the Escambia. Federal forces, which had held Pensacola since 1862, began a push north toward Montgomery in March of 1865. They were harried and briefly confronted by a small rebel force. Casualties were light in this Union victory.

The town of Century is located along the Escambia River just south of the Alabama border. This town had its start around 1900, with the establishment of the large Alger-Sullivan Lumber Company sawmill. This mill operated for over 50 years, and was the final destination for millions of trees from huge tracts of southern Alabama.

Extensive flooding occurred along the river in February of 1990, and in connection with Tropical Storm Alberto in 1994. In 2004, Hurricane Ivan, which came ashore in Gulf Shores, Alabama, also caused damage in the region.

HUMAN IMPACT—Alabama portions of the watershed, while lightly populated, support some agriculture. Crops include cotton,

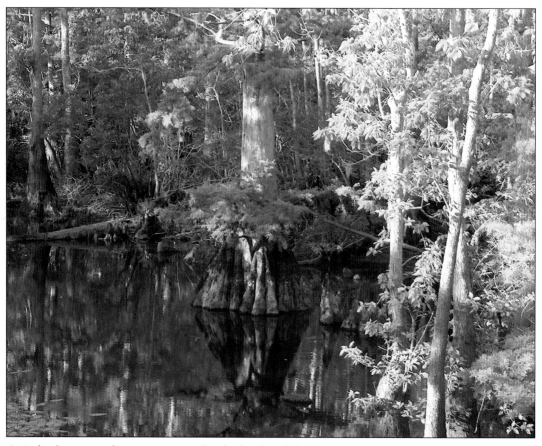

Quiet backwaters and cypress swamps line both sides of the lower river.

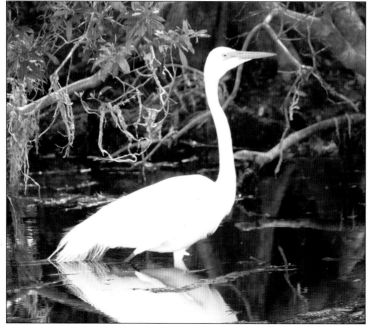

A great egret wades the shore-line of an Escambia tributary.

Fishing in the Escambia River can be superb. Bluegill and other panfish are numerous, both in the main channel and in backwaters and tributaries.

peanuts, soybeans, corn, and other vegetables. Within Alabama, the river is dammed in two locations. Gantt Dam is located in Covington County, north of Andalusia. Point A Dam is also located near Andalusia. In Florida the river flows near the towns of Century, Bluff Springs, McDavid, Chumackla Springs, Molino, and Pace. The only bridges crossing the river in Florida are at State Road 4 and State Road 184. US 90 crosses the head of Escambia Bay at the mouth of the river. The lower river has been dredged. Water quality is usually good, although, during periods of heavy rain, the river carries a high silt content.

RECREATIONAL ACTIVITIES–The Escambia rates as one of the best rivers for fishing in Florida. It consistently yields large channel catfish and blue catfish. The state record blue catfish, which weighed 61.5 pounds, was taken from Little Escambia Creek. Other fish that are pursued by anglers include longear sunfish, bluegill, spotted bass, warmouth, redear sunfish, and hybrid sunshine bass.

FLORA AND FAUNA–Foliage along the banks includes laurel oak, willow oak, cypress, black willow, water tupelo, magnolia, river birch, redbay, pawpaw, mayhaw, and swamp cottonwood.

The Escambia River supports numerous freshwater mussels, including several species that are rare or threatened. Species that inhabit the river include the delicate spike, paper pondshell, rayed creekshell, round washboard, yellow lance, and many others.

Dragonflies such as the black saddlebags,

russet-tipped clubtail, and eastern amberwing are present along this waterway. Damselflies such as the ebony jewelwing, sparkling jewelwing, bluefronted dancer, familiar bluet, orange bluet, and common spreadwing, may also be observed.

With the possible exception of the Apalachicola, this river supports a number of fish species greater than that of any other river system in Florida. At least 81 species of native freshwater fish have been collected from this waterway. Blacktail shiners and weed shiners are probably the most common minnows. Rare or endangered species include Gulf sturgeon, banded topminnow, bluehead chub, crystal darter, saddleback darter, southern starhead topminnow, and cypress minnow. The saltmarsh topminnow inhabits brackish estuaries around the river mouth. At least 4 non-native fishes from have been introduced into this waterway.

The seal salamander, very rare in Florida, is known from a few rocky tributaries of the Escambia. The Escambia map turtle may be spotted basking on logs and snags. It is found primarily in the Escambia and Yellow River drainage systems. The rare gulf coast smooth softshell turtle is found in the upper Escambia. Snakes associated with this waterway include the green watersnake, diamond-backed watersnake, yellow watersnake, midland watersnake, gulf crayfish snake, banded watersnake, and venomous water moccasin. Birds include great blue heron, great egret, osprey, belted kingfisher, and various warblers. River otters can be seen along some portions of the river.

Perdido River

Waterway Type: Blackwater River
Substrate: Sand
Ecological Condition: ★★★★
Oversight: NWFWMD
Designations: OFW, CT
LENGTH: 79 miles
Watershed: 1,240 square miles

The Perdido is the westernmost river of Florida, forming the boundary between Florida and Alabama. It is a typical stream of the region, with dark waters flowing through sand hills, and high banks lined with conifers.

GEOGRAPHY AND HYDROLOGY The headwaters of the Perdido River are located in Escambia County, Alabama, near Rayburn. The river gathers its waters from a series of bogs, marshes, and seepages. The river proper begins at the confluence of Perdido Creek and Dyas Creek. The watershed drains portions of Baldwin County, Alabama, and Escambia County, Florida. The upper river flows in a south to southeasterly direction. The Perdido is characterized by tea-colored, somewhat acidic water flowing over white sand. Broad sandbars occur along the inside curves of many bends. Several tributaries add to the flow of the Perdido. Major tributaries originating in Alabama include the Styx River, which begins near Bay Minette, and the Blackwater River, which should not be confused with the Blackwater River of Florida. Florida tributaries include Brushy Creek, Boggy Creek, McDavid Creek, and Jacks Branch. The Perdido River discharges into Perdido Bay, which connects with the Gulf of Mexico. The inlet leading to Perdido Bay has shifted several times during recorded history. Tidal influences extend as much as 25 miles inland from the river mouth.

HISTORY The Spanish dubbed this river Río Perdido or "lost river." The Movila Tribe was present in the region at the time of the arrival of the Spanish. The Perdido served as the boundary between Spanish Florida and French Louisiana from 1662 until 1763. The area fell under British rule before it was returned to Spain in 1783. Spain returned Louisiana to France in 1800, and France sold this territory to the United States through the Louisiana Purchase. The United

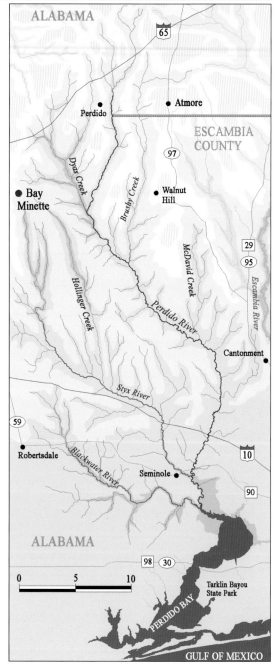

An eastern tiger swallowtail butterfly alights on damp sand along the edge of the Perdido River.

The picturesque Perdido River as it appears looking south near Barrinneau Park. Florida is on the left and Alabama is on the right.

States claimed the land west of the Perdido, while Spain maintained that the United States owned only those lands west of the Mississippi River. In 1819, this border dispute ended when Spain transferred Florida to the United States. In 1822, the Perdido became the western boundary of the Florida Territory. The Mobile and Great Northern Railroad, which ran east and west just north of the Florida border, was completed prior to the Civil War. It crossed the upper Perdido River near the town of Perdido, Alabama. A Confederate cavalry camp, Camp Powell, was established along the Perdido River in 1864. In the early 1900s, cassava was farmed in the Perido River basin. This root crop was used for animal feed and as a source of starch. Extensive logging has also been conducted in the region. Hurricanes Georges and Ivan caused flooding in the Perdido River basin.

HUMAN IMPACT Overall water quality in the Perdido is very good. The state of Alabama has purchased large tracts of land around the river and headwaters. Development in the area is sparse. La Floresta Perdido Wildlife Management Area and holdings of the Florida Conservation Association make up much of the land along the Florida side of the river. Timber companies, hunting clubs, and other private entities own extensive tracts along the river. The small Florida towns of Perdido, Barineau Park, Muscogee, and Bedah are located near the river.

RECREATIONAL ACTIVITIES The Perdido is a good river for flat water paddling, with a gentle current and little development along the banks. A 24-mile canoe trail may be accessed from various points along the river. Powerboats are frequent on the river below US 90. Fishing in the river is good, especially for catfish and spotted bass. Speckled sea trout and croaker are abundant near the mouth of the river.

FLORA AND FAUNA The river is surrounded by sandy uplands, forests of longleaf pine, and stands of hazel alder, juniper, Atlantic white cedar, and water elm grow in some areas along the banks. Damselflies that may be associated with this waterway include the blue-fronted dancer, powdered dancer, seepage dancer, common spreadwing, Atlantic bluet, blackwater bluet, orange bluet, turquoise bluet, and sparkling jewelwing. The Perdido River is home to about 75 species of native freshwater fish, including minnows such as the cypress minnow, flagfin shiner, bluenose shiner, longnose shiner, golden shiner, Dixie chub, speckled chub, ironcolor shiner, silverjaw minnow, clear chub, and weed shiner. Snakes that inhabit this waterway include the water moccasin, green watersnake, banded watersnake, and yellowbelly watersnake. Bird species include belted kingfisher, Mississippi kite, northern parula, Louisiana waterthrush, and many others.

Shoal River

Waterway Type: Upland River
Substrate: Sand
Ecological Condition: ★★★★
Oversight: NWFWMD
Designations: OFW, CT
Length: 31 miles
Watershed: 435 square miles

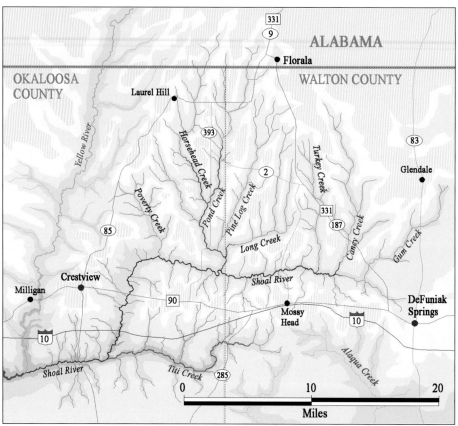

True to its name, the Shoal River of the Panhandle is a shallow stream flowing across a sandy bottom. It is a major tributary of the Yellow River, described in subsequent pages. The river remains in a natural state, with few signs of civilization apparent along the banks. Along with the Yellow River, the Shoal River drains some of the highest ground occurring in Florida.

GEOGRAPHY AND HYDROLOGY The Shoal River flows from east to west through Walton and Okaloosa Counties. It originates at the con-fluence of several small tributaries about five miles northwest of DeFuniak Springs. These include Narrows Creek, Gum Creek, Caney Creek, and Big Swamp Creek. As it flows west, it receives waters from Turkey Creek, Pond Creek, Poverty Creek, Titi Creek, and many smaller tributaries. In many places the banks are high and steep. The Shoal River is fed primarily by surface runoff, and the flow is greatly reduced in periods of low rainfall. The water is typically 2 to 3 feet deep. The Shoal River merges with the Yellow River about five miles southwest of Crestview.

Dogwoods bloom along the Shoal River in March and early April.

HISTORY People of the Creek and Choctaw Tribes inhabited the area surrounding the river from the 1500s until the early 1800s. Uplands surrounding the river basin supported cotton farming in the 1920s. Lumbering was also important in the region until the old-growth forests were exhausted. Hurricane Georges, in 1998, caused extensive flooding along the Shoal River.

HUMAN IMPACT Water quality in the Shoal River is very good. Most of the land along the river is not developed. The lower river, just before it joins the Yellow River, runs through part of the 17,000-acre Yellow River Wildlife Management Area.

RECREATIONAL ACTIVITIES A 27-mile canoe trail, designated by the state, runs from State Road 285 to the bridge at State Road 85, south of Crestview. Fishing in the river is good.

FLORA AND FAUNA The banks, which form sandy bluffs in some locations, are forested with maple, gum, southern red cedar, hazel alder, and oak. Damselflies that are found in the vicinity of this river include the variable dancer, blackwater bluet, turquoise bluet, citrine forktail, and sparkling jewelwing. The rare pine barrens tree frog is found in bogs connected with this waterway and its tributaries. Turtle species found in this river include the yellow-bellied turtle, the loggerhead musk turtle, the common musk turtle, and the common mud turtle. The rare Alabama map turtle is associated with this waterway. Snakes that may be found along this river include the venomous water moccasin, the diamond-backed watersnake, the gulf crayfish snake, and the midland watersnake. Beavers are common along some tributaries.

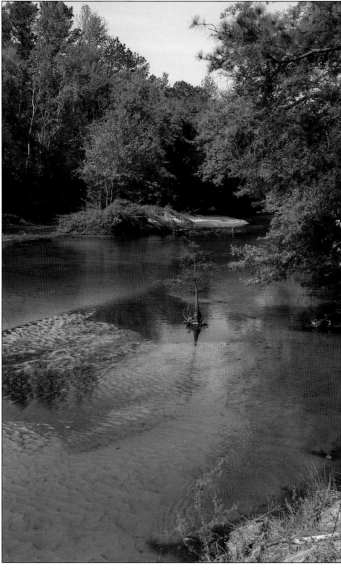

The sandy bottom of the Shoal River is clearly visible in most locations, except during periods of high water.

Yellow River

Type: Upland Stream/Coastal River
Substrate: Clay, Rock, Sand, Gravel
Environmental Condition: ★★★★
Oversight: NWFWMD
Designations: CT, AP (Marsh)
Length: 90 miles (61 in Florida)
Watershed: 1,200 square miles (700 in Florida)

This pristine Panhandle river courses through some of the highest terrain in the state. Like the Perdido and Blackwater rivers, it is a cool-water stream, similar to rivers in more northern locations. The current in the upper river is swift, and water levels can rise dramatically during periods of high rainfall. The Yellow River supports a rich and diverse wildlife community.

GEOGRAPHY AND HYDROLOGY The Yellow River rises in northern Covington County, Alabama. In Alabama, it drains the Red Hills region, including portions of Covington, Crenshaw, and Coffee Counties. Major tributaries joining the river in Alabama include Lightwood Knot Creek, Clear Creek, and Five Runs Creek. To the east, the Yellow River watershed borders on the Choctawhatchee River watershed. To the west, it borders on the Blackwater River watershed. In Florida, the Yellow River flows south, through western Okaloosa County. Tributaries joining the river in Florida include Big Creek, Horse Creek, Murder Creek, and Deadfall Creek. Just south of Crestview and Interstate 10, the Shoal River flows in from the east. The Yellow River then turns abruptly to the southwest, passing through southeastern Santa Rosa County before discharging into Blackwater Bay.

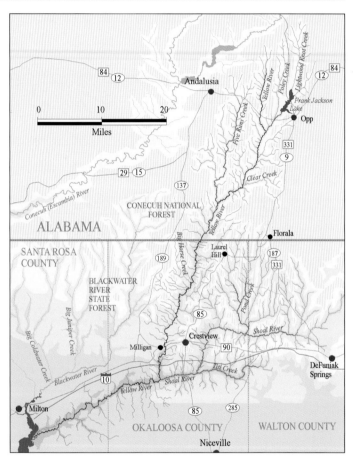

HISTORY The Choctaw people inhabited land around the Yellow River at the time of the arrival of the Spanish. The first white settlers in the river basin were of Scottish heritage. They arrived in the 1820s from North Carolina. The Pensacola and Atlantic Railroad, which linked Pensacola and Chattahoochee, was completed in 1883. It crossed the river just west of Crestview. This line, built by railroad baron William D. Chipley, opened much of the western Panhandle for development and settlement. Crestview, situated near the junction of the Yellow and Shoal Rivers, was named the county seat of Okaloosa County in 1917. Hurricane Georges, in 1998, caused extensive flooding within the Yellow River drainage basin.

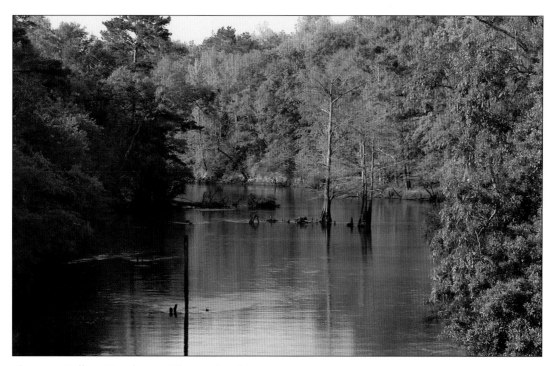
The upper Yellow River has a stiff current and many snags.

HUMAN IMPACT Development along the river is sparse. Towns near the river include Oak Grove, Milligan, and Parkerville. The United States Army Corps of Engineers has been studying a proposal to build a dam on the Yellow River to alleviate water shortages in the area. Various environmental groups oppose the concept. Overall water quality in the river is very good. Some tributaries convey a heavy load of sediment due to erosion. Some suffer minor impairment from agricultural runoff. The Yellow River Wildlife Management Area consists of over 17,000 acres. It encompasses more than 20 miles of river. The Eglin Air Force Base Reservation surrounds portions of the lower river. Much of the lower river is also encompassed within the Yellow River Marsh Aquatic Preserve.

RECREATIONAL ACTIVITIES The Yellow River Canoe Trail covers 56 miles of river. It begins at the bridge of State Road 2, near Oak Grove. It ends at the bridge of State Road 87, a few miles south of Interstate 10. Much of the river is navigable by powerboat, although rock shoals, snags, low branches, and treacherous currents are present on the upper river. Fishing is good in the river, and it sustains robust populations of blue catfish and bream. The state record warmouth, which weighed 2.44 pounds, was caught in the Yellow River.

FLORA AND FAUNA Cypress, red maple, sweetgum, hazel alder, black titi, wax myrtle, Atlantic white cedar, spruce pine, and sand pine account for much of the vegetation surrounding the river. Maidencane, pickerelweed, bulrush, and wild rice are present along the shoreline. Freshwater mussels found within this river include the elephant ear, iridescent lilliput, variable spike, and others. Damselflies found in the vicinity include the variable dancer, blue tipped dancer, blackwater bluet, and sparkling jewelwing. Dragonflies include the swamp darner, blackwater clubtail, twinstriped clubtail, common sanddragon, russet-tipped clubtail, common whitetail, common baskettail, eastern pondhawk, bar-winged skimmer, blue corporal, and yellow-sided skimmer. The Yellow River is inhabited by more than 70 species of native freshwater fishes. The quillback and black redhorse, members of the sucker family, are common. Minnows frequently collected from this river include the weed shiner, blackfin shiner, and clear chub. The one-toed amphiuma, a rare, eel-like amphibian, inhabits muddy areas along the river and its tributaries. The rare Florida bog frog is found only in small tributaries of the Yellow River and East Bay River. The Yellow River is home to the Escambia map turtle, alligator snapping turtle, chicken turtle, and common musk turtle, among others. River otters are common along some portions of this river.

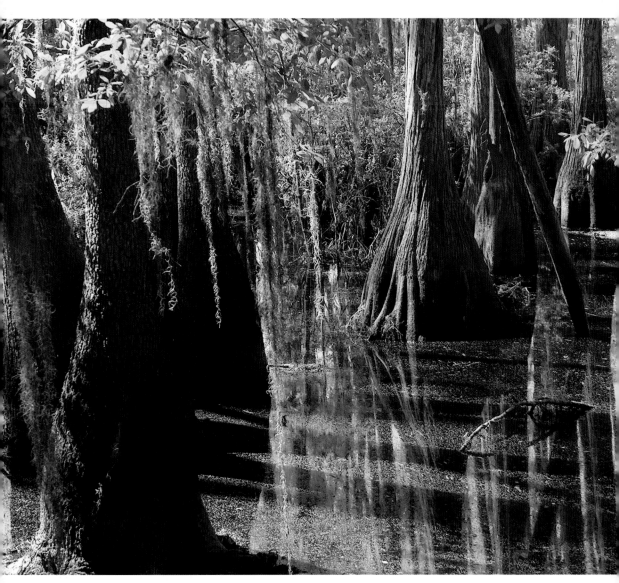
Backwaters of the Choctawhatchee River are ringed by stands of massive, five-hundred-year-old cypress trees. Such old-growth forests are exceedingly rare in Florida.

Central Panhandle

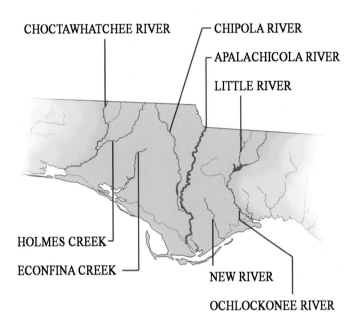

CHOCTAWHATCHEE RIVER — CHIPOLA RIVER — APALACHICOLA RIVER — LITTLE RIVER — HOLMES CREEK — ECONFINA CREEK — NEW RIVER — OCHLOCKONEE RIVER

Rivers of the central Panhandle fall under the jurisdiction of the Northwest Florida Water Management District. Two alluvial rivers, the Chocktawhatchee and the Apalachicola, are the primary waterways that cut through this region. However, the central Panhandle also houses an interesting mix of smaller waterways, some fed by springs, some fed by over-land drainage. These diverse habitats support some of the finest freshwater fishing in the state and offer superb recreational opportunities. Several of these rivers drain upland areas, comprising the southern foothills of the Appalachians. The overall ecological condition of rivers of the central Panhandle is good to very good. However, dams, dredging, commercial boat traffic, and tainted runoff have affected a few of these waterways.

Apalachicola River

Type: Large Alluvial River
Substrate: Gravel, Sand, Limestone, Mud
Ecological Condition: ★★★
Oversight: NWFWMD
Designations: OFW, AP (Bay)
Length: 107 miles
Watershed: 19,900 square miles

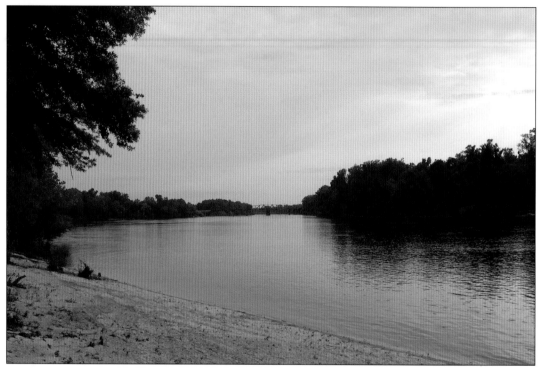

The broad Apalachicola as it appears from the landing at Chattahoochee. Big flathead catfish have been taken from this location.

The powerful Apalachicola River cuts through the center of the Panhandle. At one time, it comprised the boundary between East and West Florida. Today, it separates the eastern and central time zones. It also serves as the division between several counties of the central Panhandle. However, from a cultural standpoint, the river serves as a uniting force rather than as a division. Its waters bind this area of the state together. Those who live near the Apalachicola all have stories and memories of time spent on the big river.

GEOGRAPHY AND HYDROLOGY The Apalachicola River begins just south of the Georgia border. However, its sources can be found throughout western and northern Georgia and eastern Alabama. The two major tributaries, described below, are the Flint River and the Chattahoochee River.

The Flint River begins from groundwater seepage and runoff around Atlanta's Hartsfield International Airport and the Atlanta suburb of College Park. One of the most scenic rivers in the southeastern United States, it courses southward through Georgia's Piedmont region and then flows through limestone outcrops before reaching Lake Seminole, on the Florida-Georgia border. With a total length of 325 miles, it drains a watershed of about 8,500 square miles.

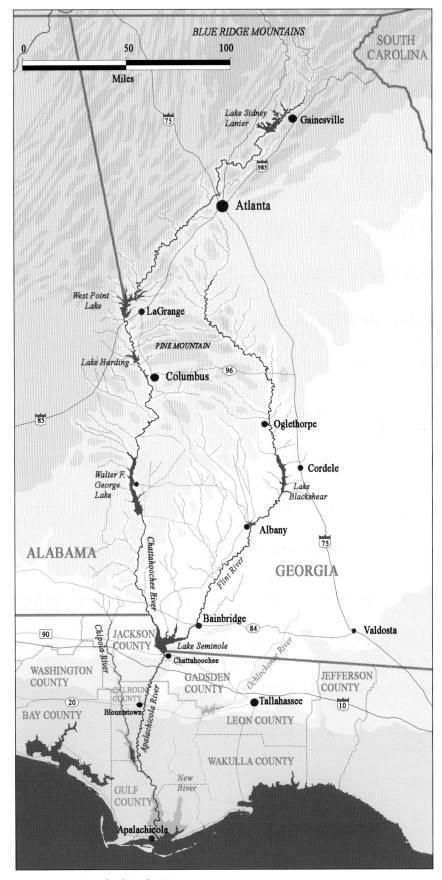

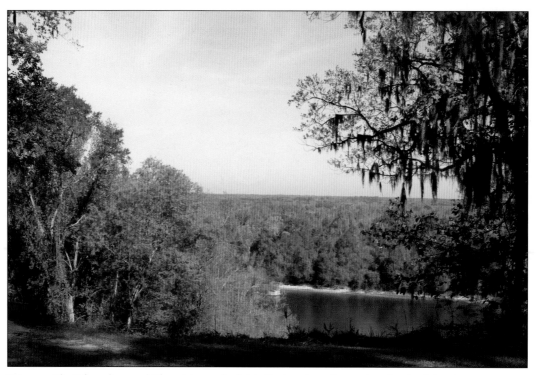

Between Chattahoochee and Blountstown, high bluffs rise along the eastern bank of the river.

The Chattahoochee begins as a tiny spring in the Chattahoochee Gap, high in the Blue Ridge Mountains of north Georgia. It traverses the highlands as a trout stream, discharges into Lake Sidney Lanier, flows southwest through the northern suburbs of Atlanta, then turns south, forming 160 miles of the border between Georgia and Alabama. With a total length of about 435 miles, the Chattahoochee drains a watershed of about 8,800 square miles, including some 2,800 miles of eastern Alabama.

The Apalachicola River begins at the Jim Woodruff Dam, at the southern end of Lake Seminole. It winds through the coastal lowlands, dropping about 40 feet before discharging its water into Apalachicola Bay and the Gulf of Mexico. The discharge rate averages about 19,602 cubic feet per second, making it the largest river in Florida in terms of flow. It is thought to account for 35 percent of all freshwater flowing into the Gulf of Mexico from Florida streams. Low limestone outcrops and a fairly steep river valley characterize upper portions of the river. High sand bluffs form the eastern bank in the Tallahassee Hills area. However, as the river emerges from the rolling hills of the central Panhandle, the flood plain broadens. Just south of the small town of Wewahitchka, the Chipola River flows in from the northwest. Tidal influences extend less than 20 miles inland from the river mouth. The Apalachicola empties into Apalachicola Bay, which connects with the Gulf of Mexico.

HISTORY Apalachicola, a Native American term, is interpreted to mean "the people on the other side" or "land of the friendly people." The area surrounding the Aplachicola has been inhabited for more than 10,000 years. Shell mounds show that early inhabitants enjoyed oysters that were plentiful near the river mouth. Hernando de Soto's army may have crossed the Apalachicola near the present-day town of Chattahoochee, during its expedition through north Florida in 1539. Apalachee Indians were present when the Spanish arrived in the area. Spanish missions San Nicolás de los Chatos and San Carlos de los Chacatos were located near the river. Creek Indians settled along the banks of the Apalachicola in the early 1700s. Between 1814 and 1818 fighting took place between Indians, runaway slaves allied with the Indians, and United States forces. The former slaves and Indians occupied a fort on a low bluff overlooking the river, near the present site of Fort Gadsden. In 1816, federal forces destroyed the "Negro fort," with a shot to the powder magazine, killing many of its defenders.

In 1817, a group of Mikasuki Indians, driven from their village in south Georgia, attacked a supply vessel on the Apalachicola. Most of the 50 or so passengers were slaughtered. This incident precipitated the First Seminole War. In 1818, Andrew Jackson marched south into Florida along the Apalachicola River, built a new fort on the site of the destroyed fort near Fort Gadsden, and launched assaults on nearby Native American settlements. By the 1840s most of the Indians in the area had left or had been relocated.

The historic port of Apalachicola (originally West Point), at the mouth of the river, was settled in 1822 and incorporated in 1829. In 1851, Dr. John Gorrie, a resident of Apalachicola, invented mechanical refrigeration. During the steamboat era, the Apalachicola became an important shipping route for cotton and other goods from Georgia and Alabama. This prompted Union forces to blockade the river during the Civil War. Following the Civil War, lumbering and turpentine production became predominant industries along the river.

Blountstown, located midway down the Apalachicola River, has always considered itself a river town. Blountstown was named for Chief Blount, a Seminole guide to Andrew Jackson's forces during the First Seminole War. Following the war, Blount established a trading post on the river. Fuller Warren (1905–1973), Florida's thirtieth governor, was born in Blountstown.

During the late 1800s and early 1900s a large number of steamboats operated on the river. These vessels, with names such as *Fannie Fearn* and *Hyperion,* typically ran from Apalachicola to Chattahoochee (originally River Junction) and further upstream to Columbus, Georgia, and Albany, Georgia. Steamboat races along the river, informally referred to as the "rivercade" were a popular sport in this bygone era.

The historic Gregory House, built in 1845 by cotton plantation owner Jason Gregory, formerly stood at Ocheesee Landing. This structure was donated to the state in 1935. It was dismantled and moved to the high bluffs overlooking the Apalachicola at Torreya State Park.

The Apalachicola and neighboring Panhandle streams represent the center of production for tupelo honey. This highly refined honey is considered by many to be the finest in the world. Apalachicola Bay has long been a center for seafood. Oysters, shrimp, and blue crabs are the primary targets of this industry.

HUMAN IMPACT The Apalachicola watershed encompasses Atlanta, other population centers, and vast tracks of agricultural land. The river tends to carry a high sediment load. Nevertheless, water quality is generally good.

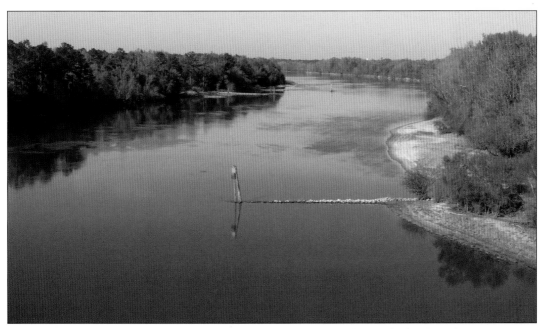

This is the view looking south from the new U.S. 20 bridge. The mighty Apalachicola makes its way to the Gulf.

The Gregory House, at Torreya State Park, overlooks the river from a perch atop the bluffs.

The estuary at the mouth of the river is considered healthy and supports large populations of shellfish and other species that require good water quality.

The Jim Woodruff Dam was completed in 1957. This dam was erected just downstream of the confluence of the Flint and Chattahoochee Rivers. It restrains Lake Seminole, a large impoundment located along the Florida-Georgia border. The Apalachicola has been dredged to accommodate barges and commercial traffic. The dredging has resulted in a loss of habitat and increased bank erosion. There have been recent calls from some groups to return the river to a more natural state. Towns located along the river include Chattahoochee, Blountstown, Bristol, Wewahitchka, and Apalachicola. Large tracts of bottomland surrounding the river are owned by the state or federal government. These lands include Apalachicola National Forest, the Apalachicola River Water Management Area, Torreya State Park, Tate's Hell State Forest, and Apalachicola Wildlife and Environmental Area. The Apalachicola National Estuarine Research Reserve protects the estuary at the mouth of the river.

RECREATIONAL ACTIVITIES Sport fishing in the river is popular. Many anglers pursue bream, sunshine bass, and striped bass. The river has yielded its share of state records. The record striped bass, which weighed 42.25 pounds, was taken from this waterway. The record spotted bass, which weighed 3.75 pounds, came from the Apalachicola. The record shoal bass, which weighed 7.83 pounds, was also taken here. The

predatory flathead catfish has been introduced into this waterway. While it has reduced native bream populations, it also provides an exciting fishery. The state record, which weighed 49.39 pounds, was caught in the Apalachicola. The Florida record white bass and common carp also came from the Apalachicola River. A breeding population of common carp, an introduced species, is present in the river. Fishing immediately below the Jim Woodruff Dam can be outstanding. The river is navigable by powerboat along its entire length. Recreational boaters should exercise caution due to the presence of barges and other commercial traffic.

FLORA AND FAUNA The river is surrounded by a broad flood plain. More than 338 plant species have been identified within this area. The banks accommodate diverse foliage, including pine flatwoods, black gum, sycamore, water elm, tupelo, swamp cottonwood, titi, magnolia, and willow. The rare Florida torreya grows on high bluffs along the eastern bank near Bristol. The rare Florida yew also grows along the eastern bank. Expanses of sawgrass are present around the mouth of the river.

The Apalachicola is home to many freshwater mussels, including several threatened or endangered species. Mussels found in the river include the arc mussel, delicate spike, fat three-ridge, Florida sandshell, giant floater, gulf moccasinshell, oval pigtoe, paper pondshell, pondhorn, purple bankclimber, rayed creekshell, variable spike, winged spike, yellow lance, and others. Two snails, the black-crested elimia and the Apalachi pebblesnail are found only on limestone outcrops below

the Jim Woodruff Dam. Apalachicola Bay is one of the nation's primary sources of oysters.

Dragonflies that may be associated with this waterway include the common green darner, comet darner, swamp darner, two-stripe forceptail, twinstriped clubtail, Belle's sanddragon, russet-tipped clubtail, steam cruiser, royal river cruiser, Halloween pennant, eastern pondhawk, painted skimmer, black saddlebags, and Carolina saddlebags.

The Apalachicola, with competition from the Escambia, may harbor the largest number of native freshwater fish species present in any river in Florida. At least 81 species are present. The grayfin redhorse, shoal bass, and rare bluestripe shiner are found only in the Apalachicola basin. The protected Gulf sturgeon sometimes enters the river. Minnows found within the river include the golden shiner, dusky shiner, coastal shiner, weed shiner, ironcolor shiner, bannerfin shiner, blacktail shiner, flagfin shiner, sailfin shiner, pugnose minnow, clear chub, and taillight shiner. About 14 non-native fish have been introduced into this waterway.

The rare Apalachicola dusky salamander and fire-back crayfish may be found in association with tributaries of the Apalachicola. Turtles present in the river include the chicken turtle, common mud turtle, common musk turtle, southern softshell, rare alligator snapping turtle, and the narrowly distributed Barbour's sawback turtle. The venomous copperhead, a snake that prefers dry uplands, is common in the Apalachicola River valley. The Gulf salt-marsh snake is present in grass flats surrounding the mouth of the river. Aquatic snakes found in backwaters and freshwater portions of the river include the banded watersnake, brown watersnake, glossy crayfish snake, eastern mud snake, and the venomous water moccasin. Alligators are very abundant. In 1989, a 14 foot-long alligator was killed on the lower Apalachicola River. This is one of the largest specimens measured in recent times.

Birds that may be sighted include Mississippi kite, swallow-tailed kite, red-cockaded woodpecker, pileated woodpecker, osprey, bald eagle, worm-eating warbler, and Swainson's warbler. The Apalachicola River basin was one of the last strongholds of the ivory-billed woodpecker. Most sources indicate that this species is extinct, although recent reports of sightings in Florida and Arkansas provide some hope that a remnant population exists.

Mammals present along the river include fox, black bear, bobcat, and coyote. The coyote is not native to Florida, but has expanded its range into this area and is now common throughout much of the Panhandle and north Florida.

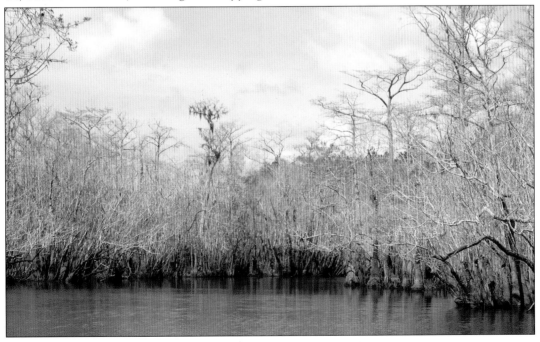

Graham Creek, a minor tributary of the Apalachicola, as it appears in late winter.

Chipola River

Waterway Type: Spring-fed Limestone River
Substrate: Limestone, Gravel
Ecological Condition: ★★★★★
Oversight: NWFWMD
Designations: OFW, CT
Length: 89 miles
Watershed: 1,300 square miles

The Chipola River, with its milky, blue-green water and high, limestone banks, is an Outstanding Florida Water. It is also one of the most distinctive rivers of the southeastern United States. The Chipola flows through the central Panhandle before merging with the Apalachicola River a few miles above the Gulf of Mexico.

GEOGRAPHY AND HYDROLOGY The headwaters of the Chipola River are located in Houston County, Alabama. Two major tributaries, Marshall Creek and Cowarts Creek, merge a few miles south of the Alabama border. The river briefly disappears below ground as it passes through Florida Caverns State Park near Marianna. More than 60 springs, most located in Jackson County, Florida, feed into the Chipola. Below Marianna, Spring Creek flows in from the east. Other tributaries include Dry Creek, Rocky Creek, Mill Creek, Tenmile Creek, Fourmile Creek, Juniper Creek, Cypress Creek, and Stone Mill Creek. The river flows directly southward, cutting through steep limestone banks as it passes through the Dougherty Karst Plain. It flows through Jackson, Calhoun, and Gulf Counties. A few miles north of its confluence with the Apalachicola River, the Chipola enters the swampy Dead Lakes Recreation Area. Dead Lake is an 8-mile-long natural impoundment, formed by a gravel bar deposited by the Alpalachicola River. The Chipola briefly parallels the Apalachicola River before flowing into the Apalachicola from the west.

HISTORY The area around this river was occupied by the Apalachee people and, possibly, by the Chatot at various times prior to European contact. Some sources indicate that Hernando de Soto crossed the Chipola River in 1539, near the present-day site of Marianna. Spanish mis-

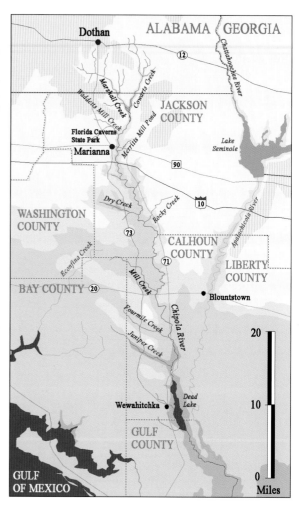

sions San Carlos de Yalcatanu and San Nicolás de Tolentino were located near or along the river. During the Second Seminole War, Fort Chipola was constructed on the east side of the river.

On September 27, 1864, Union and Confederate troops fought the Battle of Marianna for control of the Marianna Bridge over the Chipola River. This battle resulted in a Union victory. Union forces burned St. Luke's

Spring Name	Approximate Location	Discharge (cfs)	Magnitude
Jackson Blue Spring	30.790505N-85.140092W	155	1
Black Spring	30.698714N-85.294466W	65	2
Baltzell Springs	30.830722N-85.234142W	45	2
Rocky Creek Spring	30.675410N-85.132082W	29	2
Gadsen Spring	30.703357N-85.288451W	27	2
Blue Hole Spring	30.820145N-85.244895W	20	2
Millpond Spring	30.703610N-85.307500W	19	2
Maund Spring	30.746296N-85.215430W	8	3
The Crack	30.707183N-85.307356W	8	3
Springboard Spring	30.707330N-85.306680W	6	3
Peacock Spring	30.5368472N-85.16632W	-	-

The Chipola River has a unique character and is a superb stream for canoeing.

Episcopal Church and a nearby home in Marianna to flush out Confederate soldiers who refused to surrender.

The Old Spanish Trail, started in 1915 and completed in 1929, was the earliest "improved" automobile route along the Gulf Coast. It linked St. Augustine with New Orleans, and was then extended to San Diego, California. The route is similar to that of US 90 today. The Old Spanish Trail crossed the Chipola at Marianna.

HUMAN IMPACT The Chipola River has not been heavily impacted by development, and population along the river corridor is low.

Few scenes are as peaceful as the Chipola River shrouded in early-morning fog.

However, much of the land topping the banks has been touched by logging and agriculture.

RECREATIONAL ACTIVITIES The Chipola River Canoe Trail begins at Florida Caverns State Park and runs for 52 miles to Scotts Ferry. Several limestone shoals create fast water conditions. These include "Look and Tremble Falls," just south of the bridge at State Road 274. Depending on the river stage, this feature ranges from a barely perceptible shoal to moderate rapids. Bream fishing in the river is excellent, especially in the spring. The river is inhabited by red-breasted sunfish, redear sunfish, bluegill, and spotted sunfish. The Florida record redear sunfish, which weighed 4.86 pounds, came from Merritts Mill Pond, which discharges into the Chipola. The Chipola River is a stronghold of the rare shoal bass, one of Florida's premier game fish. Catch-and-release angling should be practiced with respect to this species. Gravel along the banks, bars, and bed often yield fossilized shark teeth and ancient shells. Tenmile creek, a tributary, also yields an array of fossils. Fossil hunting is best in the fall and early winter, when the water

tends to be low and clear.

FLORA AND FAUNA The banks are foliated with Carolina ash, Florida maple, red maple, chinkapin oak, Shumard oak, magnolia, dogwood, and water tupelo. Most of the forests along the river are second growth. The Chipola slabshell, a threatened freshwater mussel, is endemic to the Chipola River. The Chipola is home to many species of freshwater snails, including the thick-lipped ramshorn, marsh sprite, graphite elimia, knobby elimia, teardrop snail, and Choctaw lioplax. The beautiful American rubyspot, a damselfly that is rare in Florida, is sometimes observed along the upper Chipola River. Common minnows include blacktail shiner, coastal shiner, weed shiner, and clear chub. The rare Georgia blind salamander and the Dougherty plain cave crayfish are associated with subterranean springs feeding into the Chipola. The rare Barbour's map turtle is endemic to this river. Snakes associated with this waterway include the rainbow snake, brown watersnake, and banded watersnake. The pileated woodpecker may be observed

Blue Hole Run is a spring-fed tributary of the Chipola that flows through Florida Caverns State Park, near Marianna.

flitting among the treetops. Various warblers frequent vegetation along the shoreline, including northern parula, hooded warbler, prothonotary warbler, American redstart, and yellow-throated warbler.

The character of the river varies with the amount of precipitation. During times of drought the river runs clear, with a slight blue-green tint to the water. After a heavy rain, the river becomes brown and silted.

Choctawhatchee River

Waterway Type: Alluvial River
Substrate: Sand, Clay, Gravel, Mud, Limestone
Ecological Condition: ★★★
Oversight: NWFWMD
Designations: OFW
Length: 139 miles (62 In Florida)
Watershed: 5,300 square miles

Spring Name	Approximate Location	Discharge (cfs)	Magnitude
Morrison Spring	30.657884N-85.903938W	54	2
Washington Blue Spring	30.513259N-85.847186W	34	2
Holmes Blue Spring	30.851634N-85.885895W	12	2
Vortex Spring	30.770532N-85.948474W	11	2
Ponce de Leon Spring	30.721202N-85.930683W	11	2
Jackson Spring	30.711676N-85.928060W	-	-

The Choctawhatchee River as it appears looking north from the Caryville Landing, beneath US 90.

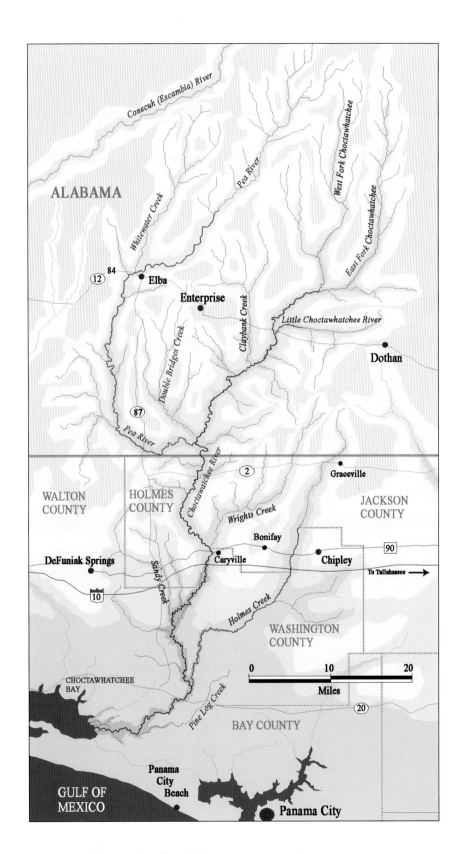

The Choctawhatchee River drains large areas of southern Alabama and the central Panhandle of Florida. It is the third largest river in Florida when measured in terms of water flow. The Florida Department of Enviromental Protection classifies the Choctawhatchee as an Outstanding Florida Water.

GEOGRAPHY AND HYDROLOGY The headwaters of the Choctawhatchee are located near the town of Clayton, in Barbour County, Alabama. The east fork is boggy in character. The west fork is a highland stream with sections of whitewater; it runs through soapstone formations. The forks merge in Dale County, Alabama. About two thirds of the watershed is located in Alabama, while the remainder is located in Florida. In Alabama, the river drains parts of Barbour, Bullock, Coffee, Covington, Crenshaw, Dale, Geneva, Henry, Houston, and Pike Counties. In Florida, the watershed includes parts of Bay, Holmes, Jackson, and Walton Counties. The Choctawhatchee River carries a heavy sediment load. A significant tributary, the Pea River, merges with the Choctawhatchee near Geneva, just north of the Alabama border. The Pea, which originates in Bullock County, Alabama, flows for nearly 130 miles before joining the Choctawhatchee. The Northwest Florida Water Management District has identified at least 13 springs within the Choctawhatchee basin. Morrison Spring is the largest of these. The largest tributary entering the Choctawhatchee River in Florida is Holmes Creek. Other significant Florida tributaries include Wrights Creek, Sandy Creek, Pine Log Creek, Seven Run, and Bruce Creek. The Choctawhatchee discharges into Choctawhatchee Bay, which is linked to Santa Rosa Sound and the Gulf of Mexico. Tidal influences extend upriver about 21 miles from the river mouth.

HISTORY Choctawhatchee means "river of the Choctaw." The Choctaw tribe once inhabited large portions of the Gulf coast, including the western Panhandle of Florida. Members were relocated to areas west of the Mississippi River, primarily Oklahoma in the early 1800s. Washington County, through which the Choctawhatchee runs, was Florida's twelfth county, formed in 1825. Cotton was the major crop in the region throughout much of the 1800s. However, a boll weevil infestation led to a decline. Sheep farming was also an important source of income. However, lumbering has been the predominant industry since the late 1800s. A large mill was established in Caryville. In more modern times, ancient cypress logs have been mined from the bottom of the river, dried, milled, and used for architectural purposes. Caryville, on the banks of the Choctawhatchee River, has experienced about a dozen serious floods, including a damaging flood in 1994. Some residents and businesses have relocated to higher ground. Choc-tawhatchee Bay has experienced periodic red-tide episodes, including severe occurrences in 1999 and 2000.

HUMAN IMPACT The Northwest Florida Water Management District owns large tracts along the river, consisting of more than 57,000 acres.

RECREATIONAL ACTIVITIES Fishing, camping, hiking, hunting, and horseback riding are available on certain lands owned by the Northwest Florida Water Management District. Robust populations of channel catfish exist in freshwater portions of the river. Fisheries biologists sampled a 46.5-pound channel catfish from this waterway, which they subsequently released. Flathead catfish are also present in this river. Anglers fishing near the river mouth and in Choctawhatchee Bay take speckled sea trout, flounder, and red drum.

FLORA AND FAUNA The banks of the river are lined with water hickory, pond cypress, sweet-

Poison ivy occurs in damp areas within river flood plains and along banks.

gum, laurel oak, Florida anise, longleaf pine, sand hickory, basswood, magnolia, red maple, river birch, spruce pine, live oak, Ogeechee tupelo, and water tupelo. While some of the forest lining the river is second growth, extensive old-growth tracts remain.

Snail species found in this river include the file campeloma, stately elimia, Choctawhatchee elimia, slackwater elimia, Gulf coast pebblesnail, and Choctawhatchee pebblesnail. Freshwater mussels present in the Choctawhatchee include the Florida sandshell, inflated floater, shiny-rayed pocketbook, variable spike, and others.

Over 115 fish species inhabit the Choctawhatchee River and its tributaries, including at least 77 species of native freshwater fish. The Florida record alligator gar, which weighed 123 pounds, was taken from the Choctawhatchee River. This record will probably stand for the foreseeable future, as it is now illegal to possess the species without a permit. Other notable fish species include the protected gulf sturgeon, spotted sucker, clear chub, weed shiner, blackfin shiner, coastal shiner, longear sunfish, and blackfin redhorse. Darters found in this river include the cypress darter, logperch, Florida sand darter, goldstripe darter, Choctawhatchee darter, gulf darter, brown darter, and blackbanded darter. The invasive green sunfish is present in the Pea River and other parts of the Choctawhatchee basin.

The rare alligator snapping turtle is present in this waterway, along with the chicken turtle, common musk turtle, and yellow-bellied turtle, and Mobile turtle. Snake species associated with the Choctawhatchee include the common banded watersnake, rainbow snake, gulf crayfish snake, yellowbelly watersnake, midland watersnake, and the venomous water moccasin.

Sightings of the ivory-billed woodpecker have been reported from the Choctawhatchee River basin. Most ornithologists indicate that this species vanished from the North American continent in the late 1940s or early 1950s. A handful of birds were present in Cuba as late as 1987. The ivory-billed woodpecker depended for survival on large tracts of old-growth cypress, black gum, and other bottomland trees. As these forests were felled for lumber, the species declined and populations collapsed. However, sporadic eyewitness accounts of ivory bills in the southeastern United States have persisted over intervening decades, including reliable reports from the Chipola River basin, in the 1950s, and Highland Hammock in south-central Florida, in the 1960s. There is a remote possibility that a few birds survived in old growth swamps surrounding the Choctawhatchee River. Definitive proof, in the form of a clear photograph, is lacking. Yet, all who appreciate nature hope that this species—the largest and most magnificent woodpecker native to North America—has somehow survived.

The pileated woodpecker is sometimes misidentified as the ivory-billed woodpecker.

Econfina Creek

Type: Upland Spring-fed River
Substrate: Limestone, Sand, Clay
Ecological Condition: ★★★★
Oversight: NWFWMD
Designations: CT
Length: 26 miles
Watershed: 115 square miles

As a rule, Florida rivers are not high-gradient streams. However, upper portions of Econfina Creek in the central panhandle provide an exception to this rule. This creek, which cuts through hilly areas of the central Panhandle, contains churning chutes, sharp turns, and patches of whitewater. Econfina Creek should not be confused with the placid Econfina River, which is located 120 miles to the east in Taylor County.

GEOGRAPHY AND HYDROLOGY Econfina Creek begins in the southwest corner of Jackson County. Several small creeks contribute to the headwaters. Tributaries include Buckhorn Creek, Goshum Branch, Sweetwater Creek, Tenmile Creek, Moccasin Creek, and Old Mill Branch. A small waterfall occurs where Sweetwater Creek empties into the Econfina over a rock ledge. Econfina Creek receives some of its flow from runoff and seepage. However, much of the flow is generated by springs. Some of these springs are open to the public but others are on private land. Econfina Creek carves its way through limestone bedrock and high bluffs, grazing the northwest corner of Calhoun County, then flowing southwest through Bay and Washington Counties. Econfina Creek discharges into Deer Point Lake, a reservoir from which Panama City draws its potable water supply. Other creeks discharging into Deer Point Lake include Bear Creek, Bayou George Creek, and Big Cedar Creek. Deer Point Lake discharges into the North Bay of St. Andrew Bay, which is located just to the west of Lynn Haven and Panama City.

HISTORY Prior to the arrival of Europeans, land

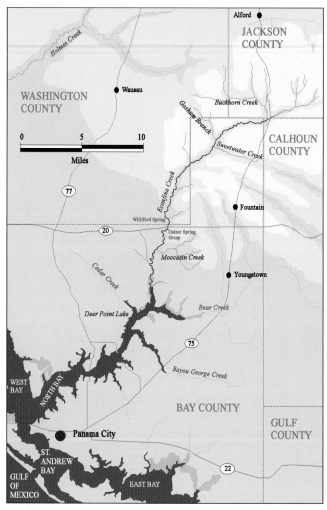

around Econfina Creek was inhabited at various times by the Choctaws and Creeks. In the 1830s, the federal government relocated most Creeks from the area. This forced migration, which involved an estimated 21,000 people from various Creek territories, resulted in tremendous hardship and cultural devastation. A few Creeks avoided resettlement and remained in hiding. Today, the North Bay Clan,

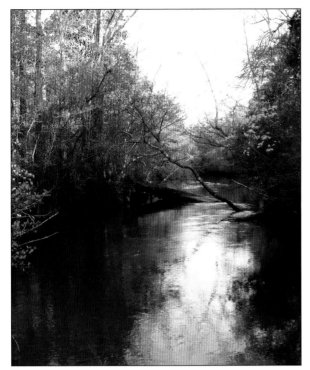

In the spring, Econfina Creek is lined with flowers and bright green foliage.

Sections now under public control are being replanted with native longleaf pine. The Northwest Florida Water Management District owns 14 miles of land along the creek. The Econfina Creek Wildlife Management Area consists of some 41,000 acres. Panama City and Lynn Haven are located on St. Andrew Bay, near the mouth of the Econfina.

RECREATIONAL ACTIVITIES Much of the creek is part of a state-designated, 22-mile canoe trail. The upper creek can be accessed from the Scotts Road bridge. It encompasses whitewater chutes, rapid currents and various obstructions. It should be attempted only by experienced paddlers and only under certain water conditions. The lower creek, which can be reached from Walsingham Bridge and Highway 20, broadens and the current slows. The creek and springs can draw considerable crowds during the summer. Recreational activities that are available within the wildlife management area include primitive camping, hiking, and horseback riding. Fishing on this stream is not especially productive, but improves as currents slow just north of Deer Point Lake.

Lower Muskogee Creeks, reside along Deer Point Lake at the mouth of Econfina Creek. Panama City, located on St. Andrew Bay, was incorporated in 1909. It received its present name because it is positioned on a direct line between Chicago, Illinois, and the Panama Canal.

HUMAN IMPACT Econfina Creek is a pristine stream with excellent water quality and extensive buffering along most of its length. Some areas surrounding the creek are owned by timber companies and are periodically harvested.

FLORA AND FAUNA Foliage along the bank includes Shumard oak, laurel oak, sugarberry, water tupelo, beech, dogwood, pyramid magnolia, holly, wild azalea, titi, St. John's wort, oak leaf hydrangea, and various ferns. The oval pigtoe, an endangered freshwater mussel, is present in this waterway. Bird species that may be observed along the river include various warblers, summer tanager, kestrel, osprey, red-shouldered hawk, and red-tailed hawk.

Spring Name	Approximate Location	Discharge (cfs)	Magnitude
Gainer Springs	30.427410N-85.547729W	177	1
Glowing Spring	30.456180N-85.532210W	35	2
Devil's Hole	30.490835N-85.522070W	32	2
Williford Spring	30.439552N-85.547581W	29	2
Sylvan Springs	30.431760N-85.548223W	17	2
Econfina Blue Spring	30.452856N-85.530446W	12	2
Pitts Spring	30.432966N-85.546429W	5	3
Strickland Spring	30.441187N-85.544277W	5	3
Fenceline Spring	30.429926N-85.547597W	4	3
Emerald Spring	30.428648N-85.549308W	-	-
Bluff Spring	30.425265N-85.548388W	-	-

Holmes Creek

Waterway Type: Spring Fed Stream
Substrate: Sand, Silt, Limestone Bedrock
Ecological Condition: ★★★★
Oversight: NWFWMD
Designations: CT
Length: 56 miles
Watershed: 260 square miles

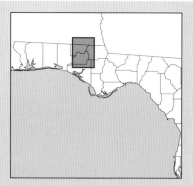

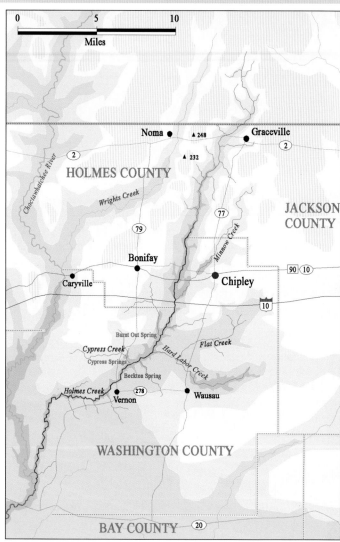

This lengthy Panhandle creek is the major Florida tributary of the Choctawhatchee River. It flows in a southwesterly direction. Holmes Creek supports an abundance of wildlife and stands of old-growth cypress.

GEOGRAPHY AND HYDROLOGY Holmes Creek begins in southern Alabama, 4 miles north of the Florida border, 6 miles north of the town of Graceville, Florida. Upper portions of the waterway are shallow and heavily vegetated. Although it passes through relatively high ground, the creek meanders through cypress swamps and sloughs for much of its upper length as it flows between Holmes and Jackson Counties. Tributaries include Gum Creek, Minnow Creek, Hard Labor Creek and Cypress Creek. Several large springs, including Burn Out Spring, just south of Highway 276A, Cypress Springs, just north of Vernon, and Becton Springs, add their waters to those of the middle and lower creek. Lower portions of the creek flow through Washington County. Holmes Creek merges with the Choctawhatchee River west of Ebro.

HISTORY The creek may have been named after Thomas J. Holmes, a settler from North Carolina. Holmes County took its name from that of the creek. Washington County, established in 1825, was named for President George Washington. In the 1840s and 1850s the basin surrounding Holmes Creek was farmed for cotton. Vernon, a quaint town located along Holmes Creek in Washington County, was named for Mount Vernon—George Washington's home.

HUMAN IMPACT Very little development is present along Holmes Creek, although much land within the upper basin is privately held.

RECREATIONAL ACTIVITIES A 16-mile, state-designated canoe trail runs from Vernon Wayside Park, off US 79, south to Live Oak

82

Some parts of Holmes Creek have the appearance of sluggish backwaters. However, this waterway gains volume and momentum from the springs along its course.

Landing, near New Hope. The route is considered an easy paddle. Fishing on Holmes Creek ranges from good to outstanding. Channel catfish, flathead catfish, and bream are the primary targets.

FLORA AND FAUNA Foliage present along this creek includes cypress, water tupelo, Florida anise, sweetbay, Carolina ash, pawpaw, and mayhaw. Holmes Creek supports an extremely rich population of freshwater snails, including at least 22 species. Damselflies associated with this creek include the blue-tipped dancer, blue-fronted dancer, and variable dancer. Gulf sturgeon congregate near the confluence of Holmes Creek and the Choctawhatchee River during the summer. Birds that are present along this waterway include great blue heron, American bittern, Mississippi kite, pileated woodpecker, northern flicker, blue-gray gnatcatcher, and various warblers.

In some areas the creek is bordered by stands of pickerelweed and duck potato. Both plants represented a food source for Native Americans. The seeds and emerging foliage of pickerelweed are edible. Tubers that form along the roots of the duck potato can be prepared like potatoes.

Spring Name	Approximate Location	Discharge (cfs)	Magnitude
Cypress Springs	30.658746N-85.684372W	90	2
Becton Spring	30.648647N-85.693663W	28	2
Jack Paul Spring	30.612859N-85.733739W	13	2
Burnt Out Spring	30.682033N-85.646017W	-	2
Brunson Landing Spring	30.609229N-85.758580W	6	3
Galloway Spring	30.597460N-85.842016W	-	3

Little River

Waterway Type: Small Blackwater River
Substrate: Sand
Ecological Condition: ★★★★
Oversight: NWFWMD
Designations: None
Length: 14 miles
Watershed: 315 square miles (95 in Florida)

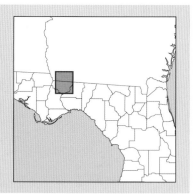

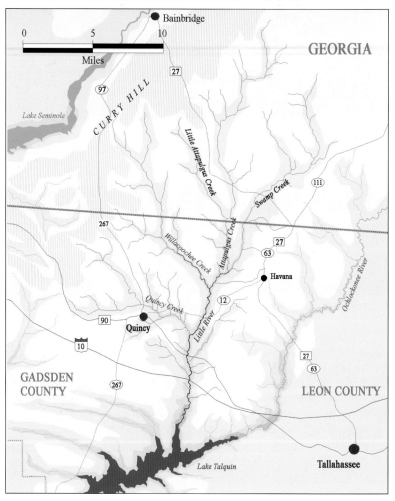

The Little River is a tributary of the Ochlockonee River of the eastern Panhandle. This blackwater stream flows through the Red Hills area between Tallahassee and Quincy. It is located entirely within Gadsden County.

GEOGRAPHY AND HYDROLOGY The Little River is formed at the junction of Attapulgus Creek and Willacoochee Creek. Attapulgus Creek begins north of the Georgia border, about 10 miles west of Cairo, near the Decatur-Grady County line. It flows south for 16 miles before joining Willacoochee Creek. Willacoochee Creek begins about 10 miles south of Bainbridge, Georgia. It flows southeast for about 13 miles before merging with Attapulgus Creek. Swamp Creek, a major tributary of Attapulgus Creek, flows in from the northeast near the town of Havana, Florida. The Little River begins about 4 miles west of Havana. It flows south through Gadsden County. Tributaries include Quincy Creek, Hurricane Creek, and Monroe Creek. The Little River flows into Lake Talquin at the Lake Talquin State Recreation Area. Lake Talquin is a reservoir on the Ochlochonee River, held back by the Jackson Bluff–Lake Talquin Dam.

HISTORY The Apalachee Indians inhabited the land surrounding the Little River when the Spanish arrived in the area. Gadsden County, through which the river flows, was established in 1823. It was named for James Gadsden, military aide to General Andrew Jackson. The town of Quincy, which is the county seat of Gadsden County, is located a few miles west of the Little River. It contains a significant historic district with several antebellum homes. Cotton farming took place on land around the Little River dur-

84

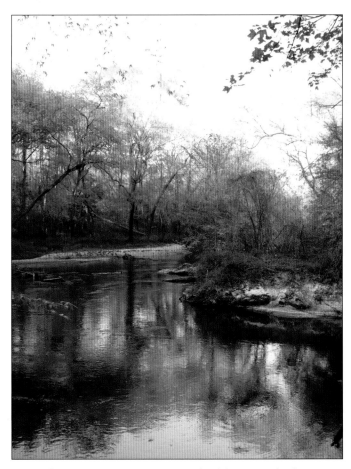

The Little River as it appears just north of the US 90 bridge.

for bream and pickerel can be productive.

FLORA AND FAUNA The banks are lined with river birch, mayhaw, spruce pine, longleaf pine, loblolly pine, southern red cedar, sycamore, swamp cottonwood, poison ivy, and various willows. Many damselflies can be observed in association with this river, including the double striped bluet, fragile forktail, southern sprite, sparkling jewelwing, swamp spreadwing, blue tipped dancer, and seepage dancer. Minnows present in the Little River include weed shiner, blackfin shiner, coastal shiner, dusky shiner, bannerfin shiner, and sailfin shiner. Turtle species inhabiting this river include the yellow-bellied turtle, coastal plain turtle, and the rare alligator snapping turtle. Deer, raccoon, gray fox, and non-native coyote are present in woodlands surrounding the river.

ing the decade preceding the Civil War.

HUMAN IMPACT Several strip mines and pine plantations are present along the river and its tributaries. Quincy Creek flows through the city of Quincy, where it receives considerable street runoff and picks up some litter. Private hunting clubs own much of the land surrounding the river.

RECREATIONAL ACTIVITIES The Little River is not a state-designated canoe trail. Upper sections are shallow and require many pullovers except during periods of high rainfall. Paddlers should exercise caution during hunting season, as forests surrounding the river are a popular destination for hunters. Lower portions of the river offer fine flat-water paddling. Fishing

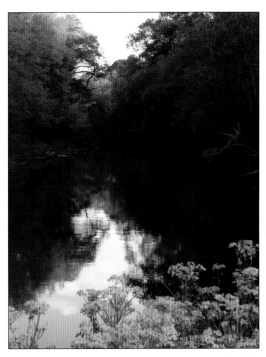

The Little River is a placid blackwater stream that flows through pristine woodland for most of its length.

New River

Waterway Type: Blackwater/Small Coastal River
Substrate: Sand, Mud
Ecological Condition: ★★★★
Oversight: NWFWMD
Designations: None
Length: 37 miles
Watershed: 315 square miles

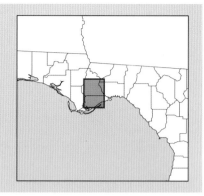

Three rivers within Florida are named "New River." One flows through Fort Lauderdale. Another forms the border between Union and Bradford Counties. The New River discussed here lies in the Florida Panhandle. It winds slowly through a remote region of Liberty and Franklin Counties.

GEOGRAPHY AND HYDROLOGY The New River originates in a boggy area about 5 miles southwest of Hosford, in Liberty County. It receives its flow from drainage, swampland outflows, and seepage. It drains the belt of land between the Apalachicola River to the west and the Ochlockonee River to the east. The New River courses southward for most of its length. It flows through white sand bars, boggy terrain, second-growth forest, and scrubland. Tributaries include Hogpen Creek, Hostage Branch, Black Creek, Bay Creek, West Prong, Cat Branch, and Juniper Creek. The New River passes through portions of the Apalachicola National Forest, Mud Swamp, and Tate's Hell Swamp. Tidal influences affect about 10 miles of the lower river. About 3 miles above its mouth the New River merges with the Crooked River, which flows in from the east. These merged streams are known as the Carabelle River. The Carabelle River discharges into the Gulf of Mexico at the fishing port of Carabelle.

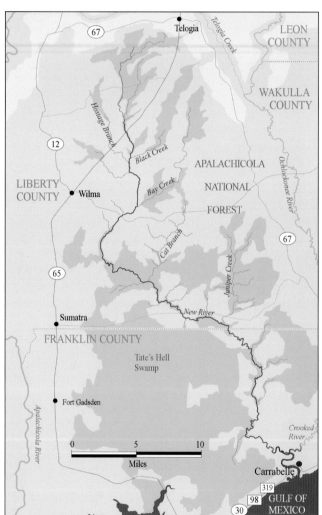

HISTORY Tate's Hell, the swamp surrounding the river, was named for Cebe Tate, a farmer who became lost while hunting panther in the late 1800s. Tate was bitten by a rattlesnake, suffered great torment, and eventually crawled out of the swamp. Legend has it that, on being found, he recited his name, stated that he'd just been in hell, and died a few days thereafter. The story has been put to song in dramatic fashion by Florida's noted folk singer Will McClean (1919–1990).

HUMAN IMPACT From the 1950s to the 1970s, forestry companies dug drainage ditches and constructed roads though lands around the river in an effort to boost timber production. Over the past two decades, the state has pur-

The New River passes through remote wilderness areas and is home to many snakes, turtles, and other wildlife.

chased large tracts. A 2005 land swap with the federal government resulted in acquisition by the state of an additional 6-mile-long tract along the river. The Division of Forestry has been working with other entities to restore this area to its natural condition. Tate's Hell State Forest, which surrounds much of the river, is composed of more than 200,000 acres. Apart from the town of Carabelle, at the river mouth, no significant development has occurred along this waterway.

RECREATIONAL ACTIVITIES Although the New River is not a state-designated canoe trail, portions are accessible by canoe and kayak. The upper river contains many pullovers and sometimes fades into a maze of sub-channels. The section that flows through Tate's Hell State Forest presents a less-stressful paddling experience. The state forest has primitive camping, horse trails, and hiking trails.

FLORA AND FAUNA Plants that are present along the river include titi, willow, mayhaw, water tupelo, and cypress. Land surrounding the river supports several rare plants such as thick-leaved water willow, Chapman's butterwort, small-flowered meadow beauty, and Florida bear grass. Minnows endemic to this river include the sailfin shiner, Dixie chub, pugnose minnow, weed shiner, ironcolor shiner, and coastal shiner. Turtles include southern softshell, chicken turtle, intergrades between

the Suwannee turtle and the Mobile turtle, and in estuarine regions, Florida diamondback terrapin. Common snakes include the water moccasin, the brown watersnake, and the redbelly watersnake. The southern coal skink, a rare lizard, may be found in seepages and boggy areas associated with this river. Most lizards, when disturbed, run away or hide in vegetation. However, the first instinct of the coal skink is to take to water and to bury itself beneath debris on the bottom. Bird species include the bald eagle, red-cockaded woodpecker, belted kingfisher, Acadian flycatcher, pine warbler, and various other warblers.

The quaint town of Carabelle, just below the junction of the New and Crooked Rivers, is home to commercial fishing vessels and excellent seafood restaurants.

Ochlockonee River

Waterway Type: Coastal/Alluvial River
Substrate: Sand, Silt
Ecological Condition: ★★★
Oversight: NWFWMD
Designations: OFW, CT
Length: 66 miles in Florida (125 miles total)
Watershed: 2,450 square miles (1,200 in Florida)

This tranquil river with the troublesome name (pronounced oak-lock-knee) ranks as one of the best waterways in Florida for fishing and wildlife observation. It courses through some of the most scenic parts of the eastern Panhandle. Although the upper watershed has suffered from water quality problems, the Florida Department of Environmental Protection has designated the Ochlockonee an Outstanding Florida Water.

GEOGRAPHY AND HYDROLOGY

The Ochlockonee has its origins in Worth County, Georgia, in the area just south of Sylvester. Within Georgia, it receives the waters of numerous tributaries, including Bridge Creek, Big Creek, the Little Ochlockonee River, Barnetts Creek, Oquina Creek, and Tired Creek. Water in the upper river is yellowish-brown, stained by the clay soil of southern Georgia. The Ochlockonee can carry a significant sediment load in periods of high rainfall. The upper river is divided from the lower river by Lake Talquin, an 8,800-acre reservoir. The name of this impoundment is derived from its location, midway between the cities of Tallahassee and Quincy. Much of the sediment load carried by the upper river is deposited in western parts of the lake and does not find its way into the lower river. A major tributary, the Little River, flows into Lake Talquin from the north. Another tributary, Telogia Creek, flows into the Ochlockonee

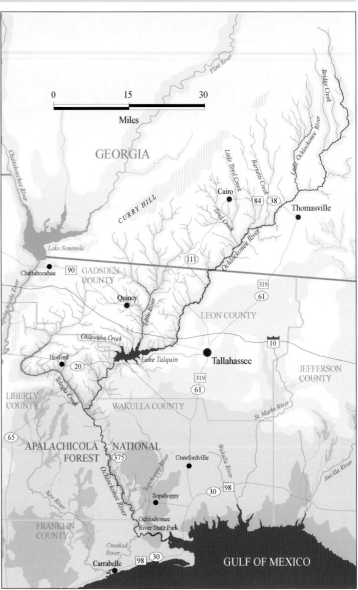

from the northwest, about 12 miles below the dam. The river ultimately discharges into Ochlockonee Bay, where its water joins with

This is the Ochlockonee from the US 90 bridge, just west of Tallahassee.

that of the Sopchoppy River, flowing in from the northwest. Ochlocknee Bay is a narrow arm of Apalachee Bay, which is part of the Gulf of Mexico. Tidal influences extend upriver 15 miles from the river mouth.

HISTORY The name Ochlockonee is thought to be a corruption of the Muskogee word for yellow—LAH'nee. When the Spanish first arrived in the area in 1539, they found it inhabited by the Apalachee Indians. The area was later settled by the Seminoles. Fort Stansbury was maintained on the river from about 1840 to 1844. Following the First and Second Seminole Wars, native people were deported from the Ochlockonee basin to territories further west. Cotton was an important crop in the region prior to the Civil War, and a number of plantations were established. Florida plantations also grew sugarcane and corn. During the Civil War, federal forces raided a salt manufacturing facility near the mouth of the river. Hurricane Dennis, in 2005, caused significant flooding along the upper river.

HUMAN IMPACT In Georgia, dairy farms, swine farms, cotton farms, peanut farms, and other agricultural uses affect land drained by the Ochlockonee. Water quality in portions of the upper river is poor. The river flows just west of the town of Moultrie and the city of Thomasville. In Florida, the Ochlockonee passes near the town of Havana. Although it flows through the western suburbs of Tallahassee, development along the river is relatively sparse. The Jackson Bluff Dam, which forms Lake Talquin, impacts the river's water cycles and moderates its flow. The Apalachicola National Forest and Tate's Hell State Forest surround much of the lower river.

RECREATIONAL ACTIVITIES Fishing opportunities abound in the Ochlockonee watershed. The upper river harbors a population of the rare and scrappy Suwannee bass. The lower river supports an excellent striped bass fishery.

A railroad bridge over the Ochlockonee near Tallahassee.

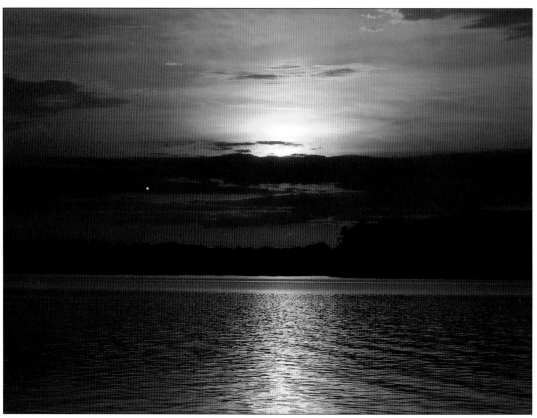

Lake Talquin is a large reservoir that is highly regarded for fishing. Trophy crappie, striped bass, sunshine bass, largemouth bass, and pickerel are regularly taken from these waters.

The area below the Jackson Bluff Dam at Lake Talquin is especially productive. The Ochlockonee ranks as one of the top waters in the state for bream fishing. Red-breasted sunfish are numerous. Lake Talquin yielded the state record pickerel, which weighed 6.96 pounds, as well as an unofficial record, which weighed 8 pounds. The state record black crappie, which weighed 3.83 pounds, was also taken from Lake Talquin. Blue crabs are abundant in brackish portions of the lower river.

Two state-designated canoe trails exist on the waterway. The first encompasses 26 miles of the upper river. It begins at the bridge of State Road 12, and ends at the bridge of US 90, just west of Tallahassee. The second trail starts immediately below the Jackson Bluff Dam and ends at the Ochlockonee River State Park, south of Sopchoppy. The park features a boat ramp, dock, and camp sites. The lower river, Lake Talquin, and some parts of the upper river are navigable by powerboat, despite the occasional snag. Traffic on the lower river can be heavy.

FLORA AND FAUNA The upper river is lined by willow, black gum, titi, Ogeechee tupelo, swamp cottonwood, mayhaw, red maple, red buckeye, cypress, river birch, and water oak. The lower river winds through pine flatwoods. Sawgrass is present around the mouth of the river. Snail species include maiden campeloma and Choctaw lioplax. Mussel species include the Florida sandshell, Ochlockonee arc-mussel, purple bank climber, round washboard, and shiny-rayed pocketbook. A few specimens of the endangered Ochlockonee moccasinshell mussel have been collected from the Ochlockonee River.

The Ochlockonee is frequented by many damselfies, including the sparkling jewelwing, smoky rubyspot, southern sprite, common spreadwing, variable dancer, orange bluet, blackwater bluet, and burgundy bluet.

The Ochlockonee is home to about 74 species of native freshwater fish. Minnows include the ironcolor shiner, dusky shiner, weed shiner, coastal shiner, bannerfin shiner, pugnose minnow, blacktail shiner, golden shiner, and sailfin shiner.

The rare four-toed salamander is known from boggy areas associated with this river and from a few other locations. Turtle species inhabiting this river include the alligator snapping turtle, chicken turtle, and intergrades between the Suwannee turtle and the Mobile turtle. A distinct population of the eastern common kingsnake is found along the lower river. The water moccasin, midland watersnake, and banded watersnake inhabit this waterway and its tributaries.

Of special interest to birders is the rare red-cockaded woodpecker, which inhabits pine forests along the lower river. Other bird species that are found along the Ochlockonee include purple gallinule, osprey, swallow-tailed kite, and various herons and egrets.

The Florida black bear can sometimes be glimpsed along the river. It is the largest land mammal native to the state. Its range is shrinking rapidly in most regions as a result of habitat destruction. The population, which once numbered about 12,000, is now thought to consist of less than 1,600 individuals. Each year, an average of about 60 bears are killed on Florida's roads. A significant population exists in Apalachicola National Forest and in a scattering of other areas around the state. While these animals should never be approached, there does not appear to be any record of bear attacks in Florida.

Telogia Creek is a blackwater tributary of the Ochlockonee River. It drains uplands between Lake Talquin and the Apalachicola River.

The lower Ochlockonee slows and broadens. It is affected by tide and wind and can make for a strenuous paddling experience.

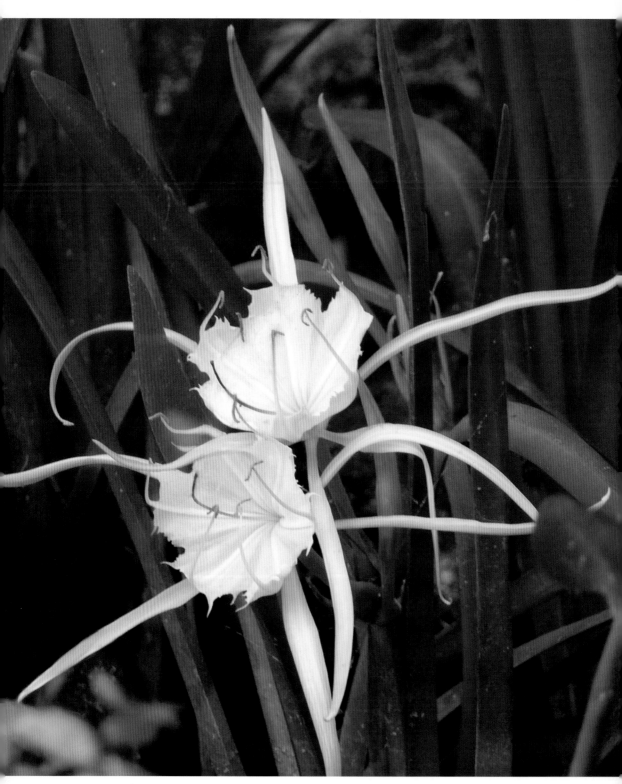

Spider lilies are found along the spring-fed rivers of the eastern Panhandle.

Eastern Panhandle

ST. MARKS RIVER

AUCILLA RIVER

SOPCHOPPY RIVER

FENHOLLOWAY RIVER

WAKULLA RIVER

ECONFINA RIVER

WACISSA RIVER

The St. Marks River and those rivers to the west fall under the jurisdiction of the Northwest Florida Water Management District. The Suwannee River Water Management District administers Panhandle rivers east of the St. Marks. Most rivers of the eastern Panhandle are small to medium in size. Several are fed by extensive spring systems, are swallowed by sinks, or are otherwise defined by the karst landscape that characterizes this region. Before they discharge into the Gulf of Mexico, most of these rivers pass through extensive coastal marshes. The eastern Panhandle contains some of the best streams for flatwater paddling, with unspoiled vistas and abundant wildlife. Brackish estuaries support superb recreational fishing and thriving shellfish populations. Population density within this region is low and development is sparse. With one notable exception, the ecological condition of the rivers is very good.

Aucilla River

Waterway Type: Medium Coastal Limestone River
Substrate: Limestone
Ecological Condition: ★★★★
Oversight: SRWMD
Designations: OFW, CT
Length: 73 miles
Watershed: 750 square miles

The Aucilla River is picturesque, peaceful, and largely untouched. Its dark brown waters flow from southern Georgia through Florida's Big Bend area and into the Gulf of Mexico. The physical characteristics of this river reflect the karst landscape through which it flows.

GEOGRAPHY AND HYDROLOGY The Aucilla River originates from a group of small creeks and sloughs about 4 miles northeast of Thomasville, Georgia. It drops below ground briefly at Howell Sinks, just east of Boston, Georgia. The river is swampy and poorly defined until shortly after it enters Florida in northeastern Jefferson County. As it snakes southward, it forms the border between Jefferson and Madison Counties. Raysor Creek, the Little Aucilla River, and Alligator Creek join the river along this stretch. High limestone banks surround many parts of the middle river. Several portions contain a swift current coursing over limestone shoals. The Aucilla contains a short section of rapids that form where the north Florida uplands give way to the coastal plain. For the last 16 miles of its run, the Aucilla forms the border between Jefferson and Taylor Counties. Near Goose Pasture, the river drops underground, disappearing and reappearing in a series of sinks. It permanently regains the surface about 7 miles south, at Nutall Rise. About 4 miles before it flows into the Gulf of Mexico, the Aucilla is joined by the spring-fed Wacissa River, flowing in from the northwest. The river slows and broadens near its mouth, coursing through broad salt marshes and mud flats laced with tidal creeks. Tidal influences extend about 4 miles upstream from the river mouth.

HISTORY Archaeological investigations, especially those conducted by the Aucilla River Prehistory Project, have unearthed human habitations and artifacts dating back 10,000 years. At the time of the arrival of the Europeans, the

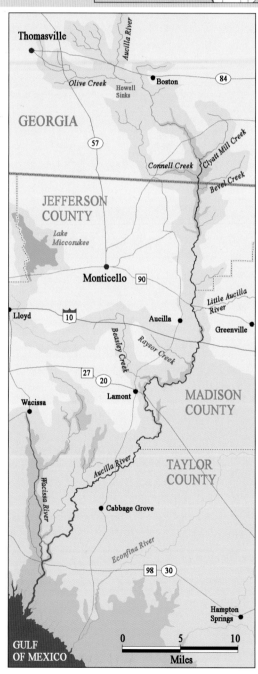

EASTERN PANHANDLE Aucilla River

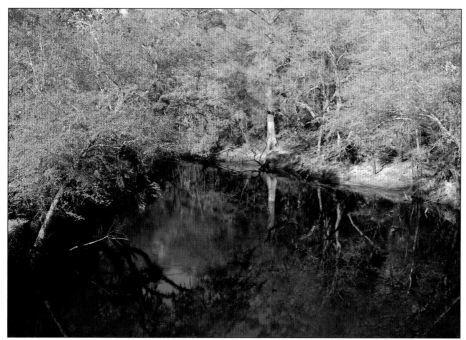

The Aucilla as it appears just north of the town of Cabbage Grove. Archaeological discoveries along this waterway have provided a window into the lives of Florida's earliest human inhabitants.

Aucilla formed the dividing line between territory controlled by the Apalachee tribe of the central Panhandle and the Timucan people of north Florida. Hernando de Soto is thought to have crossed the Aucilla over the natural bridge above Nutall Rise during his expedition of 1539. The Spanish Mission San Miguel was located near the river, along with an hacienda established by Spanish Governor, Benito Ruiz de Salazar Vallecilla. In the mid-1800s, plantation owner John Gamble used slave labor to construct a 3-mile canal through the swamp between the Aucilla and Wacissa Rivers. The "slave canal" is still in existence and can be transited by canoe. Cotton was an important commercial crop around the upper river during the period immediately before the Civil War. The Aucilla River was used for running illicit drugs in the 1970s and 1980s.

HUMAN IMPACT The Aucilla River has not been significantly touched by development. Although it flows near the small towns of Aucilla, Lamont, and Cabbage Grove, these communities are not located directly on the banks of the river. Private homes are scattered along a few sections of river. Several bridges cross the river, including those of US 90, I-10, Route 19, and US 98.

RECREATIONAL ACTIVITIES The Aucilla River Canoe Trail covers a 19-mile stretch, from Lamont to a logging road near the tiny village of Cabbage Grove. The Aucilla River is an excellent site for fossil hunting. The bones of vertebrates from the late Pleistocene and Holocene periods are sometimes discovered in river sediments. Mastodon teeth have been found in scour holes within the limestone. An entire mastodon skeleton was found on the bottom of the adjoining Little Aucilla River in 1968. It is on display at the Florida Museum of Natural History, Powell Hall, on the campus of the University of Florida. Bream fishing in this river is usually very good. Anglers also sometimes take catfish and largemouth bass.

FLORA AND FAUNA Vegetation along the banks is composed of cypress, gum, hickory, spruce pine, water oak, and river birch. Zephyr lilies, lizards tail, swamp rose, false dragonhead, and wild iris grow along the banks. Dragonflies such as the common green darner, blue dasher, eastern pondhawk, common whitetail, painted skimmer, and Carolina saddlebags can be observed in the vicinity. About 60 species of native freshwater fishes inhabit this waterway. Turtles endemic to this river include the Suwannee turtle, chicken turtle, common musk turtle, southern soft shell turtle, and alligator snapping turtle. Snakes endemic to this river include the water moccasin, banded watersnake, blue-striped ribbon snake, and eastern mud snake. Birds include the red-tailed hawk, red-shouldered hawk, bald eagle, osprey, and various wading birds. Otters are present along many sections of the river.

Econfina River

Type: Small Coastal River
Substrate: Sand, Silt
Ecological Condition: ★★★★★
Oversight: SRWMD
Designations: None
Length: 35 miles
Watershed: 240 square miles

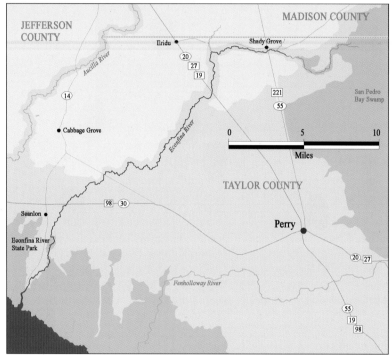

The Econfina River is a small, blackwater river located in the Big Bend region. It should not be confused with Econfina Creek, located in Bay and Washington Counties. The Econfina is almost identical in origin, appearance, and flow to the Fenholloway River, located just a few miles to the east. However, the Econfina is a clean river, while the Fenholloway is heavily polluted.

GEOGRAPHY AND HYDROLOGY The Econfina begins in San Pedro Bay, a 25,000-acre marshy expanse located along the border of Madison and Taylor Counties, northeast of Perry. The main channel is located entirely in Taylor County. The river proper begins about 4 miles east of the town of Shady Grove. Current in the upper river is swift. The Econfina meanders through an extensive series of bends on its way to the Gulf of Mexico. It passes through oak and pine forests before emerging into broad tidal marshes.

HISTORY Econfina is a Native American word meaning "natural bridge." The Spanish explorer Pánfilo de Narváez is thought to have camped for several days in the vicinity of the Econfina River during his ill-fated expedition of 1528. In 1539, Hernando de Soto's army crossed the Econfina during its journey northward along the Gulf coast. During the First Seminole War, Andrew Jackson's army, after crossing into Florida from Georgia and marching eastward from St. Marks, encountered a Red Stick Creek village on the Econfina River. On April 12, 1818, he attacked this village, killing about 40 warriors and capturing about 100 women and children. During this operation, Jackson rescued a woman who had been captured when the Creeks attacked a supply boat on the Apalachicola River in 1817.

HUMAN IMPACT The upper river flows past the small town of Shady Grove. Most portions of the Econfina are remote and pristine.

RECREATIONAL ACTIVITIES A 22-mile canoe trail begins near Route 20 and ends at State Road 14. Upper portions of the trail are considered difficult. The 4-mile run between US

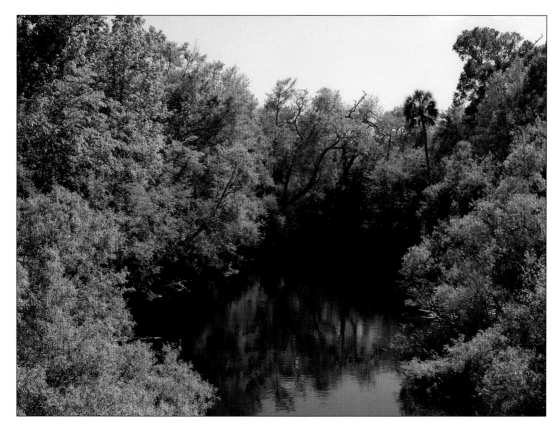

The Econfina from the bridge of US 98. Most portions of this quiet coastal river are in pristine condition.

Highway 98 and the end of State Road 14 is recommended for inexperienced paddlers. Freshwater fishing is good to excellent, and bream are especially plentiful. Tidal parts of the river and grass flats around the mouth support fine populations of redfish and speckled sea trout. Scalloping is said to be good around the river mouth. Horseback riding, hiking, and camping are available at Econfina River State Park, located off US Highway 98.

FLORA AND FAUNA Large, old-growth cypress trees are present along many parts of the river. Mayhaw, sugarberry, red maple, loblolly bay, and sweet gum also populate the banks. Among the turtles that are present in this river are the southern softshell turtle, alligator snapping turtle, Suwannee turtle, and chicken turtle. Alligators are plentiful. Birds include the belted kingfisher, prothonotary warbler, green-backed heron, red-tailed hawk, and wild turkey. Wildlife that may be observed along the river includes otters, feral hogs, and white-tailed deer.

An immature little blue heron stalks the bank in search of minnows.

Fenholloway River

Waterway Type: Small Coastal River
Substrate: Mud, Sludge, Sand
Ecological Condition: ★
Oversight: SRWMD
Designations: None
Length: 40 miles
Watershed: 392 square miles

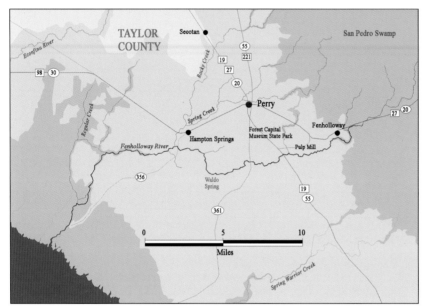

From a distance, the sad little Fenholloway River appears to be a typical blackwater stream. Its looks are deceiving. This river has been severely polluted by factory wastewater. It has been the subject of extensive legal wrangling involving the state, environmental groups, the U.S. Environmental Protection Agency, and the owner of the pulp mill responsible for contaminating the river.

GEOGRAPHY AND HYDROLOGY The Fenholloway River, like its unspoiled sister the Econfina River, originates in San Pedro Swamp. The precise origin is in an area just north of the small town of Fenholloway. While the Fenholloway receives the bulk of its flow from drainage and seepage, it also receives significant input from springs. The river flows south, then turns east. It passes just south of Perry and Hampton Springs, where a tributary, Spring Creek, flows in from the north. Both Spring Creek and its northern fork, Rocky Creek, have their beginnings in the San Pedro Swamp. Spring

Creek passes directly through Perry. During the last 8 miles of its journey, the Fenholloway again veers to the south. It flows through tidal marshes, and intersects several tidal creeks before discharging into the Gulf of Mexico.

HISTORY In 1838, during the Second Seminole War, federal forces under General Zachary Taylor confronted and routed a group of Seminoles camped between the Fenholloway and Econfina Rivers. Taylor County, established in 1856, was named in honor of Zachary Taylor. Perry, the county seat, was named after Confederate General and Florida Governor, Edward A. Perry. The sprawling Hampton Springs Resort was built in 1910 near the river about 5 miles southwest of Perry. Northern guests flocked to this destination during the winter to take advantage of the "healing" property of the spring over which it was built. The hotel boasted manicured grounds, fountains, tennis courts, and an indoor pool filled with spring water. The building was destroyed by a fire in 1954. The foundation and pool area are still visible, although the site has fallen into neglect. The state declared the Fenholloway an industrial river in 1947, a classification that may have doomed the waterway.

HUMAN IMPACT A large pulp mill has operated on the Fenholloway for decades. It is the largest employer in Taylor County. The mill siphons

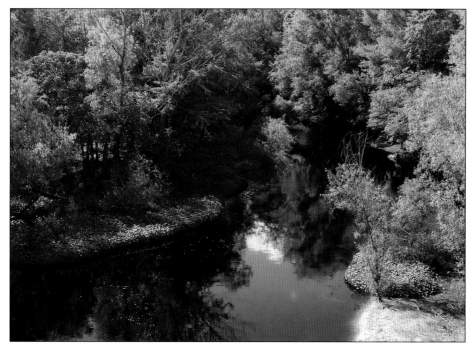

This is the Fenholloway as it appears near US 98.

Discharges from this pulp mill have severely contaminated this river.

water from the river and discharges millions of gallons of effluent. The corporation that owns the mill has proposed building a 15-mile pipeline, through which it would transport effluent directly to the Gulf of Mexico.

Environmentalists, commercial fishing interests, and shell fishing interests have criticized this plan. Other proposals have been debated. However, even if a workable solution is found, the river will probably require decades to recover.

RECREATIONAL ACTIVITIES Above the pulp mill, the Fenholloway runs clear, but is too small to provide many recreational activities. Below the pulp mill, the river is too polluted to support much recreation. For obvious reasons, anglers rarely test these waters.

FLORA AND FAUNA Despite decades of abuse, not all life has been extirpated from the river. The banks are lined with various willows, tupelo, mayhaw, red maple, sweet gum, arrowheads, and cattails. Catfish, which have shown themselves to be tolerant of pollution, are present in the lower river.

Spring Name	Approximate Location	Discharge (cfs)	Magnitude
Waldo Spring	30.049178N-83.629926W	-	2
Camp Ground Spring	30.067851N-83.553823W	-	3
Fenholloway Spring	30.073167N-83.666757W	-	-
Carleton Spring	30.057778N-83.587500W	-	-
Ewing Springs	30.073889N-83.665833W	-	-
Hampton Springs	30.081489N-83.662846W	-	4

St. Marks River

Type: Blackwater/Coastal River
Substrate: Sand, Clay
Ecological Condition: ★★★★
Oversight: NWFWMD
Designations: OFW
Length: 36 miles
Watershed: 1,150 square miles

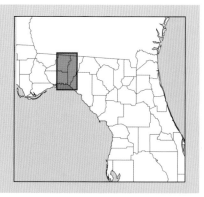

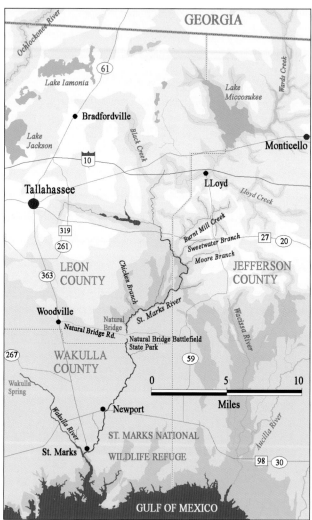

The St. Marks River of Jefferson and Leon Counties is a typical blackwater stream of the Big Bend area. Despite its proximity to Tallahassee, many portions of the river are in excellent condition. The state Department of Environmental Protection has classified the St. Marks as an Outstanding Florida Water. It is the easternmost river within the jurisdiction of the Northwest Florida Water Management District.

GEOGRAPHY AND HYDROLOGY The St. Marks River begins in the Red Hills area, just south of the Florida-Georgia border. The river rises near the town of Capitola, about 15 miles northeast of Tallahassee. The headwaters are composed of overland and subsurface seepage from nearby wetlands. It is thought that several nearby sinks, an underground connection with Lake Miccosukee, and intermittent creeks contribute to the initial flow. The river cuts across the Woodville Karst Plain of southern Leon County, a feature which gives rise to large springs such as Wakulla Spring and the Spring Creek Group. The Northwest Florida Water Management District has identified 51 springs within the St. Marks/Wakulla basin. At Natural Bridge, in Leon County, the entire river is absorbed into a sink. It reemerges a few hundred yards further south. The tannin-stained St. Marks meets the crystal clear waters of the Wakulla River near the town of St. Marks. The St. Marks continues for 3 additional miles, carrying the waters of both streams, before emptying into the Gulf of Mexico. Tidal influences extend up the St. Marks for approximately 12 miles from the river mouth.

HISTORY Spanish explorer, Pánfilo de Narváez, camped near the mouth of the St. Marks in 1528. Hernando de Soto crossed the upper river in 1539. The Spanish referred to the St. Marks as the "River of the Deer." Beginning in 1697, the Spanish constructed a wooden fort at the confluence of the St. Marks and Wakulla Rivers. A stone fort was erected at this location in 1739. It was controlled at various times by the Spanish, the English, a band of Creeks led

This is how the St. Marks River appears just before it disappears into the sink at Natural Bridge.

by former British officer William Augustus Bowles, federal soldiers, and Confederate soldiers. The San Marcos de Apalache State Historic Site, which contains the ruins of this fort, is located at the town of St. Marks. During the First Seminole War, Andrew Jackson reached St. Marks in 1818, seized the fort, and hanged two Creek leaders.

The St. Marks River functioned as a center for shipping cotton in the 1800s. The St. Marks Lighthouse, built in 1829, and relocated further inland in 1842, overlooks the mouth of the river. Camp Lawson, a log stockade, was established on the St. Marks River in 1840, during the Second Seminole War. A powerful hurricane devastated the area in 1843. In the decade leading up to the Civil War, Newport was one of the largest towns in Florida, boasting a population of 1,500.

During the Civil War, Union forces blockaded the mouth of the St. Marks. On March 6, 1865, the Battle of Natural Bridge took place on the river. This was the second-largest Civil War battle in Florida. Union forces, advancing toward Tallahassee, were repulsed by Confederate volunteers. The Natural Bridge Battlefield Monument marks the site. Abraham Kurkindolle Allison (1810–1893), Florida's

A green-backed heron grasps a bulrush stalk in the St. Marks National Wildlife Refuge, near the mouth of the St. Marks River.

The lower St. Marks River opens into a broad stream, transited by powerboats.

The Natural Bridge Battlefield Memorial is located a short distance west of the spot where St. Marks River disappears into a sink.

sixth governor, served with the Confederates in the action at Natural Bridge. Federal authorities arrested Allison shortly after he became acting governor in 1865. Francis Philip Fleming (1841–1908), who would become Florida's fifteenth governor, also participated in this battle.

HUMAN IMPACT Water quality in the St. Marks is good. Much of the land along the upper river is owned by the St. Joe Company. The state recently purchased a significant tract. The river flows near the southeastern suburbs of Tallahassee, and residences appear along parts of the river south of Natural Bridge. The town of St. Marks, located on the lower river, has been significantly impacted by development. The waterfront contains berths for seagoing barges and functions as a base for commercial fishing operations. The St. Marks National Wildlife Refuge, established in 1931, surrounds the mouth of the river.

RECREATIONAL ACTIVITIES The lower river is well suited to canoeing and kayaking. Above Natural Bridge, fallen trees and other obstructions can make paddling difficult. The Tallahassee-St. Marks Historic Railroad State Trail provides nearby opportunities for bicycling, skating, and hiking.

FLORA AND FAUNA The river flows through cypress swamps and other hardwood bottom lands. Laurel oak, Ogeechee tupelo, mayhaw, red maple, loblolly bay, beech, and sweet gum grow along the banks. Dominant fish species include white catfish, longnose gar, largemouth bass, red-breasted sunfish, spotted sunfish, bluegill, golden shiner, and chain pickerel. The rare one-toed amphiuma, an eel-like amphibian, is found in muddy banks and backwaters. Turtle species inhabiting this river include chicken turtle, alligator snapping turtle, southern softshell, and in brackish areas, Florida diamondback terrapin. Water moccasins are occasionally seen along this river. Birds that may be observed include the eastern screech owl, wood stork, limpkin, osprey, bald eagle, and various warblers and herons.

The red-bellied woodpecker scales a cabbage palm along the St. Marks RIver.

Spring Name	Approximate Location	Discharge (cfs)	Magnitude
St. Marks River Rise	30.276050N-84.148870W	433	1
Natural Bridge Spring	30.285117N-84.147183W	73	2
Elly Spring	30.280383N-84.147983W	33	2
Chicken Branch Spring	30.335767N-84.148555W	23	2
Horn Spring	30.319247N-84.128800W	12	2
Rhodes Spring	30.283817N-84.155350W	10	2
Newport Spring	30.212695N-84.178490W	4	3

Sopchoppy River

Type: Coastal/Blackwater River
Substrate: Sand, Limestone, Sand
Ecological Condition: ★★★★
Oversight: NWFWMD
Designations: CT
Length: 46 miles
Watershed: 330 square miles

The Sopchoppy River meanders through Wakulla County, southwest of Tallahassee. The upper river is pristine and most of the watershed lies within protected wilderness areas. With its steep banks, limestone outcrops, and dark water, the Sopchoppy is one of the most alluring small rivers in the state.

GEOGRAPHY AND HYDROLOGY
The Sopchoppy River originates in the wetlands of southwestern Leon County. Most of its waters come from surface drainage. The East and West Branches flow together just below the boundary of Leon and Wakulla Counties. The river loops southward, absorbing various tributaries, including Buckhorn Creek, Deep Branch, Duval Branch, Mill Creek, and Monkey Creek. Although the water appears black from above, it is actually the color of dark tea. The banks are high and heavily forested. Limestone outcrops are present in many areas. The Sopchoppy River, along with the Ochlockonee River, flows into Ochlockonee Bay. Ochlockonee Bay is an arm of Apalachee Bay, part of the Gulf of Mexico.

HISTORY The Apalachee tribe inhabited lands around the river prior to the arrival of the Spanish. Creeks later moved into the region. A Spanish map from the 1600s labels this river as the Río Chachave. Settlers began to arrive in the area in the early 1800s. Fort Number Five was established near the present-day town of Sopchoppy in 1839. The population of the region increased after the Second Seminole War. The town of Sopchoppy, which sits on the northeast bank of the river, was established in 1884. In 1899, a flood washed away the only bridge near Sopchoppy and inundated

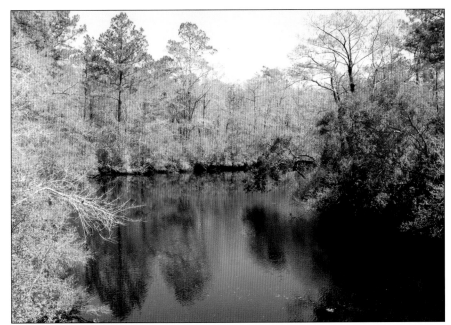

The Sopchoppy, a blackwater stream, flows through protected wilderness areas along most of its length. Some homes appear along the lower river.

the river basin and nearby residences. Highly regarded tupelo honey is produced along the Sopchoppy River.

HUMAN IMPACT Approximately 60 percent of the river is located within the 565,000 acre Apalachicola National Forest. Areas around the mouth of the river fall within the St. Marks National Wildlife Refuge. A few residences appear along the river near Sopchoppy. The southern suburbs of Tallahassee are beginning to encroach on the watershed in some areas, although this river is well buffered in most areas. Water quality is very good.

RECREATIONAL ACTIVITIES The state has designated a 15-mile canoe trail along portions of the waterway. The trail starts at the Oak Park Cemetery Bridge, on Forest Road 345. It ends at the bridge of US 319, just south of Sopchoppy. The lower river can be transited by powerboat. The small town of Sopchoppy, located just north of the river, is known for its annual worm grunting festival. Contestants rub wooden stakes with metal bars, causing vibrations that drive worms from their underground lairs. The Apalachicola National Forest provides opportunities for hiking, fishing, hunting, and camping.

FLORA AND FAUNA The banks support stands of cypress, live oak, Ogeechee tupelo, and willow. Rare plants such as scareweed, venus hair fern, Godfrey's blazing star, and water sundew are also found near this river. Various damselflies, such as the Florida bluet, Rambur's forktail,

sparkling jewelwing, common spreadwing, and swamp spreadwing, are associated with this waterway. The twelve-spotted skimmer, painted skimmer, black saddlebags, and cypress clubtail are among the dragonflies that may be present. Snakes present within the watershed include the Apalachicola king snake, brown water-snake, and the venomous water moccasin. The coal skink, a rare lizard, is also found in association with this waterway. The rare red-cockaded woodpecker inhabits pinelands surrounding the river. White squirrels are sometimes seen around the lower river. These are not albino squirrels, but are typical gray squirrels with a white coat. Why they are concentrated in this area is uncertain. Apalachicola National Forest is one of the last strongholds of the black bear within the state of Florida.

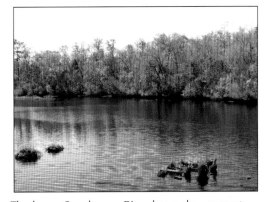

The lower Sopchoppy River has a slow current and is subject to tidal influence. Its waters join that of the Ochlockonee River, when it discharges into shallow Ochlockonee bay.

Wacissa River

Type: Spring-fed River
Substrate: Sand
Ecological Condition: ★★★★
Oversight: SRWMD
Designation: OFW, CT
Length: 14 miles
Watershed: Uncertain

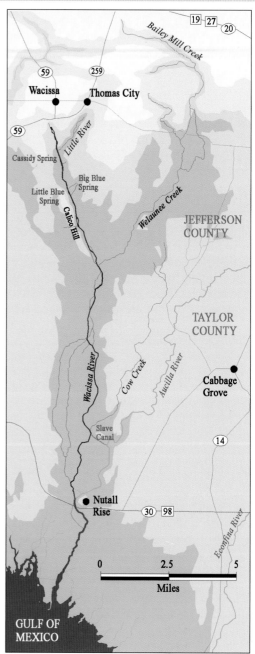

The pretty Wacissa River is located at the apex of the Big Bend, about 25 miles southeast of Tallahassee. It is the westernmost river that falls under the jurisdiction of the Suwannee River Water Management District.

GEOGRAPHY AND HYDROLOGY The Wacissa River originates just south of the small town of Wacissa in Jefferson County. It is composed of waters from about a group of about a dozen springs. The largest vent is Big Blue Spring, which is about 25 feet deep and flows into a small basin. The Wacissa springs group has a total discharge of about 388 cubic feet per second, making it one of the largest spring groups in the state.

The water is extremely clear. In some locations the river is choked with hydrilla, eel grass, lily pads, and various reeds. The river flows toward the southeast, generally through low, swampy land. About five miles downriver from its source, the Wacissa is joined by a significant tributary, Welaunee Creek. This south-flowing creek originates near the town of Waukeenah on US 19. Six miles further south, Cow Creek flows in from the northeast. The Slave Canal, an artificial waterway connects the lower Wacissa River with the Aucilla River to the east. Details regarding this waterway are provided in the profile of the Aucilla River. The Wacissa River merges its clear waters with the dark waters of the Aucilla River near Nutall Rise.

HISTORY Apalachees resided in the area at the time of European contact. The ill-fated expedition of Pánfilo de Narváez passed through the region in 1528. In 1539, Hernando de Soto's army crossed the river during its journey along the Gulf coast toward present-day Tallahassee. Miccosukees were present in the area in the 1700s. A settlers' fort, Fort Wacissa, was located on the river during the Seminole Wars.

The head-waters of the Wacissa River near the town of Wacissa.

Jefferson County, in which the river is located, was established in 1827. Watermelon was an important crop in the region in the early 1900s. Commercial production of tung oil—derived from the toxic seed of the tung tree—became an important industry in the mid-1900s. Pecans are currently grown within the spring recharge basin.

HUMAN IMPACT The park at the head of the river is a popular gathering place for locals and is not always kept up to standards. Most of the river is in excellent condition. Water quality is very good. However, in recent years, non-native hydrilla has started to crowd out native plants.

RECREATIONAL ACTIVITIES The state-designated canoe trail runs for almost the entire 14-mile length of the river. The entrance to the slave canal is easy to miss although, in recent times, it has been marked by the state.

FLORA AND FAUNA As with many Florida rivers, cypress trees reign over many sections. Also present are stands of gum, swamp maple, laurel oak, Ogeechee tupelo, and cedar. Turtles found in this river include the chicken turtle, musk turtle, and the rare alligator snapping turtle. Snakes include the water moccasin, banded watersnake, and brown watersnake. Birds that frequent the Wacissa include little blue heron, anhinga, pied-billed grebe, American coot, common moorhen, purple gallinule, limpkin, red-shouldered hawk, and many others.

Spring Name	Approximate Location	Discharge (cfs)	Magnitude
Big Blue Spring	30.327725N-83.984842W	<100	1
Cassidy Spring	30.332721N-83.989037W	-	2
Garner Spring	30.330310N-83.983115W	-	2
Horsehead Spring	30.344861N-83.994543W	-	2
Little Blue Spring	30.330842N-83.989036W	-	2
Log Springs	30.340534N-83.993004W	-	2
Minnow Spring	30.331534N-83.986611W	-	2
Thomas Spring	30.339714N-83.992324W	-	2
Wacissa Spring	30.339886N-83.991482W	-	2
Maggie Spring	30.340079N-83.982689W	-	3
Brumbley Spring	30.344830N-83.981009W	-	3
Buzzard Log Spring	30.330138N-83.986889W	-	3

Wakulla River

Type: Spring Run
Substrate: Sand
Ecological Condition: ★★★★
Oversight: NWFWMD
Designations: OFW, CT
Length: 9 miles
Watershed: Uncertain

stunning assemblage of birds and wildlife.

GEOGRAPHY AND HYDROLOGY The recharge basin feeding the Wakulla begins with runoff and drainage into the aquifer near Tallahassee. Some scientists suggest the recharge basin may extend as far north as the Georgia border. This water travels south through a series of caves until it reaches the main vent. Divers have explored and mapped more than a mile of caverns extending northward from the vent. Water from the vent wells up into a 4-acre basin. The Wakulla River flows to the southeast from this basin, eventually merging with the St. Marks River about 3 miles above the Gulf of Mexico.

HISTORY Divers have found bones and teeth of mastodons and other prehistoric animals in the underwater caves and around the springhead. It is thought that humans came to this area about 12,000 years ago. Upper Paleolithic and Paleoindian people first inhabited the area. Covis spear points and stone blades fashioned by these early Floridians have been found in archaeological digs adjacent to the

The ultra-clear waters of the Wakulla River pour forth from one of the largest springs in the world. The average flow is 250 million gallons daily. The maximum flow has been estimated at 1.23 billion gallons daily. Visitors to this river can observe a

The Wakulla River is a powerful and attractive spring run. It draws an assortment of rare birds and other wildlife.

HUMAN IMPACT The 6,000-acre Edward Ball Wakulla Springs State Park surrounds the spring head-waters. Some portions of the river below the park are lined with homes and docks. The exotic plant hydrilla, introduced into Florida through the aquarium trade, has invaded the Wakulla. Mats have now taken over substantial tracts of river bottom and displaced native eelgrass.

RECREATIONAL ACTIVITIES The Wakulla River Canoe Trail runs for about 4 miles. It begins at the bridge of County Road 345, and ends at the bridge of US 98. Visitors to the Edward Ball Wakulla Springs State Park can enjoy glass-bottomed boat rides, swimming, high diving, hiking, and other activities. Below the state park fence, the Wakulla is a very fine fishing river. Anglers can spot and target individual fish within the clear water.

springs. Wakulla may be a Native American word for spring, although the origin of the name is disputed.

The ruins of the old Spanish fort, San Marcos de Apalache, are located at the confluence of the Wakulla and St. Marks Rivers. Fort Stansbury was established on the Wakulla River in 1839, and Fort Many was established near the spring head in 1841. The springs became a tourist attraction in the early 1900s. In 1935, businessman Edward Ball purchased the land around the spring and built a massive lodge near the headwaters. Ball erected a fence across the river about 3 miles below the source. This resulted in a legal battle with nearby residents who sought access to the river. Ultimately Ball prevailed based on a court finding that the waters were not navigable. The fence remains and today protects state park boundaries. The state purchased the land around the spring in 1986.

FLORA AND FAUNA Cypress is the predominant shoreline vegetation, although red maple, sweet gum, tupelo, wax myrtle, and titi are also present. Turtles, such as the Suwannee cooter, gather in large numbers on logs. Birds commonly encountered along the Wakulla include anhinga, osprey, common moorhen, green-backed heron, limpkin, purple gallinule, cormorant, least bittern, and various warblers. Whitetailed deer sometimes drink from the river's edge.

Spring Name	Approximate Location	Discharge (cfs)	Magnitude
Wakulla Spring	30.235168N-84.302588W	598	1
Salley Ward Spring	30.241414N-84.310800W	12	2
No Name Spring	30.214814N-84.266505W	6	3
McBride Spring	30.239983N-84.269565W	5	3
Northside Srping	30.237590N-84.281060W	2	3
Wakulla Sulphur Spring	30.181633N-84.248650W	3	3
Hawks Cry Spring	30.250500N-84.268650W	-	3

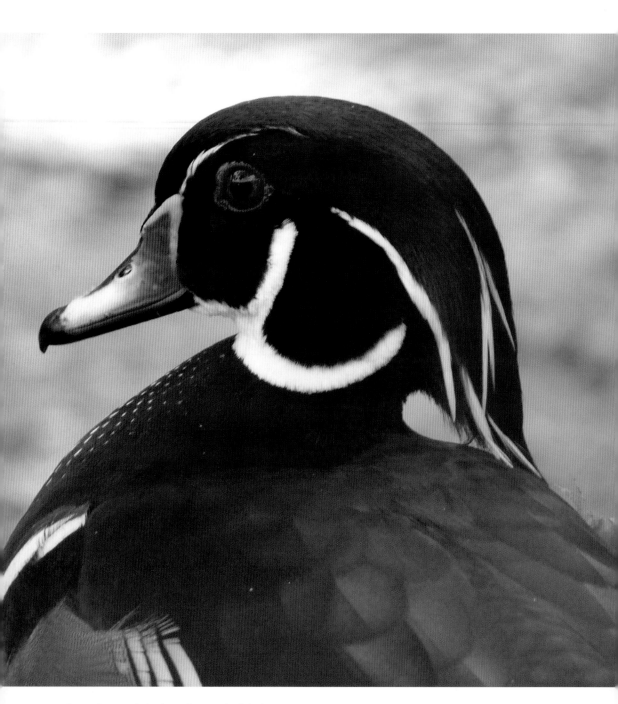

The male wood duck, with its colorful plumage, is a common visitor to many rivers of north central Florida.

North Central Florida

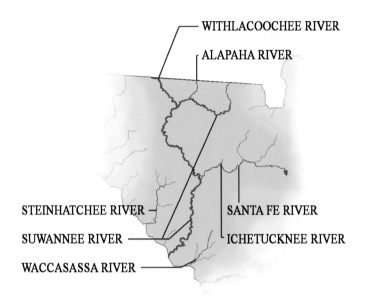

WITHLACOOCHEE RIVER

ALAPAHA RIVER

STEINHATCHEE RIVER

SANTA FE RIVER

SUWANNEE RIVER

ICHETUCKNEE RIVER

WACCASASSA RIVER

The Suwannee River Water Management District has jurisdiction over the waters of this region. North central Florida is limestone country. Rivers sometimes flow through rocky gorges or drop over rocky shoals. The Suwannee River anchors this region, carving a giant S through the landscape, connecting with Georgia and Florida tributaries, absorbing the waters of hundreds of springs. Indeed, the springs of this region are more numerous than in any other part of the state, supporting recreational activities such as cave diving, tubing, swimming, and kayaking. Rivers that flow into the Gulf of Mexico give rise to broad coastal marshes and estuaries. The ecological condition of the rivers of north central Florida is good to very good, although withdrawals for agriculture and non-point-source pollution are sources of concern within the Suwannee River basin.

Alapaha River

Type: Brown-water River
Substrate: Sand and Gravel
Ecological Condition: ★★★
Oversight: SRWMD
Designations: None
Length: 190 miles (16 in Florida)
Watershed: 1,750 square miles

The Alapaha River, a major tributary of the Suwannee River, is predominantly a Georgia river. However, it makes a brief incursion into north Florida before discharging into the Suwannee River. Water levels in the Alapaha can vary dramatically and the flow can become feeble during periods of drought.

GEOGRAPHY AND HYDROLOGY The Alapaha River originates in Dooly County, Georgia. It is joined by the Willacoochee River, near Willacoochee, Georgia. The Alapahoochee River combines with the Alapaha River just south of the Florida border, and just east of Jennings, Florida. Other tributaries that join the Alapaha in Florida include Alligator Creek and the Little Alapaha River. The Withlacoochee watershed lies to the west. The Suwannee River drains areas to the east. In Florida, the Alapaha River is confined to Hamilton County. During periods of low rainfall the river disappears into sinkholes and the riverbed may be completely dry. The Alapaha reemerges in a river rise, located just above its confluence with the Suwannee River. This first-magnitude flow has an estimated average discharge of 800 cubic feet per second.

HISTORY At the time of European contact, Timucua people inhabited the land around the river. The Alapaha received its official name from the United States Board on Geographic Names in 1891. In the 1930s extensive sand mining took place along the banks of the Alapaha in southern Georgia. Blueberries are grown commercially within the river basin. In 2004, a giant feral hog, dubbed "hogzilla" by the media, was killed in swampland surrounding the upper Alapaha River in Georgia.

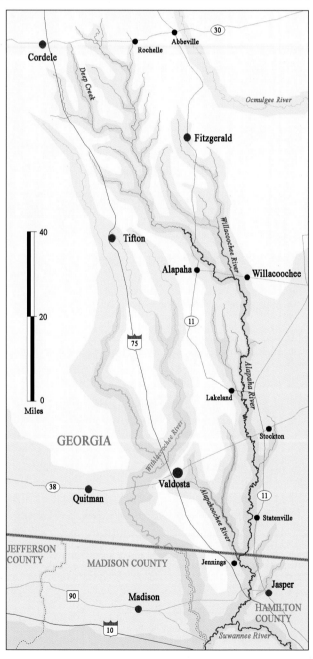

The Alapaha River viewed at low water near US 41. A bream nest can be observed near the bank in the foreground.

HUMAN IMPACT The Alapaha River flows past the small towns of Rebecca, Alapaha, Willacoochee, Mayday, and Statenville, in Georgia, and Jennings, Florida. In Florida it passes under State Road 150, Highway 41, and Route 75. The river drains a significant agricultural belt in southern Georgia. Nutrient levels are sometimes elevated, although water quality is usually good.

RECREATIONAL ACTIVITIES Although the Alapaha is not a state-designated canoe trail, large sections of the river are open to canoeing and are well suited to flatwater paddling. Gibson Park, at the juncture of the Alapaha and Suwannee Rivers, permits camping, fishing, and canoeing.

FLORA AND FAUNA Foliage along the bank includes American hornbeam, river birch, flatwoods plum. Stands of the cahaba lily grow in shallow areas and on gravel bars. This lily produces white flowers in the spring and early summer. The protected Gulf sturgeon spawns in the Suwannee River adjacent to the discharge of the Alapaha River. Turtle species endemic to the Alapaha River include the southern softshell, coastal plain turtle, alligator snapping turtle, common snapping turtle, common mud turtle, and loggerhead musk turtle. Snake species found in association with this river include the water mocassin, redbelly watersnake, and eastern mud snake.

Suwannee turtles are found in the Alapaha River and other tributaries of the Suwannee River.

Ichetucknee River

Waterway Type: Spring Run
Substrate: Sand, limestone outcrops
Ecological Condition: ★★★★
Oversight: SRWMD
Designations: OFW (as part of Santa Fe system)
Length: 6 miles
Watershed: approximately 250 square miles

The Ichetucknee River (pronounced "Itch-tuck-nee") is an exquisitely beautiful spring run located between Suwannee and Columbia Counties in north central Florida. The spring group discharges an impressive 233 million gallons of water each day. The river is a popular getaway for students from the nearby University of Florida.

GEOGRAPHY AND HYDROLOGY Much of the basin that recharges the springs is located in Columbia County. The waterway begins at Head Spring. Eight other springs are located along the upper 3 miles of river. Water temperature remains a constant 72°F throughout the year. The river averages about 50 feet wide and 4 feet deep. Six miles from its source, the Ichetucknee flows into the Santa Fe River, which is a tributary of the Suwannee River. The Suwannee River, in turn, empties into the Gulf of Mexico.

HISTORY Native Americans inhabited the lands around the Ichetucknee for thousands of years. Early Spanish explorations found Timucua people living in the area. In the early 1600s a Spanish mission, Santa Catalina de Afucia, was located near the river. Yamasee warriors destroyed this mission in 1685, killing and enslaving many of the Timucua associated with the mission. The river derived its name from that of a Seminole settlement, located near the junction of the Ichetucknee and the Santa Fe Rivers. Ichetucknee means "pond of the beaver." The river and surrounding land became part of the state park system in 1970.

HUMAN IMPACT Water quality in the Ichetucknee River is excellent. Most of the river is located within 2,241-acre Ichetucknee Springs State Park. As many as 200,000 visitors enter the park annually. At times, the influx of

(Map labels: Head Spring, Blue Hole, Mission Spring, Devil's Eye Spring, Grassy Hole Spring, Mill Pond Spring, 238, Coffee Spring, Ichetucknee Springs State Park, 137, SUWANNEE COUNTY, to Branford, Ichetucknee River, 20, 27, COLUMBIA COUNTY, Santa Fe River, GILCRIST COUNTY, 0 1 2 Miles)

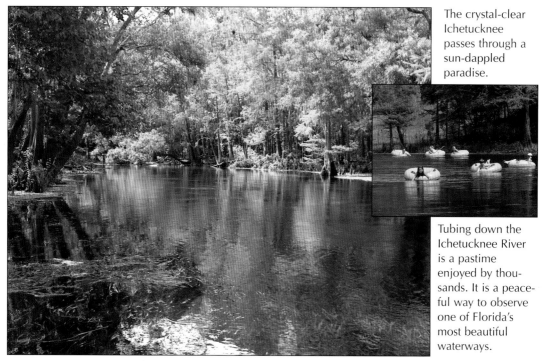

The crystal-clear Ichetucknee passes through a sun-dappled paradise.

Tubing down the Ichetucknee River is a pastime enjoyed by thousands. It is a peaceful way to observe one of Florida's most beautiful waterways.

inner-tubers and paddlers has negatively affected eelgrass beds and other vegetation. The park service limits entry and sometimes closes portions of the river to allow this vegetation to regenerate. About 4 miles from its head, the Ichetucknee passes under US 27, through a narrow bridge. Some residences are located along the river on the south side of this bridge. The protection of the watershed, through land purchases and educational programs, is critical to water quality.

RECREATIONAL ACTIVITIES Tubing, canoeing, and kayaking are the principle recreational activities. Various local businesses rent tubes and kayaks. The state park provides a shuttle service during the warmer months. Swimming, snorkeling, and scuba diving are also available. Food and drinks are not permitted on the river.

FLORA AND FAUNA The banks are lined with cypress, wax myrtle, creeping primrose willow, sweet bay, red maple, various ferns, black gum, water hickory, palmetto, water oak, Shumard's oak, and live oak. Along the water's edge occur plants such as wild rice, arrowhead, spider lily, Florida watercress, climbing Carolina aster, cardinal flower, and water hemlock. The bottom of the river is lined with extensive beds of eel grass. Damselflies such as the ebony jewelwing and smoky rubyspot are frequently seen flitting among the shadows cast by shoreline vegetation. Fish that may be observed include Suwannee bass, largemouth bass, spotted sunfish, red-breasted sunfish, mullet, and Gulf pipefish. The alligator snapping turtle, although rarely seen, is present in the river, along with the loggerhead musk turtle and intergrades between the Florida mud turtle and common mud turtle. Alligators, while not especially common in this river, are sometimes observed sunning along the bank. Sherman fox squirrels occur within the state park.

Spring Name	Approximate Location	Discharge (cfs)	Magnitude
Blue Hole Spring	29.980524N-82.758477W	<100	1
Ichetucknee Head Spring	29.984155N-82.761950W	-	2
Devil's Eye Spring	29.973674N-82.760009W	-	2
Mission/Roaring Spring	29.976215N-82.757877W	-	2
Mill Pond Spring	29.966661N-82.759975W	-	2
Grassy Hole Spring	29.968056N-82.759822W	-	2
Cedar Head Spring	29.983300N-82.758700W	-	3
Coffee Spring	29.959457N-82.775327W	-	3

Santa Fe River

Waterway Type: Blackwater/Spring-Fed/Limestone River
Substrate: Limestone, Sand, Gravel
Ecological Condition: ★★★★
Oversight: SRWMD
Designations: OFW, CT
Length: 73 miles
Watershed: 1,380 square miles

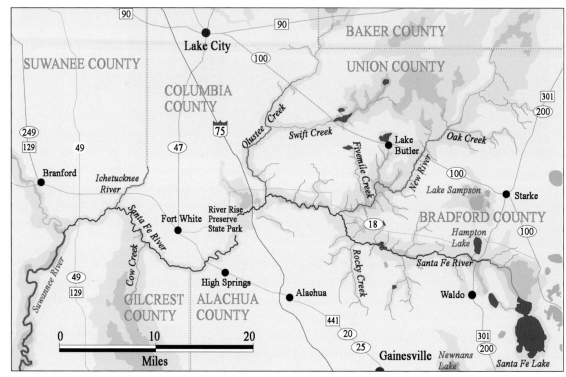

The Santa Fe River is the largest tributary of the Suwannee River that lies wholly within the state of Florida. This north Florida stream has not be been severely impacted by human activity. Along much of its length it flows between high banks and limestone outcrops. A high concentration of springs occurs within the river basin.

GEOGRAPHY AND HYDROLOGY The Santa Fe originates in the boggy, 7,050 acre Santa Fe Swamp and also receives waters from Santa Fe Lake, Little Santa Fe Lake, and Lake Altho, in eastern Bradford County. The watershed encompasses parts of Alachua, Baker, Bradford, Clay, Columbia, Gilcrest, and Union Counties. The water is tea-colored. The upper reaches of the Santa Fe are braided into several narrow

subchannels, and hold extensive beds of submerged vegetation. The Santa Fe is joined by the New River near Worthington Springs. This confluence also marks the convergence of Bradford, Alachua, and Union Counties. The New River has its origins in the New River Swamp, in the southeastern corner of Baker County. From there it flows for about 23 miles before joining the Santa Fe. Eight miles further west, Olustee Creek flows into the Santa Fe River from the north. Olustee Creek begins near the town of Olustee, site of the largest Civil War battle fought in Florida.

After a run of about 35 miles, the Santa Fe River is absorbed into a sinkhole at O'Leno State Park. It reemerges three miles to the southwest at River Rise State Park, where it continues

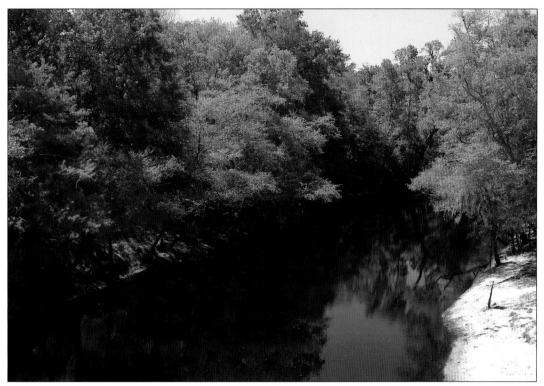

The Santa Fe River, although fed by numerous springs, is, in part, a blackwater stream.

its surface journey. The Santa Fe River functions as the northern boundary of Alachua County along much of its course. The Ichetucknee River, previously described within these pages, flows into the Santa Fe a few miles above the Santa Fe's juncture with the Suwannee. About 60 springs, exclusive of those feeding the Ichetucknee River, have been identified within the Santa Fe basin. At least six siphons suck water from the bottom of the river back down into the aquifer. The current is swift along some portions of the river. The Santa Fe joins the Suwannee River just south of Branford.

HISTORY The Timucua people inhabited the land surrounding the Santa Fe River prior to the arrival of the Spanish, and for a time thereafter. Hernando de Soto is thought to have crossed the river in 1539, during his expedition into north Florida. The river took its name from the Spanish mission Santa Fe de Toloca. This mission was attacked and destroyed by the English in 1702. During the Second Seminole War, several forts were built along the Santa Fe. Fort Harlee was constructed in 1837, near Hampton. That same year, Fort White was established about 4 miles west of

the present-day town of Fort White. Fort Ward was built on Olustee Creek, near its confluence with the Santa Fe River. Fort Number 13 was built in 1839 near High Springs. A Confederate army camp, Camp Miller, was established on the Santa Fe River in 1864, near

The red-eared slider is native to the Mississippi River basin. It has become established in the Santa Fe River, possibly as a result of releases of pet turtles by aquarists.

Spring Name	Approximate Location	Discharge (cfs)	Magnitude
Santa Fe River Rise	29.873894N-82.591636W	442	1
Siphon Creek Rise	29.856172N-82.733050W	370	1
Hornsby Spring	29.850355N-82.593201W	350	1
Treehouse Spring	29.854886N-82.602877W	240	1
Devil's Ear Springs	29.835349N-82.696600W	200	1
Gilcrest Blue Spring	29.829900N-82.682852W	70	2
Hart Springs	29.675740N-82.951711W	59	2
Ginnie Springs	29.836323N-82.700245W	58	
Columbia Spring	29.854111N-82.611953W	40	2
July Spring	29.836180N-82.696411W	-	2
Santa Fe Spring	29.934805N-82.530420W	-	2
Darby Spring	29.852622N-82.605963W	-	2
Poe Spring	29.825716N-82.648973W	-	2
Rum Island Spring	29.833520N-82.679910W	-	2

Two major tributaries of the Santa Fe are the New River (above right) and Olustee Creek (bottom left).

Elderberries are a common sight in the late summer along the Santa Fe River and many streams throughout the state.

Hampton. Flooding has occurred in the river basin in conjunction with heavy rains and tropical systems.

HUMAN IMPACT Development along the river has been light, although some homes are present along the banks. The towns of Hampton, Brooker, Worthington Springs, and High Springs are located near the river. Water quality is generally good. The Georgia Pacific Company donated the extensive Santa Fe Swamp Wildlife and Environmental Area to the Suwannee River Water Management District in 1984. Efforts by state agencies to purchase lands surrounding Lake Santa Fe may offer additional protection to the headwaters of the Santa Fe.

RECREATIONAL ACTIVITIES The state-designated Santa Fe River Canoe Trail runs from River Rise State Park to the bridge at US 129 and State Road 49. The total distance is about 26 miles. Fishing along the river is very good. The Santa Fe River harbors populations of the rare Suwannee River bass. Although these fish are not large, they are scrappy and acrobatic. The lower river can be navigated by powerboat. However, great care should be taken to avoid limestone shoals. The river above O'Leno State Park may be clogged by water hyacinth, inhibiting passage by canoes and kayaks. Fossil hunting in the Santa Fe can be produc-

tive. Dugong bones and teeth, shark's teeth, and other marine fossils are often uncovered in gravel along the bed and banks.

FLORA AND FAUNA The banks are lined with cypress, red maple, sweet bay, tupelo, water hickory, coastal plain willow, elderberry, Shumard's oak, and live oak. A large and very impressive stand of cypress is located around its confluence with the Suwannee River. Freshwater snails endemic to this river include the purple-throated campeloma, knobby elimia, and many others. Damselflies found along this waterway include the common spreadwing, elegant spreadwing, lilypad forktail, cherry bluet, and Florida bluet. Common freshwater fish species include the white catfish, channel catfish, coastal shiner, taillight shiner, and brook silverside. The hogchoker, a small marine flatfish, is sometimes encountered in the Santa Fe, especially in areas around spring vents and spring runs. Turtle species endemic to this river include the alligator snapping turtle, southern softshell turtle, chicken turtle, Suwannee turtle, and common musk turtle. The red-eared slider, which is not native to Florida, has become established in this waterway and has spread into the Suwannee River as well. Wildlife is abundant along the river, and includes whitetailed deer, raccoon, and the occasional bobcat or black bear.

Longnose gar are numerous in the Santa Fe River.

Steinhatchee River

Type: Small Coastal River
Substrate: Sand, Clay, Limestone, Silt
Ecological Condition: ★★★★
Oversight: SRWMD
Designations: None
Length: 28 miles
Watershed: 580 square miles

In many respects, the Steinhatchee River and it environs are lost in time. Slow paced, friendly, unpretentious, they represent the best of old Florida. Although it is tucked away in a remote section of the Gulf coast, tourists have recently discovered the attributes of this waterway. An influx of new residents has led to some out-of-character development around the river mouth.

GEOGRAPHY AND HYDROLOGY The Steinhatchee River rises in the Still Bay section of Mallory Swamp. This area is about 4 miles south of Mayo in Lafayette County. The land surrounding the upper river is marshy and remote. As the river flows south, it passes through a maze of subchannels and picks up several tributaries, including Owl Creek, Kettle Creek, and Eightmile Creek. Except during periods of high water, the upper Steinhatchee is little more than a braided creek. It begins to broaden after it passes under US 19/98. From that point south, it defines the boundary between Taylor and Dixie Counties. The river flows into a sink near Tennille, emerging about a half mile further south. At "Steinhatchee Falls" the river drops over a low rock shelf. After flowing past the pictur-esque town of Steinhatchee, the river winds briefly through a salt marsh before discharging into an extension of the Gulf of Mexico known as Deadman Bay.

HISTORY The name Steinhatchee is derived

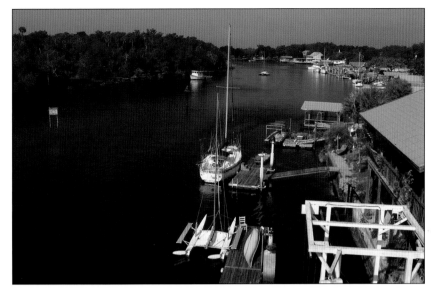

The lower Steinhatchee River as it passes the town of Steinhatchee.

from the Native American phrase esteen hatchee, meaning "river of man." The area around the Steinhatchee is thought to have been occupied by Muskogean people, at about 2000 B.C., then later by the Timuacua. Yustaga People inhabited the area at the time of European contact. In 1539, Hernando de Soto's army crossed the Steinhatchee near the present-day town of Tennille. The rock shelf that creates Steinhatchee Falls served as a crossing point for horses and covered wagons. During the First Seminole War, General Andrew Jackson is thought to have led troops across the Steinhatchee River at the falls. Fort Frank Brook was established near the mouth of the Steinhatchee in 1838, during the Second Seminole War.

HUMAN IMPACT The Steinhatchee Springs Wildlife Management Area surrounds and protects portions of the river. This 20,909-acre preserve extends into parts of Dixie, Lafayette, and Taylor Counties. Water quality is generally good. A few homes appear along the river south of Tenille. Docks, marinas, cottages, and private residences line the river in the vicinity of Steinhatchee.

RECREATIONAL ACTIVITIES From July to September, scalloping is a popular activity in the river estuary and in Deadman Bay. Charters and shucking services are available. Fishing is excellent in tidal portions of the river and in nearby coves and tidal creeks. Common catches include Spanish mackerel, speckled sea trout, and redfish. Fossil hunters have recovered shark teeth and ancient whale teeth from the bottom of this river. Powerboats, and sailboats are common along the lower river. A number of inexpensive seafood restaurants are located along the waterfront in Steinhatchee.

FLORA AND FAUNA Broad needlerush, saltgrass, and sawgrass marshes are present around the mouth of the river. Dragonflies such as the seaside dragonlet and damselflies such as the American bluet may be observed in the vicinity of this river. Turtles found in this river include the common mud turtle, loggerhead musk turtle, chicken turtle, and Suwannee turtle. Birds that may be observed along this waterway include the pileated woodpecker, Acadian flycatcher, common moorhen, least bittern, great blue heron, and great egret. Mammals that frequent this watershed include whitetailed deer, feral hog, and bobcat.

Spring Name	Approximate Location	Discharge (cfs)	Magnitude
Steinhatchee River Rise	29.769912N-83.325035W	400	1
Beaver Creek Spring	29.765947N-83.335050W	75	2
Bradley Spring	29.700047N-83.411130W	5	3
Iron Spring	29.826528N-83.308044W	-	3
Steinhatchee Spring	29.841263N-83.308069W	-	4

Suwannee River

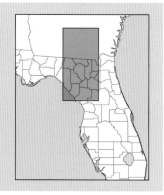

Type: Limestone/Blackwater River
Substrate: Limestone
Ecological Condition: ★★★★
Oversight: SRWMD
Designations: OFW, CT
Length: 238 miles (206 In Florida)
Watershed: 9,950 square miles

The majestic Suwannee River, immortalized in song by Stephen Foster, is the second-largest river in Florida when measured by discharge. Only the Apalachicola flows with a greater volume of water. As it slips through the heartland of north-central Florida, the Suwannee River calls to mind an era when steamboats graced its waters, or a still earlier time when Timacuan canoes plied the current. Words cannot adequately convey the historic and ecological import of this river.

GEOGRAPHY AND HYDROLOGY The Suwannee River originates in the Okefenokee Swamp of southern Georgia. This massive wetland is located about 120 feet above sea level. It contains more than 700 square miles of various habitats, including peat bog, cypress swamp, wet prairie, and bottomland forest. Among the winding creeks and waterways are the Suwannee Canal, Middle Boat Trail, Bay Creek, Alligator Creek, and Jones Creek, which contribute to the initial flow the Suwannee. The Okefenokee Swamp is replenished by rain and surface runoff.

As it leaves the Okefenokee, the Suwannee flows toward the southwest. It picks up a major tributary, Suwannoochee Creek, just below the town of Fargo, Georgia. After crossing the Florida border, it veers to the southeast, before turning to the west and eventually toward the northwest through a sweeping arc. As it makes its way through this arc, the river forms a series of rapids at Big Shoals, above the town of White Springs. This is

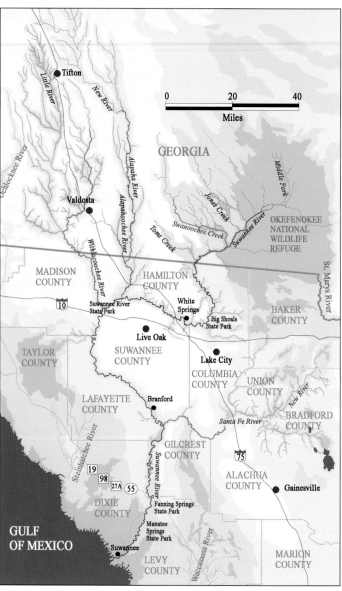

one of very few whitewater experiences available in Florida.

As the Suwannee again turns south, it picks up two major tributaries, the Alapaha River and

The Suwannee River slips between steep limestone banks.

the Withlacoochee River. Both of these waterways are covered separately in this book. Approximately 200 springs feed into the Suwannee River along its length. Those listed in the springs table represent only a sliver of the many springs associated with this river basin. Indeed, as many as 16 first-magnitude springs contribute to the flow of the Suwannee and its tributaries.

As it approaches the coast, the high banks that frame the river for most of its length drop away. The Suwannee broadens and slows. It is subject to tidal influence for about 26 miles above its mouth. The river turns brackish about 5 miles before it discharges into the Gulf of Mexico.

HISTORY Timucua people occupied land surrounding the river at the time of European contact. The Osochi group was present to the north, and the Yustaga and Potano groups probably occupied southern portions of the river basin. The name of the river is thought by some to have originated with the Timucua people. The word *Suwani* is said to mean "echo river" in the Timucuan tongue. However, another possible origin comes from a Spanish mission, San Juan de Guacara, located on the river. Some early maps identified the river as "San Juan." The Seminoles may have corrupted this name, calling the river "San Juanny." Further linguistic corruption, over time, may have resulted in the current pronunciation and spelling.

Hernando de Soto's army crossed the river in 1539, during its expedition along the Gulf coast. Some historians have suggested that this crossing took place southwest of present-day Fanning Springs, possibly at Lower Clay Landing. Several Spanish missions existed along the river. San Juan de Guacara, mentioned above, was established about 1605. It was destroyed by Indian raids in 1691, but was later rebuilt. Another mission and supply post, Cofa, was established on Hog Island at the mouth of the Suwannee River in the early 1600s. San Agustin de Urica was located near the present town of Luraville, in the early 1600s. Santa Cruz de Tarihica was located near Branford Springs.

During the Second Seminole War, several forts existed along the Suwannee River. Blount's Fort was located about 2 miles south of the Georgia border. Clay Landing Blockhouse was built in 1837 near Manatee Springs. Fort Number 17 was built north of

Spring Name	Approximate Location	Discharge (cfs)	Magnitude
Lime Run Spring	30.388997N-83.163366W	173	1
Lafayette Blue Spring	30.125834N-83.226134W	162	1
Manatee Spring	29.489529N-82.976872W	145	1
Troy Spring	30.006026N-82.997503W	137	1
Fanning Spring	29.587589N-82.935304W	109	1
Stephenson Spring	30.417089N-83.152950W	90	2
Little River Spring	29.996864N-82.966317W	84	2
Blue Sink Spring	30.335690N-82.808443W	43	2
Telford Spring	30.107049N-83.165739W	41	2
Ellaville Spring	30.384466N-83.172505W	40	2
Suwaneee Blue Spring	30.081472N-83.069021W	35	2
Rock Bluff Spring	29.799055N-82.918686W	29	2
Suwannee Springs	30.394477N-82.934538W	23	2
Turtle Spring	29.847393N-82.890286W	22	2
Lime Spring	30.391219N-83.168700W	20	2
Pot Hole Spring	29.810722N-82.935912W	20	2
Copper Spring	29.614011N-82.973856W	19	2
Anderson Spring	30.353410N-83.189726W	15	2
Branford Spring	29.954868N-82.928409W	17	2
Shingle Spring	29.934394N-82.920451W	12	2
Guaranto Spring	29.779797N-82.939958W	11	2
Peacock Spring	30.123226N-83.133154W	10	2
Otter Spring	29.644802N-82.942832W	10	2
Cow Spring	30.105283N-83.113808W	-	2
Fara Spring	30.276233N-83.235819W	-	2
Seven Sisters Spring	30.417533N-83.155333W	-	2
White Springs	30.329695N-82.761128W	-	2

Mayo in 1839. Fort McCrabb was established in 1840, about 4 miles north of Old Town, on the east bank. Fort Number 21 was constructed near Adams, in 1839.

During the Civil War, the Confederates built an earthwork near the junction of the Suwannee and Withlacoochee Rivers. This fortification protected a railroad bridge, which served as a vital supply link for the Confederacy. When federal soldiers marched west from Jacksonville to capture this bridge, they were repulsed in the battle of Olustee. This battle, which took place on February 20, 1864, was the largest Civil War battle that took place in Florida.

Steamboats operated on the river in the 1800s and early 1900s. These boats would typically run from Cedar Key to various points in south Georgia, with stops at Branford, Old Town, and other locations. The Madison, a steamboat that served as a mobile store, plied the Suwannee prior to the Civil War. During the war this boat was scuttled. Other steamboats that operated along the river included the Louisa and the Belle of the Suwannee, built in 1889. The City of Hawkinsville, one of the last steamboats to operate on the Suwannee River, was built in Georgia in 1886. Operations on the Suwannee began in 1900 and ended in 1922. The City of Hawkinsville was abandoned for lack of profitability due to competition from the railroads. Today, the remains of this steamboat can be seen resting on the bottom of the Suwannee, along the western bank near Old Town. It is a state-designated underwater preserve.

In 1851, Stephen Foster (1826–1864) penned the song "Old Folks at Home," which prominently features the Suwannee River. He never visited the river, but used the name because of the way it sounded within the song. Other well-known songs written by

The Suwannee River broadens in its lower reaches, and steep limestone banks give way to a narrow river valley, then marshes. This photograph shows the river near Fanning Springs.

Foster include "Oh! Susanna," "Camptown Races," "My Old Kentucky Home," and "Beautiful Dreamer." The Florida Legislature adopted "Old Folks at Home" as the state song in 1935. However, its use as the state song has generated controversy as a result of lyrics that are considered racially insensitive. The Stephen Foster Folk Culture Center State Park is located at White Springs on the banks of the Suwannee River.

The town of Branford had its start as the location of a ferry across the Suwannee. It was originally referred to as Rowland's Bluff. The town was incorporated in 1886 and served as an important steamboat landing during the late 1800s and early 1900s.

The town of White Springs, located in Hamilton County, had its origins as a health resort. Bryant and Elizabeth Sheffield purchased the land around the springs in 1835. The Sheffields built a hotel beside the springs and advertised the healing effects of the water. The springs began to attract northern visitors and the town became an important steamboat

landing. White Springs was incorporated in 1885. Fire destroyed much of the town in 1911, but spared many of the historic structures. The historic district of White Springs was placed on the National Register of Historic Places in 1997.

Significant flooding occurred along the Suwannee River in April, 1948; September, 1964; April, 1973; and April, 1998. The tendency of the river to flood has discouraged homebuilding and other development along the banks.

HUMAN IMPACT Water quality in the river is very good. Many miles of land within the river corridor are owned by the state of Florida or federal agencies, and development along most sections of river is sparse. Some phosphate mining has occurred in the upper watershed. Pulp mills, dairy farms, and poultry production facilities exist along or near Georgia tributaries. Increasing nitrate concentrations over the past few decades, probably caused by fertilizer and animal waste, provide additional

The largemouth bass is common in the Suwannee River, along with its cousin, the Suwannee bass.

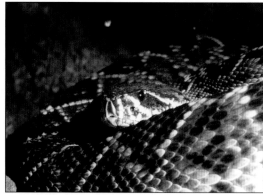

The eastern diamondback rattlesnake can be found in limestone crevasses within the banks, and in pine and palmetto flatwoods surrounding the river. This is the largest rattlesnake native to the United States and can reach a length of over 8 feet.

cause for concern. Irrigation demands and other withdrawals have diminished the river's flow.

RECREATIONAL ACTIVITIES Most of river, except for the big shoals area, can be navigated by powerboat. Hidden obstructions and limestone ledges present a hazard during periods of low water. Fishing in the river ranges from good to excellent. The rare Suwannee River bass is a frequent target of anglers. The state record, which weighed 3.89 pounds, was taken from the river. The state record redbreasted sunfish, which weighed 2.08 pounds, also came from the Suwannee River. The state record spotted sunfish was also caught here. White catfish are plentiful and big channel catfish are occasionally taken.

FLORA AND FAUNA The upper river is lined with cypress, Ogeechee tupelo, red maple, and river birch. The river mouth is bordered by marshes of cattail, cordgrass, and needlerush. The Suwannee supports several freshwater snail species, including the apple snail, alligator siltsnail, file campeloma, ovate campeloma, banded mysterysnail, and Suwannee hydrobe. It is also home to several freshwater mussels, such as the downy rainbow, elephant ear, paper pondshell, southern fatmucket, Suwannee moccasinshell, and variable spike. The estuary surrounding the mouth of the Suwannee contains extensive shellfish beds and serves as a nursery for marine fishes. Dragonflies that may be found in the vicinity

of the Suwannee include the common green darner, cyrano darter, blackwater clubtail, prince baskettail, common baskettail, cinnamon shadowdragon, faded pennant, plateau dragonlet, golden-winged skimmer, blue corporal, and great blue skimmer, among others.

About 59 species of freshwater fish are endemic to this river, along with a scattering of anadromous and marine species. The Suwannee is home to a robust population of the protected Gulf sturgeon. Common minnows include the coastal shiner, weed shiner, and taillight shiner. Other small fish present in the river include the pirate perch and brook silverside.

Pickerelweed is a common shoreline plant of many Florida rivers, including the Suwannee.

The eastern pondhawk is one of the most common dragonflies associated with Florida's rivers.

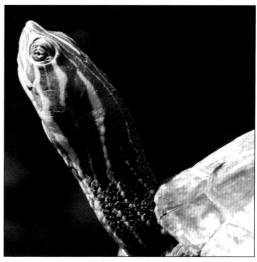

The Suwannee turtle is endemic to the Suwannee River and streams of the Big Bend region. This large cooter can attain a length of over 16 inches.

The Suwannee and its tributaries constitute the southernmost stronghold of the rare alligator snapping turtle. They also define the southern range of the northern subspecies of the common snapping turtle. Timber rattlesnakes are found in bottomlands and wet areas associated with the Suwannee and its tributaries. Eastern diamondback rattlesnakes are found on high ground bordering the river. Other snake species associated with the Suwannee include the redbelly watersnake, brown watersnake, and the uncommon glossy crayfish snake. Birds frequently sighted include red-shouldered hawk, swallow-tailed kite, osprey, and various warblers and wading birds. Non-native coyotes are sometimes sighted along the banks of the upper river, along with whitetailed deer, raccoon, and gray fox.

Waccasassa River

Type: Small Coastal River
Substrate: Clay, Sand, Gravel
Ecological Condition: ★★★★★
Oversight: SRWMD
Designations: None
Length: 29 miles
Watershed: 610 square miles

The Waccasassa River is located in a secluded area near Cedar Key on the northern Gulf coast. It is one of the least known and least visited rivers in Florida. Most of those who have encountered the Waccasassa know it only from passing over a small bridge on an uninhabited stretch of US 19/98.

GEOGRAPHY AND HYDROLOGY The Waccasassa is fed in part by springs and in part by drainage from a remote swampy area known as Devil's Hammock. It derives much of its initial flow from Blue Spring, 4 miles west of Bronson. This second-magnitude spring wells up through several vents into a 150-foot pool. The river also pulls some of its water from Waccasassa Flats, a grassy marsh located in Devil's Hammock. About 10 miles below Blue Spring run, the Magee Branch joins the Waccasassa from the northeast. This tributary begins at Deerpen Pond, five miles south of Bronson. After passing under US 19/98, just north of Gulf Hammock, the Waccasassa is joined by several other tributaries. These include the Wekiva River, flowing from the northeast, Otter Creek, flowing in from the northwest, and Cow Creek, flowing in from the east. The river empties into Waccasassa Bay, an extension of the Gulf of Mexico.

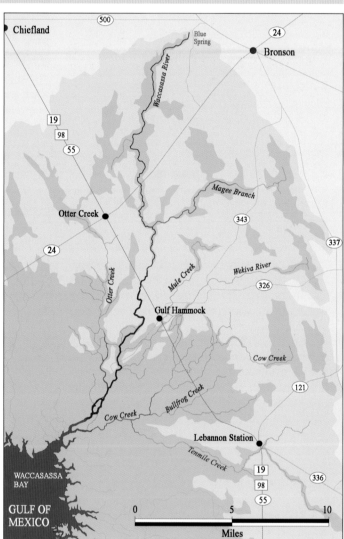

HISTORY The Potano Tribe, associated with the Timucua, inhabited this region at the time of European contact. Hernando de Soto's army crossed the Waccasassa and nearby Otter Creek in 1539. The name Waccasassa is derived from the Seminole words "wacca," meaning "cows," and "sasi," meaning "there are." So, the name translates as "where there are cows." The riverbed is a repository for jaguar bones, shark teeth, and other fossils. A military outpost, Fort Jennings, was built on the river near Otter Creek to protect settlers against

Many species of ducks visit the Waccasassa and its estuary. A male (left) and female (right) wood duck perch on a weathered snag.

The Waccasassa as it appears just south of the bridge of US 98/19. Fallen trees obstruct portions of the upper river.

attacks from Indians. Other forts located along the Waccassasa during the Second Seminole War included Fort Number Eight (renamed Fort Waccassasa), built in 1839, and Fort Number Three, built near the mouth of the Waccassassa River in 1839.

Levy County, through which the Waccasassa flows, was established in 1845. It was named for Senator David Levy, who represented Florida prior to the Civil War. During the Civil War, in May of 1863, shallow-draft boats dispatched from USS *Fort Henry*, captured the Confederate sloop *Isabella* in Waccasassa Bay. The *Fort Henry*, a New York ferry converted to military use, was charged with enforcing the federal blockade along this section of the coast. The African American community of Rosewood was located a few miles north of the Waccassasa River. This was the site of a race riot in 1922. Following a series of racially charged incidents, a mob of whites converged on Rosewood, killed an indeterminate number of citizens, and burned the town.

HUMAN IMPACT Most of the land surrounding the river is undeveloped and is owned by the state and large timber interests. The Devil's Hammock Wildlife Management Area sur-rounds the upper river. No towns are located directly on the river. The tiny communities of Gulf Hammock and Otter Creek are located nearby. Waccasassa Bay Preserve State Park, which protects the estuary around the mouth of the river and nearby coastal areas, contains 31,000 acres.

RECREATIONAL ACTIVITIES The Waccasassa Bay Preserve State park can only be reached by boat. Most of the river is only accessible by canoe or kayak. Fishing is good in the river. Small bass and bream are plentiful in the upper river. Redfish and speckled sea trout are common in estuarine portions of the river. Fossil deposits occur in gravel and sand along the river bed.

FLORA AND FAUNA Black gum, live oak, laurel oak, cabbage palm, Florida willow, Carolina ash, and second-generation pine forests grow along the banks. The marsh sprite, a freshwater snail, is endemic to the Waccasassa. Damsel-flies that may be observed include the slender spreadwing, Altlantic bluet, and smoky rubyspot. The one-toed amphiuma, an odd, eel-like amphibian, is found in muddy areas. Other wildlife includes river otter, feral hog, and whitetailed deer.

Withlacoochee River

Type: Limestone/Blackwater River
Substrate: Limestone, Gravel, Sand
Ecological Condition: ★★★★
Oversight: SRWMD
Designations: CT
Length: 101 miles (32 In Florida)
Watershed: 1.950 square miles

Two Withlacoochee Rivers are present in Florida, separated by about 100 miles. The one addressed here begins in Georgia. It is a major, south-flowing tributary of the Suwannee River.

GEOGRAPHY AND HYDROLOGY The Withlacoochee begins near Tifton, Geogia. In Georgia it passes through Tift, Cook, Colquitt, and Brooks Counties. The upper river is rocky, swift, and contains several stretches of rapids. The Little River, a major tributary, merges with the Withlacoochee River near Valdosta, Georgia. A steamboat landing once existed at this location, at the town of Troupville, Georgia. In Florida, the Withlacoochee River serves as the boundary between Hamilton and Madison Counties. It is framed by high limestone banks and contains tea-colored water. The Withlacoochee is fed by many springs along its length, including first-magnitude Madison Blue Spring and second-magnitude Pot, Tanner, and Suwanacoochee Springs. The Withlacoochee flows into the Suwannee River at Suwannee River State Park, near Live Oak.

HISTORY The name is derived from a combination of Creek words *we thako chee*, which means "little big water." Several skirmishes took place along the river during the First and Second Seminole Wars. Settlers' homes were burned. During the Second Seminole War, a local planter built a fortification known as Warner's Ferry Stockade. This structure stood on the east bank, just south of the Georgia border. Steamboats plied the Withlacoochee in the 1800s, carrying cotton and other goods from the interior of Georgia.

HUMAN IMPACT Water quality in the Withlacoochee is good, although some portions of the upper watershed drain agricultural land. Twin Rivers State Forest, composed of sev-

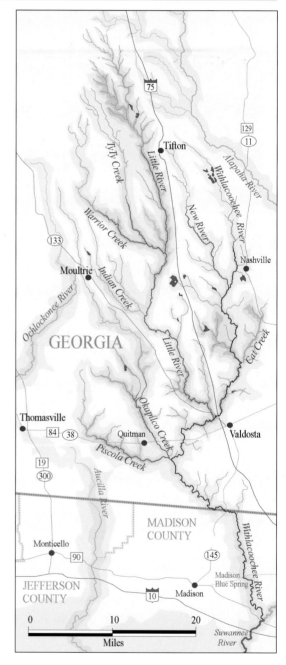

The Florida portion of the Withlacoochee River bears a strong resemblance to the Suwannee River.

The white catfish, and its larger cousin the channel catfish, are sought by anglers fishing the Withlacoochee River.

eral tracts, protects portions of the lower river. Much of the land along the river is in private hands. Residences appear atop the banks along some sections.

RECREATIONAL ACTIVITIES The Withlacoochee River Canoe Trail begins at the bridge of State Road 145, near the Florida-Georgia border. It continues for 32 miles to the Suwannee River State Park. The river supports a very good recreational fishery. Anglers pursue bass, catfish, and bream. Twin Rivers State Forest provides hiking trails, bicycle trials, and equestrian trials.

FLORA AND FAUNA Cypress, Ogeechee tupelo, magnolia, river birch, sweet gum, live oak, water oak, red buckeye, American hornbeam, and azalea are present along the banks. Damselflies that may be observed include the smoky rubyspot and purple bluet. Dragonflies include the common baskettail, cinnamon shadowdragon, and eastern pondhawk. The protected Gulf sturgeon occurs in the lower Withlacoochee. The alligator snapping turtle, common snapping turtle, loggerhead musk turtle, common mud turtle, chicken turtle, and the coastal plain turtle, among others, may be found in this river. Wildlife that may be sighted along the river includes bobcat, feral hog, and the occasional alligator.

Spring Name	Approximate Location	Discharge (cfs)	Magnitude
Madison Blue Spring	30.480436N-83.244363W	110	1
Suwanacoochee Spring	30.386672N-83.171767W	25	2
Rosseter Spring	30.544625N-83.250111W	-	2
Morgan's Spring	30.420196N-83.207420W	-	2
Pott Spring	30.470802N-83.234410W	-	2
Tanner Spring	30.464506N-83.217723W	-	2

Plume hunters, who sought feathers to decorate women's hats, decimated populations of the snowy egret in the early 1900s. Fortunately, fashions changed, protections were put in place, and the species survived.

Northeast Florida

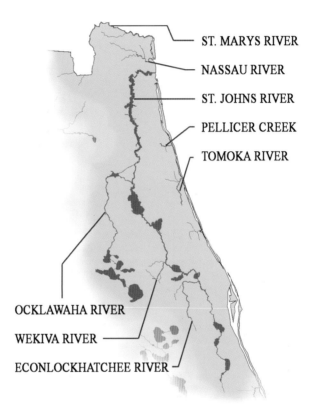

ST. MARYS RIVER

NASSAU RIVER

ST. JOHNS RIVER

PELLICER CREEK

TOMOKA RIVER

OCKLAWAHA RIVER

WEKIVA RIVER

ECONLOCKHATCHEE RIVER

The St. Johns River Water Management District has oversight of the rivers of northeast Florida. Most rivers of this region are slow, low-gradient, brownwater streams. A few derive all or part of their flow from springs. The broad St. Johns courses northward through the center of the region before emptying into the Atlantic Ocean. The text provides separate coverage for three tributaries and one sub-tributary of the St. Johns. The other rivers of northeast Florirda are small to medium streams, flowing east into coastal lagoons. Increasing population densities, extensive agriculture, and heavy use have taken a toll on some waterways. Exotic plants, such as water hyacinth, have also caused serious problems. However, a few rivers remain in very good condition and support abundant wildlife.

Econlockhatchee River

Waterway Type: Small Blackwater River
Substrate: Sand, Mud
Ecological Condition: ★★★
Oversight: SJRWMD
Designations: OFW, CT
Length: 32 miles
Watershed: 290 square miles

The Econlockhatchee River, or "Econ," as it is popularly known, is a major tributary of the St. Johns River. It passes within 10 miles to the east of Orlando. Despite its proximity to this sprawling city, the Econlockhatchee has retained most of its natural character.

GEOGRAPHY AND HYDROLOGY The Econlockhatchee originates in the Econlockhatchee River Swamp and drains other cypress-dominated swamps of northern Osceola County and Lake Conlin. It runs northward through Orange and Seminole Counties for the first two-thirds of its length, before angling off to the northeast. The river is generally shallow and portions of the upper southern river may be discontinuous during periods of low rainfall. The main tributary, the Little Econlockhatchee River, originates south of Curry Ford Road, southeast of Orlando, and flows into the Econlock-hatchee from the west. Other tributaries include Fourmile Creek, Little Creek, Green Branch, Cowpen Branch, Long Branch, Dead Deer Creek, and Mills Creek. Much of the corridor surrounding the Econlockhatchee consists of private ranches or protected wilderness. The Little Big Econ State Forest, located 3 miles east of Oviedo,

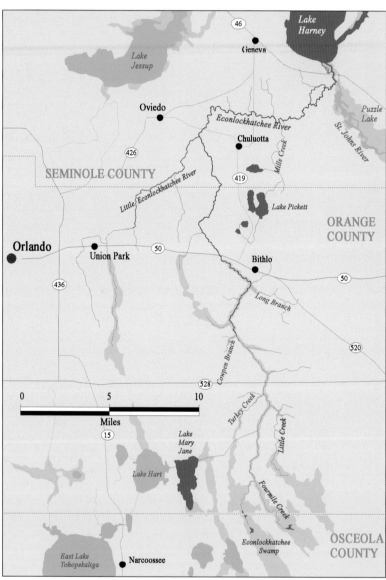

contains over 5,000 acres of woodlands. Both the Econlockhatchee and the Little Econlockhatchee flow through the property. The lower river runs between high sand banks and ham-

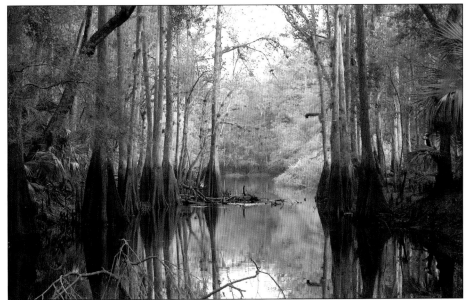

The Econlock-hatchee as it approaches State Road 50, east of Orlando. Note the high-water mark on the cypress trunks.

mocks of oak and cabbage palm. The Econlockhatchee flows into the St. Johns River from the west, just south of Lake Harney.

HISTORY Timacua people, possibly the Acuera group, occupied land around the river at the time of European contact. Orange County was created in 1824 as Mosquito County, but was renamed in 1845. Osceola County was created in 1887. Seminole County was created in 1913.

HUMAN IMPACT The Little Econlockhatchee drains areas of suburban Orlando, and various sub-tributaries have been transformed into canals and ditches. Although regulations regarding storm water treatment have been strengthened, runoff from paved roads and developed areas continues have a negative impact on water quality. Turbidity is often high. A considerable volume of trash finds its way into this major tributary of the Econlockhatchee. Water quality in the Econlockhatchee itself is usually good, although some sections have experienced problems associated with agricultural runoff and non-point-source pollution.

RECREATIONAL ACTIVITIES A state-designated canoe trail begins at the bridge of County Road 319. It ends 19 miles downstream at the State Road 46 bridge over the St. Johns River. Portions of the upper river, south of the canoe trail, may be passable during some parts of the year. Fishing in the river is good, with healthy populations of bluegill, redear sunfish, red-breasted sunfish, and white catfish.

FLORA AND FAUNA Plants lining the banks include cypress, willow, and cabbage palm. Small freshwater sponges are present in this waterway and are typically attached to logs and other wood debris. Caddisfly and mayfly larvae are abundant. Turtles found in this river include the peninsula turtle, red-bellied turtle, southern softshell, striped mud turtle, and Florida mud turtle. Birds present in the area include osprey, belted kingfisher, red-shouldered hawk, and swallow-tailed kite. Wildlife regularly observed along the banks includes otter, raccoon, white-tailed deer, gray fox, and bobcat.

The bobcat, although not often seen, is a frequent visitor to undeveloped areas surrounding the Econlockhatchee River.

Nassau River

Waterway Type: Small Coastal River
Substrate: Mud, Sand
Ecological Condition: ★★★★
Oversight: SJRWMD
Designations: AP
Length: 26 miles (including tributaries)
Watershed: 280 square miles

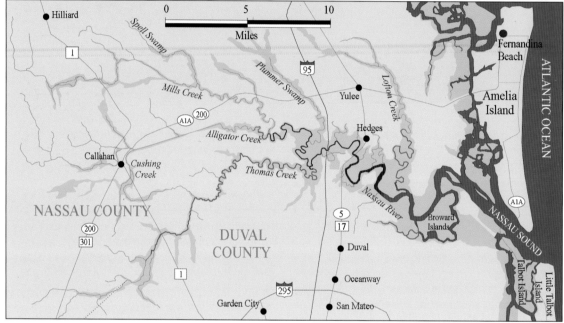

The Nassau River of northeastern Florida flows from west to east, discharging into the Atlantic Ocean south of Fernandina Beach. The area around the mouth of the river is surrounded by broad tidal marshes.

GEOGRAPHY AND HYDROLOGY The Nassau River originates in several swampy areas near the towns of Hillard and Callahan in Nassau County. Several major tributaries contribute to its flow. Working from north to south, the headwater tributaries are Swamp Creek, Little Boggy Creek, Mills Creek, Alligator Creek, and Thomas Creek. Thomas Creek flows in from the southwest, and defines part of the border between Nassau and Duval Counties. As the Nassau River flows into Nassau Sound, the South Amelia River, a coastal lagoon that is part of the Intracoastal Waterway, merges from the north.

HISTORY The Timucua people, specifically the Saturiwa group, inhabited the area around the river at the time of European contact. Fernandina Beach, a few miles north of the mouth of the river, was originally settled by the Spanish in 1567. Nassau County was founded in 1824. One of the county's prominent residents was David Yulee, railroad baron and United States Senator. Yulee established the Florida Railroad Company. He completed his cross-Florida railroad, which ran from Fernandina Beach to Cedar Key, in 1860. The railroad was dismantled during the Civil War. Following the war, Yulee spent time in prison at Fort Pulaski, Georgia, as a result of his loyalty to the Confederacy. However, he eventually returned to Florida and rebuilt the railroad. The Nassau River–St. Johns River Aquatic Preserve, consisting of 57,000 acres, was established in 1969.

HUMAN IMPACT While minor development has occurred along a few parts of the river, much of

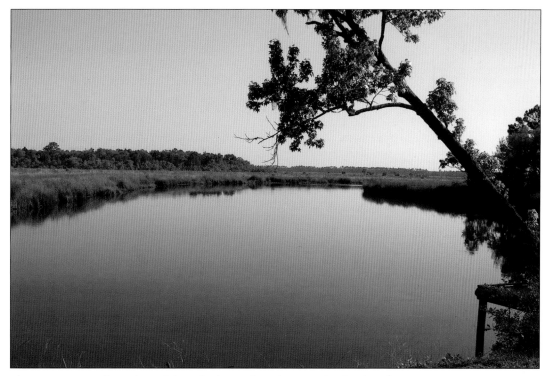

The Nassau River flows through broad salt marshes along much of its length.

the river and adjoining tidal creeks fall within the vast Nassau River–St. Johns River Aquatic Preserve. The towns of Hedges and Nassauville are located along the north bank. I-95 spans the river and marsh about 9 miles above the mouth.

RECREATIONAL ACTIVITIES The lower river is navigable by powerboats. Fishing is productive. Freshwater portions of the river contain a very good though not well-known bass fishery. Striped bass, sheepshead, black drum, speckled sea trout, flounder, and redfish are frequently taken in the lower river.

FLORA AND FAUNA Trees along the banks include Carolina ash and cypress. The lower river is dominated by extensive salt marshes and tidal flats. Areas around the mouth of the Nassau River harbor rich shellfish beds. Damselflies that may be observed in the vicinity of this river system include the Florida bluet, Carolina spreadwing, common spreadwing, swamp spreadwing, sparkling jewelwing, and variable dancer. The Nassau River appears to represent the southernmost range of the eastern painted turtle. Other turtles inhabiting this river include the southern softshell turtle, chicken turtle, coastal plain turtle, common musk turtle, and common mud turtle. Birds that can be observed in the area include bald eagle, double-crested cormorant, wood stork, painted bunting, American oystercatcher, brown pelican, and least tern.

A double-crested cormorant rests in a pine tree overlooking the Nassau River. This relative of the pelican feeds almost exclusively on fish.

Ocklawaha River

Waterway Type: Brown-water/Spring Fed River
Substrate: Sand, Silt
Ecological Condition: ★★★
Oversight: SJRWMD
Designations: OFW, AP
Length: 115 miles
Watershed: 568 square miles

The Ocklawaha River (sometimes spelled "Oklawaha") of north central Florida is the largest tributary of the St. Johns River. This historic waterway is framed by moss-draped cypress. It highly regarded for canoeing, boating, and fishing. It is primarily a brown-water stream, originating from a chain of lakes. However, it also derives much of its flow from springs, including the massive Silver Springs group.

GEOGRAPHY AND HYDROLOGY The Ocklawaha originates at Moss Bluff Dam on Lake Griffin in Lake County. However, Lake Griffin receives much of its water from other lakes within the Harris Chain. These include Lakes Yale, Eustis, Harris, and Dora in Lake County, and Lake Apopka in Orange County. Tributaries of the Ocklawaha River, moving from south to north, include the Marshall Swamp outflow, Silver River, Daisy Creek, Mill Creek, Orange Creek, and Deep Creek, all flowing in from the west. The last 10 miles of the river flow eastward. The Rodman Reservoir, a large impoundment, is located at this turn of the river. The reservoir is 15 miles long, and covers 9,500 acres. The Ocklawaha merges with the St. Johns River opposite the town of Welaka.

HISTORY Sources list the Native American name Ockli-Waha as meaning "great river" or "muddy river." The name of the river was spelled for many years without the c, until the U.S. Board of Geographic Names standardized the present spelling in 1992. In 1832, at Payne's Landing on the Ocklawaha, the federal government negotiated a treaty with the Seminoles. The Seminoles had previously been settled on a reservation in central Florida. The Payne's Landing Treaty of 1832 gave the Seminoles three years to move to

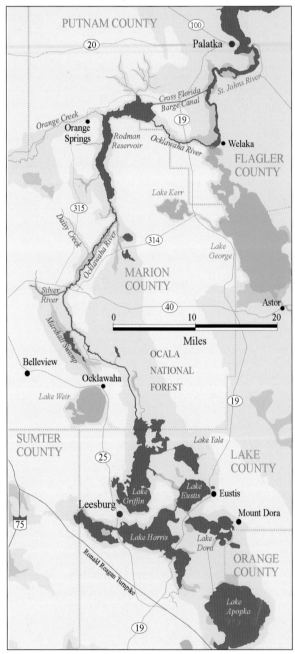

The historic Ocklawaha River was nearly ruined by the Cross Florida Barge Canal. This ill-conceived project has been cancelled.

lands west of the Mississippi River. The Seminoles resisted this forced relocation, which led to the Second Seminole War. Several forts, including Fort Fowle and Fort Connor, were built along the Ocklawaha River during the Second Seminole War.

From the late 1860s through the 1920s, steamboats laden with northern sightseers plied the river. These bore names such as *Tuskawilla, Oklawaha, Marion,* and *Osceola.* Some of these boats brought visitors from Palatka to Silver Springs. A mural in the Florida House of Representatives, painted by Christopher Still, shows the Ocklawaha as it looked in the 1880s.

Arizona Donnie Barker—also known as "Ma Barker," the notorious gang matriarch—along with one of her sons, was killed in a shoot-out in Ocklawaha on January 16, 1935. The town of Ocklawaha is located on the west bank near the head of the river.

The Florida Canal Authority was created in 1933 to supervise excavation of a shipping canal across the state. The proposal was later scaled back to allow for the transit of shallow-draft barges. An earthen dam was built in 1968

The limpkin is a curious inhabitant of river margins. Snails make up a large part of its diet. It often stands on one leg as shown here.

as part of the Cross Florida Barge Canal. This dam holds back the Rodman Reservoir. The Buckman Lock and a concrete spillway transect the dam. The Cross Florida Barge Canal project was discontinued in 1971.

Portions of the river were designated as an aquatic preserve in 1988. In recent times, some

parties have advocated a restoration of the river to its natural condition, with elimination of the dam and Rodman Reservoir. Others contend that the reservoir supports abundant wildlife, excellent fishing, and many other forms of recreation, so should be maintained in its present form.

HUMAN IMPACT The Harris chain of lakes, which makes up the headwaters of the Ocklawaha, has been plagued by serious pollution. This lake chain is nestled among the towns of Eustis, Mount Dora, Leesburg, Tavares, and Winter Garden. Lake Apopka, once a noted fishing destination, suffered years of decline as a result of agricultural runoff and other non-point-source pollution. By the 1980s, it had gained notoriety as one of the state's most polluted lakes. Recent efforts by the St. Johns Water Management District and other state and federal agencies, have resulted in substantial improvements in water quality.

About 5 miles of the upper Ocklawaha River has been channelized. The river flows past the towns of Ocklawaha and Eureka. Much of the eastern shoreline falls within the Ocala National Forest. In addition, about 30 miles of the river are contained within the Ocklawaha River Aquatic Preserve. Large tracts surrounding the river are protected. However, most of the large cypress trees around the river were taken for timber in the late 1800s and early 1900s.

Although it continues to receive some phosphorus-laden water from the Harris chain, and although nutrient concentrations are high,

The redear sunfish is a common quarry of anglers fishing the Ocklawaha River.

water quality of the Ocklawaha is fair to good. Physical changes resulting from the abandoned Cross Florida Barge Canal have significantly altered the river's natural flow. Blue tilapia, an exotic fish, now makes up a significant part of the biomass. Non-native water hyacinth forms large mats along the shoreline of this waterway. Despite diligent control efforts by the state this plant continues to interfere with navigation and other activities.

RECREATIONAL ACTIVITIES Fishing in the

Spring Name	Approximate Location	Discharge (cfs)	Magnitude
Apopka Spring	28.566602N-81.680669W	28	2
Blue Spring	29.514167N-81.856944W	-	2
Bugg Spring	28.751987N-81.901517W	12	2
Wells Landing Spring	29.421015N-81.919681W	9	3
Catfish Spring	29.515325N-81.861766W	8	3
Tobacco Patch Landing	29.428535N-81.923913W	4	3
Orange Spring	29.510651N-81.944072W	3	3

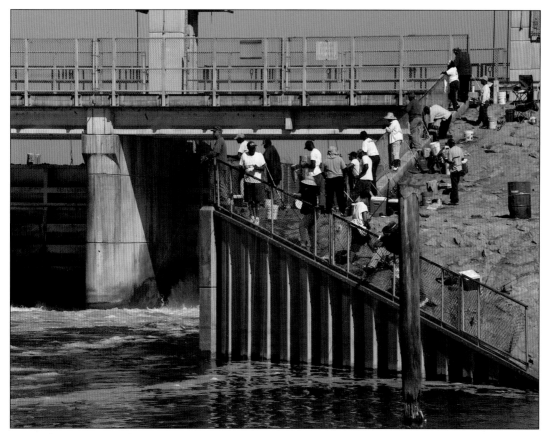

The Rodman Dam may be controversial, but no one can dispute the fact that great fishing is available near the spillway.

Ocklawaha and in the Rodman Reservoir is excellent. Many trophy bass are taken from these waters on an annual basis. Live shiners are the preferred bait. Bream, including redbreasted sunfish, bluegill, redear sunfish, and spotted sunfish, are plentiful. Powerboats operate on the river and their wakes can interfere with canoeing and kayaking.

FLORA AND FAUNA Cypress, willow, elderberry, red maple, and cardinal flower grow along the banks. Damselflies such as the common spreadwing and variable dancer and dragonflies such as the cypress clubtail and purple skimmer may be encountered along this waterway. Small fishes endemic to the Ocklawaha include the brook silverside, gizzard shad, taillight shiner, and golden shiner. The Ocklawaha is home to numerous turtles, including species such as the Florida red-bellied turtle, chicken turtle, peninsula turtle, striped mud turtle, and Florida mud turtle. Also present are a number of aquatic snakes such as the water moccasin, redbelly watersnake, eastern mudsnake, striped crayfish snake, and Florida banded watersnake. Birds that may be observed include the least bittern, tricolored heron, glossy ibis, anhinga, snowy egret, black-necked stilt, purple gallinule, sandhill crane, and various ducks. Sherman's fox squirrel, deer, and the occasional black bear or bobcat, may be seen along the banks. Otters are common.

Pellicer Creek

Type: Small Coastal River
Substrate: Sand, Mud
Ecological Condition: ★★★★
Oversight: SJRWMD
Designations: OFW, CT, AP
Length: 11 miles
Watershed: 80 square miles

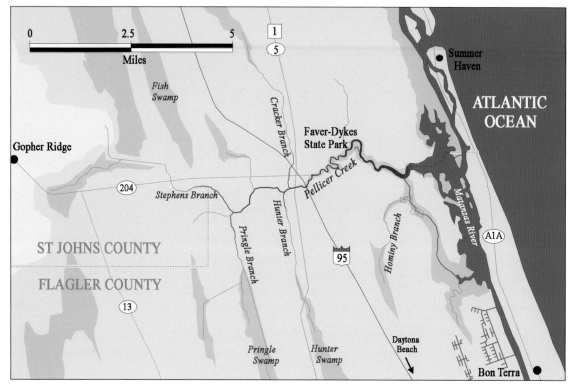

This small coastal river forms part of the border between Flagler and St. Johns Counties. It is largely unspoiled and is heavily buffered along most of its length. It thus provides a template for the appearance of many small rivers along Florida's east coast prior to development.

GEOGRAPHY AND HYDROLOGY Pellicer Creek derives its flow from several smaller creeks that drain swampy areas lying behind the coastal ridge, primarily Fish Swamp, Hulett Swamp, and Pringle Swamp. Tributaries include the Hulett, Pringle, Stevens, Dave, Cracker, and School-house Branches. The creek is brackish in areas east of I-95. The salinity is pushed further to the east during periods of high precipitation. Pellicer Creek broadens toward its mouth. It empties into

the Matanzas River, a coastal lagoon that is part of the Intracoastal Waterway. Anastasia Island separates the Matanzas River from the Altantic Ocean. The waters of the Matanzas River are exchanged with those of the Atlantic through the Matanzas Inlet, about 2.4 miles north of the creek.

HISTORY Timucua people inhabited the area around Pellicer Creek at the time the Spanish arrived. The Matanzas River, into which Pellicer Creek discharges, was named as a result of the slaughter of shipwrecked French Huguenots by the Spanish in 1565. *Matanza* is the Spanish word for slaughter. Fort Matanzas, located on the Matanzas Inlet, was built by the Spanish in the 1740s to protect St. Augustine from attack from

Pellicer Creek viewed from the Interstate 95 bridge in mid-winter.

the south. The creek itself was named for Fransisco Pellicer. Pellicer, born on the Island of Minorca, came to Florida as part of Andrew Turnbull's settlement at New Smyrna. He received a land grant along the creek from the Spanish government. The area thereafter came to be known as Pellicer Plantation. A federal fort, Fort Fulton, was constructed in 1840 near the mouth of Pellicer Creek. A large parcel of land around the creek later fell under the ownership of Princess Scherbatow, wife of an exiled Russian prince, and was called Princess Place. It is now managed by Flagler County as the Princess Place Preserve. The Princess Place Lodge, an example of the Adirondack-hunting-lodge architectural style, has been carefully restored. Marineland, the world's first oceanarium, is located on Anastasia Island, opposite the mouth of Pellicer Creek. It first opened in 1938, and was one of Florida's leading tourist attractions for decades. However, it could not compete with the Orlando-area attractions and today it operates on a reduced scale.

HUMAN IMPACT The overwhelming bulk of land within the drainage basin consists of forests and wetlands. Water quality is generally good. Some residential development has taken place on the south shore of the creek in the vicinity of Princess Place Preserve and on the north shore just east of I-95. The Pellicer Creek Aquatic Preserve protects more than 500 acres of submerged land, extending from US 1 to the mouth of the creek—a distance of about 8 miles. Faver-Dykes State Park encom-

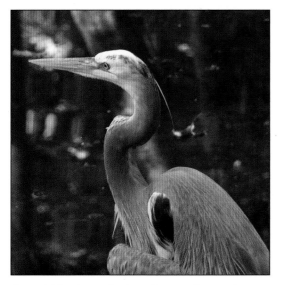

A great blue heron looks out over a finger of Pellicer Creek. The slender build of this species belies its aggressive nature. Besides taking fish, frogs, crabs, and mammals, the great blue heron occasionally raids the nests of other wetland birds, devouring their young.

The creek broadens considerably as it winds past Faver-Dykes State Park.

passes land along the north shore of the estuary. Lands along the south shore are protected by the Pellicer Creek Conservation Area, which consists of about 3,865 acres.

RECREATIONAL ACTIVITIES Pellicer Creek is a state-designated canoe trail. The trail begins at US 1 and ends 4 miles downriver at Faver-Dykes State Park. The current is slow. Portions of the river west of US 1, although not part of the state trail, make an interesting paddle and are largely undeveloped. The Stephens Branch is the only tributary that is passable by canoe for any significant distance. Areas east of Faver-Dykes State Park can also be paddled, although wind and tides tend to exert considerable influence over this portion of the creek. Crabbing is productive in brackish portions of Pellicer Creek. Fishing around the mouth of the creek can be excellent. Hiking and equestrian trails are located at Princess Place Preserve and in the state park.

FLORA AND FAUNA Foliage surrounding the creek includes cabbage palm, swamp laurel

Fishing for brackish and saltwater species is productive, but is best accomplished from a boat.

oak, bayberry, beautyberry, and coastal plain willow. Rare plant species that are present on land surrounding the river include cinnamon fern, creeping orchid, and east coast coontie. Estuarine portions of the creek are surrounded

Marshes surrounding the creek are home to countless wading birds.

by broad salt marshes and mud flats. Birds that may be present include the American oyster-catcher, brown pelican, reddish egret, roseate spoonbill, snowy egret, and tricolored heron, all of which are species of special concern. River otters are occasionally spotted. Alligators are plentiful in western portions of the creek. Turtles found here include the chicken turtle, Florida red-bellied turtle, and, in estuarine portions of the creek, the southern diamondback terrapin. The rare Atlantic salt-marsh snake may be present in marshes around the mouth of Pellicer Creek.

St. Johns River

Type: Large Coastal River/Chain of Lakes
Substrate: Various
Ecological Condition: ★★★
Oversight: SJRWMD
Designations: AP (marsh at mouth, Wekiva area)
Length: 310 miles
Watershed: 8,850 square miles

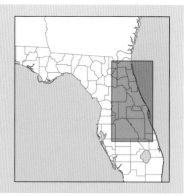

The St. Johns River looking south from the State Road 40 bridge.

The St. Johns is Florida's longest river. Its drainage basin extends to nearly a sixth of the land area of the entire state. During its leisurely journey, the St. Johns River passes through or touches 18 counties. It is one of only a handful of major rivers in the United States that flow in a northerly direction. The St. Johns River has immense historical, ecological, and economic significance. However, because many of the swamps that nourish the river have been drained, it has experienced system-wide decline.

GEOGRAPHY AND HYDROLOGY The headwaters of the St. Johns are located in Indian River County, west of Sebastian and Fellsmere, south of Blue Cypress Lake. The elevation of this area is only about 29 feet above sea level. It consists of sawgrass meadows, cypress soughs, and a patchwork of drainage ditches and levees. The most remote fingers of this northward-draining wetland extend south to within 20 miles of Lake Okeechobee.

The river is often divided into three segments or basins. The upper (southern) river basin is shallow and is bordered by marshland. It meanders through a maze of backwaters, sloughs, floating vegetation, and grass islands. The middle river begins around Lake Harney, and extends north to Palatka. High banks and a well-defined channel characterize this section of river. The lower

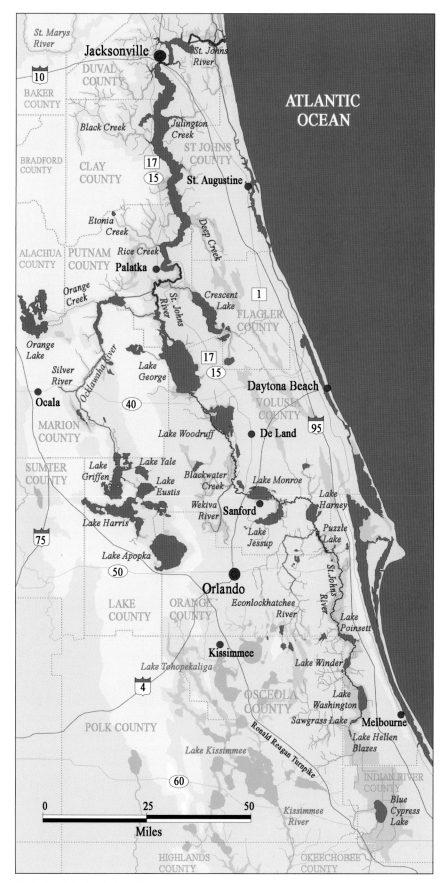

ATLANTIC
OCEAN

St. Marys River

Jacksonville

St. Johns River

10

DUVAL COUNTY

BAKER COUNTY

Julington Creek

Black Creek

ST JOHNS COUNTY

BRADFORD COUNTY

CLAY COUNTY

17
15

St. Augustine

Etonia Creek

Deep Creek

ALACHUA COUNTY

PUTNAM COUNTY

Rice Creek

Palatka

Orange Creek

Crescent Lake

1

FLAGLER COUNTY

Orange Lake

Silver River

Ocklawaha River

Lake George

St. Johns River

17
15

Ocala

40

Daytona Beach

MARION COUNTY

VOLUSIA COUNTY

De Land

95

Lake Woodruff

SUMTER COUNTY

Lake Yale

Lake Griffen

Lake Eustis

Blackwater Creek

Lake Monroe

Lake Harney

Wekiva River

Sanford

Lake Harris

Puzzle Lake

75

Lake Jessup

Lake Apopka

50

St. Johns River

Orlando

LAKE COUNTY

ORANGE COUNTY

Econlockhatchee River

Lake Poinsett

Kissimmee

Lake Winder

Lake Tohopekaliga

4

OSCEOLA COUNTY

Lake Washington

Sawgrass Lake

Melbourne

POLK COUNTY

Ronald Reagan Turnpike

Lake Hellen Blazes

Lake Kissimmee

INDIAN RIVER COUNTY

60

0 25 50

Blue Cypress Lake

Kissimmee River

Miles

HIGHLANDS COUNTY

OKEECHOBEE COUNTY

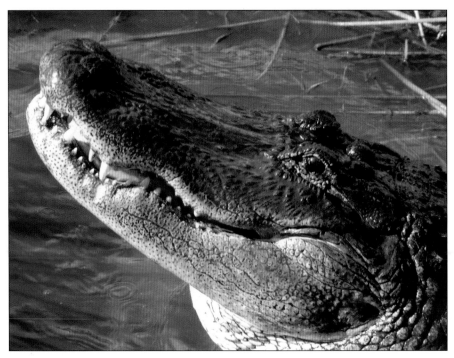

Alligators approaching 14 feet in length inhabit the St. Johns River and its chain of lakes.

(northern) segment, from Palatka to the Jacksonville area, broadens considerably, averaging about 2 miles in width. Here, the water becomes brackish and is subject to tidal influence. As a result of the weak current and low gradient of the river, saltwater and tidal influence may extend more than 100 miles upstream from the mouth.

The St. Johns flows through and connects an extensive chain of lakes. The upper basin contains Lake Hell 'n' Blazes, Sawgrass Lake, Lake Washington, Lake Winder, Lake Poinsett, Ruth Lake, and Puzzle Lake. The middle basin contains Lake Harney, Lake Jesup, and Lake Monroe. Lake George is the most northerly lake within the middle basin. It is also the largest lake within the St. Johns chain, and the second-largest lake in Florida.

The St. Johns is fed by three major tributaries, the Ocklawaha River, the Econlockhatchee River, and the Wekiva River. All three are discussed separately within this book. The St. Johns also receives inflow from an array of smaller tributaries. Moving from south to north, these include Tenmile Creek, Jane Green Creek, Pennywash Creek, Wolf Creek, Cox Creek, Taylor Creek, Jim Creek, Tootoosahatchee Creek, Christmas Creek, Buscombe Creek, Deep Creek, Dunns Creek, Rice Creek, Sixmile Creek, Black Creek, Julington Creek, Ortega River, Arlington River,

Trout River, Broward River, and Dunn Creek.

For almost the whole of its length, the St. Johns parallels the east coast of the peninsula. At Jacksonville, the river turns east, then empties into the Atlantic Ocean.

HISTORY The St. Johns River basin was once a shallow coastal lagoon, broadly connected to the Atlantic Ocean. However, as sea levels dropped, the river became isolated from the coast. Salt deposits, remaining from the period in which the St. Johns was an arm of the sea, have left some portions of the river with an elevated salt content.

At the time of European contact, the Timucua people inhabited the area surrounding the St. Johns River. This group included more than 30 tribes. Chief Saturiwa ruled over Timucua regions east of the St. Johns in the 1560s and was responsible for establishing a relationship with the French. The Timucua people were slowly driven from existence through conflict and by diseases introduced from Europe. It is believed that the last member of this once-numerous tribe was Juan Alonso Cabale, who died in Cuba in 1767. Southern portions of the river extended into territory controlled by the Myaca, the Jojoro, and possibly the Ais tribes.

The Timucua named the river Welaka, "river of lakes." The Spanish, at various times,

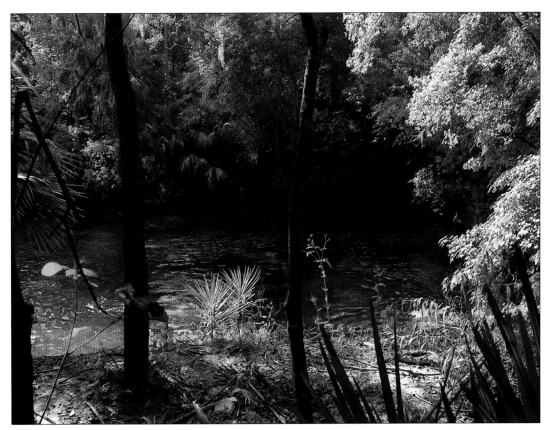

Blue Spring, just south of DeLand, is one of the largest springs discharging into the St. Johns. Manatees frequent the spring during winter cold spells.

Spring Name	Approximate Location	Discharge (cfs)	Magnitude
Blue Spring	28.947484N-81.339588W	158	1
Alexander Spring	29.081300N-81.575884W	103	1
Silver Glenn Spring	29.245844N-81.643473W	102	1
Salt Springs	29.350655N-81.732792W	80	2
Croaker Hole	29.438333N-81.361390W	76	2
Ponce de Leon Spring	29.134280N-81.362748W	27	2
Sweetwater Spring	29.218778N-81.659869W	13	2
Juniper Spring	29.183706N-81.712412W	11	2
Gemini Spring	28.862772N-81.311404W	10	2
Welaka Spring	29.494554N-81.673249W	-	2
Beecher Spring	29.448658N-81.646863W	9	3
Clifton Spring	28.699872N-81.238118W	-	3
Satsuma Spring	29.512600N-81.675500W	-	3

referred to the river as Río de Corrientes (river of currents), Río Dulce (sweet river), and Río de San Juan. The later name referred to a mission, San Juan del Puerto, located near the mouth of the river. The English converted this Spanish name to St. Johns.

A French expedition reached the Florida coast near Cape Canaveral in 1562. The French then sailed north to the mouth of the St. Johns River. Initial contacts between the

An airboat presents the most convenient means of navigating the shallows, marshes, and grassy islands of the upper river.

French and Timucua were friendly. A later French expedition led by René Coulaine de Laudonnière constructed Fort Caroline in 1564. The fort was built on high ground a few miles upriver from the mouth of the St. Johns. A Spanish force, under the direction of Pedro Menéndez de Avíles, attacked the fort in 1565, overrunning the French garrison.

A Spanish mission, San Salvador de Mayaca, was established along the St. Johns south of Lake George in the 1590s. The exact location is uncertain. San Juan del Puerto, another Spanish Mission, was established on Fort George Island at the mouth of the river, in about 1587. San Antonio de Enacape, a mission founded south of the present-day site of Palatka, is thought to have lasted for about 100 years, from the 1580s until the 1680s or later.

John Bartram (1699–1777), royal botanist, and his son William Bartram (1739–1823) explored the river in the 1760s, documenting many native plants and animals. William Bartram conducted further explorations in the 1770s, and in 1791 published his well-known book, *Travels of William Bartram*.

During the Second Seminole War, a number of forts were located along the St. Johns and its tributaries. These included Fort Gates, constructed in 1835 on the west bank near Fruitland; Fort Lawson, constructed in 1839 near Palatka; Fort Shannon, a fort and depot located at Palatka; Fort Florida, constructed in 1836 near DeBary; Fort Lane, constructed in 1837 on Lake Harney; and Camp Monroe, located on Lake Monroe. Camp Monroe was the scene of a Seminole raid in 1837, which resulted in the death of commanding officer Captain Charles Mellon. The fort was later renamed Fort Mellon in his honor. The town of Sanford later grew up in this area.

Several of the lakes through which the St. Johns passes were named after officers who fought in the Seminole Wars. Lake Harney was named for Colonel William Selby Harney. Lake Jesup was named for General Thomas Sidney Jesup, who captured the Seminole warrior Osceola. Lake Monroe was named for James Monroe, the fifth president. Lake Poinsett was named for Joel Robert Poinsett, the first American ambassador to Mexico. Poinsett, an amateur botanist, is responsible for introducing the poinsettia to the United States.

Kingsley Plantation, located on Fort

George Island near the mouth of the river, was established in 1791. The third owner, Zephaniah Kingsley, built the main house in the early 1800s. The plantation produced cotton, sugarcane, rice, and citrus. Several buildings are still standing and can be toured by the public.

During the Civil War, Jacksonville came under the control of the federal government in 1862 and was occupied by Union troops until the close of the war. Fortifications protecting the city included Battery Myrick, Battery Hamilton, Fort Foster, Fort Hatch, Redoubt Sammon, and Redoubt Fribley.

The famous racing yacht, *America,* was taken over by the Confederacy and positioned at Jacksonville. As the federal troops prepared to occupy the city, the Confederates took the yacht to Dunns Creek, a tributary of the St. Johns, and scuttled her. Federals found the yacht, raised her, restored her, and used her to enforce the Union blockade.

Between October 1 and 3, 1862, a conflict played out near the mouth of the St. Johns River. Confederate Brigadier General Finegan established a battery on a bluff overlooking the river to contest the passage of federal vessels. Federal infantry landed to the rear of the gun emplacements, while federal gunboats made a display along the river. Confederate troops abandoned the position at night, leaving the river under federal control for the remainder of the war. A Confederate fort, Camp Milton, was located on McGirt's Creek, just west of Jacksonville. Federal troops destroyed this post in 1864.

Fort Butler, originally built during the Second Seminole War, also played a role in the Civil War. This fort, just south of Lake George, was occupied by federal troops. However, in 1864, Confederates captured the fort and took a number of federal prisoners. William Astor established a town at this site in the 1870s. Upon his death the project was taken over by his son, John Jacob Astor IV. However, John Jacob Astor IV was killed when the RMS *Titanic* foundered in mid-Atlantic.

In 1864, Confederate cavalry captured a Union tug, *Columbine,* in the river between Palatka and Welaka. They burned and sank the vessel, thus ensuring that it would be of no use to the federals. The wreck was discovered on the bottom of the river in the 1970s.

Following the Civil War, steamboats such as the *Okahumkee, Dictator, City of Jacksonville, Starlight, Mayflower,* and *Chesapeake,* plied the waters of the St. Johns River. This riverboat traffic supported a bustling commercial, passenger, and tourist trade. Passengers who traveled through the region by steamboat included Grover Cleveland, Ulysses S. Grant, and Robert E. Lee.

Several early governors had an association with the St. Johns River. William Dunn Moseley (1795–1863), Florida's first governor following statehood, spent his latter years in Palatka, along the St. Johns. Florida's ninth governor, Harrison Reed (1813–1899), established a farm along the St. Johns after leaving politics. Florida's tenth governor, Ossian B. Hart (1821–1874) was born in Jacksonville. He was raised on a plantation along the St. Johns. Hart opposed secession during the Civil War. Elected governor in 1872, he served for just over a year before dying of pneumonia in Jacksonville. George Franklin Drew (1827–1900), Florida's twelfth governor, was a prominent Jacksonville businessman and owned lumber mills along the St. Johns. Napoleon Bonaparte Broward (1857–1910), Florida's nineteenth governor, was a steamboat pilot and tug owner on the St. Johns. John Wellborn Martin (1884–1958), Florida's twenty-fourth governor, resided in Jacksonville both before and after he served as governor.

The ring-billed gull, primarily a coastal bird, is often seen many miles inland from the mouth of the St. Johns River.

The future of the superb fishery that exists in many portions of the St. Johns depends on successive generations of juvenile fish, including the large-mouth bass (bottom) and redear sunfish (right)

The town of Palatka grew up across the river from the site of a failed English plantation, Rollestown, founded in 1767 by Denys Rolle. The town had its beginning as a trading post in 1821, and was the site of a federal fort during the Second Seminole War. It derived its name from the Creek, "Pilo-takita," meaning "ferry or boat crossing." It was incorporated in 1853. Following the Civil War, Palatka became an important steamboat stop and railroad junction. In the early 1900s, Palatka was the site of several large sawmills. Today, Palatka is a quiet riverside town and is home to Ravine Gardens State Park and the historic Brunson-Mulholland House.

The city of Jacksonville had its start in 1791 as the settlement of Cowford. In 1822 the town was renamed Jacksonville in honor of military governor Andrew Jackson. It received its charter in 1832. Following the Civil War, Jacksonville became an important tourist destination, seaport, and steamboat port. A great fire in 1901 destroyed much of the city. An errant spark from a stove set fire to Spanish moss drying at a mattress factory. The flames spread rapidly, burned to the river's edge, and forced thousands of refugees to seek shelter on the south bank of the St. Johns. By the time the fire was extinguished, more than 2,000 buildings had been destroyed and seven people had been killed.

HUMAN IMPACT Water draining into much of the upper (southern) basin has been degraded by agricultural runoff, primarily from citrus production. In addition, large portions of the headwater marshes have been drained and converted to pasture or other uses. These efforts started in 1895, with landowner W. W. Russell's attempt to drain portions of the St. Johns marsh. Nelson Fell, another early developer, built miles of canals and earthworks through the marshes. The town of Fellsmere, just west of Sebastian, was named in his honor. The St. Johns River Water Management District is working to restore large sections of

the St. Johns Marsh. Whooping cranes are being reintroduced into this area.

Water hyacinth, an exotic plant, forms huge floating mats in some areas of the river. Herbicides are used to control this plant so that it does not impede navigation. Hydrilla, another exotic introduction, has also colonized parts of the river.

Residential homes and docks are present along much of the middle and lower river. Jacksonville is a major port and the river mouth has been dredged and altered to accommodate large vessels.

Water quality in the river has been degraded as a result of stormwater runoff, excess nutrients from agricultural land, discharges from wastewater treatment plants, and the destruction of the headwater marshes. Algae blooms and fish kills occur with some frequency in the lower basin.

RECREATIONAL ACTIVITIES Water quality issues notwithstanding, the river supports a thriving recreational fishery. Trophy largemouth bass are often taken from the river and its lakes. Shad, crappie, striped bass, bream, catfish, and many other species draw anglers from around the country. The state record American shad, weighing 5.19 pounds, was taken from the St. Johns. Curiously, flounder, croaker, Atlantic stingray, tarpon, and other marine species occur in freshwater portions of the river, beyond the zone of tidal influence. Black drum, red drum, and speckled sea trout frequent brackish portions of the river. Other recreational activities include boating, water skiing, and crabbing.

FLORA AND FAUNA The river margins are lined with sand cordgrass, arrowhead, pickerelweed, sawgrass, maidencane, and needlerush. Along higher banks, stands of longleaf pine and palmetto alternate with hardwood hammocks.

The St. Johns is home to numerous freshwater snails, including the applesnail, armored siltsnail, cockscomb hydrobe, slough hydrobe, thick-shell hydrobe, purple-throated campeloma, goblin elimia, rasp elimia, squaremouth amnicola, and others. It also supports several freshwater mussel species, including the barrel floater and Florida spike.

The city of Jacksonville is perched on the north bank of the St. Johns River.

The black crappie is plentiful in the St. Johns and is a common target of recreational anglers. The key to catching crappie lies in ascertaining the depth at which they are suspended.

Juniper Creek, with the combined discharge of Juniper Springs and Fern Hammock Springs, flows into the southwest corner of Lake George.

The St. Johns at Astor is a moderate-sized river, lined with houses and docks.

Dragonflies found along the St. Johns include the regal darner, common green darner, twilight darner, taper-tailed darner, Carolina saddlebags, two-stripe forceptail, tawny sanddragon, four-spotted pennant, Amanda's pennant, Halloween pennant, banded pennant, faded pennant, eastern pondhawk, golden-winged skimmer, purple skimmer, sandhill clubtail, maidencane cruiser, and hyacinth glider.

The St. Johns River is inhabited by about 53 species of native freshwater fish. However, when anadromous species (those that migrate from salt water to fresh water), marine intruders, and exotic introductions are added in, the number of fish species in the river more than doubles. The Atlantic sturgeon, shortnose sturgeon, and Atlantic lamprey—all three of which are rare in Florida—have been found in this river system. The St. Johns is the southernmost stronghold of the American shad and hickory shad. Common minnows include the golden shiner, taillight shiner, and coastal shiner.

Turtle species inhabiting the St. Johns and its tributaries include the Florida snapping turtle, southern softshell turtle, common musk turtle, Florida mud turtle, striped mud turtle, Florida red-bellied turtle, chicken turtle, peninsula turtle, and southern diamondback terrapin. Alligators are plentiful along many portions of the river. Snakes found in association with the St. Johns include the rainbow snake, Florida banded watersnake, brown watersnake, striped crayfish snake, eastern mud snake, and water moccasin.

Bird species include great blue heron, great egret, snowy egret, limpkin, yellow-crowned night-heron, black-crowned night-heron, Florida grasshopper sparrow, peregrine falcon, Cooper's hawk, yellow rail, black rail, least bittern, purple gallinule, painted bunting, osprey, white ibis, glossy ibis, bald eagle, swallow-tailed kite, white-tailed kite, and snail kite.

St. Marys River

Type: Blackwater River
Substrate: Sand, Mud
Ecological Condition: ★★★★
Oversight: SJRWMD
Designations: CT
Length: 130 miles
Watershed: 1,390 square miles

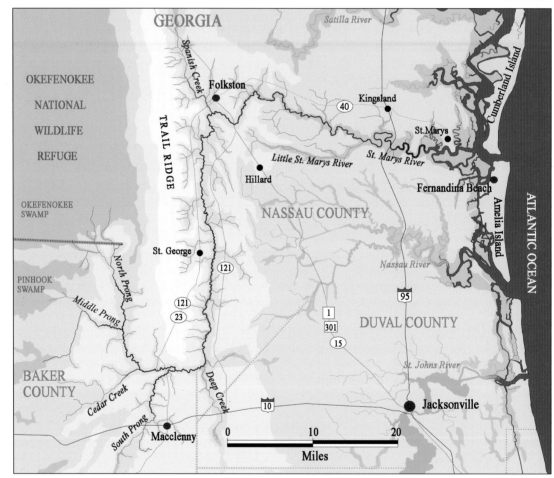

The St. Marys River comprises a substantial part of the border between Florida and Georgia. It possess an unspoiled beauty, with white sand bars, dense stands of cypress, and dark, swamp-fed water.

GEOGRAPHY AND HYDROLOGY The St. Marys River drains portions of the Okefenokee Swamp of southern Georgia, and the Pinhook Swamp of North Florida. The North Prong and the Middle Prong merge in an area about 10 miles northwest of Macclenny, Florida. Other tributaries, working eastward, include Cedar Creek, South Prong, Deep Creek, Mill Creek, Cabbage Creek and Little St. Marys River, all draining into the river from Florida. Spanish Creek flows in from Georgia, just south of Folkston. The river initially flows to the south, then to the east, then to the north, then to the southeast. The lower river emerges into a broad basin of salt marshes and mud flats. Tidal influences extend inland as much as 50 miles from the river mouth. Tides are signif-

White banks of sand can be found along many portions of the St. Marys. This blackwater stream defines the boundary between Georgia and Florida.

icant in this part of northeast Florida, and can raise or lower river levels by as much as 5 feet. The St. Marys discharges into Cumberland Sound. That water body connects with the Atlantic Ocean north of Fernandina Beach.

HISTORY The Timucua inhabited land around the St. Marys River prior to the arrival of the Europeans. Native people referred to this river as Thlathlothlaguphka or Phlaphlagaphaw, thought to mean "rotten fish." The present name was taken from that of a Spanish Mission, Santa Maria, on Amelia Island. On May 3, 1592, Jean Ribaut, French colonizer, explored the area around the mouth of the St. Marys River. A British fort, Fort Tonyn, was constructed at the confluence of the St. Marys River and Peter's Creek in 1776. The fort was located near present-day Kings Ferry. Patriot forces captured this fort in 1778. During the War of 1812, another fort, Fort Pickering is thought to have existed at this location. During the Second Seminole War, Fort Moniac, was located on the North Prong near the Georgia border. James Burnsed's Blockhouse was also located on the North Prong, near Taylor.

At least two Confederate army camps were located near the St. Marys during the Civil War. These were Camp Pinckney and Camp Jackson, both established in 1864. On February 10, 1864, federal soldiers that were part of the advance guard of a Union advance into north Florida reached the South Fork of the St. Marys River. Confederate cavalry under Major Robert Harrison ambushed these men as they approached a bridge over the river. Five Union soldiers and two Confederate soldiers were killed. Union forces captured 70 Confederate soldiers along with some horses and supplies. Ten days later the federals suffered defeat in the battle of Olustee.

The river served as an avenue for commerce during the 1800s and early 1900s. Logging was conducted on a broad scale. Cotton, rice, and indigo were farmed in the river basin. Shallow-draft steamboats plied its waters. However, these industries faded and the river gradually returned to its natural state. White Oak Plantation, located on the river, is a well-known resort made up of more than 7,400 acres. The King's Bay nuclear submarine base is located near the mouth of the river. During the spring of 2007 a massive wildfire, designated the Bugaboo Scrub Fire, consumed much of the timber around upper regions of the St. Marys River. The fire, which originated

A snowy egret snatches and swallows a fish in the estuary at the mouth of the St. Marys River.

A female merganser makes its way upstream. This duck, a winter visitor to Florida, consumes fishes and crabs.

The St. Marys cuts through the sandy highlands along the southern edge of Trail Ridge.

in Georgia, jumped the river and burned into Baker and Columbia Counties in Florida. By the time it was contained, it had scorched more than 360 square miles in Georgia and north Florida. This was the largest forest fire in Florida history.

HUMAN IMPACT Water quality in the St. Marys is very good. Most of the river basin is forested. The headwaters are within the Okefenokee National Wildlife Refuge and Wilderness Area. The Ralph E. Simmons Memorial State Forest encompasses about 7 miles of shoreline. Treated wastewater is discharged into at least two tributaries. Towns lying along the river include Baxter, Florida; Mosaic, Georgia; St. George, Georgia; and Boulogne, Florida. The city of St. Marys, Georgia, is located on a peninsula near the river mouth.

RECREATIONAL ACTIVITIES Fishing in the St. Marys ranges from good to superb. Speckled sea trout, flounder, sheepshead, and redfish enter tidal portions of the river. Stripped bass fishing on the lower river can be excellent. Bream fishing, especially for red-breasted sunfish and bluegill, is productive on many sections of river. The St. Marys is a popular stream for paddling.

FLORA AND FAUNA Trees lining the St. Marys include cypress, live oak, longleaf pine, spruce pine, water elm, black gum, magnolia, red maple, willow, azalea, and river birch. The St. Marys is home to a number of freshwater mussels, including the barrel floater, downy rainbow, elephant ear, and variable spike. Damselflies that may be found in association with this river include the blackwater bluet. purple bluet, fragile forktail, southern sprite, sparkling jewelwing, Carolina spreadwing, and swamp spreadwing. Dragonflies include the tapertail darner, phantom darner, cypress clubtail, eastern pondhawk, blue corporal, common whitetail, painted skimmer, eastern amberwing, and Carolina saddlebags. Upwards of 60 species of freshwater fishes are known to inhabit the river. The carpenter frog and many-lined salamander, both rare in Florida, are found in boggy areas associated with the headwaters of the St. Marys. The St. Marys supports a number of turtle species including the eastern painted turtle, common snapping turtle, loggerhead musk turtle, various cooters, and the rare spotted turtle. Otter and beaver frequent the upper river.

Silver River

Type: Spring Run
Substrate: Sand, Limestone
Ecological Condition: ★★★★★
Oversight: SJRWMD
Designations: OFW
Length: 4.5 miles
Watershed: Uncertain

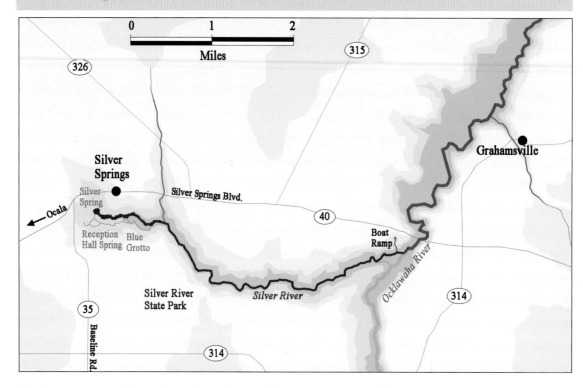

This short spring run, located 6 miles east of Ocala, offers crystal-clear water coursing through a serene setting. The spring group at the head of the Silver River pours forth an astounding 530 million gallons of water each day. It served as Florida's first tourist attraction and continues to mesmerize visitors from around the world.

GEOGRAPHY AND HYDROLOGY The spring group at the head of the Silver River consists of several vents. The main vent is located in a steep-walled pool at a depth of about 35 feet. Other significant vents, designated "Reception Hall" and "Blue Grotto," are located a short distance downstream. Silver Springs flows from west to east, meandering through cypress and hardwood swamps. After a run of about 4.5 miles, the Silver River merges with the brown waters of the Ocklawaha River.

HISTORY At the time of European contact, Timucua people inhabited the area around the river. Seminoles settled in this area in the early 1700s. Fort Duval, a federal fort, was built near the springs in 1826. Since the 1870s, the Silver River has served as a tourist attraction. In 1878, Hullam Jones built the first glass-bottom boat to operate at Silver Springs. Just above where the Silver River flows into the Ocklawaha River, are the remains of the river steamer *Metamora*, which sank at this location in 1903. Several movies were filmed at Silver Springs.

HUMAN IMPACT Most of the Silver River is in pristine condition and water quality is excellent. The state has been working with various entities to acquire property within the Silver River watershed.

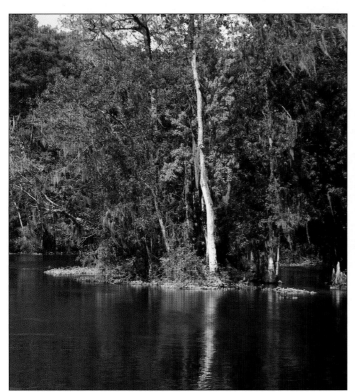

The Silver River was Florida's first major tourist attraction.

Beds of native eel grass wave in the current beneath the surface of the Silver River.

RECREATIONAL ACTIVITIES Silver Springs is a 350-acre park surrounding the springhead. It provides visitors with the opportunity to view the spring through glass-bottomed boats and offers many other attractions. The spring is surrounded by a retaining wall. Shops, restaurants, rides, and wildlife exhibits surround the spring area. The grounds are immaculate and beautifully planted.

Silver River State Park contains over 5,000 acres and protects several miles of riverfront. Visitors can hike, canoe, picnic, and camp. The Silver River Museum and Environmental Education Center, located within the park, displays ancient human artifacts, a mastodon skull, and many other exhibits. It is a joint venture between the Department of Environmental Protection, Marion County School System, and the St. Johns Water Management District.

The Silver River is an excellent stream for paddling. Canoes and kayaks can be launched at Ray Wayside Park, at the Delks Bluff Bridge over the Ocklawaha River on Highway 40. The upstream paddle, against the current, is strenuous. The return trip is easy.

FLORA AND FAUNA Stately cypress and cabbage palms line the river. Turtles found in this stream include the Florida mud turtle, striped mud turtle, common musk turtle, chicken turtle, and red-bellied turtle. The rare short-tailed snake is found in boggy areas surrounding the river. Aquatic snakes frequenting this river include the rainbow snake, redbelly watersnake, and Florida green watersnake. Birds that may be sighted along the river include anhinga, belted kingfisher, turkey vulture, osprey, and egret. Several troops of Rhesus monkeys make an odd addition to the native creatures that inhabit the area. It is thought that the operators of a sightseeing boat released these animals in the 1930s. They are aggressive and should not be approached or fed.

Spring Name	Approximate Location	Discharge (cfs)	Magnitude
Main Vent	29.216 206N-82.052631W	500+	1
Abyss/Reception Hall	29.214613N-82.051403W	-	-
Blue Grotto	29.215252N-82.049886W	-	-
Jacob's Well Spring	29.214976N-82.051823W	-	-

Tomoka River

Type: Small Coastal River
Substrate: Sand, Silt
Ecological Condition: ★★★
Oversight: SJRWMD
Designations: OFW, CT, AP
Length: 16 miles
Watershed: 110 square miles

The Tomoka River is located on the east coast of north central Florida, just west of Ormond Beach. The Florida Department of Environmental Protection has designated this tranquil waterway an Outstanding Florida Water. Its proximity to Daytona Beach makes the Tomoka River a popular destination for paddlers, bird watchers, and anglers.

GEOGRAPHY AND HYDROLOGY The Tomoka river begins in a swampy area to the southwest of Daytona Beach, just south of Interstate 4. Its waters are stained dark brown with tannins and suspended solids. The main river roughly parallels the coast, flowing in a northerly direction. The Little Tomoka River flows in from the west, about 5 miles above the mouth. As it approaches the coast, the Tomoka River turns to the northeast. It picks up two minor tributaries flowing in from the south, Thompson Creek and Strickland Creek. Broad salt marshes surround estuarine portions of the river. The Tomoka discharges into the Halifax River, which is actually a coastal lagoon. This lagoon connects with the Atlantic Ocean through the Ponce de Leon Inlet, located 22 miles south of the Tomoka Basin.

HISTORY The name of the river is derived from that of the Timucua people, who inhabited the region at the time of European contact. It has been estimated that as many as 14,000 Timucua lived in the region between St. Augustine and Cape Canaveral. The Timucua village of Nocoroco was located near the mouth of the river, at the present site of Tomoka State Park. Seminoles moved into the region in the 1700s. During the Second Seminole War, the Addison Blockhouse was built near the Tomoka River. This fortification was the scene of several skirmishes and the site has been preserved as a state park. It is located a short distance southwest of Tomoka State Park.

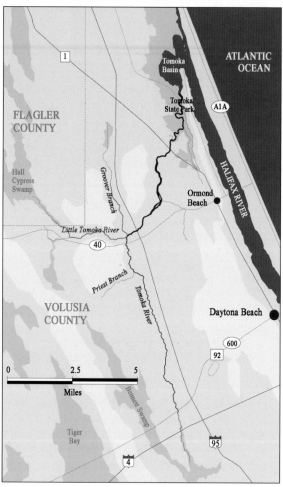

HUMAN IMPACT Most of the river flows through woodlands and is buffered from development. However, residences line portions of the river east of US 1. Areas around the river mouth fall within Tomoka State Park and the 8,000-acre Tomoka Marsh Aquatic Preserve. Eastern portions of the watershed are more heavily populated. Water quality is generally good.

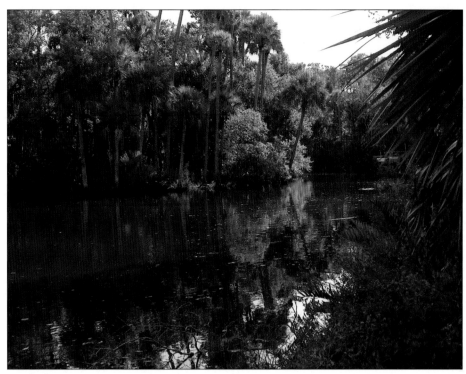

The Tomoka River is a coastal stream, similar to other small rivers along Florida's east coast. The view here is from just south of State Road 40.

RECREATIONAL ACTIVITIES The state-designated Tomoka River Canoe Trail encompasses 13 miles of river. It begins at the bridge of State Road 40 and ends at Tomoka State Park. Current in the river is slow. The state park provides camping facilities, a boat ramp, and a nature trail. While power boats ply the lower river, idle and slow-speed zones are strictly enforced, as this zone is a manatee sanctuary. Anglers pursue black drum, red drum, gray snapper, speckled sea trout, snook, jack crevalle, sheepshead, and tarpon.

FLORA AND FAUNA Impressive stands of live oak frame the river. Cabbage palms, cypress, and giant leather ferns are also found along the banks. Great concentrations of mullet can be observed milling about in brackish areas. Dragonflies such as the eastern pondhawk, seaside dragonlet, plateau dragonlet, Needham's skimmer, marl pennant, wandering glider, eastern amberwing, and the common green darner, are found in the area. Softshell turtles are plentiful. At least 160 species of birds have been recorded from this vicinity. These include the brown pelican, American oystercatcher, anhinga, double-crested cormorant, summer tanager, pied-billed grebe, eastern kestrel, common moorhen, green-winged teal, wood duck, yellow-billed cuckoo, purple martin, greater yellowlegs, and various egrets, herons, warblers, terns, gulls, and sandpipers. Manatees and bottlenose dolphins sometimes enter estuarine portions of the river. River otters are also present in this waterway.

A giant leather fern grows along the bank of the Tomoka River. This tough plant can tolerate brackish water and flooding. The roots are a favorite food of the West Indian manatee.

Wekiva River

Type: Spring Fed River
Substrate: Sand
Ecological Condition: ★★★★
Oversight: SJRWMD
Designations: WSR, FWSR, OFW, CT, AP
Length: 16 miles
Watershed: 265 square miles (Spring recharge basin uncertain)

The Wekiva River of central Florida is a tributary of the St. Johns River. The Wekiva has received both state and federal recognition as a Wild and Scenic River. It is the only river in Florida to garner this distinction.

GEOGRAPHY AND HYDRO-LOGY Wekiwa Springs, at the head of the river, pours forth 42 million gallons of crystal-clear water each day. Rock Spring also contributes its water to the Wekiva through Rock Spring Run, a major tributary that leads in from the north. Water in the river is clear and flows over a sand bottom with thick beds of eelgrass. Further east, the Little Wekiva River flows in from the south. This tributary originates at Lake Lawne, near the Central Florida Fairgrounds. Finally, just before it merges with the St. Johns, the Wekiva is joined by Blackwater Creek, which drains an extensive basin to the north of the Wekiva basin.

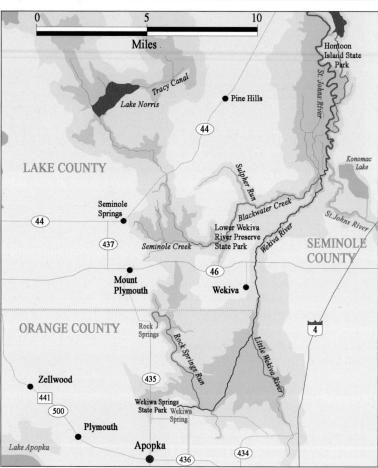

HISTORY The Creek term Wekiva means "flowing water." Wekiwa, in turn, means "spring of water." This explains the difference between the name of the spring and the name of the river. Timucua people inhabited this area at the time of the Spanish conquest. Many mounds or kitchen middens are located along the river. For many years, a unique wooden restaurant overhung the south bank of the river at Wekiva Marina in Altamonte Springs. It was destroyed by a fire in 2005. The Florida Legislature passed the Wekiva River Protection Act in 1988, recognizing the unique natural character of the waterway.

HUMAN IMPACT Water quality in the upper river is excellent. Water quality in the lower river is good. Exotic water hyacinths have encroached on some parts of the waterway. Wekiwa Springs State Park surrounds the spring and much of the river. Rock Springs Run State Preserve protects portions of Rock Springs Run. Four miles of the lower river fall within the Lower Wekiva River Preserve State Park. The Wekiva River Aquatic Preserve also protects

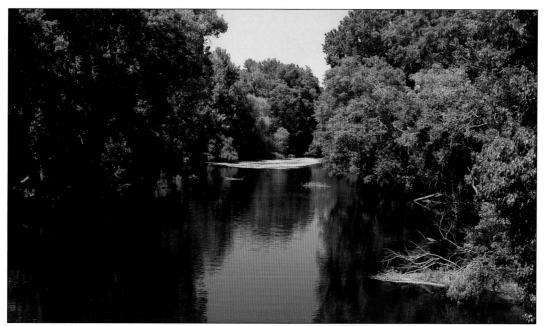

The wild and scenic Wekiva River is one of Florida's most celebrated natural treasures.

much of this waterway and adjoining portions of the St. Johns River. The Wekiva River grazes the northern fringes of Altamonte Springs and Apopka, and some homes are present along south bank. The Little Wekiva River runs through developed areas and its water quality has been negatively affected by storm water runoff and erosion. For part of its length, the Little Wekiva is contained within a culvert.

RECREATIONAL ACTIVITIES Wekiwa Springs State Park and the Lower Wekiva River Preserve State Park offer hiking, horseback riding trails, and camping. The 27-mile Wekiva River Canoe Trail begins at Kings Landing on Rock Springs Run. Largemouth bass and bream are plentiful in this river. Striped bass occasionally enter the lower river.

FLORA AND FAUNA The upper river flows beneath a dense canopy of mature live oak and cypress. Also visible along the river are tupelo, laurel oak, wax myrtle, water ash, red maple, swamp dogwood, and rare plants such as the Florida shield fern, needle palm, and water orchid. Freshwater snail species endemic to this waterway include the apple snail, Wekiwa hydrobe, and Wekiwa siltsnail. Various damselflies may be seen along this river, including the big bluet and Rambur's forktail. The rare bluenose shiner is present in this waterway. Bird species include great egret, white ibis, limpkin, tricolored heron, wood stork, and great blue heron. Despite its proximity to Orlando, the Wekiva River is home to abundant wildlife. River otter, whitetailed deer, gray fox and, occasionally, black bear occur within the river corridor.

Spring Name	Approximate Location	Discharge (cfs)	Magnitude
Wekiwa Springs	28.711886N-81.4604200W	67	2
Rock Springs	28.756445N-81.5017347W	57	2
Seminole Spring	28.845555N-81.522777W	35	2
Sanlando Spring	28.688700N-81.395296W	19	2
Starbuck Spring	28.697013N-81.391171W	14	2
Nova Spring	28.817506N-81.418514W	9	3
Miami Spring	28.710165N-81.443031W	5	3
Witherington Spring	28.731592N-81.489907W	4	3
Sulpher/Kittridge Spring	28.770181N-81.509183W	1	4
Palm Spring	28.691119N-81.392842W	1	4
Harden Spring	28.821388N-81.416870W	-	-

A commercial fishing boat docked at Tarpon Springs, near the mouth of the Anclote River.

West Central Florida

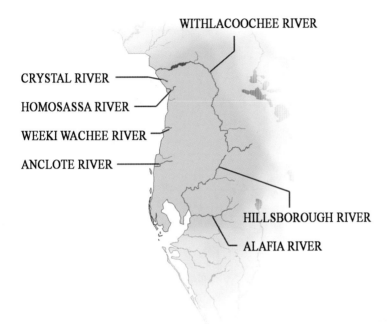

Rivers of west central Florida fall under the jurisdiction of the Southwest Florida Water Management District. These rivers flow west into the Gulf of Mexico and Tampa Bay. Springs are plentiful in the northern half of the region. This book covers three coastal spring runs, unique to this area of the state. In these habitats, saltwater fish mingle with freshwater fish and manatees seek winter refuge. Two medium coastal rivers and two small coastal rivers round out the profiles contained in this section. Most of the rivers of west central Florida have been touched by development, and some are under immense pressure.

Alafia River

Waterway Type: Small Coastal River
Substrate: Sand, Mud
Ecological Condition: ★★
Oversight: SWFWMD
Designations: CT
Length: 26 miles
Watershed: 420 square miles

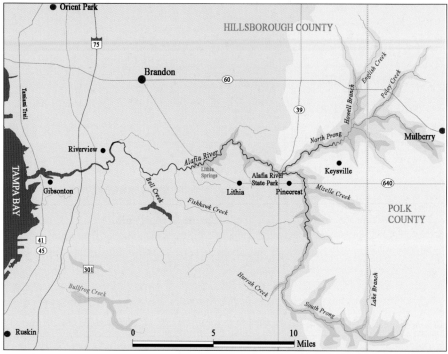

The Alafia River is the southernmost river profiled within the section of this book covering west central Florida. It is located just southeast of Tampa in Polk and Hillsborough Counties. It flows from east to west, emptying into Tampa Bay. While the Alafia is picturesque and is popular with paddlers, water quality issues plague this waterway.

GEOGRAPHY AND HYDROLOGY The Alafia originates in western Polk County. The river flows through various types of terrain, including upland hammocks and swamps. While the current is generally slow, swift water occurs in areas around shoals and ledges. During periods of high precipitation, water levels can rise quickly. The river periodically floods and has inundated nearby residences. The North Prong originates near Mulberry. It is fed by Thirtymile Creek, Poley Creek, Howell Branch, and Rice Creek. The

Alafia River South Prong originates in Hookers Prairie, just south of Bradley Junction. It is fed by several tributaries including the West Branch, Lake Branch, Hurrah Creek, Owens Branch, Halls Branch, Chito Branch, Mizelle Creek, and Boggy Branch. The two prongs join to form the main river just south of Riverview. Fishhawk Creek and Bell Creek flow into the Alafia from the south near Lithia Springs. Lithia Springs is a popular recreation area. The spring discharges into the Alafia through a short spring run. Bullfrog Creek and the Little Manatee River drain areas to the south of the Alafia River Basin. The Hillsborough River drains areas to the north.

HISTORY At various times, the region around the Alafia River came under the dominion of the Timucua and Calusa tribes. The Timucua, although typically associated with north Florida,

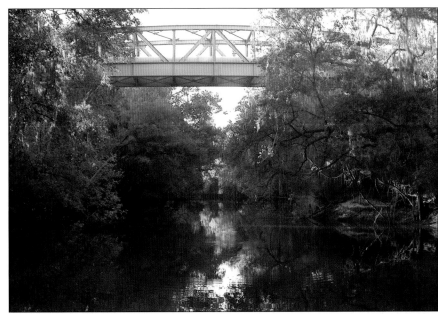

The Alafia River near Lithia Springs.

occasionally ranged as far south as the northern Tampa Bay area. The Tocobaga group of Native Americans, also known as the Safety Harbor Culture, was established along the northern rim of Tampa Bay at the time of the arrival of the Spanish. In 1539, Hernando de Soto's army crossed or passed near the headwaters of the Alafia River during its journey north along the Gulf coast. By 1760, most native populations had died out or had been removed from the area. Extensive flooding occurred in the Alafia River Basin as a result of Hurricane Donna in 1960 and Hurricane Frances in 2004.

HUMAN IMPACT The Alafia River flows past the towns of Willow Oak, Keysville, Pinecrest, Lithia, Riverview, and Gibsonton. While some of the river is in its natural state, many areas have been touched by development. Tidal portions of the river are lined with docks and boathouses and significant dredging has occurred. The location of the mouth of the river has been shifted through dredging activities. Interstate 75, US 301, and the Tamiami Trail (US 41) span the river as it approaches Tampa Bay. County Road 640 crosses the Alafia south of Brandon. Phosphate mining and agriculture have had a negative impact on water quality. In fact, this river exhibits phosphate levels that are among the highest of any waterway in the state.

RECREATIONAL ACTIVITIES A 13-mile canoe trail runs from Alderman's Ford County Park, near Lithia, to the Bell Shoals Road Bridge, near Bloomingdale. Access is also available from Lithia Springs Park. The south prong of the river runs through Alafia River State Park, with trails for hiking and biking. Tidal portions of the river are navigable by larger vessels.

FLORA AND FAUNA The banks are lined with live oak, sand pine, slash pine, cypress, buttonbush, red maple, and thickets of popash. Damselflies such as the ebony jewelwing, blue-ringed dancer, and Florida bluet may be found in association with this waterway. Turtles endemic to this river include the peninsula turtle, southern softshell turtle, Florida mud turtle, chicken turtle, and Florida red-bellied turtle. The trees often merge to form an overhead canopy. A bird sanctuary occupies two spoil islands near the mouth of the river. It may house as many as 16,000 pairs of nesting birds of various species.

The lower river opens into a broad estuary, lined with homes and traversed by powerboats.

Anclote River

Type: Small Coastal River
Ecological Condition: ★★
Oversight: SWFWMD
Designations: None
Length: 16.5 miles
Watershed: 98 square miles

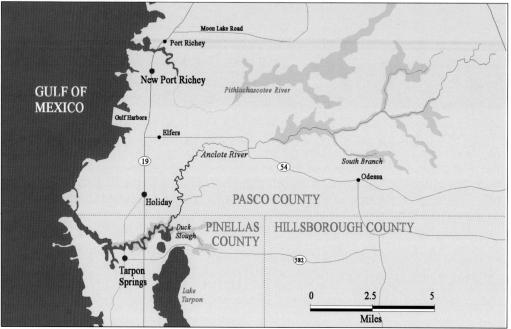

The Anclote River is located on the west coast of the peninsula, about 15 miles north of Tampa. This small coastal river flows through populated areas and is under considerable pressure from development.

GEOGRAPHY AND HYDROLOGY The Anclote originates near Land O' Lakes, in southwestern Pasco County. It drains Wilderness Park, the Southwest Florida Water Management District's Starkey Wellfield, the Anclote River Ranch, and nearby agricultural land and forests. Upper portions of the river pass through cypress swamp and marshes. The river generally flows west. However, as it nears the coast it takes a southward jog into the northwest corner of Pinellas County, before continuing to the west. Tributaries include the Sandy Branch, the South Branch, and Duck Slough. As it nears the coast, the water turns brackish and is bordered by a narrow mangrove swamp and tidal flats. The Anclote flows past the popular sponge docks and Greek restaurants of Tarpon Springs before discharging into the Gulf of Mexico at the Pasco-Pinellas border. The Anclote Keys, a 3-mile long cluster of islands, are located in the Gulf opposite the mouth of the Anclote. Tarpon Springs, located near the mouth of the river, no longer flows. It is thought that at one time, Tarpon Springs had an underground connection with Lake Tarpon, to the southeast.

HISTORY The Tocobaga people inhabited the region at the time of European contact. The Seminoles referred to the river as Est-has-hotee. However, the present name originated with the Spanish, who referred to the area as Cabo de Anclote, or "cape of the kedge anchor." The sponge industry of Tarpon Springs started in the 1880s, with an agreement between local businessman John Cheyney and sponge merchant

While sections of the river appear unspoiled, development is rapidly encroaching on the Anclote watershed.

John Cocoris. Cocoris recruited Greek sponge divers to work offshore sites. These divers and their families settled around Tarpon Springs, near the mouth of the river. Their culture and cuisine lives on in the region. Pasco County, through which the river flows, was created in 1887. The river experienced flooding during Hurricane Donna in 1960 and Hurricane Frances in 2004.

HUMAN IMPACT The lower Anclote flows through considerable development, and several industrial sites are located in close proximity to the river. The communities of Holiday and Tarpons Springs are located along the river. The population of the area has increased dramatically over the past several decades, and subdivisions have spread eastward. A golf course community already exists on the river and additional construction is planned. Riparian buffer zones are relatively narrow.

RECREATIONAL ACTIVITIES While the Anclote is not a state-designated canoe trail, lower portions are accessible by canoe or powerboat from the Anclote River Park in Holiday. Boat traffic in the area can be heavy, especially on weekends. The Pithlachoscotee River, which parallels the Anclote a few miles to the north, contains a state-designated canoe trail. Fishing in the lower Anclote River can be productive. Snook, spotted seatrout, and redfish are frequently taken, along with the occasional shark or tarpon.

FLORA AND FAUNA Red maple, live oak, red myrtle, coastal plain willow, and buttonbush grow along the banks. Various damselflies, such as the citrine forktail, Rambur's forktail, and purple bluet, are associated with freshwater reaches of this waterway. Birds that may be observed along the river include wood stork, marsh wren, catbird, kingfisher, yellow-throated warbler, palm warbler, white ibis, and various herons. Dolphins and manatees sometimes enter lower portions of the river.

As it approaches the Gulf of Mexico, the Anclote River broadens and makes several loops through surrounding marshes.

Crystal River

Waterway Type: Coastal Spring Run
Substrate: Sand, Limestone
Ecological Condition: ★★★
Oversight: SWFWMD
Designations: OFW
Length: 7 miles
Watershed: Uncertain

This spring run, located about 60 miles north of Tampa, supports a unique ecosystem. Water temperature is a constant 72 degrees throughout the year. Crystal River is popular with divers, snorkelers, boaters, and anglers, and is an important sanctuary for manatees during cooler months. The springs discharge about 600 million gallons of ultra-clear water on a daily basis.

GEOGRAPHY AND HYDROLOGY Crystal River is located in Citrus County. The headwaters are composed of a group of about 30 springs, distributed in and

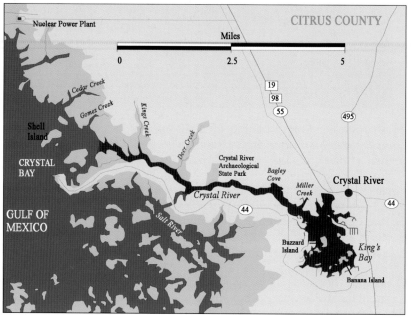

around a half-mile-wide body of water named King's Bay. Crystal River is one of the largest spring groups in Florida. The spring run is about 7 miles long and discharges directly into the Gulf of Mexico. Water clarity is generally excellent.

HISTORY The Crystal River State Archaeological Site is located north of Crystal River and the town of Crystal River. It consists of 6 mounds constructed by pre-Columbian mound builders. This area served as a burial ground and important trading center for Native Americans. The site is thought to have been in use for more than 1,500 years, beginning about 200 B.C. During the Civil War, the converted ferry USS *Fort Henry* patrolled this area of the Gulf coast. In June, 1863, an expedition from the *Fort Henry* surprised and routed a small group of Confederates manning a fortification on the Crystal River. Citrus County was created in 1887. The city of

Crystal River was incorporated in 1903. The Crystal River old city hall, built in 1933, is a historic structure that houses the Museum of Citrus County History.

HUMAN IMPACT The area surrounding Crystal River is heavily developed. The city of Crystal River is centered on the north side of the waterway. Recent rises in nitrate levels may be caused by the seepage of fertilizers into the aquifer. Nevertheless, water quality is generally excellent. The Crystal River Nuclear Power Plant and Energy Complex is located in a remote area a few miles north of the river.

RECREATIONAL ACTIVITIES Swimming, snorkeling, scuba diving, canoeing, and fishing are popular activities in Crystal River and adjacent waters. Those who enter the water should be aware that virtually any form of interaction with the manatees constitutes harassment and is there-

Kings Bay, at the head of the Crystal River, is an important recreational hub.

The snook is a frequent visitor to the headwaters of the Crystal River. Tarpon and other saltwater fishes are also present.

fore prohibited by law. While boating is permitted, strict speed restrictions apply.

FLORA AND FAUNA The Crystal River National Wildlife Refuge consists of several islands and portions of the King's Bay basin. A curious mix of saltwater and freshwater fish species coexist within the river, including bluegill, redear sunfish, largemouth bass, Atlantic needlefish, gray snapper, tarpon, morreja, pinfish, sheepshead, mullet, and various killifish. The amphiuma, an elongated aquatic salamander, is also present in the river. The crystal siltsnail, a freshwater snail, is endemic to this waterway. The southern softshell turtle and Florida diamondback terrapin are among the species of turtles that inhabit the Crystal River. The best time to observe the manatees is December through March.

Spring Name	Approximate Location	Discharge (cfs)	Magnitude
King (Tarpon) Spring	28.881769N-82.595049W	<100	1
Idiot's Delight	28.887950N-82.589473W	-	1
Three Sisters Spring	28.888727N-82.589190W	-	2
Hunter Spring	28.894430N-82.592482W	-	2
Little Hidden Spring	28.885781N-82.594062W	-	3
Miller's Creek Spring	28.901100N-82.603800W	-	-
Catfish Spring	28.898000N-82.599080W	-	-

Hillsborough River

Waterway Type: Coastal River
Substrate: Sand, Silt, Limestone Rubble
Ecological Condition: ★★★
Oversight: SWFWMD
Designations: OFW, CT
Length: 54 miles
Watershed: 740 square miles

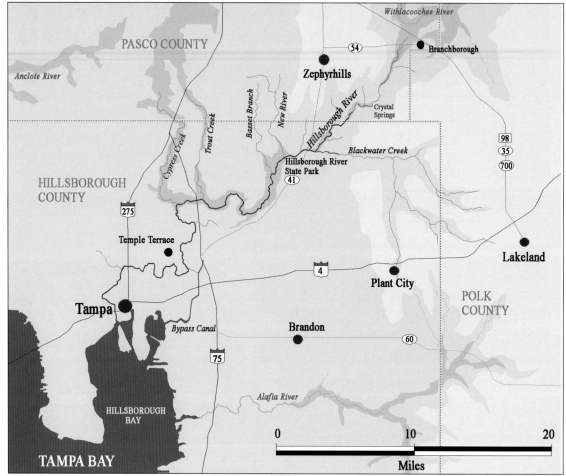

The Hillsborough River is a compilation of two very different waterways. The lower river is an urbanized stream that flows through downtown Tampa between concrete seawalls. The upper river is pristine and wild. The Hillsborough is the only river in peninsular Florida that flows over significant rapids.

GEOGRAPHY AND HYDROLOGY The Hillsborough River flows southwest, through Pasco and Hillsborough Counties. Tributaries also drain portions of Polk County. Like the Withlacoochee River, which flows north, the Hillsborough River has its origins in the Green Swamp. It begins as a broad sheet flow, fed in part by overflow from the Withlacoochee River. Crystal Springs contributes a considerable volume of crystal-clear water to the river. It is located about 9 miles downstream from the river's headwaters. Five major tributaries—Blackwater

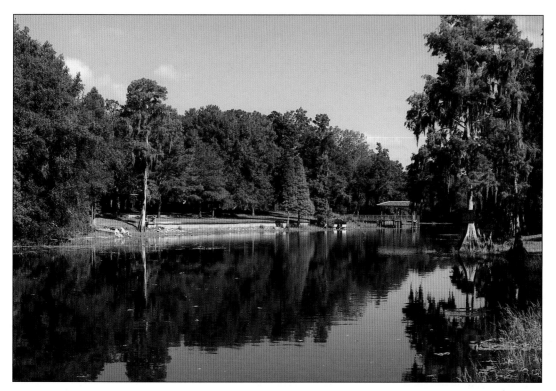

The Hillsborough River, just west of Interstate 75. This waterway weaves through Temple Terrace and Tampa.

Creek, Flint Creek, New River, Trout Creek, and Cypress Creek—add their waters to those of the main river. Blackwater Creek, which flows in from the southwest, originates near Lakeland. Cypress Creek, which flows in from the north, has its origins in the Big Cypress Swamp of southern Pasco County. The Hillsborough River Reservoir is located just south of Temple Terrace. Below the dam, the Hillsborough River turns brackish and is subject to tidal influence. The river passes through downtown Tampa in a concrete-walled channel before emptying into Tampa Bay.

HISTORY Timucua and Calusa people inhabited the land around the river at various times prior to the arrival of the Spanish. The Tocobaga group of Native Americans, also known as the Safety Harbor Culture, was established along the northern rim of Tampa Bay at the time of European contact.

The Seminoles called the river "Lockcha-Popka-Chiska," roughly translated as "the river one crosses to eat acorns." Pánfilo de Narváez was probably the first European to see the river, during his expedition of 1528, which began in the Charlotte Harbor or Tampa Bay region, and ended with starvation, illness, and ruin in the region of present-day St. Marks. In 1539, Hernando de Soto's army crossed the river at the present site of Hillsborough River State Park.

The British gave the river its current name, after the Earl of Hillsborough (1718–1793), who served as colonial secretary of state. Fort Foster, a reconstructed fort from the Second Seminole War, is located within Hillsborough River State Park. The original fort was built in 1836 to protect a crossing over the river.

Hillsborough County, through which the river flows, was created in 1834. Tampa is a Calusa term of uncertain meaning. The city of Tampa had its beginnings as Fort Brooke, a military outpost established in 1823. The city was incorporated in 1849. During the Civil War, the Confederates occupied Tampa until 1864, when it was seized by federal troops.

HUMAN IMPACT The upper Hillsborough River is undeveloped. The Green Swamp has been the subject of various protection initiatives. The Southwest Florida Water Management District owns large tracts. The river runs just south of Zephyrhills, but little development

Gars, which are present in nearly every river covered in this book, are numerous in slow-moving sections of the Hillsborough River.

Anglers fishing this waterway regularly take sizeable warmouth. Preferred baits are wigglers and crickets.

has occurred along the banks in this area. Hillsborough River State Park surrounds several miles of the river. The Hillsborough passes under US 301, Morris Bridge Road, I-75, and various bridges in the north Tampa suburb of Temple Terrace. As the river enters populated areas, it intersects the Tampa Bypass Canal. During periods of high rainfall, this 14-mile-long waterway redirects excess water from the Hillsborough River to prevent flooding of low-lying streets, homes, and businesses. In 1948, following the destruction of several earlier dams, the river was impounded by the Water Works Dam to create the Hillsborough River Reservoir. This 1,300-acre lake, just north of Tampa, is a major water source for the city. The river below the dam has been contaminated to some degree by urban street runoff.

RECREATIONAL ACTIVITIES A state-designated canoe trail begins at Crystal Springs in Pasco County. It can be accessed from the 3,950-acre Hillsborough River State Park, off of US 301. In addition to canoe rentals, the park offers swimming, fishing, camping, and hiking. The canoe trail encompasses 34.5 miles of river. It ends at Rowlett Park in Tampa. The upper river can be a challenging paddle due to rapids, numerous subchannels, and fallen timber that may require portages. The lower river flows at a more leisurely pace and is navigable by motor boats. The river affords anglers a chance to pursue bass, chain pickerel, and bream.

FLORA AND FAUNA Cypress, red maple, hazel alder, and laurel oak grow along the banks.

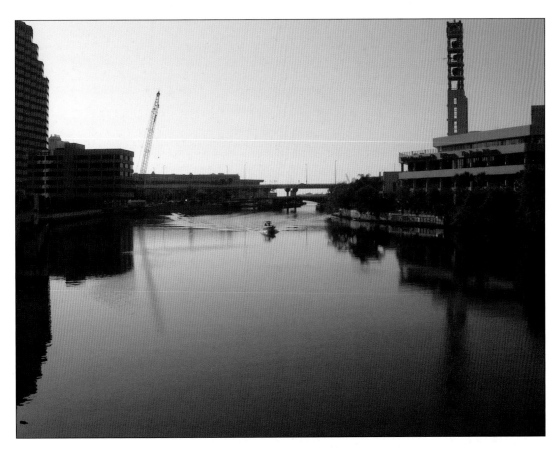

The lower Hillsborough River is the centerpiece of downtown Tampa.

Apple snails are plentiful in this waterway, and they lay their eggs just above the water line on cypress knees and fallen timber. The hyacinth siltsnail, another freshwater snail, also is endemic to these waters. Damselflies that may be observed along this river include the ebony jewelwing, variable dancer, citrine forktail, and Rambur's forktail. The Hillsborough River is home to about 40 native freshwater fish, as well as a scattering of marine species and exotic invaders. Turtles are numerous in this river. Species include the chicken turtle, Florida red-bellied turtle, Florida snapping turtle, southern softshell turtle, and the Florida mud turtle. Water moccasins and nonvenomous water snakes can be observed along the bank. Birds that may be observed include the anhinga, limpkin, belted kingfisher, pileated woodpecker, prothonotary warbler, blue-gray gnatcatcher, osprey, turkey vulture, and various herons. Other wildlife includes deer, wild hogs, raccoons, and alligators.

Homosassa River

Waterway Type: Spring Fed Coastal River
Substrate: Sand, Silt, Limestone
Ecological Condition: ★★★
Oversight: SWFWMD
Designations: OFW
Length: 8 miles
Watershed: Uncertain

The clear waters of the Homosassa River flow through a coastal area of Citrus County before emptying into the Gulf of Mexico. The area around the river has experienced significant development. The river itself receives heavy traffic from recreational boats. Nevertheless, it has been designated an Outstanding Florida Water.

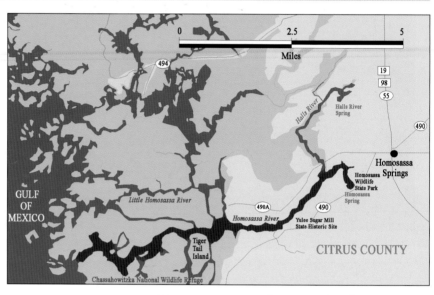

GEOGRAPHY AND HYDROLOGY The second-magnitude spring at the head of the river is 45 feet deep and produces 50 million gallons of water each day. Various other springs contribute their flow to the Homosassa River. A major tributary, Halls River, flows in from the north. The Homosassa River winds to the west, through a narrow and irregular channel. It passes through "Hells Gate," a navigational bottleneck, before discharging into the Gulf of Mexico. Various passes and backwaters around the mouth of the river create a maze of low-lying islands.

HISTORY Pre-Columbian mound builders first inhabited this region. Artifacts such as canoes, cooking utensils, and other items have been unearthed through archaeological digs. A sugar mill and plantation were established near the river in the 1840s. A small state park preserves the ruins of the mill and its machinery. The owner, David Levy Yulee (1810–1886), was an early railroad baron and United States Senator. In 1904, famous American artist Winslow Homer created a series of watercolors showing the Homossasa River. The spring has been a tourist attraction since in the early 1900s. In 1964, a floating underwater observatory was positioned over the spring headwaters. In 1984, land making up the present-day state park was purchased by Citrus County. It was purchased by the state in 1989.

HUMAN IMPACT The Homosassa Springs Wildlife State Park surrounds the headwaters. Away from the park, many areas are lined with homes, seawalls, and docks. The town of Homosassa Springs has grown up around the river. The clarity of the water fades with greater distance from the headwaters. Some dredging has occurred, including dredging aimed at removing silt that has accumulated on the river bottom. Efforts have been made to replant mangroves along some areas of the shoreline.

RECREATIONAL ACTIVITIES Boat traffic on the river is often heavy. Boats are not permitted to enter the state park. The state park offers displays

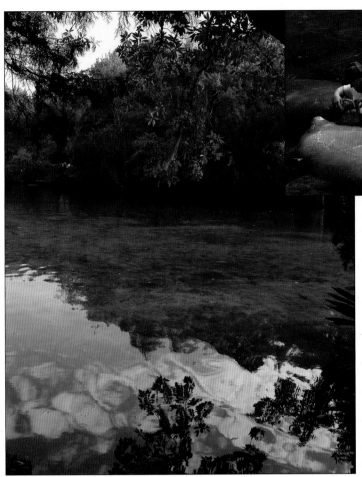

At Homosassa Springs Wildlife State Park, sick and injured manatees are rehabilitated and returned to the wild.

The Homosassa River supports an impressive mix of freshwater and saltwater fishes.

of native animals such as black bear, river otter, whitetailed deer, panther, and bobcat. Perhaps the main attraction is the underwater observatory. Here, the visitor can observe an odd mix of freshwater and saltwater fish. While fishing is not permitted in the state park, fishing throughout the lower river and among the flats and oyster bars surrounding the river mouth is excellent. Large tarpon are plentiful, along with sheepshead, redfish, and mangrove snapper.

FLORA AND FAUNA About 34 species of fish are found in the Homosassa River, including remora, largemouth bass, gray snapper, bluegill, sheepshead, redear sunfish, mullet, gar, tarpon, snook, and many others. Turtles found in this waterway include the Florida diamondback terrapin, southern softshell turtle, Florida mud turtle, common musk turtle, chicken turtle, and Florida red-bellied turtle. Homosassa Springs is an important gathering place for manatees seeking shelter from winter cold.

Spring Name	Approximate Location	Discharge (cfs)	Magnitude
Homossassa	28.799350N-82.588550W	106	1
Pumphouse Spring	28.796524N-82.588370W	-	2
Trotter Spring/Echo	28.796527N-82.586400W	69	2
Alligator Spring	28.800450N-82.587976W	-	-
Banana Spring	28.801010N-82.588177W	-	-
Belcher Spring	28.796747N-82.586286W	-	-
Blue Hole Spring	28.798787N-82.589538W	-	-
Halls River Spring	28.826777N-82.580485W	-	-

Weeki Wachee River

Type: Coastal Spring Run
Substrate: Sand, Limestone
Ecological Condition: ★★★
Oversight: SWFWMD
Designations: OFW
Length: 8 miles
Watershed: Uncertain

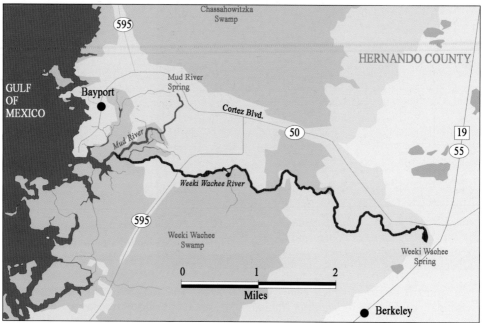

The Weeki Wachee River is a short spring run on the north-central Gulf coast. The spring at the head of the river is a historic roadside tourist attraction. The Florida Department of Environ-mental Protection has classified this attractive waterway as an Outstanding Florida Water.

GEOGRAPHY AND HYDROLOGY The headwaters of the Weeki Wachee River emanate from a very deep vent just a few hundred feet west of US 19. The crevice extends more than 100 feet beneath the water surface and discharges about 170 million gallons of water each day. The impressive limestone pool surrounding the vent brims with crystal-clear water that flows to the northwest through a narrow cut. The river winds to the west, through the Weeki Wachee Swamp. About 8 miles below the headwaters, Mud River flows in from the north. The Weeki Wachee River discharges into the Gulf of Mexico, just south of Bayport.

HISTORY The name Weeki Wachee is derived from the Seminole phrase *Weiwa chee*, meaning "little spring." The town of Bayport, at the river mouth, was an important port in the mid-1800s. During the Civil War, federal vessels captured several blockade runners operating within the area.

The park surrounding the springs was started in 1947. The founder, Newton Perry, trained navy divers during World War II. He built an underwater theater into the western bank of the spring basin, installed a system of underwater air hoses, and recruited local "mermaids" to entertain visitors. The mermaids performed underwater plays, synchronized routines, and acrobatics. In the 1960s, the park expanded and became a popular destination for those traveling along Florida's Gulf coast. Competition for positions as mermaids was fierce and those girls who made the cut were treated as celebrities. The tiny city of

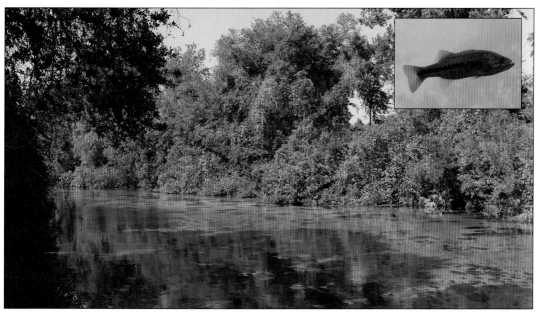

The spring run at Weeki Wachee is impressively clear. Inset: A largemouth bass hovers over the spring vent at Weeki Wachee Spring.

Weeki Wachee was established in 1966.

With the advent of the Orlando-area theme parks, competition for tourist dollars grew. Motorists opted to travel on major interstates, bypassing US 19. Tastes in entertainment changed. Consequently, attendance at the park dwindled. By the 1990s, many aspects of the park appeared dated and some of the buildings had fallen into disrepair. In 2001, the state purchased the land around the spring. Disputes quickly developed between Southwest Florida Water Management District and the company that leased and operated the park. In 2003, the owners donated the attraction to the city of Weeki Wachee for tax credit. Legal wrangling continues over the lease agreement. The future of Weeki Wachee as a classic roadside attraction is in doubt.

HUMAN IMPACT An underwater theater has been built along the western wall of the spring basin. A road encroaches on the north shore of the upper river. Shoal Line Boulevard crosses the river near its mouth. Considerable development has taken place around the mouth of the river. Marinas and residences now line some of the waterfront.

RECREATIONAL ACTIVITIES The park surrounding the spring basin offers several activities including the famous mermaid show and a river boat cruise. The river makes for a pleasant kayak or canoe trip.

FLORA AND FAUNA From the underwater theater, visitors can view largemouth bass and bream hovering over the spring vent. Turtles found in the Weeki Wachee River include the Florida red-bellied turtle and chicken turtle. Various wading birds, such as great blue heron, little blue heron, yellow-crowned night-heron, black-crowned night-heron, green-backed heron, snowy egret, and great egret may be observed along this waterway.

Spring Name	Approximate Location	Discharge (cfs)	Magnitude
Weeki Wachee Spring	28.517120N-82.573261W	113	1
Mud Spring	28.546383N-82.624897W	98	2
Little/Twin Dees Spring	28.513668N-82.580716W	-	2
Salt Spring	26.546250N-82.619043W	-	2

Withlacoochee River

Type: Coastal River
Substrate: Clay, Sand
Ecological Condition: ★★★
Oversight: SWFWMD
Designations: OFW, CT
Length: 157 miles
Watershed: 2,100 square miles

The Withlacoochee River of west-central Florida, along with the St. Johns, is one of very few rivers in the United States that flow north. This river should not be confused with the Withlacoochee of north Florida, described earlier.

GEOGRAPHY AND HYDROLOGY The Withlacoochee River, along with the Hillsborough River, begins in the Green Swamp along the boundary between Polk and Lake Counties. The headwaters flow from east to west, before turning north. The river receives much of its initial flow from runoff and seepage. Gator Creek, flowing in from the south, increases the volume of the upper river. During periods of high precipitation, the upper Withlacoochee overflows across a broad lip into the headwaters of the Hillsborough River. On its journey northward, the

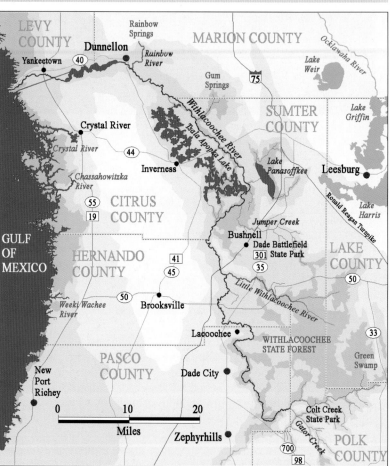

Withlacoochee flows through Lake, Sumter, Pasco, Hernando, Citrus, Marion, and Levy Counties. Tributaries include Gator Creek, Little Withlacoochee River, Jumper Creek, Gum Creek, and the Rainbow River. About 25 springs contribute to the flow of the Withlacoochee. The largest of these is the Rainbow Spring Group in Marion County. The river also receives input from the outlets of Lake Panasoffkee and the Tsala-Apopka lake complex. The lower (northern) Withlacoochee veers to the west. A 7-mile section is impounded behind

Inglis Dam to form Lake Rousseau. Eleven miles below the dam the Withalcoochee flows into the Gulf of Mexico, near Yankeetown.

HISTORY The Ocale people inhabited the area around the lower (northern) Withlacoochee at the time of European contact. Timucuan villages may also have existed along the river. In 1539, Hernando de Soto crossed the Withlacoochee River during his journey north along the Gulf coast. This crossing is thought to have occurred near the present-day town of Dunnellon. The

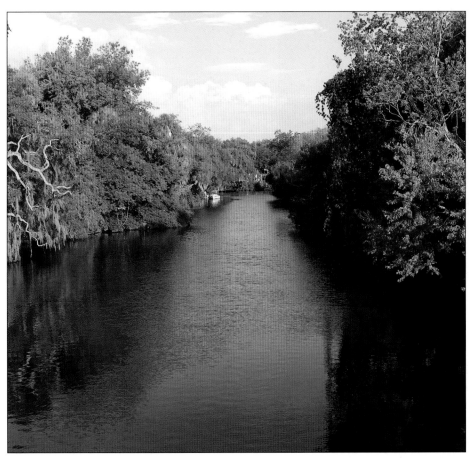

The Withlacoochee passes through diverse habitats and supports a rich ecosystem.

Spanish referred to the Withlacoochee as the River of Discord. The Native American term Withlacoochee means "crooked river."

The Battle of Camp Izard, which took place along the Withlacoochee, was one of the most intense engagements of the Second Seminole War. On February 28, 1836, about 1,000 Seminoles attacked a comparable force of federal troops as the federals attempted to cross the river. Federal troops were trapped behind makeshift fortifications for several days and were eventually forced to retreat from the region. Five federal soldiers were killed and 46 wounded. The Seminoles lost 33 warriors.

Other military outposts located along the river during the Second Seminole War included Camp Graham, built in 1836; Fort Lindsay, built in 1836; Fort McLemore, built in 1836; and Fort McClure, built in 1839. Fort Dade, built in 1837, was erected on the west side of the river near Lacoochee. On March 6, 1837, 5 Seminole chiefs surrendered at this location. Seminoles burned the fort in 1938.

HUMAN IMPACT Water quality in the upper (southern) river is very good. However, water quality tends to decline as the river absorbs various tributaries and outflows from adjacent lakes. Large tracts of land surrounding the river are owned by the state, including the massive Withlacoochee State Forest. However, some sections of the river are lined with private residences. The towns of Lacoochee, Rerdell, Nobleton, Dunnellon, Inglis, Crackertown, and Yankeetown are located on or near the river. Invasive waterweeds, especially hydrilla and water hyacinth, have become a serious nuisance in some parts of the watershed.

RECREATIONAL ACTIVITIES The state-designated Withlacoochee River Canoe Trail encompasses 83 miles of river. It begins at the Coulter Hammock Recreation Area near Lacoochee and ends at the bridge of US 41, at Dunnellon Wayside Park. Numerous access and take-out points are located along this route. Fishing can be outstanding. The Withlacoochee yields its share of trophy largemouth bass, especially from the area around Lake Rousseau. Panfish are abundant in all sections of the river. The Florida and world-record white catfish, which weighed 18.88 pounds, was caught in the

An osprey wheels overhead. This fish-eating raptor is found throughout Florida.

The double-crested cormorant is a year-round resident. It is most common along open areas of the river.

Withlacoochee. The Florida record yellow bullhead, which weighed 2.75 pounds, was caught in the Little Withlacoochee River. The Florida record longnose gar, which weighed 41 pounds, was caught in Lake Panasoffkee, which connects to the Withlacoochee.

FLORA AND FAUNA The river flows through a mix of cypress swamps, oak-dominated hammocks, sand pine communities, and other types of habitat. The Florida apple snail is abundant. Other freshwater snail species include the smooth-ribbed hydrobe, conical siltsnail, and hyacinth siltsnail. The rare and magnificent purple skimmer, a dragonfly, can sometimes be observed around slow-water

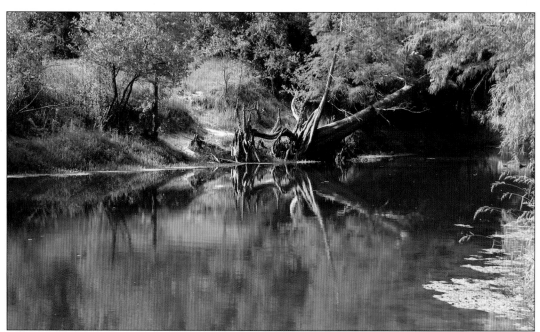

The middle Withlacoochee is a placid stream, sometimes flowing between high sand banks, sometimes flowing through cypress swamps.

The Withlacoochee is one of only a handful of rivers within the United States that flows from south to north.

Spring Name	Approximate Location	Discharge (cfs)	Magnitude
Rainbow Springs Group	29.102475N-82.437465W	447	1
Indian Creek Springs	29.093220N-82.421066W	-	2
Gum Springs Group	28.958722N-82.231526W	-	2
Citrus Blue Spring	28.969333N-82.314540W	-	-
Wilson Head Spring	28.979762N-82.321466W	-	-
Bubbling Spring	29.101238N-82.434848W	-	-
Norman Spring	28.839444N-82.202778W	-	-
Belton's Millpond	28.758242N-82.062586W	-	-
Sumter Blue	28.785822N-82.045592W	-	-
Shady Brook	28.779711N-82.043417W	-	-

portions of the river. About 43 species of freshwater fish are native to the Withlacoochee. Like many Florida rivers, the Withlacoochee is home to an abundant population of alligators and turtles. Turtle species include the Florida snapping turtle, common musk turtle, Florida mud turtle, southern softshell turtle, and various cooters. Birds such as the black-crowned night-heron, turkey, white ibis, wood stork, and anhinga may be observed. Whitetailed deer, raccoon, and otter are common along some portions of the river corridor.

From a distance, the roseate spoonbill qualifies as one of the most beautiful birds native to south Florida. However, when viewed through a telephoto lens, the head and beak present a bizarre image.

Southwest Florida

LITTLE MANATEE RIVER

MANATEE RIVER

PEACE RIVER

FISHEATING CREEK

BRADEN RIVER

MYAKKA RIVER

HORSE CREEK

CALOOSAHATCHEE RIVER

ESTERO RIVER

The Southwest Florida Water Management District has jurisdiction over most rivers covered within this section. However, the Caloosahatchee River, the Estero River, and Fisheating Creek come within the province of the South Florida Water Management District. The rivers of this region are low-gradient streams, although a few have their origins in upland areas. Several rare semitropical birds can be observed in connection with the waterways of this region. Several rivers of southwest Florida are extremely rich in deposits of fossils, ancient shells, and shark teeth. Several are also rich in phosphate and have been degraded as a result of phosphate mining. While some of the rivers flow through state parks and protected tracts, the burgeoning population of southwest Florida is encroaching on many watersheds.

Braden River

Waterway Type: Small Coastal River
Substrate: Mud, Sand
Ecological Condition: ★★★
Oversight: SWFWMD
Designations: None
Length: 21 miles
Watershed: 83 square miles

The Braden River of the south-central Gulf coast is the largest tributary of the Manatee River. It runs in a northwesterly direction, passing through coastal areas that have undergone considerable development.

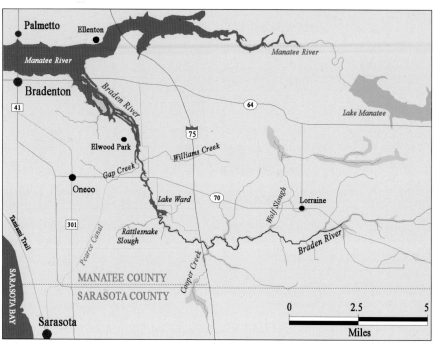

GEOGRAPHY AND HYDROLOGY The Braden River begins in swampy portions of southern Manatee County and northern Sarasota County. Several unnamed tributaries along with Wolf Creek, Hickory Hammock Creek, Rattlesnake Slough, and Nonsense Creek contribute to the flow. Cooper Creek, a major tributary, has its origins in Long Swamp, east of I-75. The upper Braden River is a picturesque stream, tracking from east to west for approximately 9 miles though lowland topography. The middle and lower portions of the river flow in a more northerly direction. Ward Lake, an impoundment, is located upstream from where State Road 70 crosses the river. Below the lake, the Braden River is subject to tidal influence. Williams Creek, Gap Creek, and Glenn Creek empty into the lower river. The Braden River merges with the Manatee River about 6.5 miles inland from the discharge of the Manatee River into Tampa Bay.

HISTORY The Calusa Indians inhabited the area surrounding the Braden River prior to the arrival of European settlers. Sugar plantations were located around the mouth of the river prior to the Civil War. Manatee County was established in 1855. Bradenton, the largest city and county seat, is located adjacent to the river mouth. Originally known as Manatee, the city was renamed Bradenton in honor of Dr. Joseph Braden, an early settler and sugarcane planter. The river sometimes floods nearby lowlands during periods of heavy rainfall. A tropical storm in 1992 caused significant flooding throughout the drainage basin.

HUMAN IMPACT Among the key human alterations to the Braden is a weir, or low dam, constructed in 1936. This structure, which holds back Lake Ward, is located about 5.5 miles upstream from the junction of the Braden and Manatee. The water below the weir is brackish. The water above the weir is fresh. Several sections of the river are lined with houses and boat docks. Portions of the City of Bradenton intersect

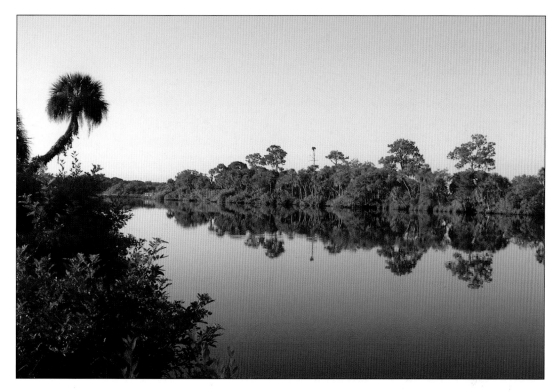

On a still morning, the glasslike surface of the Braden River forms a near-perfect reflection.

lower parts of the river. State Road 64 crosses the Braden a few hundred feet south of the confluence between the Braden and Manatee Rivers.

RECREATIONAL ACTIVITIES The lower river is navigable. Nearly the entire river is open to canoeing and kayaking, with several access points. The lower river can be confusing to paddlers, as portions are laced with a web of mangrove islands and blind alleys.

FLORA AND FAUNA Lower reaches of the river run through sawgrass marshes and thick mangrove swamps. Manatees often enter the lower river. The upper river is inhabited by various species of turtle including the Florida snapping turtle, chicken turtle, peninsula turtle, Florida red-bellied turtle, southern softshell turtle, and Florida mud turtle. The Florida bluet, purple bluet, duckweed firetail, furtive forktail, and Rambur's forktail comprise some of the damselflies found in the vicinity. Common birds include ibis, wood duck, ruddy duck, mottled duck, ring-necked duck, anhinga, great blue heron, little blue heron, great egret, and snowy egret.

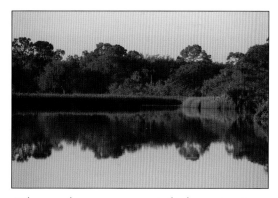

Where no homes are present, the lower river is bordered by salt marshes and mangrove swamps.

The ruddy duck is an occasional visitor to the waters of the Braden River.

Caloosahatchee River

Waterway Type: Medium Coastal River
Substrate: Mud and Gravel
Ecological Condition: ★★
Oversight: SFWMD
Designations: None
Length: 76 miles
Watershed: 1,380 square miles

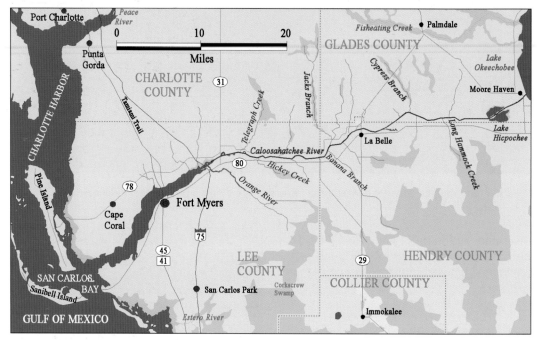

The Caloosahatchee River drains a large section of southwest Florida. Dredging, dams, and development have significantly altered this river. Like the St. Lucie River to the east, it has been negatively affected by freshwater discharges from Lake Okeechobee. It is part of the inland waterway and connects to the east coast through canals and Lake Okeechobee.

GEOGRAPHY AND HYDROLOGY Before human modification, the Caloosahatchee was a shallow river meandering through a broad flood plain and coastal wetlands. It originated in sawgrass meadows just west of Lake Okeechobee. From there, it flowed through Lake Flirt, over a low waterfall at the west end of the lake, and then through a series of broad loops. The Twelve Mile Slough, Okaloacoochee Slough, and other wetlands supplied surface water to eastern portions of the Caloosahatchee. The connection to Lake

Okeechobee was tenuous.

As the result of an artificial canal connecting river and lake, the Caloosahatchee now receives a substantial percentage of its flow directly from Lake Okeechobee. Its course takes it through parts of Glades, Hendry, and Lee Counties. Tributaries include Pollywog Creek, Jacks Branch, Hickey's Creek, and Telegraph Creek, which drains the Telegraph Swamp to the north. The river broadens considerably in its lower reaches and is subject to tidal influence. A major tributary, the Orange River, flows in from the southeast, just east of Fort Myers. This slow-moving river originates near the border of Lee and Hendry Counties. Just west of Fort Myers, at Shell Point, the Caloosahatchee empties into San Carlos Bay.

HISTORY The river was named for the Calusa Tribe, which inhabited the region at the time of

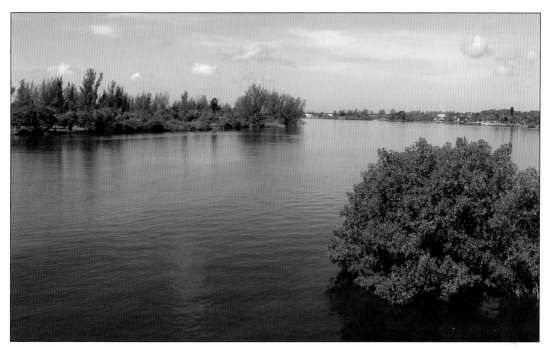

The Caloosahatchee River looking west from the bridge of State Road 31.

the arrival of the Spanish. Caloosahatchee means "river of the Calusa." Seminoles, displaced from their homelands in Alabama and Georgia, settled in this area in the 1700s. During the Second Seminole War, several forts were established along this waterway including Forts Denaud (1837), Simmons (1841), and T. B. Adams (1838). In 1839, about 150 warriors attacked a federal outpost on the Caloosahatchee River. Most of the soldiers guarding the outpost were killed. However, the commander, Colonel William S. Harney, and several soldiers escaped by boat. Three forts—Fort Dulaney (circa 1839), Fort Harvie (1841), and Fort Myers (1850)—were erected during succeeding periods at the mouth of the river at the location of present-day Fort Myers. The city of Fort Myers was settled in 1866. The inventor Thomas Edison built his winter home in Fort Myers in 1866. Nearby stands the winter home of automobile builder Henry Ford, built in 1911 and purchased by Ford in 1916.

HUMAN IMPACT Human modifications to this watershed started with the construction of the Disston Canal in the 1880s. This waterway connected Lake Okeechobee with Lake Flirt. In the early 1900s, freshwater portions of the Caloosahatchee River were dredged and straightened. A lock and dam system was put in place. The Moore Haven Lock and Dam con-

A great blue heron perches in foliage overlooking the river.

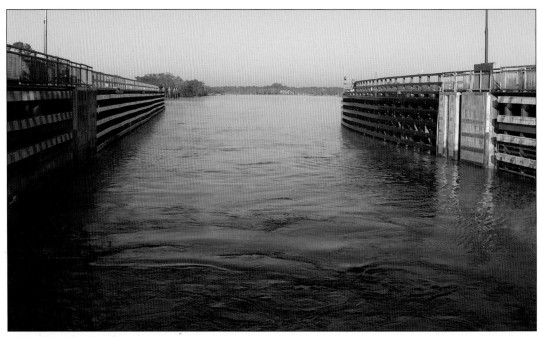

The Caloosahatchee is part of the 154-mile-long Okeechobee Waterway, which cuts across the state. Boats headed east enter a series of three locks, which raise them from sea level to the surface of Lake Okeechobee.

trols water flow into the east end of the canal. The Ortona Lock and Spillway regulates water flow in central portions of the canal. The Franklin Lock and Dam controls flow into the lower river and estuary. The straightened river was redesignated as the C-43 Canal. This canal extends for 45 miles and is transited by recreational and commercial boats. Many oxbows formed by the original river remain in place. Some are cut off from their source. Others remain connected to the channelized river.

Water quality in the river ranges from poor to fair, depending on the amount of discharge from Lake Okeechobee and nutrient levels in the lake. Algae blooms in the river have occurred with some frequency. The river is the

The Orange River, a major tributary of the Caloosahatchee, merges with the river just east of Fort Myers.

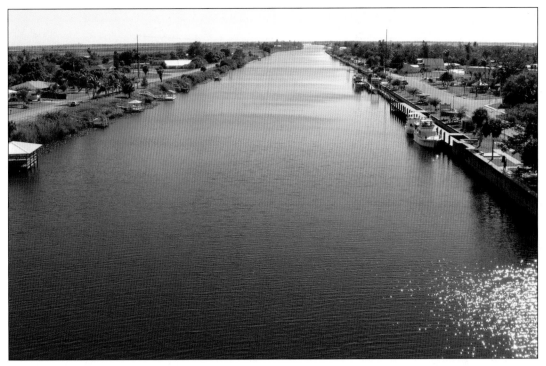

The Okeechobee Waterway, near Moore Haven, is purely artificial, and has no overlap with the historic Caloosahatchee River.

primary source of potable water and agricultural water within the river basin. Large portions of the eastern basin are dedicated to agriculture, predominantly citrus, sugarcane, and pastureland. Substantial residential development has taken place along the river. Towns include Ortona, LaBelle, Alva, and Fort Myers Shores. The city of Fort Myers occupies the south bank near the mouth. North Fort Myers and Cape Coral occupy the north bank.

Few areas surrounding the river have been protected from development. The Caloosahatchee State Recreation Area and the Caloosahatchee National Wildlife Refuge are located on the river in Lee County. The Matlacha Pass Aquatic Preserve protects portions of the estuary around the mouth of the river.

RECREATIONAL ACTIVITIES The Caloosahatchee is not recommended for flatwater paddling due to heavy boat traffic. However, a least three tributaries—Hickey Creek, Orange River, and Telegraph Creek—can be accessed by canoe and kayak. Hickey Creek is a state-designated canoe trail. Tarpon and snook fishing in the river estuary can be excellent. Fishing is especially productive around the power plant at the junction of the Orange and

Caloosahatchee Rivers. The Caloosahatchee and its tributaries have yielded significant finds to fossil hunters. Shark teeth, ancient shells, and mastodon teeth have been recovered from eroded sections of bank and from dredging spoils.

FLORA AND FAUNA Undeveloped parts of the estuary contain extensive mangrove swamps and shallow grass flats. In the winter, manatees often congregate in the discharge from the power plant located on the south bank. Oxbows usually contain healthy populations of turtles, including the Florida red-bellied turtle, chicken turtle, southern softshell turtle, Paradise Key mud turtle, and Florida snapping turtle. Dragonfly species associated with this waterway include the two-stripe forceptail, four-spotted pennant, Halloween pennant, scarlet skimmer, Needham's skimmer, roseate skimmer, and hyacinth glider. About 31 species of native freshwater fish have been collected from this waterway. Birds include the osprey, gray kingbird, American coot, boat-tailed grackle, sandhill crane, various herons and egrets, and rarely, in estuarine areas, the mangrove cuckoo.

Estero River

Waterway Type: Small Coastal River
Substrate: Gravel, Sand
Ecological Condition: ★★★
Oversight: SFWMD
Designations: CT, AP
Length: 6 miles
Watershed: Uncertain

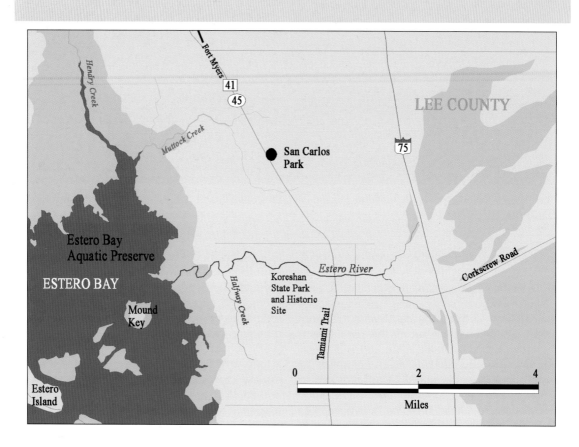

The Estero River is a coastal stream located between Naples and Fort Myers. Although it is small and is under some pressure from nearby development, this river is a magnet for wildlife and is certainly worth exploring. It is the southernmost river discussed within the section of this book covering the southwestern peninsula. While several waterways termed "rivers" lace the Everglades, these are little more than canoe paths and are part of the broad sheet flow that makes up the Everglades.

GEOGRAPHY AND HYDROLOGY The Estero River originates from flowing wells and seepage along the western fringes of the Corkscrew Swamp.

Two forks flow together about a mile east of the Tamiami Trial. From that point they flow directly west, passing under the Tamiami Trail and emptying into Estero Bay near Mound Key.

HISTORY The Calusa Indians were present in the area surrounding the river during periods preceding settlement by Europeans. Mound Key, a massive shell mound built up by the Calusa Tribe, is located near the river mouth. It is believed to date back 2,000 years. The Koreshan State Historic Site is located on the upper river just east of the Tamiami Trail. This state park preserves the remnants of a unique pioneer settlement. Dr. Cyrus Reed Teed, founder of the Koreshanity

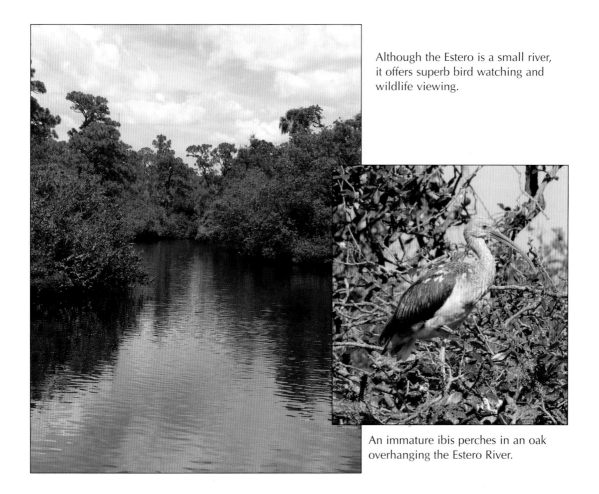

Although the Estero is a small river, it offers superb bird watching and wildlife viewing.

An immature ibis perches in an oak overhanging the Estero River.

faith, believed that the universe existed within a hollow sphere. He brought a small group of followers to the banks of the Estero in 1894. Although Teed died in 1908, his settlement persisted until 1961. Eleven of the original buildings remain on the site, along with other works, ancient mango trees, and other fruit trees.

HUMAN IMPACT Development pressure in the area is significant. San Carlos Park is located to the north. Bonita Springs is located to the south. The Estero Bay Aquatic Preserve protects the estuary and mangrove swamps around the river mouth.

RECREATIONAL ACTIVITIES The Estero is a popular spot for kayaking and canoeing. Koreshan State Park has campsites, hiking trails, a boat ramp, canoe rentals, a picnic area, and other amenities. Fishing is good in brackish areas and around the river mouth, the primary quarries being snook and redfish. Bream are plentiful in freshwater portions of the river.

FLORA AND FAUNA Diverse hammocks, draped with Spanish moss, frame the upper river. In places, the trees form a dense canopy over the water. The lower river is bordered by mangrove swamps. Dragonflies such as the scarlet skimmer, blue corporal, pin-tailed pondhawk, great pondhawk, marl pennant, eastern amberwing, roseate skimmer, Needham's skimmer, black saddlebags, and Carolina saddlebags, may be observed. Turtle species include the peninsula turtle, Florida red-bellied turtle, and Paradise Key mud turtle. The mangrove saltmarsh snake may be found in estuarine areas around the river mouth. The American crocodile, recently reclassified as threatened rather than endangered, may occasionally enter this river. Birds such as osprey, anhinga, great blue heron, little blue heron, white ibis, glossy ibis, bald eagle, red-breasted merganser, great crested flycatcher, blue-gray gnatcatcher, yellow-crowned night-heron, swallow-tailed kite, black skimmer, and roseate spoonbill may be observed along the bank or overhead.

Fisheating Creek

Waterway Type: Small Lowland River
Water Color/Clarity:
Substrate: Sand, Mud
Ecological Condition: ★★★★
Oversight: SFWMD
Designations: None
Length: 48 miles
Watershed: 918 square miles

Fisheating Creek is the second-largest natural tributary that feeds Lake Okeechobee. It has not been substantially altered from its natural state and is protected from development along nearly its entire length. Exploring this creek is one the most authentic wilderness experiences available within a short drive of the population centers of south Florida.

GEOGRAPHY AND HYDROLOGY
Fisheating Creek has its origins in marshy areas of Highland County, just west of central ridge uplands surrounding the Lake Placid area. Most of the discernable channel is relegated to Glades County. The upper half of the creek flows in a southerly direction. The lower half flows from west to east. As it approaches Lake Okeechobee, Fisheating Creek passes through open prairie and marshland.

HISTORY Native Americans comprising the Belle Glades Culture inhabited this region from about 1000 B.C. to about 1700 A.D. The Seminole tribe referred to this waterway as Thlothlopopka-Hatchee, or "the creek where fish are eaten." Until recent times, land surrounding the creek was owned by a private concern. This land was purchased by the state in 1999, after years of legal wrangling over whether the creek was a navigable waterway properly belonging to the state.

HUMAN IMPACT Fisheating Creek lies almost entirely within the Fisheating Creek Wildlife Management Area, consisting of over 18,000 acres. The only towns in the vicinity are Palmdale, Harrisburg, and Lakeport, near the outflow into Lake Okeechobee. Some pastureland

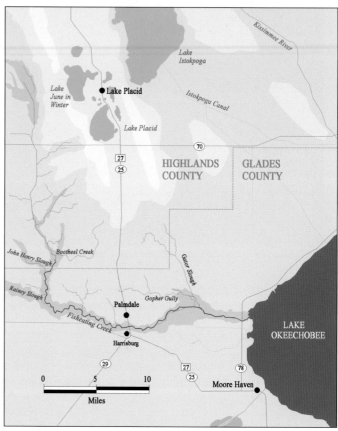

occurs along the creek just west of its discharge into Lake Okeechobee. Exotic West Indian marshgrass has displaced some native vegetation along the banks of the creek. Water quality in the creek is generally good, although sections can become stagnant in periods of drought.

RECREATIONAL ACTIVITIES Fisheating Creek offers many opportunities for kayaking and canoeing. The amount of water in the creek varies with the amount of rainfall. In the spring, the water level may fall so low as to make canoeing impracticable on many stretches of water. Bass fishing in the creek can be excellent, although most fish are of modest size.

Fisheating Creek is a popular destination for paddlers. The view is looking west from US 27.

FLORA AND FAUNA The banks are lined with cypress and oak. Fisheating Creek is populated by an amazing assortment of damselflies and dragonflies. Damselflies include the Atlantic bluet, big bluet, purple bluet, vesper bluet, fragile forktail, furtive forktail, Rambur's forktail, duckweed firetail, Carolina spreadwing, and Everglades sprite. Dragonflies include the gray-green clubtail, blue-faced darner, taper-tailed darner, phantom darner, cypress clubtail, royal river cruiser, Florida baskettail, Halloween pennant, eastern pondhawk, band-winged dragonlet, great blue skimmer, and roseate skimmer.

Turtles inhabiting this river include the southern softshell turtle, Florida snapping turtle, common mud turtle, common musk turtle, Florida red-bellied turtle, and chicken turtle. The cottonmouth may be present along the bank or draped over low hanging tree limbs. The south Florida rainbow snake, a distinct subspecies of rainbow snake, is known only from the vicinity of this waterway.

Birds that may be seen include the osprey, swallow-tailed kite, marsh wren, limpkin, wood stork, and various herons and egrets. The bald eagle, snail kite, red-cockaded woodpecker, Florida grasshopper sparrow, scrub jay, and crested caracara are also occasionally observed. Wildlife that frequents the area includes the black bear, wild hog, river otter, bobcat, and alligator. The Florida panther, although rarely seen, has been documented within the wildlife management area.

A large colony of crested caracara roosts in the vicinity of Fisheating Creek.

Horse Creek

Waterway Type: Blackwater Stream
Substrate: Sand, gravel
Ecological Condition: ★★★
Oversight: SWFWMD
Designations: None
Length: 42 miles
Watershed: 395 square miles

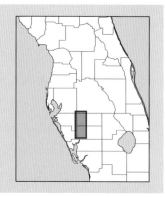

This pretty blackwater stream is a tributary of the Peace River of southwest Florida. Horse Creek contributes about 15 percent of the volume of the Peace River. Its dark, rust-colored waters flow over a sand and gravel bottom.

GEOGRAPHY AND HYDROLOGY Horse Creek begins in the Four-Corners region—the intersection between Hillsborough, Polk, Hardee, and Manatee Counties. The headwaters of the Manatee River, Little Manatee River, and Paynes Creek, another tributary of the Peace River, also begin within a 10-mile radius of this intersection. Horse Creek flows south through Hardee and DeSoto Counties, before joining the Peace River just west of Fort Ogden. Major tributaries of Horse Creek, moving from north to south, include the West Fork, which flows in from the northwest; Cypress Branch, which feeds in from the west; Brushy Creek, which enters from the northeast; and Buzzard Roost Branch, which flows in from the northwest. Most land along the creek is in private hands.

HISTORY The Calusa people resided around this waterway at the time of European contact. DeSoto County was created in 1887. Hardee County was created from a portion of DeSoto County in 1921. It was named in honor of Florida's twenty-third governor, Cary A. Hardee (1876–1957). Flooding occurred along Horse Creek in 2003 as a result of a series of severe thunderstorms.

HUMAN IMPACT Phosphate mining has occurred in northern parts of the Horse Creek watershed. This activity is slated to expand in the future, as a result of extensive phosphate deposits in the area. However, phosphate levels in Horse Creek are presently less than those in the Peace River, into which Horse Creek discharges. In addition, cattle ranching and nearby citrus groves have

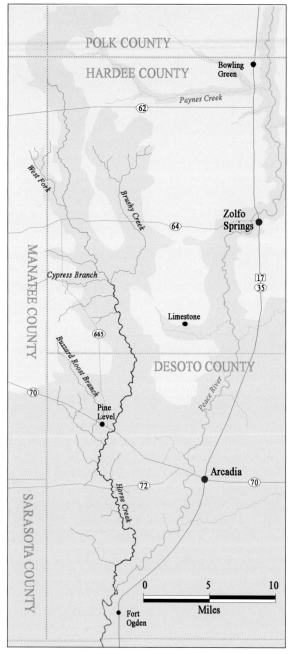

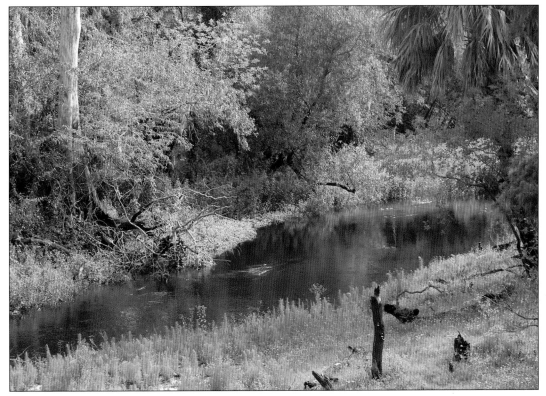

Horse Creek, a major tributary of the Peace River, flows through rolling terrain.

had some negative impact on water quality. Cattle ranchers have strung barbed wire across upper portions of the waterway.

RECREATION Lower portions of Horse Creek can be accessed by canoe and kayak. Horse Creek lies within Bone Valley and has yielded dugong bones, shark teeth, and other vertebrate fossils.

FLORA AND FAUNA Foliage along horse creek includes live oak, cypress, buttonbush, red maple, cabbage palm, arrowhead, pickerelweed, frog's bit, maidencane, and St. John's wort. Various damselflies may be found in the vicinity of this waterway, including the purple bluet, citrine forktail, Rambur's forktail, variable dancer, and blue-ringed dancer. Dragonflies found in the area include the blue dasher, twilight darner, roseate skimmer, and eastern amberwing. About 34 species of native freshwater fish inhabit this waterway. Holmes Creek supports large populations of largemouth bass and bluegill. This creek is home to many turtles, including the Florida snapping turtle, chicken turtle, Florida red-bellied turtle, and peninsula turtle. Birds that may be seen along the creek include purple gallinule, limpkin, red-tailed hawk, turkey vulture, wood stork, and various herons and egrets.

Horse Creek is considered a blackwater stream. Phosphate mines and agricultural concerns have affected water quality.

Little Manatee River

Waterway Type: Small Coastal River
Substrate: Sand
Ecological Condition: ★★★
Oversight: SWFWMD
Designations: OFW, CT, AP
Length: 41 miles
Watershed: 243 square miles

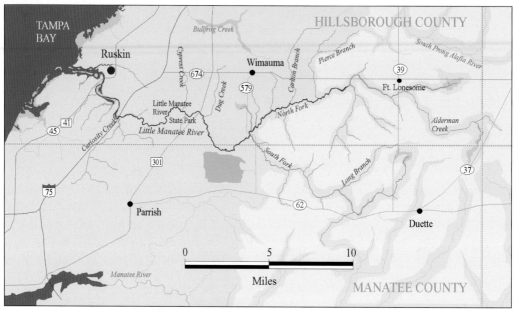

The Little Manatee River is the northernmost river discussed in the section covering the rivers of southwest Florida. Along with the Manatee River and the Alafia River, it is located in Hillsborough County. The Little Manatee River flows from east to west, discharging into Tampa Bay. The state Department of Environmental Protection lists the Little Manatee as an Outstanding Florida Water.

GEOGRAPHY AND HYDROLOGY The Little Manatee River begins near Fort Lonesome, in southern Hillsborough County. While most of the basin is located in Hillsborough County, it extends into the extreme southeastern corner of Polk County. The South Fork of the Little Manatee River drains portions of northern Manatee County. Other tributaries, listed from west to east, include Marsh Branch, Wildcat Creek, Curiosity Creek, Cypress Creek, Gully Branch, Carlton Branch, Pierce Branch, Hurrah Creek, and Howard Prairie Branch. High sand banks frame the river along much of its length. The

lower 5 miles are affected by tidal influences. The current is slow and the water is dark and tannin stained.

HISTORY The Tocabaga people probably occupied the area around the river at the time of European contact. Ruskin, near the mouth of the river, had its beginnings in 1906, when Dr. George McAnelly Miller moved to the area to establish a cooperative community and Ruskin College. The College failed, but the community lived on. Fort Lonesome, to the east, is a ghost town. It was a lumber center in the 1930s. However, the town faded when the mill that supported the town was destroyed by fire.

HUMAN IMPACT Residential and commercial development in the watershed has been relatively light to date. Communities located on the river and its tributaries include Ruskin, Sun City Center, and Wimauma. Water is withdrawn from the river to supply a cooling reservoir for an elec-

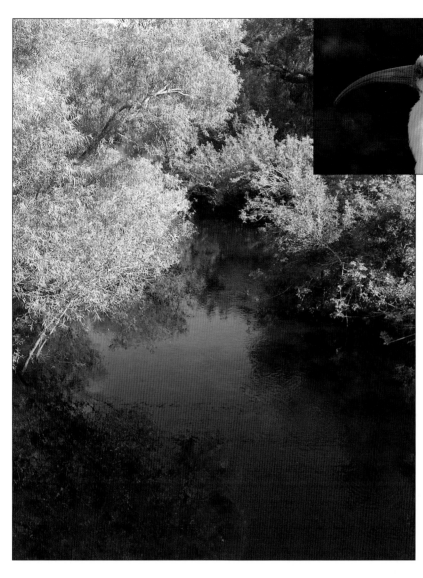

The white ibis is a distinctive bird, frequently encountered along the Little Manatee and other waterways emptying into Tampa Bay.

The Little Manatee River looking west from the bridge of US 301.

trical generating plant. This reservoir is located along the south bank in Manatee County. Significant lands within the drainage basin are devoted to agriculture, primarily citrus groves, vegetable farms, and cattle ranches. Nevertheless, water quality is generally good. The Little Manatee River State Recreation Area consists of 2,433 acres surrounding the river. It was acquired by the state in 1974. The Hillsborough County Parks, Recreation and Conservation Department and the Southwest Florida Water Management District manage other tracts surrounding the river.

RECREATIONAL ACTIVITIES A 5-mile, state-designated canoe trail runs from the bridge of US 301 to the Little Manatee River State Park. Little Manatee River State Park has equestrian trails, hiking trails, and camping.

FLORA AND FAUNA The Little Manatee River is part of the Cockroach Bay Aquatic Preserve. The river runs through hardwood hammocks, sand pine scrubland, and willow swamps. Mangrove swamps surround brackish portions of the waterway. Various damselflies, including the citrine forktail, and duckweed firetail, can be observed along this river. Turtles inhabiting this waterway include the common musk turtle, Florida mud turtle, peninsula turtle, and Florida red-bellied turtle. Birds found in conjunction with this river include little blue heron, green-backed heron, yellow-crowned night-heron, various egrets, anhinga, black-whiskered vireo, and boat-tailed grackle. Manatees sometimes enter the lower river.

Manatee River

Waterway Type: Small Coastal River
Substrate: Sand
Ecological Condition: ★★★
Oversight: SWFWMD
Designations: CT
Length: 58 miles
Watershed: 370 square miles

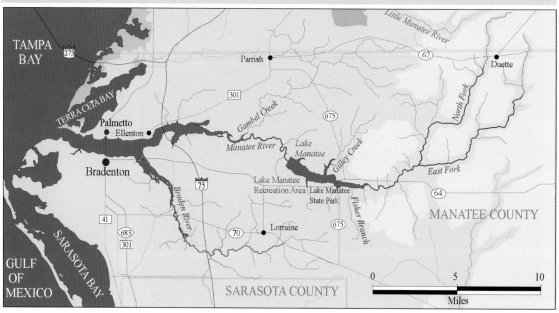

The Manatee River is the southernmost river discharging into the Tampa Bay estuary. In many locations, the river is overhung by moss-draped oaks and is shaded by high banks.

GEOGRAPHY AND HYDROLOGY The Manatee River, along with the Little Manatee River, Horse Creek, and Payne Creek, originates on high ground near the four-corner intersection between Polk, Hillsborough, Manatee, and Hardee Counties. It receives most of its water from runoff and drains several swampy areas. The river flows west, winding through coastal lowlands that comprise the heart of Manatee County. The watershed extends into a tiny portion of southern Hillsborough County and a small area of northern Sarasota County. Moving from west to east, major tributaries include Peacock Branch, Webb Branch, Fisher Branch, Gilley Creek, Boggy Creek, Rye Branch, Water Hole Creek, Goddard Creek, Mill Creek, Gamble Creek, and Ware Creek. The Braden River, covered earlier in this

book, is a major tributary that flows into estuarine portions of the Manatee River from the south. As the river widens, just west of Interstate 75, it forms a maze of channels, sandbars, islands, and blind alleys. The Manatee River empties into Tampa Bay just west of Bradenton.

HISTORY The Calusa or Tocobaga inhabited the area around the river at the time of European contact. Some historians suggest that in 1539 de Soto's army passed near the headwaters of the Manatee on its journey northward. Others place his point of disenbarcation at Tampa Bay. During the Seminole Wars several forts were located along the river including Fort Crawford, Fort Rough and Ready, and Fort Hamer. Camp Palmetto Beach, located at Palmetto near the river's mouth, was an assembly point for the Spanish-American War. The Gamble Plantation, located near Ellenton on the north shore of the river, was once the center of a large sugar plantation. The mansion, built between 1843 and 1850,

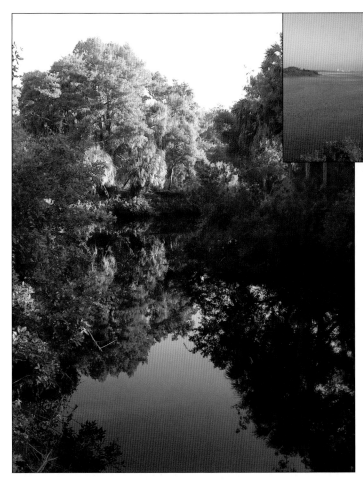

Lake Manatee is a large impoundment on the Manatee River. The Lake Manatee Dam was completed in 1967.

The Manatee River, a short distance below Lake Manatee, is a vision of serenity.

is the only plantation house left in south Florida. In 1855, 151 slaves worked the plantation. In the late 1800s and early 1900s, the town of Rye existed along the river. The graveyard is all that remains of this settlement. Several other settlements, which depended on river traffic for their existence, have likewise disappeared. Severe flooding occurred along the Manatee River in June of 2003.

HUMAN IMPACT In the mid-1960s a substantial dam was constructed on the river about 18 miles above the mouth. This resulted in a 2,400-acre impoundment, Lake Manatee. The upper river and its tributaries drain pastures and agricultural land. Runoff from these sources has resulted in excess nutrients entering the waterway and related algae blooms. Areas surrounding the lower river are highly developed, and include the city of Bradenton on the south shore, and the towns of Palmetto and Ellenton on the north shore. Much of this area is lined with private homes.

RECREATIONAL ACTIVITIES A portion of the Manatee River has been designated by the state as a canoe trail. The 5-mile paddle begins at the Rye Road Bridge and ends at the Aquatel Lodge. The trip can be extended by continuing to the Fort Hamer Boat Ramp. Fossilized shark teeth are sometimes found in river gravel and sediments. Hiking, boating, and camping are available in the Lake Manatee State Recreation Area. Lower portions of the river present angling opportunities for redfish and speckled sea trout.

FLORA AND FAUNA The Manatee River passes through pine flatwoods, oak hammocks, and sandhill communities. River otters are found along some stretches. The Manatee River is frequented by various damselflies such as the blue-ringed dancer and duckweed firetail. Dragonflies found in the vicinity include the blue-faced darner, common green darner, blue dasher, blackwater clubtail, dragonhunter, four spotted pennant, Halloween pennant, great blue skimmer, and roseate skimmer. Alligators and turtles are numerous. Manatees sometimes enter the lower river.

Myakka River

Waterway Type: Coastal River
Substrate: Sand
Ecological Condition: ★★★★
Oversight: SWFWMD
Designations: OFW (lower river), FWSR, AP (Charlotte Harbor)
Length: 66 miles
Watershed: 580 square miles

The Myakka is a classic brown-water stream with a gentle current. Although suburban sprawl from the Gulf coast has touched a few areas of the basin, most sections of river are pristine and support abundant wildlife. The Florida Legislature designated the Myakka a Wild and Scenic River in 1985.

GEOGRAPHY AND HYDROLOGY The Myakka River gathers much of its initial flow in Flatford Swamp north of State Road 70 and Myakka City. Seven tributaries—Boggy Creek, Coker Creek, Long Creek, Maple Creek, Ogleby Creek, Sand Slough, and Young's Creek—converge in this area. Other tributaries, moving from north to south, include Wingate Creek, Owen Creek, Mossy Island Sough, Howard Creek, and Deer Prairie Creek. The Myakka watershed encompasses a large area of Manatee County, a small area of western Hardee County, and eastern portions of Sarasota County. The upper river flows toward the southwest. Lower portions flow toward the southeast. The last 18 or 20 miles are affected by tidal influences. Warm Mineral Spring, a third-magnitude spring, is located within the town of North Port near the mouth of the river. The Myakka widens toward its mouth and discharges into Charlotte Harbor, where its waters merge with those of the Peace River.

HISTORY The Calusa inhabited land around the Myakka at the time of initial Spanish incursions. This group disappeared by the late 1700s. Many died from disease, were taken as slaves by

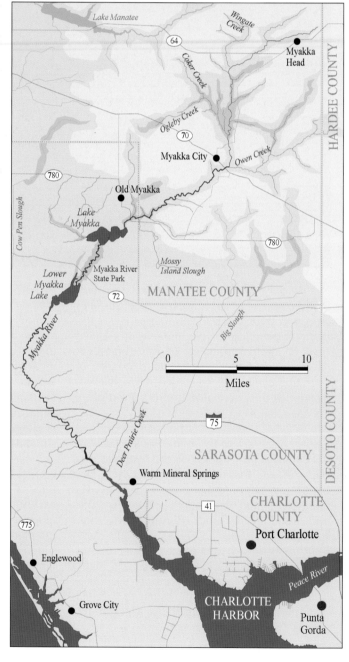

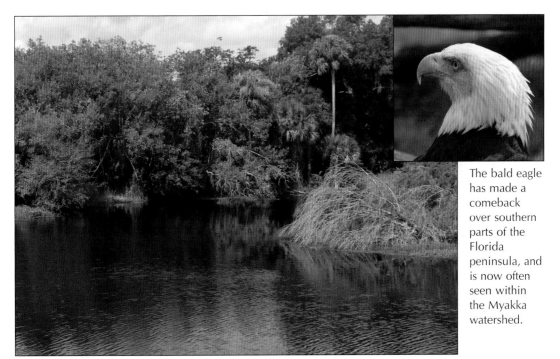

The bald eagle has made a comeback over southern parts of the Florida peninsula, and is now often seen within the Myakka watershed.

The Myakka River near Route 72 is a sluggish stream, linking Lake Myakka with Lower Myakka Lake.

other tribes, or were absorbed into other tribes. A few departed for Cuba when Spain transferred control of Florida to England. Pánfilo de Narváez may have crossed the lower Myakka during his expedition of 1528, although some historians suggest he landed farther north. Historians similarly debate whether Hernando de Soto landed in Charlotte Harbor or the southern part of Tampa Bay during his expedition of 1539. Those who believe de Soto landed in Charlotte Harbor suggest that he led his army up the eastern bank of the Myakka before crossing to the west side near Howard Creek. The Native American name Myakka means "big." Myakka River State Park, one of the oldest parks in the system of state parks, opened in 1942.

HUMAN IMPACT Large tracts of land surrounding the river are protected and much of the river is in a pristine state. However, development associated with the west-coast cities of Venice and Sarasota is spreading eastward. This has resulted in some encroachment on the lower river. The upper river passes just to the southeast of Myakka City. Cattle ranching, citrus production, vegetable farming, and mining takes place in the upper basin and around various tributaries. Nevertheless, water quality is usually good to very good. The Myakka

River State Park, encompassing more than 45 square miles, surrounds and protects 14 miles of river.

RECREATIONAL ACTIVITIES Myakka River State Park provides opportunities for hiking, camping, and wildlife viewing. Canoe rentals and airboat tours of the lakes are available.

FLORA AND FAUNA The banks are lined with live oak, water oak, red maple, pickerelweed, fire flag, maidencane, giant leatherfern, and Cuban bulrush. Mats of water hyacinth and other types of floating vegetation may be present in backwaters and along the bank. About 35 species of freshwater fish are native to this river. Common species include the redear sunfish, largemouth bass, bluegill, golden shiner, flagfish, brook silverside, Florida gar, and white catfish. Turtle species include the Florida snapping turtle, southern softshell turtle, peninsula turtle, chicken turtle, and Florida mud turtle. Birds that may be observed in the area include bald eagle, swallow-tailed kite, turkey vulture, white ibis, limpkin, wood stork, sandhill crane, green-backed heron, black-crowned night-heron, blue heron, roseate spoonbill, and, during the winter, greater yellowlegs.

Peace River

Waterway Type: Blackwater River/Coastal River
Substrate: Sand, Clay
Ecological Condition: ★★★
Oversight: SWFWMD
Designations: OFW, CT, AP (Charlotte Harbor)
Length: 76 miles
Watershed: 2,300 square miles

The Peace River, in keeping with its name, is a placid waterway. It courses slowly through the heartland of south central Florida. With its amber water, gentle current, and abundant wildlife, this is one of the finest canoeing rivers in the state. The tidal portion of the river has been designated an Outstanding Florida Water by the Florida Department of Environmental Protection.

GEOGRAPHY AND HYDROLOGY The primary source of the Peace River is Lake Hancock and creeks and nearby water bodies flowing into the lake. Lake Hancock occupies the valley between the Lakeland Ridge and Winter Haven Ridge in northern Polk County. It is fed by Saddle Creek from the north and drained by Saddle Creek leading to the south. The Peace River proper begins where Saddle Creek meets the Peace Creek Drainage Canal. The Peace Creek Drainage Canal connects to the Winter Haven chain of lakes. This chain is composed of 19 lakes, located at the northeastern periphery of the Peace River drainage basin.

The Peace River runs south from Polk County through Hardee, DeSoto, and Charlotte Counties. Tributaries include Bowlegs Creek, Little Charlie Creek, Paynes Creek, Troublesome Creek, Charlie Creek, Joshua Creek, Horse Creek, and Shell Creek. The current is slow, except in areas where the river narrows or crosses shoals. The terrain surrounding the river is diverse, at places consisting of high, steep banks; at other places consisting of low sandbars or marshes. The Peace River discharges into Charlotte Harbor estuary. There its waters mingle with those of the Myakka River, which flows into the harbor from the northwest. Tidal influences extend about 22 miles inland from the mouth of the river.

HISTORY The Spanish named the river Río de la Paz, or "river of peace," in the 1500s. Calusa

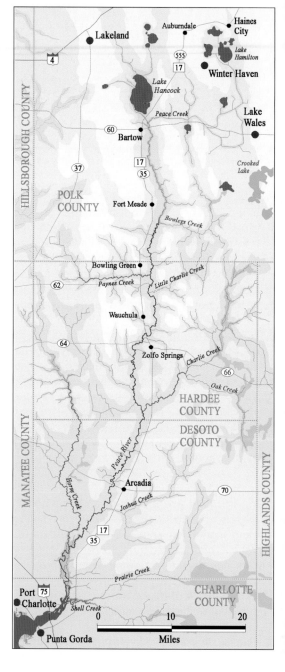

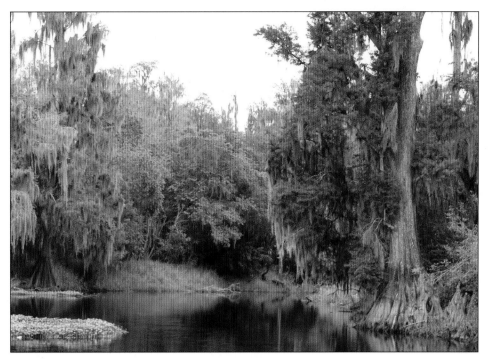

Each turn of the Peace River reveals a magnificent vista. This is the upper river, just east of Bartow.

people inhabited the region around the Peace River until the late 1600s or early 1700s. The Seminoles, displaced from other lands, settled along the banks of the river in the 1700s, while Florida was still a territory of Spain. Several conflicts of the Second Seminole War played out along this waterway.

The area surrounding the Peace River was the scene of several conflicts of the Second and Third Seminole Wars. In 1849, a renegade band of warriors attacked the Kennedy and Darling store on Paynes Creek, a tributary of the Peace River. The so-called Paynes Creek Massacre precipitated a period of souring relations between settlers and native populations. The federal government accelerated efforts to remove the remaining Seminoles to Indian Territories west of the Mississippi River.

Billy Bowlegs, known also by his Seminole name, Holata Miccoa, was a Native American leader who lived in the area of the Peace River. In 1855, federal surveyors and soldiers entered lands belonging to the Seminoles. The Seminoles, led by Bowlegs, launched a surprise attack on this party, killing four. This encounter provoked the Third Seminole War. Military establishments built or maintained along the Peace River during this period included Fort Blount and Riley Blount's Fort, at Bartow; Fort Hooker, north of Fort Meade; Fort Winder, near Fort Ogden; and Camp Whipple, near the mouth of the river. In 1858, the federal government paid Bowlegs and his followers to relocate to Indian territories. Bowlegs fought for the Union Army during the Civil War.

Bartow, the town nearest the head of the Peace River, is also the county seat of Polk County. It features a preserved downtown business district, historic homes, and large oaks. The city got its start as Fort Blount, established in 1850. In 1867, the town was renamed Bartow to honor Francis S. Bartow, the first Confederate officer killed in the Civil War. Spessard Lindsey Holland (1892–1971), Florida's twenty-eighth governor, was born in Bartow. Florida's twenty-fifth governor, Doyle Elam Carlton (1885–1972), was born in Wauchula, a riverside town located a few miles south of Bartow.

The small town of Arcadia is located downriver from Wauchula, on high ground along the eastern bank. It was originally called Waldron's Landing and was later known as Raulerson's Landing. Arcadia was named as the county seat of DeSoto County in 1888. Arcadia played a role in the cattle wars of the 1890s and was considered a rough town during its early history. The central business district was destroyed by fire in 1905. Arcadia has

The roseate spoonbill is a distinctive bird, most often encountered in southern parts of the peninsula. While by no means common, populations appear to be increasing.

The American flag fish is one of Florida's most beautiful native fishes. It is found in the Peace River and its tributaries.

hosted a well-known rodeo since 1929. Cattle ranching and agriculture are mainstays of the local economy.

In the 1880s, extensive phosphate deposits were discovered in the Peace River watershed. The watershed has been the site of extensive mining activity. In 2004, Hurricane Charley impacted many areas along the Peace River, causing extensive damage in Arcadia, Wauchula, Fort Meade, Port Charlotte, Punta Gorda, and Zolfo Springs. Winds in Wauchula were measured at 149 miles per hour.

HUMAN IMPACT Phosphate mining and agriculture have degraded water quality in the Peace River watershed. Spills of slurry clay have resulted in fish kills. Population growth along the Peace River corridor has caused an increase in the amount of pollution and street runoff entering the waterway. Lake Hancock and other headwater lakes contain nutrient-rich water and suffer from other water quality issues.

As a result of withdrawals for human, agricultural, and industrial use, the flow of the Peace River has declined substantially over

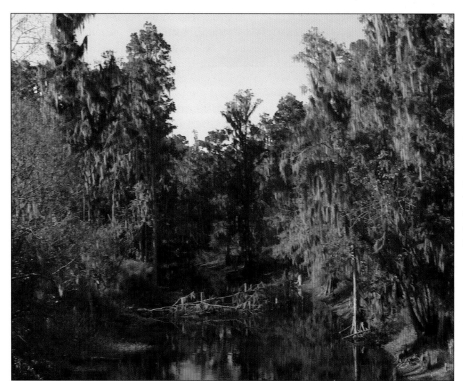

In most places, the upper Peace River is a quiet stream framed by cypress draped with Spanish moss.

This view shows the Peace River just north of Arcadia.

the past 80 years. If this trend continues, salt water is likely push further north within the river basin. Kissengen Springs, once a second-magnitude spring flowing into the river, ceased flowing in the 1950s as a result of over-pumping from the surrounding aquifer.

On its journey south, the Peace River passes near the towns of Bartow, Fort Meade, Bowling Green, Wauchula, Zolfo Springs, Arcadia, Port Charlotte, and Punta Gorda. The river receives heavy recreational use and some litter has accumulated along the banks and bed.

RECREATIONAL ACTIVITIES A state-designated canoe trail runs from the bridge off US 98 at Fort Meade, to State Road 70 in Arcadia. The trail meanders for about 67 miles, and can be accessed at various points along its length. The full journey is a several-day trip. The Peace River is one of the most productive spots in Florida for fossil hunting. Teeth of the extinct giant shark, megalodon, are retrieved from this waterway with some frequency. Fossil hunters have also recovered mastodon teeth and tusks, whale vertebrae, dugong teeth, dugong ribs, camel teeth, horse teeth, and other traces of prehistoric life.

FLORA AND FAUNA The banks are lined with cabbage palm, palmetto, live oak, cypress, water locust, buttonbush, elderberry, beauty-berry, sand pine, and sweet gum. Mangroves border tidal portions of the river.

Freshwater mussels found in the Peace River include the barrel floater and iridescent lilliput. Dragonflies that may be observed in the vicinity of the Peace River include the twi-light darner, four-spotted pennant, Amanda's pennant, Carolina saddlebags, eastern pond-hawk, hyacinth glider, eastern amberwing, and blue dasher.

Approximately 35 species of freshwater fish are native to the Peace River. Prominent species include the bluegill, redear sunfish, spotted sunfish, largemouth bass, white cat-fish, and Florida gar. Minnows found within the river include the golden shiner, pugnose minnow, and coastal shiner. Two exotic species, the blue tilapia and the suckermouth catfish, have proliferated in the river to the point that they are now dominant species. Turtle species found in this river include the southern softshell, chicken turtle, peninsula turtle, and Florida red-bellied turtle. Birds that frequent the area include, the red-shouldered hawk, turkey vulture, little blue heron, limp-kin, wood stork, Florida scrub-jay, black-necked stilt, and sandhill crane. Gray foxes and river otters are occasionally observed.

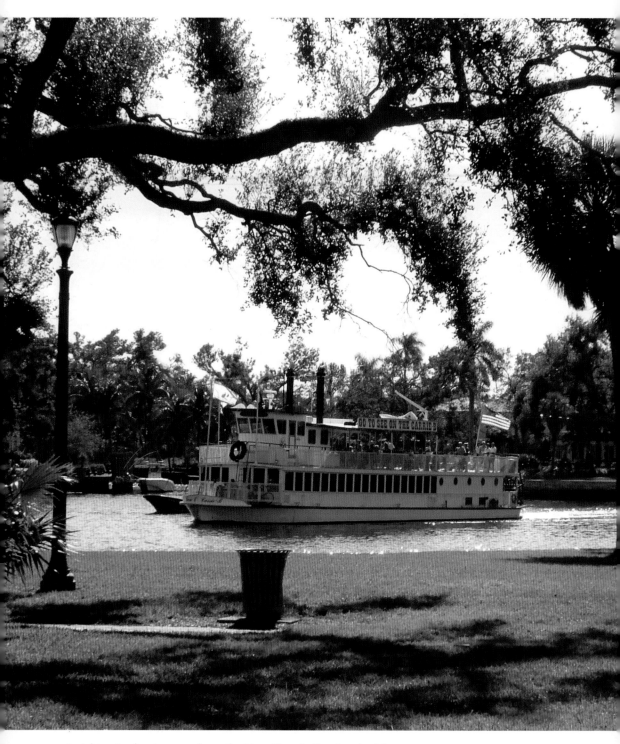

A sightseeing boat passes down the New River in Fort Lauderdale.

Southeast Florida

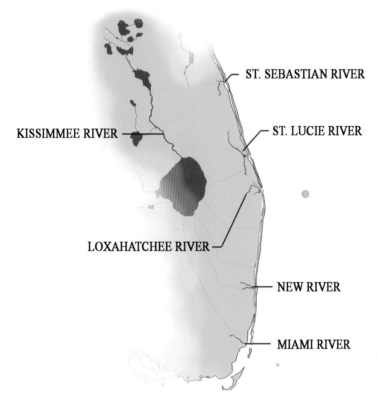

With the exception of the Sebastian River—which lies within the St. Johns Water Management District—all the rivers covered within this section fall under the jurisdiction of the South Florida Water Management District. Most rivers within this region are slow coastal streams. The subtropical climate and the proximity to the Gulf Stream influence the fauna and flora of the river systems. Many birds, fishes, and plants are tied more closely to the Caribbean than to North America. In addition, the rivers of this region harbor numerous exotic fish and plant species, which have spread and displaced native species. Most of the rivers covered within this section have been physically altered and substantially degraded. Some, such as the New River and Miami River, flow through urban settings.

Kissimmee River

Waterway Type: Channelized Lowland River, Chain of Lakes
Substrate: Sand, Silt
Ecological Condition: ★★
Oversight: SFWMD
Designations: None
Length: 103 miles
Watershed: 3,013 square miles

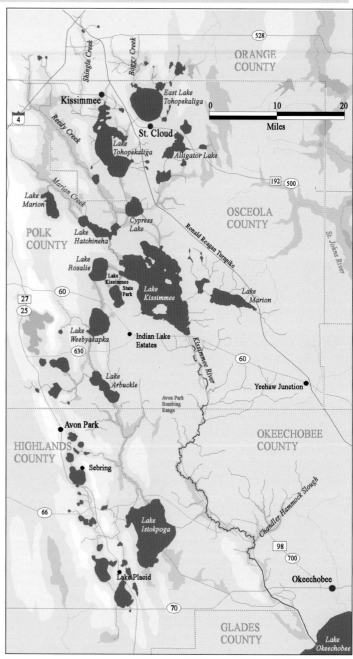

The Kissimmee River of south central Florida is the largest tributary flowing into Lake Okeechobee and is the primary source of water for the Everglades. The flow of this waterway has been extensively altered to enhance navigation, to control flooding, and to "improve" surrounding land for human use. Now, through a massive restoration project, the Kissimmee is gradually being returned to its original bed.

GEOGRAPHY AND HYDROLOGY The upper Kissimmee basin consists of a series of interconnected lakes and various creeks and sloughs that drain into these lakes. The headwaters drain several areas of southern Orange County. Reedy Creek originates in the vicinity of the Disney theme parks. It flows for about 29 miles to the southeast, eventually merging with the Dead River and flowing into Lake Hatchineha. Other tributaries, such as Shingle Creek and Boggy Creek, feed the Tohopekaliga Lakes. The eastern tributary, Canoe Creek, drains an area encompassing Alligator Lake and Lake Gentry. Other tributaries include Lake Marion Creek, Catfish Creek, and the Jackson Canal. All of these waters eventually flow southward into Lake Kissimmee.

The Kissimmee River runs south from Lake Kissimmee to Lake Okeechobee. Historically, it consisted of an extensive series of curves and turns. A shallow maze of channels and islands resulted in a braided effect. The river was surrounded by

The Kissimmee has been subjected to extensive modification for purposes of drainage, flood control, and navigation.

extensive wetlands. During periods of high precipitation, the Kissimmee would spread out over a 2-mile-wide flood plain.

HISTORY Early residents of the upper basin of the Kissimmee River included the Jororo Tribe. Guacata and Calusa may also have controlled portions of the river basin at various times. The Seminoles settled in areas surrounding the river in the 1700s, after leaving their homelands in north Florida, Alabama, and Georgia. During the Second Seminole War, several forts were built along the river, including Forts Gardner and Basinger. On December 25, 1837, Colonel Zachary Taylor fought the Battle of Okeechobee in the area east of the river. Although Taylor forced the Seminoles to withdraw, his own forces sustained significant casualties.

During the 1880s steamboat trade was established along the Kissimmee River. The Florida land boom of the 1920s brought settlers to the upper river basin. Cattle ranching began in earnest in the 1930s. The opening of Walt Disney World and other attractions spurred more recent population increases in the Orlando/Kissimmee/St. Cloud area.

The last Carolina parakeet—the only parrot indigenous to the United States—is thought to have been killed in Okeechobee County in 1904. Demand for its bright feathers for women's hats and its role as an agricultural pest led to its extinction. In 1936, Marvin Chandler was appointed as the first wildlife warden of Okeechobee. Among his duties was enforcement of laws preventing plume hunters from poaching egrets and herons. When First Lady Eleanor Roosevelt visited the area, Chandler reportedly became hostile to her upon seeing an egret plum in her hat.

Prior to flood-control efforts, hurricanes and late-summer precipitation caused the Kissimmee River to overflow its banks on a frequent basis. Serious floods occurred in 1945, 1947, 1948, 1953, and 1956. These events spurred public demands for action. Between 1962 and 1971, the United States Army Corps of Engineers straightened and channelized the lower Kissimmee. However, by the time the project was complete, a move was already afoot to restore the river and surrounding wetlands. In 1992, the United States Congress

Deer are plentiful along the Kissimmee River, especially within the Avon Park Bombing Range and adjacent areas.

directed the Corps to restore portions of the river by filling in 22 miles of channel. The first phase of the project was completed in 2001. The second phase is near completion at the time of this writing. The overall project consists of four phases. It constitutes the most ambitious and expensive river restoration effort ever undertaken.

HUMAN IMPACT Prior to settlement the upper basin was marshy. Rainwater gradually drained southward through sheet flows, lake overflows, and cypress swamps. Land reclamation efforts resulted in a lowered water table. Today, the upper basin is heavily populated and includes the southern suburbs of Orlando and the cities of Kissimmee and St. Cloud. Several large cattle ranches exist on the outskirts of these cities. Street runoff, agricultural runoff, and culverts have had a negative impact on water quality.

By channeling the lower Kissimmee, the Corps of Engineers managed to turn a winding 103-mile-long river into a 56-mile-long, 325-foot-wide ditch. The broad flood plain surrounding the river was drained and turned into pastureland. This undertaking resulted in a dramatic reduction in wildlife. Bank erosion became a significant problem. Natural filtration, which took place when water passed through swamps, flood plains, and other natural features, was eliminated. Pollution, agricultural runoff, and suspended sediment flowed directly into Lake Okeechobee. This nutrient-rich water was then directed into the Everglades and adjacent coastal estuaries, where it caused additional harm.

Restoration of the river is well underway. However, the entire river cannot be returned to its natural state as a result of concerns over flood control. Much of the land surrounding the river is protected or undeveloped. The restoration project has required extensive purchases of private land along the river. The Avon Park Bombing Range and Hickory Hammock Wildlife Management Area are located along the west bank.

RECREATIONAL ACTIVITIES The lake chains that make up the upper Kissimmee River Basin support one of the nation's premier freshwater fisheries. Largemouth bass, black crappie, redear sunfish, and other species draw anglers from across the nation. Lake Kissimmee, at the head of the river, yielded the state record bowfin, which weighed 19 pounds. Fishing in the river itself can be productive, with bream and catfish being the primary targets. The river and adjoining lakes are navigable and some areas receive heavy boat traffic. Lakes and tributaries provide opportunities for kayaking and canoeing. Hunting and camping is permitted on portions of the adjacent Avon Park Bombing Range.

FLORA AND FAUNA Native plants common to the river's edge include pickerelweed, cattail, soft rush, maidencane, sand cordgrass, and sawgrass. Also present are primrose willow, alligator flag, elderberry, buttonbush, wax myrtle, and live oak. Cypress grows in oxbows and areas adjacent to the original riverbed, but is rare along channelized portions of the river.

Softshell turtles are highly aquatic and generally come ashore only to lay eggs. They can attain a length of up to 19 inches and a weight of about 22 pounds.

SOUTHEAST FLORIDA Kissimmee River

The little blue heron is a common wading bird in Florida. It often feeds on minnows, killifish, and juvenile sunfish.

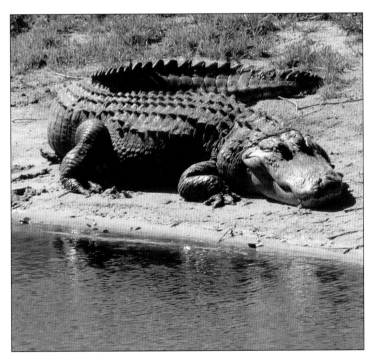

Some large alligators are present in the Kissimmee River. Specimens exceeding 11 feet in length are sometimes observed. Alligators exceeding 13 feet in length are extremely rare in Florida.

About 41 species of freshwater fish are native to the river. Minnows found within the river include the pugnose minnow, ironcolor shiner, coastal shiner, taillight shiner, and golden shiner. Turtles include the Florida red-bellied turtle, chicken turtle, peninsula turtle, southern softshell turtle, and Florida snapping turtle. The Kissimmee basin is an important overwintering area for ducks and other waterfowl. Bird species found in the area include black-necked stilt, snail kite, swallow-tailed kite, crested caracara, wood stork, and bald eagle. Wildlife is already beginning to return to restored portions of the river. Deer, gray fox, gopher tortoise, raccoon, opossum, and bobcat can be seen along the banks.

Loxahatchee River

Waterway Type: Small Coastal River
Substrate: Sand
Ecological Condition: ★★★
Oversight: SFWMD
Designations: WSR, OFW
Length: 17 miles
Watershed: 210 square miles

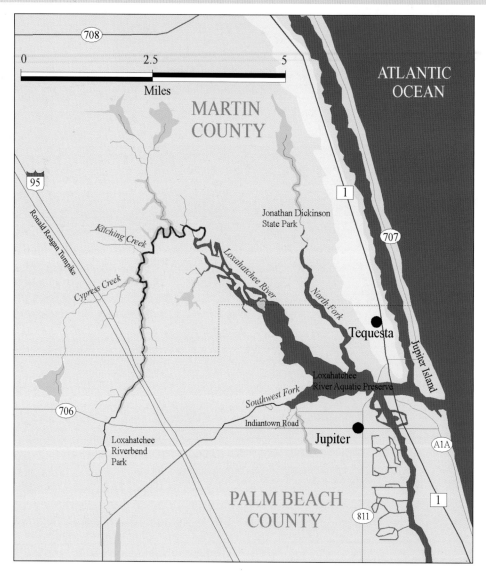

The Loxahatchee River is situated on Florida's lower east coast, about 15 miles north of West Palm Beach. Although it flows through a densely populated area, portions of the river are picturesque and have not been touched by development. The Loxahatchee is one of only two rivers in the state to receive federal recognition as a wild and scenic river.

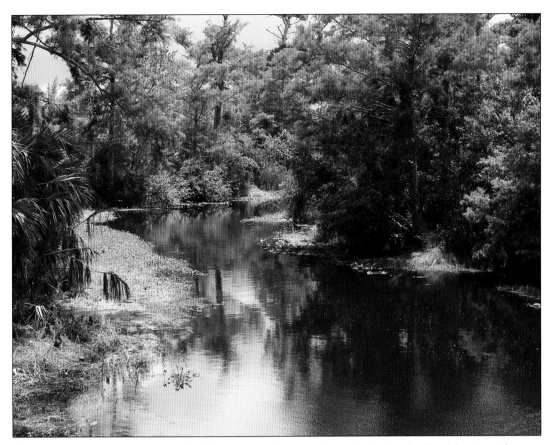

The Loxahatchee is it appears south of State Road 706 near Riverbend Park. A battle of the Second Seminole War occurred here.

GEOGRAPHY AND HYDROLOGY The Loxahatchee River is made up of three forks that merge into an open, brackish estuary. The basin drains portions of eastern Palm Beach County and southeastern Martin County. The Northwest Fork, which is the longest of the three, has its origins in the Loxahatchee Slough, located in the Grassy Waters Preserve of Palm Beach County. The Northwest Fork flows north for about 9 miles before arching to the southeast. Tributaries include Cypress Creek, Moonshine Creek, and Kitching Creek. The North Fork flows south from Jonathan Dickinson State Park before entering the lower estuary. The Southwest Fork has been transformed into the C-18 Canal.

HISTORY The town of Tequesta, on the north shore of the river, is named for the Tekesta tribe. However, this tribe occupied lands well to the south, primarily in what is now Miami-Dade County. The Jeaga tribe occupied land surrounding the river at the time of the arrival of the Spanish. During his explorations of the Florida coast, Ponce de León discovered Jupiter Inlet on April 21, 1513. In 1696, the barkentine *Reformation* wrecked on Jupiter Island, just north of the river mouth. Jonathan Dickenson's journal recalls the travels of the shipwrecked party up the east coast of Florida to St. Augustine. The Seminoles named the river Loxahatchee, meaning "river of turtles." Fort Jupiter, a stockade, was located on the lower river during the Second Seminole War. The Battle of Loxahatchee, an engagement of that war, was fought in 1838 in the vicinity of present-day Riverbend Park. Although the Seminoles were forced to retreat, they made a stand on the far side of the river. The battle is generally classed as a victory for federal troops; however, after inflicting a number of casualties most of the Seminoles simply disappeared into the wilderness. In 1860 the Jupiter Inlet Lighthouse was completed at the mouth of the river. George Mead designed this structure. He would later serve as a Union general in the Civil War. The historic Dubois house was construct-

The black-crowned night-heron is an opportunistic predator, consuming minnows, crabs, shrimp, lizards, frogs, and other small animals found along the margins of waterways.

ed near Jupiter Inlet in the 1890s atop a Native American shell mound.

HUMAN IMPACT The towns of Jupiter, Tequesta, Palm Beach Gardens, and Hobe Sound are located within the Loxahatchee watershed. While great efforts have been made to preserve the natural corridor surrounding the river, street runoff and suburban lawn runoff, as well as agricultural endeavors, have diminished water quality. This has been partially offset by strict storm water management practices. Septic tanks have been eliminated from many areas surrounding the river,

reducing potential sources of contamination. East of I-95, open portions of the river are lined with expensive homes, canals, and marinas. Excavation of the Jupiter Inlet, in the 1940s, permitted salt water to intrude into formerly freshwater portions of the river. The problem has been exacerbated by reductions in flow caused by the diversion of surface water. Water quality is generally good.

RECREATIONAL ACTIVITIES In 1985, the federal government designated the northwest fork a Wild and Scenic River. This fork is also a state-designated canoe trail. The canoe trail runs from Riverbend Park, on State Road 706 (Indiantown Road), to Jonathan Dickinson State Park, off of US 1. The 8-mile run, assisted by a gentle current, is considered easy. However, if water levels are low, several pullovers may be required. Guided boat tours are available at Jonathan Dickison State Park. This park, which contains more than 11,300 acres, provides visitors with opportunities for hiking, camping, bicycling, and fishing. Trapper Nelson's Cabin, located within the park, is the site of the home of a settler who

The peninsula turtle is numerous in the Loxahatchee River and in other Atlantic coastal rivers. While primarily aquatic, this turtle sometimes takes to land, and is often killed by vehicles when attempting to cross roadways.

lived on the river beginning in 1936. The lower river, although shallow in places, is navigable. Boat traffic may be heavy, especially on weekends. Snook fishing in the river estuary and inlet is outstanding.

FLORA AND FAUNA Cypress, pond apple, cabbage palm, swamp fern, and giant leather fern grow along the shoreline. Lower portions of the river and estuary are bordered by mangrove swamp. The Loxahatchee is home to the indigenous apple snail. However, in recent years two exotic snails, the channeled apple snail and the spike-topped apple snail, have appeared in this waterway. Alligators are plentiful. While these animals generally ignore paddlers, some caution is warranted. In 1993, an 11-foot alligator fatally attacked a 10-year-old boy who was wading in the river. Many birds are present in the area, including osprey, red-shouldered hawk, boat-tailed grackle, little blue heron, yellow-crowned night-heron, black-crowned night-heron, great blue heron, green-backed heron, and snowy egret. Anhingas are often seen drying their feathers in vegetation overhanging the river. The smooth-billed ani, a bird native to the Caribbean that has been present in Florida since the 1950s, is sometimes seen in the area. Raccoons frequent the banks and can become a nuisance to picnickers and others.

The sailfin molly (top left) and mosquitofish (bottom right) are common in small coastal rivers of south Florida. Both species can move between fresh and brackish water.

The glossy crayfish snake, although rarely seen, is present in the Loxahatchee River.

Miami River

Waterway Type: Small Coastal River
Substrate: Sludge, Mud
Ecological Condition: ★
Oversight: SFWMD
Designations: None
Length: 5.5 miles
Watershed: Uncertain

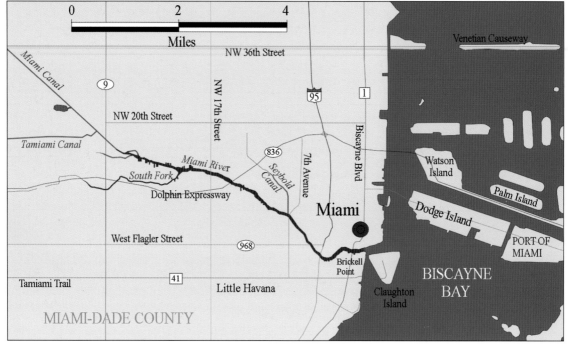

The Miami River, located in Miami-Dade County, flows in an easterly direction, discharging into Biscayne Bay. It is a highly modified waterway, encompassed within an urban setting. The lower reaches are used as a shipping channel and comprise Florida's fifth-largest seaport.

GEOGRAPHY AND HYDROLOGY The Miami River, in its original configuration, drained portions of the eastern Everglades. It was fed by seepage and runoff. The river branched into a north fork and a south fork about 4 miles west of the mouth. Rapids existed on both forks, where water from the Everglades tumbled across a limestone shelf. Another low gradient tributary, Wagner Creek, flowed in from the north close to the river mouth. Today, the lower 5.5 miles of the river consist of a navigable channel, hemmed in by sea walls, riprap, piers, and other structures.

Upper portions of the river have been fashioned into canals.

HISTORY The Tekesta people lived around the Miami River when the Spanish arrived in Florida. The name Miami is derived from *Mayaimi*, a Native American word believed to mean "large lake." In 1998, archaeologists discovered a prehistoric monument known as the Miami River Circle. This monument is thought to be between 1,700 and 2,000 years old. The Miami River Circle is carved into bedrock at Brickell Point, on the south bank of the river mouth. The Spanish built a blockhouse near the mouth of the river in 1567. The natives subsequently burned this fortification. A Jesuit mission, Santa María de Loreto, was established at the same location in 1743. During the Second Seminole War, Fort Dallas existed near the mouth of the river. Dade County

The Miami River looking north from the south bank. Although the river has been altered and degraded, it remains a fascinating destination. Vessels of nearly every conceivable description use this waterway.

was created in 1836 and was renamed Miami-Dade County in 1997. The city of Miami was incorporated in 1896. Flagler's east coast railroad reached the Miami River in 1896 and spurred development in the area. In 1909, excavation of the Miami Canal ended the natural flow of the river. This waterway connected the river to Lake Okeechobee, 85 miles to the northwest. Over the past several decades the Miami River has become a center of commerce with Caribbean nations.

HUMAN IMPACT The falls on the upper Miami River were dynamited in 1909. In 1935, the lower river was dredged to a 15-foot depth, allowing for the passage of commercial vessels. Pollution in the river has long been a problem. The Miami River received significant inflows of sewage until the late 1950s. Oil spills, bilge-water purges, and other forms of chemical pollution have occurred over the years. Bottom sediments are contaminated with chromium, mercury, copper, cadmium, and lead. Efforts to remove bottom sediments should improve water quality, both in the river and in Biscayne Bay. A comprehensive dredging project was started in 2004.

RECREATIONAL ACTIVITIES Although its character is industrial and many waterfront structures are dilapidated, the Miami River makes an interesting excursion for power boaters. Despite poor water quality, snook appear to be plentiful in the river.

FLORA AND FAUNA The Miami River does not provide any significant opportunity for wildlife viewing. Exotic iguanas may be seen sunning on concrete structures along the bank.

Recreational boats line portions of the South Fork of the Miami River.

New River

Waterway Type: Urbanized Coastal River
Substrate: Coral Rock, Silt
Ecological Condition: ★★
Oversight: SFWMD
Designations: None
Length: 11 miles
Watershed: Uncertain

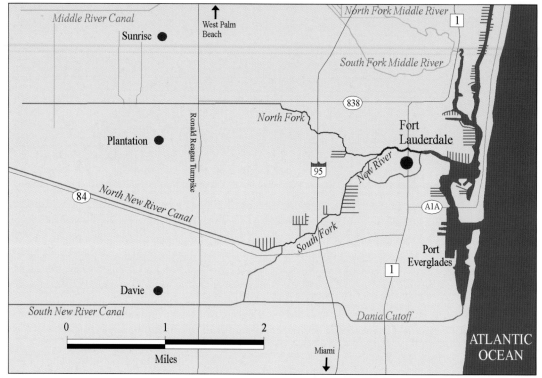

The New River, which runs through Fort Lauderdale, has been heavily modified. Nevertheless, it is colorful, historically significant, and home to many attractions. Along with adjacent waterways, it gives rise to an intricate maze of canals. This has led the city of Fort Lauderdale to proclaim itself the "Venice of America."

GEOGRAPHY AND HYDROLOGY Historically, the New River flowed from the Everglades east across the coastal ridge. It was a pristine stream, meandering through a cypress marsh. Two forks, the North Fork and the South Fork, merged about three miles west of the mouth. The river did not directly connect with the ocean, instead emptying into a coastal lagoon known as Lake Mabel.

As the result of an inlet excavated in the late 1920s, salt water and tidal influence extend westward to the upper reaches of the river. The water in most parts of the river is surprisingly clear, although trash, flotsam, and bottom sludge accumulates in some backwaters.

HISTORY Early residents along the river included the Glades Culture, followed by the Tekesta Indians. The Tekesta abandoned the area by the late 1700s. Seminoles settled along the river in the 1820s. During the Second Seminole War, in 1838, a fort was constructed along the river. It was named after Major William Lauderdale. The first fort was built at the junction of the South Fork and North Fork. Its replacement was built at Tarpon Bend. A subsequent Fort Lauderdale was

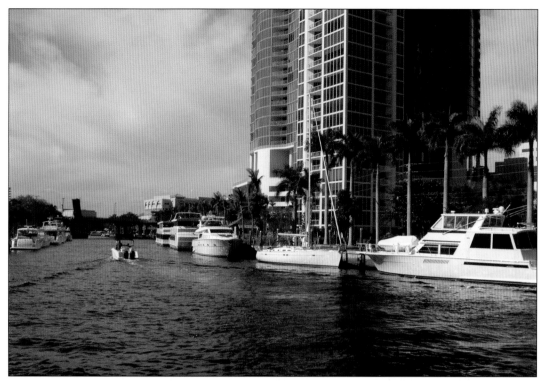

The New River passes through the heart of Fort Lauderdale. Boat traffic is often heavy.

built on the barrier island at present-day Bahia Mar. In the 1890s, a trading post was established at a ferry crossing over the New River. In 1901, Frank Stranahan, the proprietor, built a large structure at the site where US 1 now crosses the river. This house is still in existence and is the oldest structure in Fort Lauderdale. The Florida East Coast Railroad crossed the New River by 1896. The city of Fort Lauderdale was incorporated in 1911. Broward County was created in 1915 from northern portions of Dade County and southern portions of Palm Beach County.

HUMAN IMPACT In 1906, construction of the North New River Canal commenced, as part of the Everglades drainage project. The canal became operational in 1912. The South Fork was subsequently straightened, and the South New River Canal was extended westward to intersect with the Miami Canal, which links Miami to Lake Okeechobee. In 1928, a cut was excavated between Lake Mabel and the ocean, thus creating a deep-water harbor. Port Everglades has become an important cruise ship terminal and container cargo port. The New River passes through the heart of Fort Lauderdale. Much of the fresh water entering

the river comes from stormwater runoff. The banks are lined with seawalls, docks, residences, marinas, and other structures.

RECREATIONAL ACTIVITIES The primary recreational activity along the New River is boating. The river and its canals make a fascinating sightseeing cruise, with posh homes, manicured yards, mega-yachts, ocean racing boats, water taxis, restaurants, cityscapes, boat works, and other attractions. The river can accommodate large vessels. Boat traffic is often heavy. In the downtown area, Riverwalk Park provides access to shops, restaurants, bars, and entertainment. Old Fort Lauderdale Village, where the Florida East Coast Railway crosses the river, encompasses several historic buildings and a museum.

FLORA AND FAUNA Most vestiges of native wildlife long ago vanished from the banks of the New River. Snook, tarpon, and mullet still frequent the waters. A mangrove preserve, Secret Woods, is home to land crabs and wading birds. Some parts of the North Fork are still lined with pond apple, cypress, and giant leatherfern.

St. Lucie River

Type: Coastal River
Substrate: Sand, Silt
Ecological Condition: ★★
Oversight: SFWMD
Designations: AP (North Fork)
Length: 17 miles
Watershed: 775 square miles

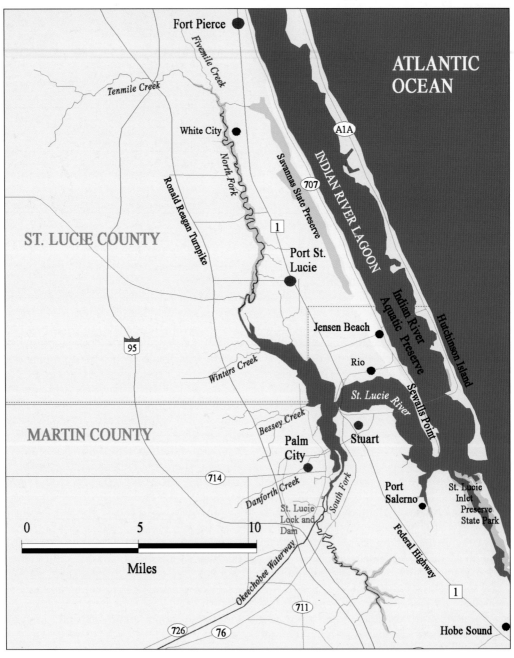

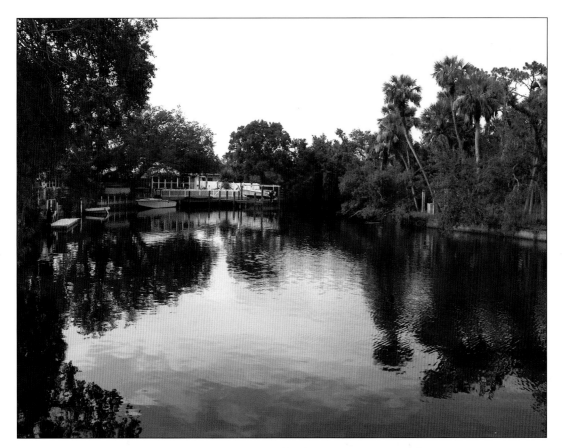

The South Fork of the St. Lucie as it appears just south of Route 76 (Kanner Highway).

The St. Lucie is a scenic river that is under intense pressure from development. Discharges from Lake Okeechobee and other sources have degraded water quality and harmed the once-rich estuary. Nevertheless, the river retains much of its original charm and offers unparalleled opportunities for boating and fishing.

GEOGRAPHY AND HYDROLOGY The St. Lucie drains parts of Martin and St. Lucie Counties. The North Fork and South Fork of this river are really two separate rivers that converge in a broad brackish estuary. The North Fork has its origins about 10 miles southwest of Fort Pierce. It begins at the confluence of Tenmile and Fivemile Creeks. These waterways drain agricultural land, primarily citrus groves and cattle ranches. The North Fork flows south for about 17 miles before it combines with waters of the South Fork.

The South Fork begins at the convergence of several tributaries 5 miles northwest of Hobe Sound. It meanders northward for about 11 miles through an extensive series of loops. It passes through wet hammocks, pine flatwoods, and residential communities. The South Fork merges with the Okeechobee Waterway in Palm City. The Okeechobee Waterway connects through locks to Lake Okeechobee and provides a navigation route across the state.

The North and South Forks unite just west of the Roosevelt Bridge (US 1) in Stuart. From there, they flow east, around Sewalls Point to the four corners area. There, the St. Lucie River intersects the Intracoastal Waterway. The St. Lucie discharges into the Atlantic Ocean through the St. Lucie Inlet.

HISTORY Prior to European settlement, the Jeaga people may have inhabited the area around the South Fork. The Guacata, a subtribe of the Ais, were present around other portions of the river. In 1566, the St. Lucie may have served as an outpost for men under the

A yellow-crowned night-heron stands among the fronds of a cabbage palm growing on the bank of the St. Lucie River.

Levin Powell and a group of Seminoles.

In 1880, Waveland was settled on a peninsula jutting out into the river. This settlement was later renamed Sewall's Point. The first settlers arrived in Stuart (originally known as Potsdam) in about 1883. By 1894, Henry Flagler's east coast railroad spanned the river at Stuart. During this period pineapples became an important commercial crop on lands surrounding the river. This industry was eliminated by a series of freezes and by competition from Cuba. The Okeechobee waterway, which connects the St. Lucie River with the Caloosahatchee River, was completed in 1937. The region received severe damage from hurricanes in 1928, 1933, and 1949. During 2004 and 2005 three hurricanes raked this area, causing moderate damage.

HUMAN IMPACT Water quality in the St. Lucie River and St. Lucie Estuary has declined markedly over recent decades. Nutrient-rich water from Lake Okeechobee is discharged over the Okeechobee Waterway Dam. These releases have caused extensive siltation in the river. They have also led to wild swings in the salinity of the estuary. The C-23 and C-24 canals also discharge nutrient-rich water into the estuary. Suburban sprawl with associated

leadership of Pedro Menéndez de Avilés. The Spanish abandoned this outpost in 1568 as a result of attacks by native people and supply problems. In 1696, following the wreck of the barkentine *Reformation* on Jupiter Island, the survivors traveled north along the coast toward St. Augustine. They were mistreated by a group of Native Americans in the vicinity of the St. Lucie Inlet, but were ultimately allowed to pass through the region. The 1715 Spanish Plate Fleet was destroyed by a hurricane in the area between the St. Lucie Inlet and the Sebastian Inlet. During the Second Seminole War, in 1838, the Palm City Depot was established on the South Fork. No traces of this structure have been located. During this same year a minor skirmish occurred on the North Fork, between men under navy lieutenant

The anhinga is very common in the St. Lucie River and estuary. Because this bird lacks oil glands, it spends considerable periods with wings outstretched, drying its feathers.

The cardinal air plant, a bromeliad, is sometimes spotted in riverside trees.

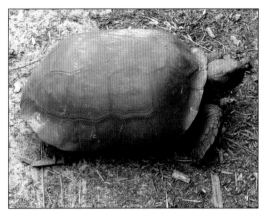

The gopher tortoise sometimes makes its burrow in sandy uplands around the St. Lucie River.

stormwater runoff has contributed to the problem. In 1972, approximately 10 miles of the North Fork were designated as an aquatic preserve.

RECREATIONAL ACTIVITIES Several miles of the South Fork and North Fork are navigable by powerboat. Brackish portions of the river provide excellent fishing for snook, tarpon, redfish, sheepshead, gray snapper, jack crevalle, and speckled sea trout.

FLORA AND FAUNA Undeveloped portions of the river are lined with stands of cabbage palm, pond apple, red maple, sand pine, and live oak. Brackish areas support extensive mangrove swamps. In some areas, exotic Brazilian pepper trees have crowded out native vegetation. Damselfies that may be found in the vicinity of this river include Rambur's forktail and variable dancer. Dragonflies include the blue dasher, Carolina saddlebags, Florida baskettail, eastern pondhawk, plateau dragonlet, hyacinth glider, wan-

dering glider, and eastern amberwing.

The river is home to several rare fish species such as the opossum pipefish, river goby, and slash-cheek goby. Native freshwater species found in the river include white catfish, brown bullhead, Florida gar, redear sunfish, warmouth, bowfin, American eel, golden shiner, coastal shiner, Seminole killifish, pirate perch, flagfish, and sailfin molly. Several exotic species have become established in this waterway, including the brown hoplo, suckermouth catfish, and black acara. Estuarine portions of the river were once home to huge sawfish, but populations have been wiped out through overfishing and habitat degradation. Turtles found in the St. Lucie include the southern softshell turtle, chicken turtle, Florida red-bellied turtle, and the southern diamondback terrapin. Manatees frequently enter the river and dolphins are common within the estuary.

St. Sebastian River

Waterway Type: Small Coastal River
Substrate: Mud, Silt
Ecological Condition: ★★
Oversight: SJRWMD
Designations: None
Length: 10 miles
Watershed: 154 square miles

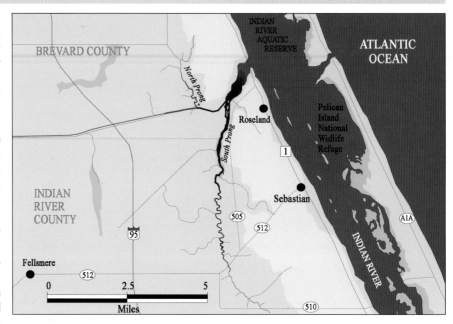

The St. Sebastian River, sometimes referred to as the Sebastian River or Sebastian Creek, is a small coastal river in east-central Florida. This river, like the St. Lucie River to the south, is under pressure from development and population growth.

GEOGRAPHY AND HYDROLOGY The St. Sebastian River consists of two prongs. The short North Prong flows toward the southeast. It forms from the confluence of several small tributaries and intersects the C-54 canal. The C-54 Canal runs from west to east along the boundary of Brevard and Indian River Counties. The South Prong flows from south to north, paralleling the Indian River Lagoon to the east. Where the two prongs meet, the river broadens considerably and flows eastward. Water in the lower river is brackish, and the shoreline is ringed with mangrove thickets. The St. Sebastian River empties into the Indian River Lagoon. The waters of the Indian River Lagoon are exchanged with those of the Atlantic Ocean through the Sebastian Inlet.

HISTORY At the time of the arrival of the Spanish, Ais Indians occupied the area around the river and most of the land west of the Indian River Lagoon. The 1715 Spanish Plate Fleet, laden with treasure, foundered in a hurricane along the coast adjacent to the mouth of the river. This river was referred to as St. Sebastian or San Sebastian in English maps of the 1770s. During the Second Seminole War, the mouth of the river was the campsite for a military expedition. On March 14, 1903, President Theodore Roosevelt established Pelican Island, just across the Indian River Lagoon from the mouth of the river, as the first federal bird reservation. In 1988, the United States Board on Geographic Names officially designated this river the St. Sebastian River, following a request by the Sebastian Area Historical Society.

HUMAN IMPACT Water quality in the St. Sebastian River has been adversely affected by several sources. Orange groves and other agricultural lands drain into western portions of the watershed. Ditching and water diversion activities have resulted in an increase in the amount of fresh water received by the St. Sebastian River. Much of this water is nutrient laden. The lower river intersects the city of Sebastian, with street runoff discharging into the river in some areas.

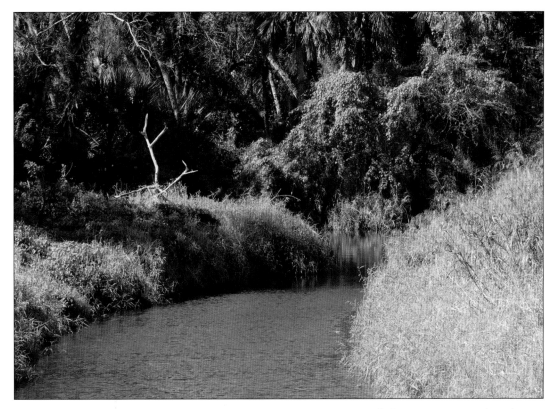

The St. Sebastian River near Fellsmere Road is a narrow stream. It nevertheless gives rise to a broad estuary before emptying into the Indian River.

Population growth and development have been rapid. Residences appear along much of the shoreline of the lower river. In 2006, a three-year dredging project was started, to remove silt that had accumulated in the lower river. While this project is likely to improve water quality, some biologists have expressed concern over its impact on rare fish species that inhabit the river.

RECREATIONAL ACTIVITIES St. Sebastian River Preserve State Park is located along the western shore of the river and encompasses about 22,000 acres. The lower river is navigable by powerboat. However, slow speeds are required as the river is part of a manatee protection zone. The South Prong is a fine stream for kayaking and canoeing with access at Dale Wimbrow Park in Roseland. Paddlers can proceed beyond the bridge of County Road 512. However, frequent pullovers may be required in the upper reaches of the river. The North Prong is also accessible by canoe.

FLORA AND FAUNA Shoreline vegetation includes golden club, roserush, wax myrtle, pickerelweed, and water pennywort. Cabbage palm, sand pine, saw palmetto, blackberry, flag pawpaw, and live oak occur on higher ground. However, exotic Brazilian pepper and other invasive species have a strong presence. Birds frequently seen include osprey, pelican, common moorhen, and anhinga. This river is home to the rare opossum pipefish, river goby, slash-cheek goby, and bigmouth sleeper. Common freshwater fish species include Florida gar, bowfin, white catfish, and various sunfish. Manatee and dolphin often enter lower reaches of the St. Sebastian River.

The brown pelican is a common sight along brackish portions of the St. Sebastian River.

References and Further Reading

Akersey, Harry Jr., Raymond Arsenault, and Gary R. Mormino. *The Stranahans of Fort Lauderdale: A Pioneer Family of New River* (The Florida History and Culture Series). Gainesville, FL: University Press of Florida, 2003.

Alabama Water Watch. *Rivers of Alabama.* Alabama Water Watch Association. www.riversofalabama.org

Barrios, Kristopher. *Choctawhatchee River Springs Inventory,* Special Report 05–02. Havana, FL: Northwest Florida Water Management District, 2005.

Barrios, Kristopher. *St. Marks and Wakulla River Springs Inventory,* Water Resources Special Report 06–03. Havana, FL: Northwest Florida Water Management District, 2006.

Barrios, Kristopher, and Angela Chelette. *Chipola River Springs Inventory,* Water Resources Special Report 04–01. Havana, FL: Northwest Florida Water Management District, 2004.

Barrios, Kristopher, and Angela Chelette. *Econfina Creek Spring Inventory,* Water Resources Special Report 04–02. Havana, FL: Northwest Florida Water Management District, 2004.

Bartlett, Richard D, and Patricia Pope Bartlett. *Florida's Snakes: A Guide to Their Identification and Habits.* Gainesville, FL: University Press of Florida, 2003.

Belleville, Bill. *River of Lakes: A Journey on Florida's St. Johns River.* Athens, GA: University of Georgia Press, 1999.

Benke, Arthur C., and Colbert E. Cushing, Eds. *Rivers of North America.* Burlington, MA: Elsevier Science & Technology Books (Academic Press), 2005.

Benshoff, P.J. *Myakka.* Sarasota, FL: Pineapple Press, 2002.

Todd Bertolaet. *Crescent Rivers: Waterways of Florida's Big Bend.* Gainesville, FL: University Press of Florida, 1999.

Blake, Nelson M. *Land into Water-Water into Land: A History of Water Management in Florida.* Gainesville, FL: University Presses of Florida, 1980.

Brown, Robin C. *Florida's First People: 12,000 years of Human History.* Sarasota, FL: Pineapple Press, 1994.

Brown, Robin C. *Florida's Fossils: Guide to Location, Identification and Enjoyment, Second Ed.* Sarasota, FL: Pineapple Press, 1996.

Bucker, George E. *Blockaders, Refugees, and Contrabands: Civil War on Florida's Gulf Coast, 1861–1865.* Tuscaloosa, AL: University of Alabama Press, 2004.

Burr, Brooks M., and Lawrence M. Page. *A Field Guide to Freshwater Fishes: North America North of Mexico* (Peterson Field Guides). Boston, MA: Houghton Mifflin, 1998.

Butcher, Clyde. *Apalachicola River: An American Treasure.* Gainesville, FL: University Press of Florida, 2006.

Champion, Kyle M. and Roberta Starks. *The Hydrology and Water Quality of Springs in West Central Florida.* Brooksville, FL: Southwest Florida Water Management District, Water Quality Monitoring Program. http://www.swfwmd.state.fl.us/documents/reports/springs.pdf

Comprehensive Everglades Restoration Plan 2003 Annual Report: Central and Southern Florida Project. South Florida Water Management District and Florida Department of Environmental Protection, 2004.

Conant, Roger, and Joseph T. Collins. *A Field Guide to Reptiles and Amphibians of Eastern and Central North America* (Peterson Field Guide Series), 4th Ed. Boston, MA: Houghton Mifflin 1998.

Copeland, R. *Florida Spring Classification System and Spring Glossary* (Special Publication No. 52). Tallahassee, FL: Florida Geological Survey, 2003.

Cushing, Cobert E., and J. David Allen. *Streams: Their Ecology and Life.* Burlington, MA: Elsevier Science & Technology Books (Academic Press), 2001.

DeLorme (Ed.). *Alabama Atlas and Gazetteer.* Yarmouth, ME: DeLorme, 2000.

DeLorme (Ed.). *Florida Atlas and Gazetteer,* 7th Ed. Yarmouth, ME: DeLorme, 1999.

DeLorme (Ed.). *Georgia Atlas and Gazetteer ,* 4th Ed. Yarmouth, ME: DeLorme, 2003.

Dunkle, Sidney W. *Dragonflies through Binoculars: A Field Guide to Dragonflies of North America.* New York, NY: Oxford University Press, 2000.

Eidse, Faith, Ed. *Voices of the Apalachicola.* Gainesville, FL: University Press of Florida (2006).

Ernst, Carl H., Roger W. Barbour, Jeffrey E. Lovich. *Turtles of the United States and Canada.* Washington, DC: Smithsonian Books, 1994.

Fernald, Edward A., and Elizabeth D. Purdum. *Water Resources Atlas of Florida.* Tallahassee, FL: Institute of Science and Public Affairs, Florida State University, 1998.

Follman, Joe, and Richard Buchanan. *Springs Fever, A Field and Recreation Guide to Florida Springs.* http://fn1.tfn.net/springs/

Gannon, Michael V., Ed. *The New History of Florida.* Gainesville, FL: University Press of Florida, 1996.

Gilbert, Carter R., Ed. *Rare and Endangered Biota of Florida, Volume II, Fishes,* Rev. Ed. Gainesville, FL: University Press of Florida, 1992.

Gore, Jeffery A., and Carl R. Studenroth Jr. *Status and Management of Bats Roosting in Bridges in Florida.* Research Project #BD433. Tallahassee, FL: Florida Department of Transportation, 2005.

Hann, John. *Apalachee: The Land Between the Rivers.* Gainesville, FL: University of Florida Press, 1988.

Hedgepeth, Marion, and Richard Roberts. *Preliminary Report on the Riverine and Tidal Floodplain of the Loxahatchee River and its Major Tributaries, 2006.* South Florida Water Management District, Coastal Ecosystem Division and Florida Department of Environmental Protection, Florida Park Service, District 5, 2006.

Huff, Sandy. *Paddler's Guide to the Sunshine State.* Gainesville, FL: University Press of Florida, 2001.

Hunt, Bruce. *Visiting Small Town Florida,* Rev. Ed. Sarasota, FL: Pineapple Press, 2003.

Johnson, Greg. *The Florida Springs Database and Florida Springs Overview.* http://www.thiswaytothe.net/springs/

Kale, Herbert W. II, and David S. Maehr. *Florida's Birds: A Handbook and Reference, Second Edition.* Sarasota, FL: Pineapple Press, 2005.

Kinder, Larry. *Flyfisher's Guide to Freshwater Florida.* Belgade, MT: Wilderness Adventure Press, 2003.

Knetsch, Joe. *Florida's Seminole Wars 1817–1858.* (Making of America). Mount Pleasant, SC: Arcadia Publishing, 2003.

Lane, E. *Florida's Geological History and Geological Resources.* Special Publication No. 35. Tallahassee, FL: Florida Geological Survey 1994.

Latvis, Joseph, Ed. *Aucillla River Times,.* Aucilla River Prehistory Project, Vol. X, No. 1, April 1997; Vol XI, No. 1, March, 1998; Vol. XII,

No. 1, May, 1999. http://www.flmnh.ufl.edu/natsci/vertpaleo/arpp.htm

Livingston, Robert J. *The Rivers of Florida* (Ecological Studies 83). New York, NY: Springer-Verlag, 1990.

Macmahon, Darcie A. and William H. Marquardt. *The Calusa and Their Legacy: South Florida People and Their Environments.* Gainesville, FL: University Press of Florida, 2004.

Mahon, John K. *History of the Second Seminole War, 1835–1842.* Gainesville, FL: University Press of Florida, 1991.

Marth, Del, and Marty Marth, Eds. *The Rivers of Florida.* Sarasota, FL: Pineapple Press, 1990.

McCarthy, Kevin M. *Apalachicola Bay.* Sarasota, FL: Pineapple Press, 2004.

McCarthy, Kevin M. *St. Johns River Guidebook.* Sarasota, FL: Pineapple Press, 2004.

McEwan, Bonnie G. *The Spanish Missions of La Florida.* Gainesville, FL: University Press of Florida, 1993.

Milanich, Jerald T. *Florida Indians and the Invasion from Europe.* Gainesville, FL: University Press of Florida, 1995.

Milanich, Jerald T. *Florida's Indians from Ancient Times to the Present.* Gainesville, FL: University Press of Florida, 1998.

Milanich, Jerald T., and Charles M. Hudson. *Hernando de Soto and the Indians of Florida.* Gainesville, FL: University Press of Florida, 1993.

Minno, Marc C., Ph.D., Stephen J. Miller, Kimberli J. Ponzio. *Assessing the Potential Occurrence of Rare, Threatened, and Endangered Species in the Upper St. Johns River Basin,* Technical Publication SJ2001-3. Palatka, FL: St. Johns River Water Management District, 2001.

Moler, Paul E., Ed. *Rare and Endangered Biota of Florida: Amphibians and Reptiles,* 2nd Ed. Gainesville, FL: University Press of Florida, 1992.

Molloy, Johnny, Elizabeth F. Carter, John Pearce, Lou Glaros, Doug Sphar. *A Canoeing and Kayaking Guide to Florida.* Birmingham, AL: Menasha Ridge Press, 2005.

Morris, Theodore. *Florida's Lost Tribes.* Gainesville, FL: University Press of Florida, 2004.

Myers, Ronald L., and John J. Ewel, Eds. *Ecosystems of Florida.* Orlando, FL: University of Central Florida Press, 1990.

Nelson, Gil. *The Trees of Florida.* Sarasota, FL: Pineapple Press, 1994.

Newson, Malcom. *Land, Water and Develop-*

ment: *Sustainable Management of River Basin Systems, Second Edition.* New York, NY: Routledge, 1997.

Northwest Florida Water Management District. *The Big Picture, Looking at The Choctawhatchee River and Bay.* http://www.nwfwmd.state.fl.us/pubs/big_ picture/chocktawhatchee.pdf

Northwest Florida Water Management District. *Econfina Creek, Looking at the Big Picture.* http://www.nwfwmd.state.fl.us/pubs/big_ picture/Econfina_Creek.pdf

Northwest Florida Water Management District. *Looking at The Big Picture, The St. Marks River Watershed.* http://www.nwfwmd.state. fl.us/pubs/big_picture/st_marks.pdf

Northwest Florida Water Management District. *Looking at The Big Picture, The Pensacola Bay Watershed.*http://www.nwfwmd.state.fl. us/pubs/big_picture/pensacola.pdf

Northwest Florida Water Management District. *The Big Picture. The St. Andrew Bay Watershed Including St. Joseph Bay.* http://www.nwfwmd.state.fl.us/pubs/big_ picture/st_andrew_bay.pdf

Osburn, William, David Toth, and Don Boniol. *Springs of the St. Johns River Water Management District.* Palatka, FL: St. Johns River Water Management District, 2006.

Paige, Emeline K., Ed. *History of Martin County.* Martin County Historical Society, reprinted Florida Classics Library (1975).

Petrides, George A. *Field Guide to Eastern Trees: Eastern United States and Canada, Including the Midwest, Second Edition* (Peterson Field Guides). Boston, MA: Houghton Mifflin, 1998.

Peyton, Daniel W. *Sovereignty Lands in Florida: It's All About Navigability.* Column, *Florida Bar Journal,* Tallahassee, FL: The Florida Bar, January, 2002.

Pratt, Thomas R,. Christopher J. Richards, Katherine A. Milla, Jeffry R. Wagner, Jay L. Johnson and Ross J. Curry. *Hydrogeology of the Northwest Florida Water Management District, Water Resources Special Report 96-4.* Havana, FL: Northwest Florida Water Management District. http://www.nwfwmd. state.fl.us/pubs/hydrogeo/gwhydro.pdf

Purdum, Elizabeth D. *Florida Waters: A Water Resources Manual from Florida's Water Management Districts.* State of Florida, Water Management Districts, 2002.

Randazzo, Anthony F., and Douglas S. Jones, Eds.

The Geology of Florida. Gainesville, FL: University Press of Florida, 1997.

Reimer, Monica K. *Historic Protection for Florida's Navigable Rivers and Lakes,* Article, *Florida Bar Journal,* The Florida Bar, Tallahassee, April, 2001.

Renz, Mark. *Fossiling in Florida: A Guide for Diggers and Divers.* Gainesville, FL: University Press of Florida, 1999.

Renz, Mark. *Megalodon: Hunting the Hunter.* Lehigh Acres, FL: Paleo Press, 2002.

Ryan, Patricia, Paul Thorpe, Christine Stafford, Ron Bartel, Tyler Macmillan, Duncan Cairns, and Karen Horowitz, Eds. *St. Andrew Bay Watershed Surface Water Improvement and Management Plan, 2000, Program Development Series 00-02.* http://www. nwfwmd.state.fl.us/pubs/sabswim/sab-swimf/pdf

St. Johns River Water Management District. *Upper St. Johns Basin Program Overview.* http://www.sjr.state.fl.us/programs/acq_restoration/s_water/usjr/overview.html

St. Johns River Water Management District. *Upper St. Johns River Basin Project Fact Sheet.* http://www.sjr.state.fl.us/programs/outreach/pubs/order/pdfs/fs_usjrbproject.pdf

St. Johns River Water Management District. *St. Johns River General and Historical Facts Fact Sheet.* http://www.sjr.state.fl.us/programs/outreach/pubs/order/pdfs/fs_stjohnsriver.pdf

St. Johns River Water Management District. *The St. Marys River Guide.* http://www.sjr.state.fl.us/programs/outreach/pubs/smr_guide/smr_guide.html

St. Johns Water Management District. *Watershed Facts 02233200 (Little Econlockhatchee River); 20010137 (Little Wekiva River); 19020002 (Nassau River); NRI (Nassau River); 20020012 (Ocklawaha River); ORD (Ocklawaha River); PEL (Pellicer Creek); 20010002 (St. Johns River); 20030157 (St. Johns River); 20030373 (St. Johns River); 19010001 (St. Marys River); MPS (St. Marys River); SSR (Silver River); 27010579 (Tomoka River); 27010024 (Tomoka River); 02235000 (Wekiva River).* http://www.sjr.state.fl.us/archyrdo/factsindex.html

St. Johns River Water Management District, Upper St. Johns River Basin Surface Water Improvement and Management Plan, Draft. Palatka, FL: St. Johns River Water Management District, 2006.

St. Marys River Management Plan. Folkston, GA:

St. Marys River Management Committee, 2003.

Scott, Thomas M., Guy H. Means, Rebecca P. Meegan, Ryan C. Means, Sam B. Upchurch, R. E. Copeland, James Jones, Tina Roberts, and Alan Willet. *Springs of Florida*, Bulletin 66. Tallahassee, FL: Florida Geological Survey, 2004.

Sherrod, John P., and Eugene C. Beckham. *A Field Guide to Freshwater Fishes: North America North of Mexico, Second Edition* (Peterson Field Guides). New York, NY: Houghton Mifflin, 1998.

Snyder, James D. *Five Thousand Years on the Loxahatchee: A Pictorial History of Jupiter-Tequesta, Florida.* Jupiter, FL: Pharos Books, 2003.

Snyder, James D. *Life and Death on the Loxahatchee: The Story of Trapper Nelson.* Jupiter, FL: Pharos Books, 2004.

South Florida Water Management District. *Caloosahatchee Watershed Management Plan, April 2000.* http://www.sfwmd.gov/org/exo/cwmp/final/cplan.html

South Florida Water Management District. *Focus on the St. Lucie River*, Brochure, 1999.

South Florida Water Management District. *Kissimmee River Restoration Studies*, Executive Summary and Planning Documents, Volume I and Volume II; West Palm Beach, FL: South Florida Water Management District, 2006.

Southwest Florida Water Management District. *Charlotte Harbor SWIM Plan, 2000.* http://www.swfwmd.state.fl.us/documents/plans/charlotte_harbor_2000.pdf

Southwest Florida Water Management District. *Crystal River/Kings Bay SWIM Plan, 2000.* http://www.swfwmd.state.fl.us/documents/plans/crystal_river-kings_bay_2000.pdf

Southwest Florida Water Management District. *Rainbow River SWIM Plan, 2004.* http://www.swfwmd.state.fl.us/documents/plans/rainbow_river_2004.pdf

Southwest Florida Water Management District. *Tampa Bay SWIM Plan, 1999.* http://www.swfwmd.state.fl.us/documents/plans/tampabay_1998.pdf

Southwest Florida Water Management District. *Alafia River Comprehensive Management Plan, 2001.* http://www.swfwmd.state.fl.us/documents/plans/cwm/cwm-alafiariver.pdf

Southwest Florida Water Management District. *Hillsborough River Comprehensive Manage-ment Plan, 2000.* http://www.swfwmd.state.fl.us/documents/plans/cwm/cwm-hillsboroughriver.pdf

Southwest Florida Water Management District. *Little Manatee River Comprehensive Management Plan, 2002.* http://www.swfwmd.state.fl.us/documents/plans/cwm/cwm-littlemanateeriver.pdf

Southwest Florida Water Management District. *Manatee River Comprehensive Management Plan, 2001.* http://www.swfwmd.state.fl.us/documents/plans/cwm/cwm-manateeriver.pdf

Southwest Florida Water Management District. *Myakka River Comprehensive Management Plan, 2004.* http://www.swfwmd.state.fl.us/documents/plans/cwm/cwm-myakkariver.pdf

Southwest Florida Water Management District. *Peace River Comprehensive Management Plan, 2001* (Parts 1 and 2). http://www.swfwmd.state.fl.us/documents/plans/cwm/cwm-peaceriverpart1.pdf and http://www.swfwmd.state.fl.us/documents/plans/cwm/cwm-peaceriverpart2.pdf

Southwest Florida Water Management District. *Tampa Bay/Anclote River Comprehensive Management Plan, 2002.* http://www.swfwmd.state.fl.us/documents/plans/cwm/cwm-tampabayanclote.pdf

Southwest Florida Water Management District. *Withlacoochee River Comprehensive Management Plan, 2001.* http://www.swfwmd.state.fl.us/documents/plans/cwm/cwm-alafiariver.pdf

Stewart, Laura, and Susanne Hupp. *Historic Homes of Florida.* Sarasota, FL: Pineapple Press, 1995.

Swart, Jan M., *Rediscovering Tanner's Woodpecker, Reflections on the Survival of the Ivory Bill.* http://www.birdingamerica.com/Ivorybill/ivorybilledwoodpecker.htm.

Tebeau, Charlton W. *History of Florida.* Miami, FL: University of Miami Press, 1980.

Thoemke, Kris. *Fishing Florida.* A Falcon Guide, Globe Pequot Press, 1995.

Thompson, Fred. *An Identification Manual for the Freshwater Snails of Florida.* www.flmnh.ufl.edu/natsci/malacology/fl-snail/SNAILS1.htm

Thorpe, Paul, Ferdouse Sultana, and Christine Stafford. *Choctawhatchee River and Bay System Surface Water Improvement and Management Plan, 2002 Update, Program Development Series 05-02.* Havana, FL:

Northwest Florida Water Management District. http://www.nwfwmd.state.fl.us/pubs/chocswim/chockswim.pdf

Thorpe, Paul, Ron Bartel, Patricia Ryan, Kari Albertson, Thomas Pratt, and Duncan Cairns. *Pensacola Bay System Surface Water Improvement and Management Plan,1997, Program Development Series 97-2*. Havana, FL: Northwest Florida Water Management District.http://www.nwfwmd.state.fl.us/pubs/swimpens/pbswim/pdf

Thurlow, Sandra Henderson. *Historic Jensen and Eden on Florida's Indian River*. Stuart, FL: Sewall's Point Company, 2004.

Thurlow, Sandra Henderson. *Sewall's Point: The History of a Peninsular Community on Florida's Treasure Coast*. Stuart, FL: Sewall's Point Company, 1992.

Thurlow, Sandra Henderson. *Stuart on the St. Lucie: A Pictorial History*. Stuart, FL: Sewall's Point Company, 2001.

United States Environmental Protection Agency. *Surf your Watershed*. http://cfpub.epa.gov/surf/locate/map2.cfm

Walsh, John P. *Spanish Missions in La Florida*. http://flspmissions.tripod.com/

Whitney, Eleanor Noss, D. Bruce Means, Anne Rudloe, and Erick Jadaszewski. *Priceless Florida: Natural Ecosystems and Native Species*. Sarasota, FL: Pineapple Press, 2003.

Willoughby, Lynn. *Fair to Middlin': The AnteBellum Cotton Trade of the Apalachicola/Chattahooche (I.E. Chatta-hoochee) River Valley*. Tuscaloosa, AL: University of Alabama Press, 1993.

Williams, Winston. *Florida's Fabulous Canoe and Kayak Trail Guide*. Hawaiian Gardens, CA: World Publications, 2006.

Woodley, John Paul Jr., Assistant Secretary of the Army, Public Works, and P. Lynn Scarlett, Deputy Secretary of the Interior. *Central and Southern Florida Comprehensive Everglades Restoration Plan 2005 Report to Congress*. U.S. Army Corps of Engineers, U.S. Department of the Interior, 2005.

Wright, Albert, and Anna Allen Wright. *Handbook of Snakes of the United States and Canada*, New Edition. Ithaca, NY: Comstock Publishing, 1994.

Index

Page numbers in boldface indicate photographs.

Here are some other books from Pineapple Press on related topics. For a complete catalog, write to Pineapple Press, P.O. Box 3889, Sarasota, Florida 34230-3889, or call (800) 746-3275. Or visit our website at www.pineapplepress.com.

St. Johns River Guidebook by Kevin M. McCarthy. From any point of view—historical, commercial, or recreational—the St. Johns River is the most important river in Florida. This guide describes the history, major towns and cities along the way, wildlife, and personages associated with the river. You'll go by Sanford and Georgetown, Palatka and Orange Park. And at the mouth of the river, you'll encounter the metropolis of Jacksonville and the Naval Station in Mayport. (pb)

Myakka by Paula Benshoff. Discover the story of the land of Myakka. This book takes you into shady hammocks of twisted oaks and up into aerial gardens, down the wild and scenic river, and across a variegated canvas of prairies, piney woods, and wetlands—all located in Myakka River State Park, the largest state park in Florida. Each adventure tells the story of a unique facet of this wilderness area and takes you into secret places it would take years to discover on your own. (pb)

Priceless Florida by Ellie Whitney, D. Bruce Means, and Anne Rudloe. An extensive guide (432 pages, 800 color photos) to the incomparable ecological riches of this unique region, presented in a way that will appeal to young and old, laypersons and scientists. Complete with maps, charts, and species lists. (hb, pb)

Florida Magnificent Wilderness: State Lands, Parks, and Natural Areas by James Valentine and D. Bruce Means. Photographer James Valentine has captured environmental art images of the state's remote wilderness places. Valentine also offers his poetic interpretations of the meaning of his images. Dr. D. Bruce Means has written the main text, "Florida's Rich Biodiversity." The book is divided into six sections, covering the wildlife and natural ecosystems of Florida, with the introduction to each written by a highly respected Florida writer and conservationist, including Al Burt, Manley Fuller, Steve Gatewood, D. Bruce Means, Victoria Tschinkel, and Bernie Yokel. (hb)

Florida's Birds, 2nd Edition by David S. Maehr and Herbert W. Kale II. Illustrated by Karl Karalus. This new edition is a major event for Florida birders. Each section of the book is updated, and 30 new species are added. Also added are range maps for certain species and color coded guides to months when the bird is present and/or breeding in Florida. Now with color throughout, each bird is illustrated three times: with the text about the bird, in the index listing, and on a plate with similar species for help in identification. (pb)

The Springs of Florida by Doug Stamm. Take a guided tour of Florida's fascinating springs in this beautiful book featuring detailed descriptions, maps, and rare underwater photography. Learn how to enjoy these natural wonders while swimming, diving, canoeing, and tubing. (hb, pb)